Black Artists in British Art

Eddie Chambers is an associate professor in the department of Art and Art History at The University of Texas at Austin, where he teaches the art history of the African Diaspora.

Eddie Chambers' *Black Artists in British Art* is a breathtaking *tour de force*. Brilliantly conceptualised, beautifully written and inspirationally theorised, this volume's seminal contribution to art history is unparalleled. Tracing the lives and works of Black British painters, sculptors, photographers, mixed-media, and installation artists over a vast time-frame, Chambers' book sheds unprecedented light on a myriad of social, political, historical, philosophical, cultural and artistic contexts. A spectacularly well-researched and stunningly original volume, *Black Artists in British Art* is an exemplary scholarly feat, essential for researchers, students and general audiences alike, and one which offers yet further confirmation of Chambers' reputation as the leading international scholar of his generation.

Celeste-Marie Bernier,
Professor of African-American Studies,
University of Nottingham.

BLACK ARTISTS IN BRITISH ART

A HISTORY SINCE THE 1950S

EDDIE CHAMBERS

I.B. TAURIS

LONDON · NEW YORK

For Jane and Emilia

Published in 2014 by
I.B.Tauris & Co. Ltd
London • New York
Reprinted 2015, 2017
www.ibtauris.com

ISBN: 978 1 78076 272 2
eISBN: 978 0 85773 608 6

A full CIP record for this book is available from the British Library
A full CIP record for this book is available from the Library of Congress

Library of Congress Catalog Card Number available

Typeset in Stempel Garamond by Ellipsis Digital Limited, Glasgow
Printed and bound by CPI Group (UK) Ltd, Croydon, CR0 4YY

Contents

List of Illustrations

Image credits as follows:

1. *'effigy of Joseph Johnson'*, John Thomas Smith, 1815
2. Yinka Shonibare, Trafalgar Square Fourth Plinth unveiling, May 2010, photograph by Geoff Pugh, © Telegraph Media Group Limited
3. *Bird that Never Was* (1964) photograph by George W. Hales, © Hutton Archive/ Getty Images
4. Aubrey Williams, *Arawak*, 1959, oil on canvas, 61 x 76 cm, private collection © Estate of Aubrey Williams. All rights reserved, DACS 2013
5. Francis Newton Souza, *Negro in Mourning*, 1957, oil on hardboard, 122 x 61 cm, © Estate of F N Souza and © Birmingham Museums Trust, All rights reserved, DACS 2013
6. Anwar Shemza, *The Wall*, 1958, oil on board, 60 x 44.5 cm, © Birmingham Museums Trust and © Mrs Mary Shemza
7. Vanley Burke, Africa Liberation Day rally, Handsworth Park, Handsworth, Birmingham, 1977, photograph, © Vanley Burke
8. *Caboo: The Making of a Caribbean Artist*, *Race Today*, February 1975, magazine cover, © Darcus Howe
9. Uzo Egonu, *Piccadilly Circus*, 1969, oil on canvas, 82 x 115 cm © Mrs Hiltrud Egonu
10. Catalogue cover for *Caribbean Art Now*, Commonwealth Institute, London, 17 June – 4 August 1986. Cover: *Whispers in the Rain Forest*, Kenwyn Crichlow (b. Trinidad and Tobago, 1951, studied at Goldsmiths College, London) © Kenwyn Crichlow
11. Errol Lloyd, drawing for Walter Rodney, *The Groundings with my Brothers*, Bogle L'Ouverture Publications, London, 1969, book cover © Errol Lloyd
12. Tam Joseph, *Spirit of the Carnival*, 1988, screenprint, 77 x 86.5 cm, private collection © Tam Joseph
13. Winston Branch, *West Indian*, 1973, oil on canvas, 105 x 90.2 cm, Rugby Art Gallery and Museum Art Collections © Winston Branch
14. Denzil Forrester, *Police in Blues Club*, 1985, oil on canvas, 214 x 365 cm © Denzil Forrester
15. Eugene Palmer, *Our Dead*, 1993, oil on canvas, 102 x 120 cm, private collection (after a photograph by early 20th century African-American photographer, Richard Samuel Roberts) © Eugene Palmer
16. Chila Kumari Burman, *Auto-Portrait*, 1995-2014, Mixed Media Individual Pigment Print on Hahnemuhle Fine Art Paper, embellished with Rhinestones 118 x 84.1 cm © Chila Kumari Burman
17. Shaheen Merali, *PG Tips: 80 Exploitation Flavour Flow Tea Bags*, 1989, batik on khadi (an Indian homespun cotton cloth), 143 x 98 cm © Shaheen Merali

Note

In this study, the issue of upper-case B or lower-case b in the writing of the word 'Black/black' is of some importance. The use of the word 'black' as an adjective, noun, or racial descriptive has a history marked by contention and strategizing. There is, firstly, the matter of identifying a single word to effectively describe what is in effect a disparate range of groups and individuals. Secondly there is the equally vexing issue of the continuing evolution of the word 'black' and the continued ways in which it means different things to different people. To these issues can be added the matter of whether or not the word 'black' should be capitalized.

In a footnote to her foreword to the catalogue accompanying the ICA exhibition *Mirage: Enigmas of Race, Difference and Desire* (1995), Gilane Tawadros signalled the editorial and curatorial struggles that had revolved around 'the use of the word black and indeed its spelling.'[1] Tawadros and her colleagues were faced with the task of collectively describing a particularly disparate grouping of artists. As Tawadros wrote, 'One contentious issue raised many times within this publication is the use of the word black and indeed its spelling. Many terms or expressions could have been used throughout this publication. The general editorial position has been to use the term 'black' (with a lower case b) as referring to peoples of African, Asian, South East Asian, Latino (Puerto Rican, Mexican, Cuban) or Native American descent.'[2]

This particular study – Black Artists in British Art - has also used 'Black', but with an upper case B, to refer to individuals and communities of African, African-Caribbean and South Asian background, though as Gen Doy has noted, "Black with an upper case B has tended to be used to refer to Black as a proudly chosen identity, history and culture associated with African roots, distinguishing the term from a simple adjective 'black' describing colour."[3]

To a certain extent, the British use of the term 'Black' takes its cue from an earlier, American usage. In the US, *Black*, as a designation for Americans

of African descent, became both widely used and accepted in the 1960s and 1970s, supplanting the somewhat discredited and archaic term 'Negro'. As with 'Negro', spelled with a capital N, there were those who insisted on, or preferred to capitalize, 'Black', regarding such an act as both a statement of empowerment and a demand for respect. Unlike the US however, 'black'/'Black' now exists, in Britain, within a largely accepted trans-racial usage, perhaps akin to the term 'AfroAsian' championed by Rasheed Araeen.

Emphatic determinations of these intriguing matters continue to evade us, particularly when 'black'/'Black' year on year, gains ever-greater complexities. In recent years, the term 'ethnic minority' has given way to 'minority ethnic', which in turn has evolved into the arguably particularly peculiar term BME – Black and Minority Ethnic. Several decades ago, certain Black people happily described themselves (and were in turn described) as 'coloured'. A somewhat generational shift saw the introduction of the term 'Afro-Caribbean', which in turn gave way to 'Black', and 'African-Caribbean'. In some instances, these designations were loaded with particular nuances when coming from spaces such as governmental bureaucracy or journalistic designation. (Few people, one imagines, would describe themselves as BME, unless required to do so on such things as censuses or monitoring forms). But when coming from a space of personal, individual or group empowerment, terms such as *Black* were, and indeed are, loaded with altogether different, though not uncomplicated, nuances.

The reader will likely notice that, throughout this text, I choose to write 'Black' with a capital B and this has been retained throughout, except in direct quotations in which the word 'Black' or 'black' has been left as it was originally written.

Acknowledgements

In researching and writing this book, I have incurred a number of debts of gratitude. I would, in the first instance, like to thank Philippa Brewster, of I.B. Tauris, for taking such a pronounced interest in my original proposal. I would similarly like to thank Anna Coatman and Lisa Goodrum, also of I.B. Tauris, who subsequently guided the project with great diligence. My profound thanks and gratitude are extended to my friend and colleague Richard Hylton, whose comments and suggestions did much to both enhance my manuscript and reassure me. From the other side of the Atlantic he responded to my numerous requests for information and references, with both patience and assiduity. I am particularly grateful to Stephen Cashmore, my sub-editor, whose rigour, objectivity and proficiency have improved the flow of this book enormously. Stephen gave my manuscript an extraordinarily close reading and in so doing, significantly enhanced the text. I came to value, and indeed, rely on his suggested revisions. In similar regard I thank Ricky Blue, for diligently guiding the manuscript in its final stages.

In identifying and sourcing images for this book, many individuals are to be thanked. Not for the first time, my profound thanks to Dawn O'Driscoll, Syndication Account Manager of the Telegraph Media Group, who provided me with a number of portraits of Yinka Shonibare for my consideration. I am, as ever, grateful to her. Rebecca Mei of Jack Shainman Gallery responded to my requests with speed, efficiency, and remarkable generosity. Lucy Kelly and several of her colleagues at Getty Images facilitated in my plans to use the Ronald Moody photogrpah that appears in this study. Domniki Papadimitriou, of Birmingham Museums Trust likewise facilitated my access to, and use of the Anwar Shemza and Francis Newton Souza paintings that are reproduced in this book. Mrs Hiltrud Egonu, Mrs Brenda Locke and Mrs Mary Shemza must be thanked, particularly for the diligence with which they responded to my approaches. Diane Symons was again characteristically generous in granting me permission to reproduce an image of one of Donald Rodney's works. I

would be remiss in not thanking Victoria Avery, Acquisitions Coordinator, Arts Council Collection, for guiding me through my use of Mowbray Odonkor's *Onward Christian Soldiers*. In similar regard, Jessica Litherland, Senior Exhibitions Officer, Rugby Art Gallery and Museum guided me through my use of Winston Branch's *West Indian*, and Sara Manco, Photo Services, Eliot Elisofon Photographic Archives at the Smithsonian National Museum of African Art who advised me about the use of the Sokari Douglas Camp image reproduced in this book. There would be one or two gaps in the range of images reproduced in this study, had it not been for the hard work of Amy English, Licensing Administrator of the Design and Copyright Society (DACS).

I need to thank the following artists and photographers, listed alphabetically, all of whom granted me generous and unrestricted permission to reproduce images of their work: Faisal Abdu'Allah, Said Adrus, Hurvin Anderson, Zarina Bhimji, Sonia Boyce, Winston Branch, Vanley Burke, Chila Kumari Burman, Romano Cagnoni, Sokari Douglas Camp, Kenwyn Crichlow, Godfried Donkor, Kimathi Donkor, Mary Evans, Denzil Forrester, Tam Joseph, Permindar Kaur, Shaheen Merali, Eugene Palmer, and Barbara Walker.

I thank Juginder Lamba for the swift and generous way in which he responded to a query. Since writing my doctoral dissertation in the 1990s it has been my hope to dialogue with Sue Smock, a fascinating US-born artist referenced in this study. When finally I was able to reach her, she was every bit as generous and engaging as I had hoped she would be. In seeking to reach Sue Smock, I must pay respects to Mora Beauchamp-Byrd, and William A. Fagaly, the Francoise Billion Richardson Curator of African Art, New Orleans Museum of Art, who helped me in my quest to locate Sue Smock. Timeri Murari provided me with invaluable information about a substantial feature on Sue Smock that he wrote for the *Guardian* many years ago. I'm grateful to Veena Stephenson for her help in identifying a text she wrote for the now defunct *Bazaar* magazine. A special note of thanks, gratitude and appreciation must go to Dr. Celeste-Marie Bernier, for her support.

No doubt other individuals helped me with one aspect or another of this publication. If I have overlooked anyone by name, please forgive me.

Celebrating Nelson's Ships

In 1815 an extraordinary set of prints by John Thomas Smith was produced in London, titled *Etchings Of Remarkable Beggars, Itinerant Traders And Other Persons Of Notoriety In London And Its Environs*. Within a year or so, the prints appeared in book form, the publication having been given the equally extravagant title *Vagabondiana or, Anecdotes of Mendicant Wanderers Through the Streets of London; with Portraits of the Most Remarkable Drawn From the Life*. Smith (Keeper of the Prints in the British Museum) produced etchings that were amongst the earliest attempts to depict the poor of London in ways that sought to avoid caricature, and relied to some extent on the artist's quest to capture the personalities of his subjects as well as the hardships they reflected. As such, the etchings presented 'a dramatic survey of street folk, blind beggars, cripples, the indigent poor of all kinds and hawkers of trifles, observed with objectivity.'[1] In this summary, the writer, Simon Houfe, adjudged that 'Smith had the sense to perceive that it was more important to paint blindness, beggary and poverty than personifications of them.'[2] Houfe may perhaps have been somewhat generous as Smith, speaking of himself, declared: 'it occurred to the author of the present publication, that likenesses of the most remarkable [beggars], with a few particulars of their habits, would not be unamusing to those to whom they have been a pest for several years.'[3]

Vagabondiana presented a fascinating study of contemporary beggary in London, which, Smith claimed, 'of late, particularly for the last six years, had become so dreadful in London, that the more active interference of the legislature was deemed absolutely necessary.'[4] Smith seemed keen to disabuse his audience of any notion of liberalism or sentimentality on his part, or indeed empathy between artist and subject. He continued his preface with, 'indeed the deceptions of the idle and sturdy were so various, cunning and extensive, that it was in most instances extremely difficult to discover the real object

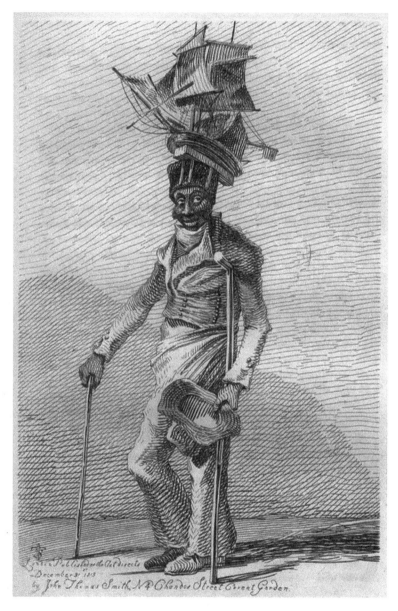

1. *effigy of Joseph Johnson* (1815).

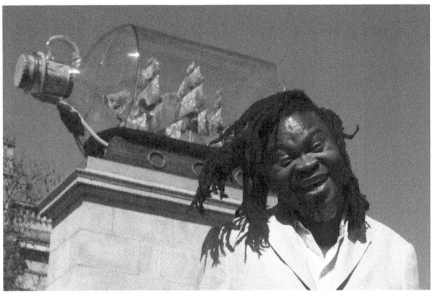

2. Yinka Shonibare, Fourth Plinth, photograph (2010).

of charity from the impostor.'[5] He opined that, as a positive consequence of the required governmental attempts to eliminate beggary, 'several curious characters would disappear by being either compelled to industry, or to partake of the liberal parochial rates, provided for them in their respective work-houses.'[6]

One particularly fascinating etching in the series captured *Joseph Johnson, a black sailor, with a model of the ship Nelson on his cap.*[7] The gentleman depicted in the print was, apparently known as 'Black Joe', who had been a seaman in the Merchant Navy until he was wounded and subsequently discharged. At the time that Smith took to the streets of London to document characters such as Johnson, the population of the capital's homeless and workless was swelled significantly by the large numbers of military personnel demobbed following the recent ending of the Napoleonic Wars. As such, Johnson's reduction in fortunes was perhaps typical. It was said that he was not entitled to a seaman's pension, and that other forms of assistance, such as parish relief, could not be claimed by him because he was not British by birth.

To survive, Johnson apparently turned to busking. He was able to draw particular attention to himself on account of his novel head attire – he built and wore a model of the seafaring military vessel *Nelson* on his cap. London

had for centuries been home to distinct numbers of Black people, and the little that is known of 'Black Joe' actually reveals much about some of the ways in which the free Black presence in the capital was constituted two centuries ago. By building a model of the *Nelson*, Johnson was not only telling a instantly recognisable and understandable story about his own biography (having been a seaman), he was also utilising a representation of what was one of the most recognisable and celebrated military sea craft of its day. (The building of the *Nelson*, at the Woolwich dockyard, began in 1809 and the ship was launched in July 1814 in the presence of the Royal Family and a large audience said to have been in excess of 20,000 people.)

This ship bearing the name HMS *Nelson*, was named to honour one of Britain's greatest heroes of the time, Horatio Nelson. His fame and status was secured when the Royal Navy, under his leadership, vanquished the combined fleets of the French Navy and Spanish Navy at the Battle of Trafalgar, one of the decisive episodes of the Napoleonic Wars that finally ended in 1815. Nelson was killed during the battle of Trafalgar in October 1805, thereupon (or thereafter) becoming arguably Britain's greatest admiral. Johnson's rendering of the *Nelson* was particularly faithful, in that the *Nelson* was a full-rigged ship, which is to say that it was a sailing ship of three masts all being square-rigged, as depicted by Johnson's singular headwear. Smith noted of Johnson's model: 'when placed on his cap, he can, by a bow of thanks, or a supplicating inclination to a drawing room window, give the appearance of sea-motion.'[8] Smith's etching of Johnson shows us a Black man with a walking stick in one hand and in the other, supported by a crutch under his arm, he holds a hat, presumably for the purpose of receiving money in exchange for his busking. In discussing and describing Black beggars in London, Smith claimed, 'Black people, as well as those destitute of sight, seldom fail to excite compassion.'[9]

Having modelled the celebrity vessel, and been himself duly recorded, we are perhaps, in Smith's portrait of Johnson, looking at one of the first documented examples of a Black-British artist (in this case, a sculptor) in London. Two centuries later, another Black artist (if I might designate Johnson as such) undertook to produce another singular work that celebrated another of famous fighting ship associated with Nelson. London-born, Nigeria-raised Yinka Shonibare executed a Fourth Plinth[10] sculpture, unveiled in May 2010, and pictured here, which saw him give his trademark faux African fabric treatment to a scale model of the fighting ship most closely identified with

Nelson, the figure who stands as one of Britain's greatest heroes of empire, whose iconic statue stands only a short distant away from where Shonibare's commission was exhibited, in the centre of Trafalgar Square, in the heart of London.

Michael McCarthy in the *Independent* newspaper, in one example of the significant volume of press coverage the commission garnered, wrote:

It is Trafalgar Square, named after the naval battle of 1805, so it might seem fitting that the space on the celebrated empty fourth plinth should be occupied by a memorial of the battle – and, as of yesterday, it is. *Nelson's Ship in a Bottle* is a 1:30 scale replica of HMS *Victory*, the flagship of Admiral Horatio Nelson who at Trafalgar defeated the combined fleets of France and Spain in the greatest sea battle of the Napoleonic wars. It has been created by the leading Anglo-Nigerian artist, Yinka Shonibare. But inside its 4.7 m by 2.8 m bottle, is the model battleship, with its 37 large sails made of brightly patterned African fabric, a celebration of British historical power and victory? Or a subtle subversion of it? [11]

Some Problems with History and its Treatment of Black-British Artists.

In seeking to contribute to the researching and establishing of more substantial and credible histories of Black artists in the UK, the would-be researcher is faced with a number of difficulties and issues. These difficulties and issues begin with the question of terminology. Strictly speaking, 'Black artists', as a self-declared and self-identified body of practitioners, did not emerge in the UK until the early 1980s. Before this time, there were no 'Black artists' as such. There were, instead, 'Afro-Caribbean' artists, 'West Indian' artists, 'African' artists, 'Asian' artists and so on. And within artists signified as 'African' or 'Asian', there were, oftentimes, more specific labels of nationality such as 'Nigerian', 'Ghanaian', 'Ceylonese', 'Indian', and so on. This particular history of Black artists in Britain begins with those young artists from African, Asian, and Caribbean countries of the then British Empire, who made their way to Britain in the decades of the mid twentieth century, to begin, or continue, careers as visual artists. Without exception, none of these artists referred to themselves, or their practice, as 'Black'. Many of these artists presupposed, or imagined, that they were part of a cosmopolitan, metropolitan art world in which seemingly blunt labels of 'ethnic' or 'racial' difference had no substantial place. A history of Black artists in Britain, stretching back to the mid twentieth century, tends to presuppose that 'Black' artists existed as such, over the duration of many decades. With 'Black artists' only emerging and being so named in the early 1980s, there is perhaps a need for circumspection in the use and application of labels, as well as adjectives such as 'Black'.

No one knows when the first artists of African, Asian or Caribbean origin made their way to Britain. It could have been 100 years ago; it could have been several centuries ago. It could have been, as I speculate in the Foreword to this book, in 1815, when *Joseph Johnson, a black sailor, with a model of the ship Nelson on his cap* was documented. It could have been earlier than

that. Simply put, we don't know, because either no records were made, or no records were kept within reach of subsequent generations of researchers and scholars. There is a terrible burden of invisibility and eradication that history has bequeathed the Black-British artist. Setting aside what we don't know leaves us with what we do know, and we know for certain that a substantial history of Black artists practicing in Britain can be traced back to at least as early as the 1920s, with the arrival in Britain of Jamaican-born Ronald Moody, who would go on to become a much-respected pioneer figure in the sorts of histories this book seeks to bring together.

Perhaps most alarmingly, what might be called an invisible-izing of Black-British artists continues right up to the present time. Certain histories (such as the recent revisiting of the work of the Blk Art Group of the early 1980s) are being excavated and reconsidered. But the overwhelming body of material and knowledge on Black-British artists remains vulnerable to the same sorts of adverse pressures and conditions that have existed in this country for centuries, when it comes to the contributions of certain artists and people.

So although the history presented here starts with Ronald Moody, it does so knowing, or at least suspecting, that Moody could well have been preceded by other, equally singular artists with skins as similarly dark as his. The problem of the invisible-izing of Black-British artists has other, equally alarming dimensions. In a great many instances, not even the scantiest records of important exhibitions taking place in decades such as the 1970s have been produced or kept in safe custody for reference by researchers or historians. Whilst being mindful not to cast researchers and art historians as gatekeepers of knowledge, it is certainly the case that a paucity of historical information on Black-British artists translates into, or corresponds with, a paucity of general *awareness* of said artists. Little is generally known, for example, about an important exhibition of *Afro-Caribbean Art* that took place in 1978 in London that included work by Frank Bowling, Lubaina Himid (her first documented exhibition), Donald Locke, and Eugene Palmer.[1] Learning about, or finding out about, such exhibitions inevitably involves a certain amount of digging. We do not know for certain which artists were practicing in the time period covered by this study. Furthermore, this formidable problem of *not knowing* continues right up until the present time. In time, historians of the future may well uncover hitherto hidden histories of Black-British artists.

Wherever possible, this book draws from contemporary sources relating to the artists it discusses. (That is to say, texts written at particular moments

during the course of the artist's life or career). Though such texts frequently reveal – at times inadvertently or unconsciously – particular prejudices that were dominant at the time (especially with regards to matters of race, culture, and identity), they nevertheless embody a *usefulness* that oftentimes far exceeds posthumous texts, or writing otherwise disconnected from its subject's space and time.

Although this book carries the title *Black Artists in British Art*, in reality virtually all of the artists studied within it are based in England, (and more specifically than that, in London). With rare exceptions, these narratives hardly venture west into Wales or north into Scotland. In that sense, it might be more accurate to speak of *Black Artists in English Art*, but the explicitly parochial sentiments attached to the notion of *English art* are self-evident. Furthermore, the strong suspicion exists that few Black British-born artists/people, if any, would signify or designate themselves as primarily *English*, or would choose *England* as their primary point of geographic or national identity and location. They would instead, one suspects, identify or signify themselves as being *British* if pushed or prompted. Similarly, they would instead, one suspects, identify or signify *Britain* as their primary point of geographic or national identity and location. Although the reasons for a resistance to the label of *Englishness* as opposed to *Britishness*, (or a preferred use of *Britain*, rather than *England*) might be imprecise and, indeed, ultimately ambiguous, the differences between *English* and *British* and between *England* and *Britain* matter enormously. Certain Black artists have a marked history of criticality when addressing notions of either their *Englishness* or their *Britishness*, so my concern about *England/Britain* is perhaps to some extent a moot point.[2]

Nevertheless, within this study, *Britain*, as a national and a geographic entity (and as an attendant signifier of identity) is preferred to *England*, the latter having arguably greater and more pronounced connotations of insularity, jingoism and racism than the former. It is for these reasons that this study is titled *Black Artists in British Art*. Similarly, although there is – again, arguably – a widespread ambivalence amongst some Black people to identify themselves as *British*, in the absence of any single, widely accepted alternative signifier, this study uses the term *British*, in relation to *Black British Artists*. It does so in the knowledge that many of those to whom the term is applied might well, to varying degrees, find the term to be somewhat lacking.

By way of an addendum, another word of caution about the limits of label-ling should be offered. Although many artists in this study might resist, or

have resisted, the term *British*[3], there can be no question that throughout much of the period of this study, a number of these artists were struggling to be included in the notion, the entity, the history, of *British art*. Bluntly put, for much of the mid twentieth century onwards, *British art* may not have wanted these artists, but many of these artists most assuredly wanted to be a part of the mainstreams of *British art*. Needless to say, with the specific and notable exceptions discussed in this study, British art itself has tended to keep Black artists – both British-born as well as immigrant – at arm's length.

We must also consider the extent to which the foreign-born artists referenced in this study retained, or were frequently not seen beyond, the labels of nationality such as 'Jamaican', 'Indian', ' Nigerian', and so on. Many of these artists may well have wanted to maintain an explicit association with the countries from which they migrated, but beyond this, these artists on occasion found themselves gravitating towards, or being pushed towards, catch-all exhibition labels such as 'Asian', African', 'Afro-Caribbean', and, in time, 'Black'. Within such exhibitions, these artists were drawn to, or were obliged to, keep each other company. Such considerations should lead us to ponder the limitations, contradictions and on occasion, the difficulties of seemingly emphatic labels of identity, imposed, declared or aspirational.

A fairly familiar aspect of the attention paid to a number of the artists discussed in this study is the level of posthumous attention they received. A somewhat lavish monograph on Francis Newton Souza appeared in 2006, the artist having died some four years earlier. The most substantial publication on Souza to appear during his lifetime had been published more than four decades previously. In similar regard one can consider Ivan Peries, who died in 1988, and who was the subject of a splendid monograph, issued in 1996, the best part of a decade after his death, not having been the focus of such substantial scholarship during his lifetime. Lancelot Ribeiro is another artist for whom significant and notable attention could only be enjoyed posthumously. He died in 2010, and within three years, was the subject of a major exhibition and substantial monograph.[4] Aubrey Williams and Ronald Moody, both pioneering artists within this study, posthumously experienced similar escalations in critical attention to their practices following their deaths. Williams has been the subject of two substantial publications, relating to major exhibitions of his work, taking place some years after his death. Likewise Ronald Moody, who, more than two decades after his death, found himself being somewhat rehabilitated into narratives of British art.

Lavish posthumous attention paid to an artist is in so many ways the flip side of these same artists being consistently ignored or marginalised during their working lifetimes. The phenomenon that certain artists have to wait until they are dead before scholarship is advanced on them has had a quite debilitating effect on the creating of histories of Black-British artists' work. Being compelled to practice in relative or absolute obscurity during their lifetimes ensures that these artists themselves cannot be a part of a living, functioning history, but must exist as minor characters with bit parts, as far as their individual contributions to this history is concerned.

In examining archival documents relating to Black-British artists, (particularly from the 1970s onwards) the question, *where are they now?* is never far from the mind of the researcher, such is the speed and regularity with which certain artists pass into relative or absolute obscurity. One particular artist – one of many – to have suffered this fate was a painter going by the name of Caboo. Referenced elsewhere in this study, Caboo was the subject of an extensive, four-page article in *Race Today* magazine in February 1975. Not only was the magazine's cover given over to trailing the text on Caboo, but the following month's issue of *Race Today* featured two substantial responses to the feature on Caboo, one of which was signed by Rasheed Araeen and H.O. Nazareth. This particular response concluded, 'Roy Caboo, in the courageous pursuit of artistic creation, affords an example for black youth. He also helps to teach us some mistakes we must avoid in our development.'[5] What became of Caboo and numerous others like him?

Other factors, equally dispiriting, must be brought into the consideration of the oftentimes skewed ways in which so many Black-British artists are ignored or only attended to posthumously. A relatively successful artist such as Maud Sulter could pass away (as she did in 2008) with hardly anything in the way of acknowledgement and obituaries.[6] And an artist such as Brenda Agard, relatively young though she was, could fall from view and pass into oblivion as if her stellar contributions were somehow insignificant and unimportant.[7] In effect, a colossal number of artists who have made important contributions to the history of Black artists in Britain have passed into obscurity or disappeared from all vestiges of public professional view. In reality, each of this book's chapters could have been titled *Problems and Progress*, because each step that Black artists have taken towards greater visibility has been invariably accompanied by either an entrenching of ongoing challenges, or the creation of new difficulties. In so many ways, the history of Black

artists in Britain could be told as a despondent narrative of interlinked episodes of thwarted ambition, born of an art world steadfastly indifferent to the practices of these artists. Notwithstanding these pressures of invisibilisation, the work of Black-British artists has been, and continues to be, deserving of ever-greater levels of critical attention. But until the artists discussed in this study are accorded more respect and attention during their lifetimes, it seems inevitable that Black-British art history will continue to be, in some measure, a skewed and lopsided construction.

To date, there have been two principal attempts at compiling and presenting a history of Black-British artists from the mid twentieth century onwards: the exhibitions and related catalogues for *The Other Story* (1989), and *Transforming the Crown* (1997).

The Other Story was a landmark exhibition which sought to outline a history of 'Afro-Asian artists in postwar Britain'. The exhibition took place towards the end of what had, in turn, been something of a landmark decade for Black-British artists, insofar as a range of new artistic voices and initiatives relating to these practitioners had emerged, taken place, or established themselves over the course of the 1980s. The exhibition was curated by Rasheed Araeen and organised by the Hayward Gallery in the South Bank Centre, London, 1989. Following its showing in London it travelled to galleries in Wolverhampton and Manchester. There were many significant aspects of *The Other Story*, but perhaps the two central achievements of the exhibition were the ways in which it fashioned an art historical framework within which to locate the practices of Black artists in Britain, and the extent to which it introduced this broad range of work to new audiences. This latter endeavour was accomplished, in part, through the sheer volume of press coverage the exhibition generated. The considerable amount of press attention that the exhibition garnered included broadsheets such as *The Times*, the *Daily Telegraph*, and other mainstream magazines and newspapers that reviewed the exhibition, creating a volume of press coverage relating to one particular exhibition which even today remains unsurpassed in its scope and scale.

The Other Story featured work by the following artists: Rasheed Araeen, Saleem Arif, Frank Bowling, Sonia Boyce, Eddie Chambers, Avinash Chandra, Avtarjeet Dhanjal, Uzo Egonu, Iqbal Geoffrey, Mona Hatoum, Lubaina Himid, Gavin Jantjes, Balraj Khanna, Donald Locke, David Medalla, Ronald Moody, Ahmed Parvez, Ivan Peries, Keith Piper, A J Shemza, Kumiko Shimizu, F N Souza, Aubrey Williams and Li Yuan-Chia. These artists were

grouped into something of a chronological narrative, locating the work of Jamaican-born sculptor Ronald Moody in the first room of the exhibition, and thereafter taking its audiences through artists of the Fifties, Sixties, Seventies and Eighties. The final sections of the exhibition related to those artists who themselves had emerged into practice only a few years earlier, in some cases, well into the Eighties.

Within *The Other Story*, Araeen was able to fashion a sense that Black-British artists not only had their own history, or even histories, but perhaps even more importantly, they were part of a wider art history, from which they were, or had been thus far, routinely excluded. With the ambitious scope of the exhibition, Araeen was able to excavate and narrate histories that were, astonishingly, relatively unknown to even some of the exhibitors themselves. The challenges that faced certain artists were presented in a chronology in which such challenges resurfaced, facing different artists, some years later. Likewise, the triumphs achieved by certain artists were set within the context of subsequent achievements by other artists.

The other hugely significant aspect of Araeen's exhibition was that the histories it excavated and narrated were committed to print and took the form of a fairly substantial catalogue, which ran to some 160 pages. Thus, for the first time, a sort of history book of Black-British artists was brought into existence, thereby emphatically challenging the exclusion of Black artists from all manner of narratives of British art history of the twentieth century. The exhibition catalogue featured an introduction, four essays and a postscript by Araeen. The catalogue also had room for a range of other voices, including those of Balraj Khanna, Guy Brett, David Medalla, and Lubaina Himid and Maud Sulter. As if to embellish the sense in which histories were being presented in both exhibition and catalogue, there was also, within the publication, a *Chronology* and a summary of *Artists' biographies.*

Mention should also be made of another significant aspect of *The Other Story.* That is, the extent to which responses to it brought out into the open divergent and sometimes discordant voices, ranging from a handful of high-profile artists who let it be known that they would rather not participate in what they perceived as a problematic and peripheral curatorial construction, through to harsh critics of the exhibition, who took to task different aspects of *The Other Story.* Criticisms ranged from a perceived racial segregating (a sentiment expressed by several white critics), through to an alleged bias that saw women artists under-represented in the exhibition.

Some seven years after *The Other Story*, another exhibition and attendant catalogue that had the aim of fashioning a substantial history of Black-British artists took place, though in a number of ways it was quite different from its predecessor. *Transforming the Crown: African, Asian and Caribbean Artists in Britain 1966–1996*[8] was a curatorial venture presented by the Caribbean Cultural Center, New York. The exhibition was shown across three venues in and around the greater New York area. Between October 1997 and March of the following year, *Transforming the Crown* was shown at the Studio Museum in Harlem, the Bronx Museum of the Arts and the Caribbean Cultural Center itself. Mora Beauchamp-Byrd, who was at the time Curator and Director of Special Projects at the Caribbean Cultural Center curated the exhibition. *Transforming the Crown* was an ambitious exhibition and though there were several notable and conspicuous omissions, it was nevertheless a comprehensive undertaking which brought together a large number of artists, all of whom had connections to the UK, either by birth, or by residence, either permanent or temporary.

Transforming the Crown featured work by Faisal Abdu'Allah, Said Adrus, Ajamu, Henrietta Atooma Alele, Hassan Aliyu, Marcia Bennett, Zarina Bhimji, Sutapa Biswas, Sylbert Bolton, Sonia Boyce, Winston Branch, Vanley Burke, Chila Kumari Burman, Sokari Douglas Camp, Anthony Daley, Allan deSouza, Godfried Donkor, Nina Edge, Uzo Egonu, Rotimi Fani-Kayode, Denzil Forrester, Armet Francis, Joy Gregory, Sunil Gupta, Lubaina Himid, Bhajan Hunjan, Meena Jafarey, Gavin Jantjes, Emmanuel Taiwo Jegede, Claudette Elaine Johnson, Mumtaz Karimjee, Rita Keegan, Fowokan George Kelly, Roshini Kempadoo, Juginder Lamba, Errol Lloyd, Jeni McKenzie, Althea McNish, David Medalla, Shaheen Merali, Bill Ming, Ronald Moody, Olu Oguibe, Eugene Palmer, Tony Phillips, Keith Piper, Ingrid Pollard, Franklyn Rodgers, Veronica Ryan, Lesley Sanderson, Folake Shoga, Yinka Shonibare, Gurminder Sikand, Maud Sulter, Danijah Tafari, Geraldine Walsh, and Aubrey Williams. Donald Rodney was included in the catalogue, but his work was not in the exhibition itself.

Though the reasons for the 30-year focus of the exhibition were not particularly clear, the exhibition was nevertheless a bold undertaking that included a number of artists that *The Other Story* had not taken into consideration. One of the biggest problems with exhibitions (and indeed publications, for that matter) that attempt to fashion grand historical narratives is that the more artists are included, the smaller the individual contributions

can be made by each artist. *The Other Story*, featuring as it did some 24 artists, ensured that each practitioner's contribution, or section, was relatively substantial, thereby allowing audiences a significant opportunity to appraise each artist's work. With *Transforming the Crown* including the work of almost 60 artists, spread across several venues, there were perhaps ways in which the exhibition relied on sheer numbers to support its historical narratives and arguments. Like *The Other Story* catalogue before it, the *Transforming the Crown* catalogue proved to be a most useful document in fashioning and presenting tangible histories that, even a decade earlier, had largely existed as fragments, rather than as a recognisable whole.

The catalogue was extensively illustrated throughout, thereby adding another dimension to its usefulness, particularly to those people in Britain who had not been able to travel to New York to see the exhibition for themselves. Furthermore, essays by writers such as the exhibition's curator, Mora J. Beauchamp-Byrd, Okwui Enwezor, Kobena Mercer, Gilane Tawadros, Anne Walmsley, Deborah Willis and Judith Wilson ensured that a range of voices contributed to the telling of the story of the history of Black-British artists. The exhibition secured a significant amount of press coverage, both within the US and the UK.

In addition to these two major attempts at compiling and presenting a history of Black-British artists from the mid twentieth century onwards, one should also be mindful of shorter, but nevertheless important texts such as Courtney J. Martin's 'Surely, There Was a Flow: African-British Artists in the Twentieth Century', in the *Flow* exhibition catalogue.[9]

Finally, I should stress that this study is not, and does not claim to be, a definitive account. Such a study would run to several substantial volumes. My intention, in presenting this material, is to point to a number of the significant personalities, exhibitions, and other initiatives that have benchmarked the postwar history of Black artists in Britain. I seek to embellish dominant narratives of the history of Black artists in Britain and in so doing, the reader will likely notice that a number of artists are referenced who have, in effect, become somewhat obscure or unfamiliar names. In seeking to create a textured history, I freely admit that more research is needed, and more scholarship is needed, before a comprehensive and exhaustive history can be truly brought into existence.

The Pioneering Generation of Caribbean Artists

When Rasheed Araeen included the sculpture of Ronald Moody in *The Other Story: Afro-Asian artists in post-war Britain*, Hayward Gallery, London, 1989, it was an opportunity for gallery audiences to acquaint themselves, or reacquaint themselves, with the work of an important Jamaican-born sculptor who had died about five years earlier. *The Other Story* brought together 11 of Moody's key works, and collectively they formed a striking and impressive introduction to the exhibition. Whilst Moody had had a lifetime filled with making and exhibiting art, and undertaking other visual arts projects, it was only in the wake of his death that his work became more widely known, beyond the Caribbean art circles in which it had often been exhibited.

Moody was born in Jamaica in 1900 and was to spend well over half a century making art, right up until the time of his death in 1984. Though Jamaican by birth, Moody maintained something of an uneasy relationship with the country. There were no major exhibitions of his work in Jamaica during his lifetime, though he was awarded the prestigious Gold Musgrave medal by the Institute of Jamaica in the late 1970s. The first substantial exhibition of Moody's work at the National Gallery of Jamaica took place in 2000, some 16 years after his death.

Moody was a sculptor who came to his practice after being inspired by visits to the British Museum, where he was particularly drawn to the galleries of Egyptian and Asian art. From his earliest work through to his later practice, Moody's sculptures reflected his interest in ancient and world ideas of metaphysics (the branch of philosophy that deals with the first principles of things, including abstract concepts such as being, knowing, substance, cause, identity, time, and space.) In contrast to this distinctive work, Moody produced a number of portraits, in a somewhat more conventional, though nevertheless striking, vein. These included a bust, made in 1946, of his brother Harold Moody. Some years previously, in the early 1930s, Harold Moody

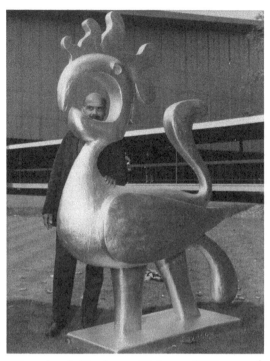

3. *Bird that Never Was* arrives in Kensington (21 August 1964), press photograph with the following note:

> Placed in position on the lawn of the Commonwealth Institute in High Street, Kensington, today, was a 7ft 10in tall, 5 cwt cast aluminium sculpture of a mythical "SAVACOU" bird, which was designed by Jamaican sculptor RONALD MOODY. The "SAVACOU" which existed only in Caribbean mythology, will remain there on view to the public for about a month before going to Jamaica where it will be placed in front of the Epidemiological Research Unit of the University of the West Indies, to whom it was presented by their director, and the director of a smaller unit in South Wales.

had been instrumental in founding, in London, the League of Coloured Peoples, which had the aim of racial equality for all peoples throughout the world, though the league's principal focus of activity was the racial situation in Britain itself. Another very important bust produced by Ronald Moody was his rendering of Paul Robeson, the African-American singer, actor of stage and screen, and civil rights campaigner, in copper resin, in 1968.

In looking at his sculpture, particularly his dramatic faces, heads, and figures, his work has the appearance not so much of racialised imagery (what we might term the Black image, or the Black form); instead, it presents itself to us as a compelling amalgamation of the breadth of humanity. It is in work

such as *Johanaan* that we see most clearly the artist's embrace of the tran-scendental and the metaphysical. Veerle Poupeye noted that 'In the 1960s Moody became more actively interested in his Caribbean background. His best-known work of the period, *Savacou* (1964) represents a stylized, emblem-atic parrot figure inspired by the mythical bird deity of the Carib Indians.'[1] The work exists in both its finished form (as a commission for the Mona campus of the University of the West Indies in Kingston, Jamaica) as well as in maquette form. The finished work, made of aluminium, is a dramatic and distinctive feature of the campus. A photograph of the work is reproduced in this book.

In the years following *The Other Story*, Moody's niece, Cynthia Moody, worked tirelessly to preserve, safeguard and advance his legacy. A hugely significant landmark of this process was the acquisition by the Tate Gallery, in 1992, of the magnificent and imposing figure of *Johanaan* (sometimes known as *John the Baptist*). Unfortunately, Moody's sculpture has yet to be the subject of a major monograph, though a number of texts on his life and practice have been published. Chief amongst them perhaps is Cynthia Moody's own *Ronald Moody: A man true to his Vision*, which appeared in *Third Text*;[2] and Guy Brett's substantial feature on Ronald Moody in the magazine *Tate International Arts and Culture*.[3] The Brett article, 'A Repu-tation Restored', was introduced as follows: 'Self-taught wood-carver Ronald Moody, a former dentist born in Jamaica, is revealed as one of Britain's most remarkable Modernist sculptors in a new display at Tate Britain.'[4]

An invaluable appraisal of Moody and his work appeared in British maga-zine *The Studio*, in the January 1950 issue of the magazine.[5] The writer, Marie Seton, had the measure of Moody when, early on in the text, she expressed the view that the sculptor's work, 'is concerned with man as an evolving type, is unique, haunting and far from easy to label.' The wide-ranging text recalled moments of high drama in Moody's life, particularly his escape, with his wife, from Nazi-occupied France. He had earlier moved to Paris, where his first one-man exhibition 'took place towards the end of 1937 at the Galerie Billiet-Vorms.' Recounting Moody's flight, Seton wrote:

Then the German juggernaut approached Paris and many of Moody's most beautiful works were dispersed across occupied France. Moody and his wife escaped from Paris with the stream of refugees and finally reached Marseilles on foot. For months the existence of a refugee kept

him inactive. This terrible period has left its mark upon his later work, accomplished when at last he escaped to England (by the daring act of walking across the Pyrenees into Spain and crossing that country with the help of the 'underground' to Gibraltar.'[6]

Clearly a great admirer of Moody's work, Seton noted, 'With each work he has captured a greater degree of sensitivity within the human spirit and achieved a greater and more subtle feeling of spiritual unity.'[7]

Moody's work was included in the exhibition *Rhapsodies in Black: Art of the Harlem Renaissance*, which toured to galleries in the UK and the US in 1997 and 1998. Within the exhibition's catalogue there is a fascinating full-page reproduction of a gallery installation view of *Children looking up at Ronald C. Moody's Midonz (Goddess of Transmutation), taken in 1939*. Within the credit, neither the United States' gallery nor the exhibition itself are identified. The exhibition was very likely to have been one sponsored by the Harmon Foundation, which was particularly active in exhibiting work by Negro artists during the 1930s.

Guyana (formerly British Guiana), a relatively small country nestled between Venezuela, Brazil and Surinam, produced several pioneering Caribbean artists who made their way to Britain during the mid twentieth century. These artists included Denis Williams, born in 1923, Aubrey Williams (1926), Donald Locke (1930) and Frank Bowling (1936). In years to come, another Guyana-born artist, Ingrid Pollard, born in 1953, would also figure prominently in narratives of Black artists in British art. Bowling first came to London at the age of 14, to complete his schooling. He was first a poet, eventually turning to painting in his late teens. After periods of study at art colleges in London, his career as a painter began in earnest with solo exhibitions in London in the early 60s. Bowling has come to be universally known and widely respected for his abstract paintings, ranging from large expansive affairs rich with colour and texture, through to smaller, much more compact works. He came to abstract art via figurative painting, at the beginning of the 1970s. Before that time, his art of the late 50s and 60s was figurative and resonated with distinct social and political narratives. Bowling himself cited the death of Patrice Lumumba (in 1961) as being one of his themes during this period.[8]

Whilst Bowling was born in Bartica, a tip of land by the Essequibo river, Williams was born in Georgetown, Guyana's capital. After settling in London

in his late twenties, he enrolled at St Martin's School of Art and soon established a career as a prolific and on occasions widely exhibited artist. An active member of the Caribbean Artists Movement (CAM), Williams came to be closely associated with the presence of Caribbean art/artists in London and his work was featured in a very significant number of Caribbean art exhibitions. One critic sought to explore the commonalities shared by Bowling and Williams.

On the face of it, Aubrey Williams and Frank Bowling have little in common apart from being modern artists from Guyana who chose to work in different modes of abstraction. Abstract expressionism was predominant when Williams enrolled at St Martin's School of Art in London in the mid 1950s, whereas Bowling's career began after he graduated from the Royal College of Art in 1962 when Pop Art was the rising paradigm of the mid 1960s. While such generational differences account for their dissimilarities as abstract artists, it could be observed, however, that Williams and Bowling shared a modernist

4. Aubrey Williams, *Arawak* (1959).

commitment to the practice of painting as an intellectual activity that demanded continuous reflection on the ideas, sources and materials of their work.[9]

In a number of ways, the environment that Black immigrant artists found in the London art world of the 1950s and early 1960s was wholly conducive to their ambitions as artists and their keenness to contribute to the exciting culture of Modernism, which they regarded as having pronounced international dimensions that created a tangible commonality amongst artists. This moment ultimately proved to be something of a fleeting one, though whilst it lasted artists such as Williams and Indian artist Francis Newton Souza were able to exhibit regularly. Kobena Mercer described London's environment of what he called 'a post-colonial internationalism':

Williams also participated in what could be called a post-colonial internationalism that played a significant role in the independent gallery sector. The New Visions Group, which hosted three solo exhibitions by Williams between 1958 and 1960, had been formed by South African artist Denis Bowen in 1951. Dedicated to non-figurative art, the group operated as a non-profit artists'-run organisation whose exhibition policy for the Marble Arch gallery it opened in 1956 promoted abstract artists from Commonwealth countries alongside tachisme, constructivism and kinetic art from various European contexts. Gallery One, set up by Victor Musgrave in 1953, hosted five exhibitions by the Bombay artist Francis Newton Souza, as well as exhibiting avant-garde Europeans such as Yves Klein and Henri Michaux for the first time in Britain. Such openness towards non-western artists was part and parcel of a broader generational shift. Artists such as Souza, Anwar Shemza and Avinash Chandra, who had already achieved professional recognition in India and Pakistan, featured in Gallery One's widely acclaimed Seven Painters in Europe (1958) exhibition.[10]

Both Bowling and Williams secured significant exhibition opportunities for themselves, as young painters in London in the late 1950s and early 1960s. In this endeavour, the Grabowski Gallery (which one art historian succinctly described as having a 'global outlook')[11] was of huge importance. Grabowski Gallery, London, operated between 1959 and 1975. It was the art gallery of

a Polish pharmacist, located at 84 Sloane Avenue, Chelsea, London SW3. In 1960, Williams exhibited there alongside Denis Bowen, Max Chapman, and Anthony Underhill, in an exhibition titled *Continuum*. In 1962, it was the venue for *Image in Revolt*, two concurrent solo exhibitions of paintings by Derek Boshier and Frank Bowling. Both artists were at the time in their early to mid twenties. Shortly thereafter, Grabowski Gallery again exhibited the work of Bowling in a group show that also included the work of two other artists from Commonwealth countries: William Thomson (Canada) and Neil Stocker (Australia). Williams also had a solo exhibition at Grabowski Gallery, in January of 1963. The extent to which Bowen and Williams worked together during the late 1950 and early 1960s was indicated in an addendum that Bowen wrote for an obituary on Aubrey Williams, published in the *Guardian* newspaper shortly after the artist died in 1990: 'Aubrey Williams was one of the most outstanding and individual of the artists who exhibited at the New Vision Centre Gallery in London which I directed from 1956 to 1966.'[12]

These early career successes of Bowling and Williams were followed by other periods of notable accomplishments, though in the case of Williams, his most substantial exhibitions were very much posthumous endeavours, the artist himself dying in 1990. But for pretty much all of the rest of the twentieth century, these artists' (and indeed other Black artists) periods of relative success very much alternated with periods during which they struggled to maintain professional visibility. To a great extent, this cycle of periods of relative visibility being punctuated by longer periods of invisibility was something that has to differing degrees characterised the history of Black-British artists from the mid twentieth century onwards. In some instances, as mentioned earlier, certain artists' most successful episodes of visibility have been posthumous. Throughout the period covered by this book, the visibility of Black-British artists – both individual visibility and group visibility – has been subject to a variety of pressures, factors and on occasion, initiatives taken by artists themselves. Again, some of these initiatives have been taken at an individual level and some have come about as a result of group or institutional activity.

An indication of Bowling's determination to succeed as an artist can be ascertained in the opening remarks of a review of the aforementioned exhibition he shared with Derek Boshier, *Image in Revolt*, at Grabowski Gallery in 1962:[13]

> [Bowling] is twenty-seven years old and comes from British Guiana which he left about eleven years ago. Born to be an artist, he has felt a certainty of his own destiny that will not be denied, come hell or high water.[14]

Despite early career successes, Bowling found himself on a trajectory somewhat different from that of the white friends and colleagues with whom he had studied and enjoyed early exhibition opportunities. In one of his essays for *The Other Story* catalogue, Rasheed Araeen took up the dispiriting tale.

> [Bowling] was on his way to a successful career when things began to go wrong. Although he considered himself part of that Royal College group (Hockney, Boshier, Kitaj, Phillips) which represented the emergence of 'new figuration' in Britain, [Bowling] found that he was being left out of group exhibitions, on the basis that his work was different from theirs.

Bowling himself refers to his apparent exclusion in decidedly unvarnished terms. 'So I was isolated. It was a racist thing anyway, the whole thing.'[15] Perhaps the most shocking and sobering passage of Araeen's discussion of Bowling in *The Other Story* catalogue was the reference to an exchange that apparently confirmed Bowling's marginalisation.

> After [Bowling's] exclusion from the important 'New Generation' exhibition at the Whitechapel in 1964, which featured all his friends who were later to become famous, he was shocked. He was confused because he had received critical acclaim from almost every art critic of note and there was tremendous enthusiasm for his work. When he tried to find out why he was turned down he was told: 'England is not yet ready for a gifted artist of colour.' [16]

From then, up to the present day, Black-British artists have often found themselves not generally included, or not much more than a peripheral presence, in exhibitions that purport to be representative of wider or specific trends in British art. Notwithstanding apparent discrimination, there have been pronounced historical episodes during which artists such as Bowling, Williams and others enjoyed the professional company of other artists,

thereby allowing, or enabling, them to be included in wider dialogues about artistic practice. One such exhibition was the *1st Commonwealth Biennale of Abstract Art*, an innovative undertaking held at the Commonwealth Institute, London, in the autumn of 1963. The exhibition featured a number of artists from Commonwealth countries, many of whom had settled in Britain over the course of the preceding decade or so. For example, Aubrey Williams had been resident in England since 1954; South Asian artists such as Ashu Roy had lived in London since 1951, Viren Sahai since 1954, Kamil Khan since 1957 and Ahmed Parvez since 1955.

Within the *1st Commonwealth Biennale of Abstract Art* were contributions from artists such as John Drawbridge, from New Zealand, James Boswell, also from New Zealand, and Bill Featherston, from Canada. The exhibition clearly demonstrated the extent to which abstract art had been embraced, championed and pioneered by artists from all over the world, including African, Asian and Caribbean countries of the Commonwealth. The exhibition was supplemented by contributions from 'well and lesser-known artists from the United Kingdom'[17] including Frank Avray Wilson, Peter Lanyon, Denis Bowen and Victor Pasmore. The slim accompanying catalogue had the following text on its back cover:

> The aims of the Commonwealth Biennale are to bring to public attention the work of Commonwealth abstract artists living and working in the United Kingdom, to define the part played by them in the development of painting and sculpture in this country, and to draw to the attention of various Commonwealth countries the achievement of their nationals.
>
> The grouping of the Exhibition is not intended to convey a specific trend in abstract art, but is rather a cross section of significant development in avant-garde work in the United Kingdom.
>
> The Commonwealth Biennale will bring these aims into effect by means of exhibitions at two yearly intervals organised by the artists themselves and with the co-operation of the Commonwealth Institute, and by means of touring exhibitions of selected work in the United Kingdom and the Commonwealth.

In his Foreword/Introduction, Charles Spencer wrote:

This exhibition, it will immediately be seen, is restricted to abstract painting. This in itself imposes and presents certain significant suggestions. On one level it establishes the fact that artists from 10 different countries, from widely different cultural backgrounds, and, needless to say, of different religious and racial origins, share a common technical and aesthetic language. Whatever has provoked them to express themselves in visual terms, and whatever philosophical or spiritual comment they wish to make, they have chosen the rather more difficult and complex method of non-figuration.

One of Bowling's notable accomplishments of the early 1960s was having his work acquired for the Arts Council Collection, in 1962, making him one of the first Black artists to be thus recognised. But Bowling dealt with the frustrations of his halting career by becoming more and more interested in the American painting scene, particularly the exciting things that were continuing to happen in New York. By the early 1960s Bowling had taken the first of the innumerable transatlantic flights that enabled him to maintain studios in New York and London, and maintain profiles as an energetic and prolific painter on both sides of the Atlantic. As one critic noted:

> Bowling, both as a man and as an artist, has travelled enormous distances during his life [...] His art has continued to evolve, and is still evolving today [...] In another decade he will doubtless be painting in some quite new, unforeseeable idiom and dimension'.[18]

Having decamped to the United States, it was in New York, around 1966, that Bowling met, engaged with, and was influenced by abstract artists, both African-American and European-American. Thus began Bowling's enduring love affair with Modernism, something to which he has remained steadfastly loyal, decade after decade. He has been quoted as citing influential critic of modern art, Clement Greenberg, as a major influence on this important and seismic development (a pronounced embrace of abstract painting) in his practice: 'Clem was able to make me see that modernism belonged to me also, that I had no good reason to pretend I wasn't part of the whole thing'[19]. The central and pivotal esteem in which Bowling places Modernism is evidenced by his statement that 'I believe that the Black soul, if there can be such a

thing, belongs in modernism.'[20] It was perhaps this attachment to Modernism that made Bowling, particularly within a British context, such a unique and fascinating artist.

Thus, with his pronounced embrace of Modernism, Bowling consistently refused to aesthetically rule himself out of this main current of mid twentieth century art practice, and its enduring application. Herein lay one of his most interesting aspects. As a Black artist, he (and indeed a few other Caribbean-born artists such as Williams, and later, Winston Branch) confounded and frustrated stereotypes of what work a 'Black artist' should be producing or might be expected to produce. Through his painting, he relentlessly expressed the view that for him, art should not be burdened down by considerations of race, racism or racial/national identity, notwithstanding the unpleasant ways allegations of race prejudice impacted on his emerging career in early to mid 1960s London.

Bowling did not make an immediate transition from figurative to non-figurative painting. A particularly fascinating body of work, known as his map paintings, formed something of a bridge between his figurative and abstract practices. Bowling's map paintings were produced at a time when he was moving away from explicit figuration within his painting, but had not yet adopted the non-figuration with which he is now most commonly associated. In an essay on Bowling's map paintings, Kobena Mercer suggested that they

> come from a key moment of transition. Produced between 1967 and 1971, the works have been acknowledged as a distinct strand in his oeuvre that arose out of a shift from figurative painting to post-painterly abstraction during the artist's relocation from London to New York in this period.[21]

Positing that Bowling's map paintings were 'perhaps an attempt to recover an identity that he had tried to suppress in the past', Rasheed Araeen has described these paintings as 'a mixture of colour fields superimposed upon iconographic allusions to his mother's house in Guyana, maps of South America with Guyana emphasised, maps of Africa,' etc.'[22] There are three remarkable aspects of Bowling's map paintings. Firstly, the ways in which they seek to visually craft the biography, the identity of this African-Caribbean person around and within the motif of the outline of the South

American continent, on which he himself was born. Secondly, the map paintings create a South America visually charged with and by pronounced signifiers of Pan-African, or African Diasporic, identity. And thirdly, Bowling's map paintings laid claim to, or declared themselves a part of, a modernist tradition in which South America was included. It may have been a keenness on the artist's part for his work to engage in a dialogue with Pan-Latin Americanism that led him, in the early 1970s, to exhibit at the Center for Inter-American Relations, on Park Avenue, New York.[23]

Bowling's achievements were, perhaps belatedly, acknowledged in dramatic fashion when he was elected to the Royal Academy in 2005, making him the first Black British artist to be elected to the Royal Academy in its 200-year history. Further recognition was to come when he was made an OBE (Officer of the Order of the British Empire) in the Queen's Birthday Honours of 2008).[24]

Concurrent to twists and turns in Bowling's career, Williams' own career was no less dramatic. An active member of an important and influential group of like-minded writers, intellectuals, poets and artists known as the Caribbean Artists Movement, Williams came to be closely associated with the presence of Caribbean art/artists in London and his work was featured in a very significant number of Caribbean art exhibitions. Writing in 1968, Edward Brathwaite described Williams as 'an internationally recognised Guyanese painter who, with [Orlando] Patterson was to become one of the leading theoreticians of the [Caribbean Arts Movement].'[25] The early years of Williams' practice in the UK was, as mentioned earlier, characterised by the decidedly mixed exhibiting company he was able to keep. Mention has already been made of exhibitions such as *Continuum* at Grabowski Gallery, and *1st Commonwealth Biennale of Abstract Art* at the Commonwealth Institute. To such exhibitions of Williams' work can be added *Appointment With Six*, a group show held at the Arun Art Centre, which was at the time a functioning gallery in Arundel, West Sussex. The exhibition took place towards the closing months of 1966 and featured Williams showing alongside Gwen Barnard, Pip Benveniste, Oswell Blakeston, Max Chapman, and A. Oscar. (The exhibition came with a modest but important catalogue, which had something of a homemade feel and aesthetic. The works listed in the catalogue were priced in guineas).

A passionate believer in humanity's art and culture in its many and varied forms, Williams was responsible for a substantial body of work and his

paintings have found their way into a number of important collections, including that of the Arts Council. It might in some ways be difficult to characterise Williams' art, as the work for which he is perhaps most known and celebrated contains both figurative and non-figurative elements. On the one hand, his paintings reflected his interests in such varied subjects as aboriginal South American culture, cosmology, and the music of the Russian composer Dmitri Shostakovich. On the other hand, his work also declared an interest in form, shape, colour and composition. As art critic Guy Brett, a long-time friend and admirer of Williams noted, 'Williams' painting fluctuates between representational references and abstraction.'[26] Alongside such paintings there exists Williams' sensitive and faithful renderings of bird life. In his concluding remarks in one of his essays on Williams, Brett cautioned against the instinct to typecast Williams' practice.

> It may be futile to try to explain painting. But it is also true that merely to name a motif in Williams' painting as 'pre-Columbian' or Mayan does not suggest the complicated life it leads in its changed form within his work, where it moves between past and present, between natural and artificial beauty, between excitement and warning. To grant Aubrey Williams' paintings their enigma only awakens one to their links with the actual, contemporary world.[27]

One of the few London galleries to support Williams' work, up to the time of his death in 1990, was October Gallery. This was, and indeed remains, a hugely important central London venue that has been a staunch supporter of a wide range of artists from a plurality of diasporic backgrounds, including Williams. The artists exhibiting there are drawn from places that include the countries of Africa, Asia and the Caribbean. A major exhibition of Williams' work was held at Whitechapel Art Gallery in the summer of 1998. It was, perhaps, belated recognition for this artist, who had, as mentioned, died some eight years earlier at the relatively young age of 64. Williams' posthumous Whitechapel exhibition was organised in collaboration with the Institute of International Visual Arts (INIVA). Notwithstanding the substantial nature of this bringing together of paintings produced over several decades, Williams arguably still does not occupy a significant position in the declared history of British postwar painting. Williams himself recounted the despondency he

felt upon realising that his position in the British art world was perhaps more marginal than he would have liked:

> But then, after two years all my shows were ignored. I began to ask myself what was wrong with me, what was wrong with my work. For the next five years I was in a terrible confusion. You know, I thought I had hit the level which would see me through both economically and respectably as a recognised artist in the British community.[28]

This sentiment, substantially, alarmingly, reflects the despondency and bewilderment felt by Frank Bowling on finding his progress emphatically stymied by a British art world apparently only prepared to allow his career to progress thus far and no further.

In a substantial obituary on Aubrey Williams,[29] Guy Brett revisited a number of the sentiments and ideas he had expressed about Williams and his art in other, previously published texts. Though the piece was written more than two decades ago, the extent to which Williams has posthumously been incorporated into the British art world is striking. Wrote Brett:

> There is as yet no work by Williams in the Tate Gallery. Historical and artistic changes we have been living through in the past 40 years have still not sunk into the national psyche. There has never yet been the [recent] opportunity to compare directly the abstract paintings produced by Williams with those of his fellow 'English' artists working at the same time and in the same place, like Victor Pasmore, Alan Davie, Peter Lanyon or Peter Heron.[30]

Since Brett wrote those words, the Tate has acquired several works by Williams, and he has been the subject of several major exhibitions. Brett concluded his obituary with;

> The global ecological crisis was something he felt deeply. It was always coming up in his conversation: he would often take off and describe a bird, or the quality of the air in the rain forest, with inimitable precision and poetry. But he was not a doom merchant. He had, equally strongly, a sense of possibility and of danger. In this the painting and the person were one.[31]

Whilst Ronald Moody had arrived in England to pursue a professional career (in his case, dentistry) and Frank Bowling had arrived as a schoolboy to complete his education, other artists of what might be called the pioneering generation arrived to pursue or complete an art school education or to pursue fledgling careers as young artists. In this regard, Denis Williams, mentioned earlier, was particularly significant. Williams' talent was recognised and by his early twenties he had secured a two-year British Council scholarship to the Camberwell School of Arts and Crafts in London. He was to live in London for the next decade or so, during which time he taught fine art and held several exhibitions of his work. These pioneering artists, primarily young men from the countries of Africa, Asia and the Caribbean migrated to London during the 1940s, 1950s and 1960s. Some came directly. Others took an indirect route; for example, Rasheed Araeen came to London having first spent time in Paris. Each one though, took his own particular route to art practice, at a time when the UK was experiencing varying degrees of immigration from the areas of the world just mentioned. There was a pronounced sense in which these individuals were moving not so much from one part of the world to another, but from one part of the British Commonwealth to London – the centre of a Commonwealth of nations that literally covered the globe. These were the countries of the increasingly-former British Empire.

An exhibition such as the *1st Commonwealth Biennale of Abstract Art* bore compelling testimony to this sense of coming together at the centre of the Commonwealth. As mentioned earlier, Aubrey Williams had been resident in England since 1954, and Ashu Roy and Kamil Khan were both born in Calcutta, India and had lived in London since 1951 and 1957 respectively; Viren Sahai too was born in India but had lived in London since 1954, and Ahmed Parvez was born in the pre-partition Indian city of Rawalpindi in 1926 and had lived in London since 1955. Evidence of the extent to which the artists of the world were, by the beginning of the 1960s, within comfortable reach of London audiences can be seen in the hugely important inaugural exhibition at the Commonwealth Institute, *Commonwealth Art Today*,[32] that took place from late 1962 through to early 1963. Frank Bowling and Aubrey Williams represented British Guiana, Ivan Peries was one of the artists who represented Ceylon, and Avinash Chandra and Francis Newton Souza were two of the artists who represented India. By the early 1960s, the number of young painters in London from India was such that a number of them formed themselves into a group known as the Indian Painters Collective.[33]

Sometimes showing with each other, sometimes showing in mixed exhibitions, and sometimes showing alone, these artists from the countries of South Asia represented a dynamic new presence in the London and UK art scene. India's independence in 1947 provided something of a fillip to British interest in South Asian culture in a variety of ways. Prior to independence, a number of British activists and sympathisers had distinguished themselves through their conspicuous support for the Indian independence movement, which by the mid 1940s had already been active for several decades.

By the late 1950s, artists from elsewhere across the globe were, for the first time, being exposed to London's gallery-going, and art-appreciative public. Such artists included the likes of Hussein Shariffe, a Sudanese artist who had studied at the Slade School of Fine Art and had also been a prize-winner, at the John Moores Liverpool Exhibition, in 1961. His first one-man exhibition had taken place at Gallery One, London, in 1959. In the years thereafter, like a number of artists referenced in this book, Shariffe became a largely forgotten figure.

Early Contributions by South Asian Artists

The evolution of the 'Black' artist in Britain is a story that has many intriguing parts. In marked contrast to the collective identity of Black artists in the US, Britain gave rise to a unique and decidedly British manifestation of the 'Black' artist – one characterised by a definition of 'Black' artists that came to include artists of South Asian origin. Such a development came about during the course of the mid 1980s, after decades during which artists of African and African-Caribbean origin and those of South Asian origin essentially pursued different agendas and initiatives. During the 1950s, 60s and 70s, the commonality that these two groups of artists shared was similar to that shared by all artists – that is, the desire to have their work exhibited on its own, in solo exhibitions, or in the company of their (white) peers, in group exhibitions. The artists who arrived in this country in the postwar decades were able, to varying degrees, to have their work shown in a variety of exhibitions in which pronounced references to ethnic identity (in the titling and framing of exhibitions) were conspicuous by their absence. This excludes, of course, those exhibitions in which these artists represented their countries of origin. A number of artists of African and Asian heritage represented their countries in the inaugural exhibition at the Commonwealth Institute, *Commonwealth Art Today*,[1] which took place from late 1962 through to early 1963. The countries represented were the countries of the artists' birth, rather than the country of their subsequent residence. Frank Bowling and Aubrey Williams represented British Guiana, Ivan Peries was one of the artists who represented Ceylon, Avinash Chandra and Francis Newton Souza were two of the artists who represented India.

And yet, simultaneously during this fascinating period of the late 1950s and early 1960s, several artists from what used to be commonly referred to as the 'Asian subcontinent' were explicitly regarded as *British*, rather than as *immigrant* artists. Intriguingly, given the subsequent decades in which the

5. Francis Newton Souza, *Negro in Mourning* (1957).

practice of a select group of white male artists tended to be called on to represent Britain in the international arena,[2] Souza, in 1958, 'Represented Great Britain in the Guggenheim International Award in New York.'[3] One of the focal points of London's cosmopolitan, international art scene of the time was Victor Musgrove's Gallery One, which celebrated a decade of activity in 1963.[4] In his introduction for the tenth anniversary exhibition's catalogue, Musgrave stated:

Here is a selection from some of the artists we have presented over the last ten years. It includes British artists who had their first one-man showings at this gallery (Henry Mundy, Gwyther Irvin, F. N. Souza, Bridget Riley, and others) as well as the first exhibitions in England of such artists as Henri Michaux, Rufino Tamayo, Enrico Baj, and Kemeny.[5]

Musgrave referenced the significance of Souza and located his practice and his contributions of the time in several important contexts:

Our artists have been prizewinners in every one of the John Moores Liverpool Exhibitions since they began. The acceptance in this country and then abroad of the work of Souza paved the way more easily for other exponents of the postwar Indian School, and such group exhibitions as 'Oeuvres d'Art Transformables' in 1958 brought together in

London the newcomers and the pioneers of optical, kinetic and mechanical works of art – Man Ray, Duchamp, Albers, Agam, Bury, Tinguely, Vasarely, and others.[6]

The significance of Gallery One's programme cannot be overstated, as it had been the venue for the first exposure, within London, of several South Asian artists, including Tyeb Mehta, who had been born in Bombay in 1925 and had his first one-man exhibition at Gallery One in 1962.

South Asian artists coming to Britain in the 1950s and 60s found themselves engaging, albeit in piecemeal fashion, with an art world seemingly happy to interact with these artists as individuals, rather than as a homogenous group. The same could be said of the ways in which Caribbean artists such as Moody, Bowling and Williams were exhibited. Within two or three decades, however, a marked trajectory could be noticed, in which many artists, for better or for worse, one way or another, found themselves and their practice associated with a somewhat trans-racial umbrella term of 'Black'. To these artists could be added those practitioners of a younger generation who declared a particular embrace of the 'Black Art' label. In the 1950s, however, such developments (and indeed, the ensuing complications of the 1980s) were still several decades off. The Black-British artist had not yet been created, had not yet arrived.

Anwar Jalal Shemza's work was included in the landmark exhibition *The Other Story: Afro-Asian artists in post-war Britain*, Hayward Gallery, London, 1989. When a detail of his painting *The Wall* (1958) was used on the front, spine and back cover of the catalogue for *The Other Story*, it was perhaps the first time new audiences were made aware of the work of this pioneering artist. Alongside South Asian artists such as Ashu Roy, Viren Sahai, Kamil Khan and Ahmed Parvez, Shemza was one of the first South Asian artists to settle in the UK, having arrived in the mid 1950s. His work came to be characterised by an intriguing and often visually charged fusion of modernist Western abstraction and motifs that appeared derivative of Islamic aesthetics. *The Wall* was an inspired choice for the cover of *The Other Story* catalogue, as it represented the extent to which artists such as Shemza breezily embraced the language of Modernism in their careers, that frequently began with art school training in the countries from which they migrated. In *The Wall*, Shemza was said to have used 'the Roman letters B and D to make a calligraphic pattern that reminded him of the marble screens in the Shish-mahal of Lahore Fort.'

Shemza apparently struggled to make the transition from confident young artist from Lahore, Pakistan, to confident young artist in London. Shortly after arriving in London, he sought to continue his art education by enrolling in the Slade School of Art. A few years later, he recounted dispiriting developments that echoed some of the setbacks that would be faced by Bowling and Williams some time later:

within a few months [...] I had failed my drawing test and all the paintings I'd submitted for the annual Young Contemporaries were rejected. These two shocks were too much for me. I could not forget that at home [in Pakistan] I was an 'established' painter.[7]

Like several artists in this story, Shemza's most substantial critical appreciation was perhaps posthumous. Towards the end of 1997 Birmingham Museum and Art Gallery mounted a sizeable exhibition of the artist's work. Shemza had made his home in nearby Stafford, so Birmingham Museum and Art Gallery was perhaps a fitting venue for an appraisal, a reconsideration, of Shemza's practice.

The accompanying catalogue opened with this poignant summary, which had strong echoes of the sentiments he had expressed in the early 1960s, about his somewhat rude awakening:

When Anwar Shemza lived in Lahore, he was, in his own words 'a very happy man, a celebrated artist who had his work in the national collections of his country.' In 1956 he came to England and although his work moved in a new direction which gave it greater strength and originality, he did not become 'a celebrated artist' here. Shemza's work was appreciated by critics in London in the 1960s but his name is today too little known in this country.[8]

Shemza's *The Wall* had emerged as one of the star exhibits in *The Other Story* and the work was one of two paintings by Shemza acquired by Birmingham Museum and Art Gallery in 1998. It was the interplay between the language of Modernism and motifs and symbolism strongly evocative of South Asian Islamic culture that accounted for much of the dynamism of Shemza's work. It was this profound respect for two apparently quite different cultural traditions that lay at the core of energetic and lively works such as

Love Letter (1960). Utilizing the modernist grid, the shapes and lines of *Love Letter* are in some ways an exercise in both control and movement. Looking at a work by Shemza, the viewer is unable to settle on any one part or aspect of the painting. Instead, the paintings must be engaged with as remarkable undertakings of motion coupled with composure. A near-tactile sense of dynamism and optimism exuded from Shemza's paintings, including *Love Letter*. It was in some ways a painting of its time. At once celebrating the artist's cultural heritage, the newness of Pakistan, and the promises of progress offered by Modernism, *Love Letter* was a painting that had no one focal point. Or perhaps it is more accurate to say that the painting had multiple focal points.

There was, within Shemza's work, a pronounced sense of a somewhat secularised sacred beauty. Traditionally, Islamic arabesques reflected the use of ornate patterning in repetitive formations, meant to represent the Islamic concept of the immutable oneness of God. Shemza's work echoed the tradition of creating often intricate abstract patterning, signifying the complexity of God's creation. This fascinating and highly original device for representing God and creation was born of Islamic art's eschewal of figurative artistic representations of human and animal forms. This intriguing aspect of Shemza's cultural heritage was fused with the liberating structural possibilities of Modernism, to produce remarkable paintings.

A unique confluence took place in mid twentieth century London. In various parts of the world, artists such as Shemza regarded the new language of Modernism as having a universal appeal and application. Rather than viewing Modernism as having a regional (and thereby racial) application, Modernism was seen and indeed embraced for its dynamism and its global dialogue. In mid twentieth century London, this embrace of Modernism coincided with the arrival of numbers of immigrants from the countries of the rapidly disintegrating British Empire. It was the presence, amongst these immigrants, of young artists, poets, and others steeped in various cultural histories that created this confluence.

This sense of certain artists being able to make work that was an 'expression which is Indian in spirit but also an original contribution to the modern movement' was a sentiment that lay at the heart of an appreciation of Indian artist Avinash Chandra that appeared in *The Studio* magazine of January 1961.[9] The article opened with the following biographical outline:

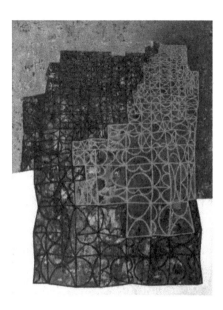

6. Anwar Shemza, *The Wall* (1958).

Avinash Chandra was born in India in 1931 and brought up in Simla and Delhi. He early showed a flair for drawing but it was not until 1947 when he entered the Delhi Polytechnic that he began to acquire a detailed knowledge of painting. At that time his main medium was tempera and in the works which he executed after he had joined the staff he expressed a youthful nostalgia for the trees and vegetation of the Punjab hills. His style was, at first, a continuation of that of Amrita Sher Gill, another Punjabi artist, but it is significant that he shrank from overtly portraying human figures and concentrated mainly on trees. He remained at Delhi Polytechnic for nine years. The atmosphere of Delhi, however, failed to satisfy him and in 1956, he came to London and settled with his wife in the comparative seclusion of Golders Green.[10]

Chandra's work was introduced to the London art public in 1958, by way of an exhibition held at Gallery One, entitled *Seven Indian Painters*. Alongside Avinash Chandra, the exhibition featured paintings by Raza, Husain, Padamsee, Souza, Kumar and Samant.[11] Texts such as the one on Chandra that appeared in *The Studio* magazine tended to reference the not insignificant examples of successful exposure and career advancement that artists such as

Chandra sometimes laid claim to. The reader of this feature learned that the Victoria and Albert Museum recently acquired one of Chandra's drawings and that the artist recently had his work shown at the Bear Lane Gallery, Oxford and the Molton Gallery, London.

There was a pronounced sense, in the ways in which critics framed Chandra, that he represented a distinct possibility that Asian artists might join those artists of Europe and the US in decisively contributing to modern art. W. G. Archer, in his catalogue text for a Chandra exhibition of 1965,[12] pointed to such a hope.

> Since its origins in Europe during the nineteenth century, modern art has undergone a series of injections. International in scope, it has drawn on one country after another in order to discover and achieve fresh modes of expression. In this process, many countries have assisted – Spain through Picasso and Miro, Russia through Kandinsky and Chagall, France through Braque, Leger and Dubuffet, Germany through Ernst and Klee, America through Jackson Pollock. Asia has been slow to rally, but in the work of Avinash Chandra, India – it might be claimed – has now made a vital contribution to modern painting.[13]

Chandra's paintings themselves were bold, emphatic, almost primeval constructions, full of certainty, movement and definition. With its earthy hues, Chandra's *City of Churches* (c.1960) consisted of jagged spires, aggressively jutting towards the heavens, where, in turn, a violent sun returns the sentiments transmitted by the spires. The scene is almost messianic, as a half-moon and other symbols of cosmic occurrence make their presence felt within the firmament of the painting, attesting to Chandra's skill in presenting bold, yet intriguingly ambiguous symbolism within his paintings. *City of Churches* also presents itself as a landscape, as much as it might be seen as a cityscape. The reds, browns, and oranges of the painting lend themselves to the idea of a daunting and formidable mountain range, violently interrupting the landscape. These singular characteristics of Chandra's paintings were described in *The Studio* text as

> the employment of fiery passionate colour – reds, yellows, blues, glowing with the intensity of medieval stained glass – its sense of muscular rhythm, welding both architectural and vegetative forms into

compulsive unities of structure, its air of radiant bursting confidence, gorgeous grandeur, joyous vitality.[14]

Perhaps not surprisingly, appreciations such as this, about artists such as Chandra, tended to stress, or make mention of, the *Indian-ness* of the artist, as if the work itself provided faithful clues of cultural identity. 'Certain features – the palette comparable to that of Basohli and Mewar painting, the sexual symbolism, the love of suns and moons – are directly Indian.'[15]

A particularly intriguing Indian artist of the pioneering generation was Francis Newton Souza, who arrived in England from India in 1949. Sometimes referred to as F. N. Souza, or just Souza, he was born in Goa in 1924. Until relatively recently, Goa existed as something of a Portuguese enclave within India, a small state bordering on India's western coastline. Portugal's lasting influence on Goa was evidenced by the fact that when Souza arrived in England in 1949, he apparently did so using a Portuguese passport. It is, however, to Portugal's distinct yet somewhat pernicious legacies of Catholicism that we must look to identify fascinating influences on Souza's practice. As Araeen noted,[16] 'The significance of Souza's work in fact lies in its paradoxes, which are made further complicated by his ambivalence towards the religion in which he was brought up. Catholicism, and his use of religious imagery and allusions.' In his section in *The Other Story* catalogue, Araeen summarised something of Souza's significance in the British art scene of the mid 1950s to mid 1960s:

> For almost ten years, from 1956 to 1966, he dominated the British art scene, showing his work and selling regularly. He was written about extensively and received praise from critics such as John Berger, Edwin Mullins and David Sylvester, to name a few. In India he is now considered to be one of the most important artists of his generation.

Subsequently, Araeen reports that, 'Souza's first few years in Britain were marked by terrible poverty and misery, until he began to show his work in France and Italy.' Notwithstanding such personal difficulties, Souza had his first one-man exhibition in London, at Gallery One, in 1955 and within a few years his work had made its way into the collection of the Contemporary Art Society.[17] By 1963 his work had appeared in prestigious galleries in London and around the country, including the Tate Gallery, the Royal

Academy, the Whitechapel Art Gallery, Bradford Museum, and Castle Museum, Norwich.

If ever a mid twentieth-century immigrant artist symbolised an impulse towards the universal languages of art that were simultaneously grounded in individual particularities of identity, it was Souza. His paintings were characterised by an astonishingly liberated approach to both execution and subject matter. And yet, on numerous occasions, the conflicted and sometimes hypocritical expressions of the Christianity, indeed, the Catholicism of his native Goa were clearly discernible strands of his practice. Many artists from the mid to late twentieth century onwards have utilised the image of the martyring of Saint Sebastian within their painting. Indeed, a portrait of Aubrey Williams in his West Hampstead studio taken around 1962 showed him executing a painting of the third century Christian saint and martyr. But few of the twentieth century depictions of the saint can match the representations undertaken by Souza. One of his mid 1950s depictions showed the saint with half a dozen arrows sticking out from his head and neck, whilst 'Mr Sebastian' himself wears a dress suit, complete with smart shirt and tie. Geeta Kapur has been quoted as commenting on the work in the following terms:

> This painting takes after Saint Sebastian but [he] wears a dark suit and the arrows that pierced the innocent body of the saint are here stuck into the man's face and neck with a vengeance which, judging from his evil countenance, he seems to merit.[18]

Example after example of Souza's work reveal him to be an artist of astonishing bravery, in his willingness to sample, reinterpret and extend iconic works by any given number of celebrated artists of the Western canon, from Titian through to Picasso. In this regard, Souza's *Young Ladies in Belsize Park* (1962) stands him in good stead. In comprehending the painting, one recognises, instantly, his studious reinterpreting of Picasso's iconic *Les Demoiselles d'Avignon* of 1907. An admirer of Souza's work made the following notes of Souza's interpretation, executed some half a century or more after Picasso's original.

> The aetiology of Souza's adaptation [...] is particularly interesting. Firstly, the improvised title *Young Ladies of Belsize Park*, and secondly, the structural and thematic similarity to Picasso's original, which

shocked Parisian society and was decried as aggressively erotic. In Souza's adaptation of what is essentially a brothel scene, there are five female figures in similar positions in Picasso's original. The figure seated on the extreme right bears the marks of an African head, which may also have been inspired by Picasso's painting. However, Souza's colours are much darker, with black outlines, and quite different from Picasso's soft beige nudes. Souza, living in Belsize Park (north London) around 1962 may have felt that a nearby red light area presented him an opportunity to produce an adaptation.[19]

But other factors must also be considered, to appreciate what Souza attempted in his singular interpretation of *Les Demoiselles d'Avignon*. Picasso's painting was itself a sampling, an appropriation, of the dramatic elements of line, shape, and form that were such a compelling aspect of the objects of African art recently discovered by early European modernists. Picasso sampled African art, and Souza, in *Young Ladies of Belsize Park*, made explicit, or reminded viewers of, the connection. More than a quarter of a century later, South African born painter Gavin Jantjes (who himself plays an important role in narratives of Black-British art history) took the dialogue a dramatic step further by his cosmic rendering of the what-goes-around-comes-around interplay between African art and Cubism, and the subsequent interplay between *Les Demoiselles d'Avignon* and the work of painters such as Souza, and indeed, Jantjes himself. In Jantjes' fascinating painting, the central figure in Picasso's *Les Demoiselles d'Avignon* is isolated on the right hand side of a rectangular, landscape canvas. The figure of the woman, from the waist up, is rendered in frugal but distinctive outline, as if in a cosmic galaxy, filled with twinkling stars. The outline of the figure is conjoined, by way of a lateral figure of eight loop, to an umbilical cord that emerges from, and returns to, the nasal and mouth orifices of a suspended-in-space African mask that bears more than a passing resemblance to one of the faces of Picasso's *Les Demoiselles*. Jantjes depicts a heavenly symbioticism though, pointedly perhaps, the mask faces away from, rather than towards, the figure.

Despite some career successes in London, (including the acquisition by The Tate of two of his works, in 1964) Souza, like Bowling before him, looked to New York to advance his life and career. Souza left for New York in 1967, settling there the following year. In the early 1980s, Souza's work was included in *India: Myth and Reality Aspects of Modern Indian Art*, an exhibition of

contemporary Indian artists' work organised by the Museum of Modern Art Oxford.[20] His biographical notes in the exhibition catalogue included the following comments,

> One of the founder members of the Progressive Artists' Group (Bombay, 1947), he was born in Portuguese Goa in 1924. Always a rebel, he organised protests against the insipid, academic system of training of the J. J. School of Art where he was a student. As a result of this, he was expelled. His paintings of the late forties project the rural life of Goa and the urban scene of Bombay in a strong expressionist idiom.
>
> He left India in 1949 and lived in London where, for almost two decades, his cruel, almost diabolical paintings and writings created a sensation and established him as an original, irrepressible talent. There is a savage intensity in most of his works where contemporary man is presented in a harsh and bitter light, as is the religious imagery connected with the Catholic church. On the other hand, the female nude is invariably rendered with a touching tenderness of feeling.[21]

However, it was not until Araeen included Souza in *The Other Story* that his contributions to the British art scene were recalled. More than two decades later, Souza has perhaps reverted to his familiar status as a somewhat peripheral figure of postwar British art, notwithstanding the substantial scholarship on this intriguing artist, particularly since his death in Mumbai in 2002.

As mentioned earlier, art criticism on South Asian artists in Britain during the 1950s and 1960s (and indeed, the decades beyond) tended to stress, or make mention of, the Indian-ness of the artist, as if the work itself provided faithful clues of cultural identity. Artists tended to find themselves in something of a double bind. Either they were perceived as demonstrating an artistically debilitating over-reliance on their Indian heritage, or they were perceived as somehow being in denial of their true selves, if their work failed to clearly demonstrate evidence of their ethnic or cultural heritage. As recently as 1980, the following sort of sentiment was being expressed:

> Balraj Khanna has no need to question his Indianness. Although he has lived in France and England since 1963, his work is suffused with a purely Indian sensibility. Its content is modestly universal, but lacks, happily, any of that overwhelming claim to Total Insight. As a true

artist he tills the field of his own emotions and responses. He is by birth a Punjabi, who is following the Western twentieth-century European artistic tradition of exploring the reservoir or matrix of his self; and this is unequivocally India, root and flower.[22]

Araeen for one took issue with such an apparently constrained understanding of the work of artists such as Khanna:

> I find it difficult to recognize Khanna's 'Indianness', which seems to me to be a quality invented by Western critics who find it hard to come to terms with Khanna's modernity. It is not a question of denying this 'Indianness', but of recognising as 'Indian' that aesthetic quality which has become part of the sensibility of modern works of art, which one would find in the works of Klee, Miró or Matisse, for example; to emphasize Khanna's 'Indianness' is to emphasize his Otherness.'[23]

Years earlier, Araeen had set out his stall with regards to such matters when he wrote, 'The question here therefore is not and should not be of ethnicity. One's creative ability in the contemporary world is not necessarily determined by one's own culture, the cultural knowledge or the country of one's origin.'[24]

The impulse of sections of the art world to assert, or seek to identify, some kind of perceptible ethnicity on the part of South Asian artists contrasted markedly by these artists' own attempts to locate themselves and their practice within a modernist discourse that lay beyond restricting notions of ethnicity and cultural identity. A somewhat aggravating factor to locate itself within this tension was the reality that South Asian artists, on occasion, either came together or were put together, in exhibitions such as *Seven Indian Painters* of 1958 and *Six Indian Painters* of 1964. Such exhibitions sometimes tended to generate a disproportionate commonality between the artists, thereby further rendering them vulnerable to an accentuated inscribing of ethnicity. In this regard, exhibitions such as those hosted by the New Vision Centre in London's West End offered audiences an opportunity to see artists' work in a mixed programme. Typical in this regard was a one-man show by Balraj Khanna, held there in October and November of 1965.[25]

Given that its landmass and population dominate those of its South Asian neighbours, it is perhaps no surprise that India has produced so many contemporary artists, and that significant numbers of them have made Britain their

home in the postwar decades. But artists from India's neighbours, particularly Pakistan (formerly West Pakistan) and Sri Lanka (formerly Ceylon) are also to be numbered amongst the early generations of immigrant artists who were making Britain their home during the 1950s and 60s. Chief amongst the artists from Pakistan were painters such as Anwar Shemza, discussed earlier, and Ahmed Parvez.[26] Chief amongst the artists from Sri Lanka was Ivan Peries. A versatile, at times almost eclectic painter, Peries nevertheless had a distinctive approach to paintings that were often decidedly strange, surreal, and dreamlike in their content and construction. Peries was the subject of a substantial monograph, posthumously produced. Within the lavish and extensively illustrated book, Peries was introduced in the following terms:

> In a lifetime of painting, extending over fifty years of consistent activity, Ivan Peries produced a body of work that makes an impressive artistic statement and a distinctive contribution to modern art in Asia. Best known for his symbolic and expressive landscapes and seascapes, and his subtle, almost musical, use of colour and tone, his works range from portrait studies, figure compositions and abstract collages to large, panoramic panels and delicate miniatures in acrylic and watercolour. Part of the post-colonial diaspora, he spent more than half his life in self-imposed exile in London and Southend-on-Sea, but his art remained to the end a prolonged meditation on his native Sri Lankan experience, and firmly takes its place in a tradition of contemporary Sri Lankan painting, exemplified in the work of the '43 Group.[27]

In 1963, a number of recently arrived artists from India came together to form the Indian Painters Collective. This was, however, a relatively short-lived initiative. One of the ventures of the Indian Painters Collective was an exhibition, *Six Indian Painters*, held at the Tagore India Centre, London, in 1964.[28] The exhibition was introduced in its catalogue as follows:

> The artists exhibited here are also the founder members of 'The Indian Painters Collective'. The group consists of Indian artists living and working in London. It has been formed with the intention of holding frequent exhibitions under their own auspices and also to participate in other exhibitions here and on the continent. Their work represents a cross section of Indian painting today. The young and talented members

of this group have won a good deal of acclaim in India and some are also known abroad.[29]

A decade and a half later, a similar venture was launched that proved to be altogether more resilient in its longevity, and more active in its profile. This was Indian Artists United Kingdom, which often went under the acronym IAUK. It was an important initiative involving a number of key artists of Indian birth and background, and involved artists such as Balraj Khanna, Yeshwant Mali, Prafulla Mohanti, Lancelot Ribeiro, Suresh Vedak, Ibrahim Wagh, and Mohammad Zakir. The brochure for an exhibition of work by IAUK artists, held in 1980, featured the following useful introduction to group:

> Throughout the history of art, at least throughout the history of modern art, there have been groups of artists. The reasons for the existence of these groups have been perhaps as diverse as the ideas behind them. But invariably there have been sound human reasons for these groups to come about.
>
> The *IAUK* too has similar reasons for its existence. It is an Association of Professional Artists of Indian origin who have lived and worked in the UK for the last fifteen years or more. It is a revised version of an earlier body – The Indian Painters Collective, 1963 – a revival which is influenced by practical reasons derived from the result of its members' efforts during their individual struggle for recognition.
>
> We, the members of *IAUK*, have come to believe that if the issues concerning us are approached collectively, we stand a better chance of succeeding and thus of making a positive contribution to the arts and culture of this country we have now made our home.
>
> Among the *IAUK*'s aims are the recognition of its members' work on an equal basis with their British contemporaries and the fulfilment of their rights to the amenities and facilities available in this democratic society. The *IAUK* would like to assist and promote Indian artists living in this country by showing their work. And, through exhibitions at 8 South Audley Street, London W1, and other selected places, it will attempt to create a growing awareness of the Indian arts and culture amongst the general public.
>
> The *IAUK* is the only organisation of its kind outside India. It functions on strict democratic lines.'[30]

IAUK had no pronounced agenda of activism, though when Mali, who had been a member of the group, exhibited at the Horizon Gallery in 1990, he was responsible for the single most pronounced episode of activism related to Indian artists in the UK. Responding to a news item in *India Weekly* of 31 August – 6 September 1990, Mali wrote a letter to the 'Director or Visual Arts Officer' of the Victoria and Albert Museum, regarding the news that 'The Nehru Gallery [at the V&A] will be opened by Her Majesty the Queen on 22 November 1990.' The letter read:

> Dear Sir/Madam, I am delighted with the news in India Weekly News Paper (31.08.90) that Her Majesty the Queen is going to open the Nehru Gallery at the V&A in November. I have several questions; 1. Who is funding this Gallery? 2. How much funds have they got? 3. Which visual artists are going to get the benefit from this Gallery? I have been in this country since 1962, working as a visual artist. There will be many artists like me, asking the same questions. Can anyone shed some light on this matter?[31]

Mali was clearly irked at the ways in which Indian artists such as himself, who had been based in the UK for several decades, were now experiencing somewhat reduced levels of visibility and were seemingly absent from considerations of how the Nehru Gallery might function. Copies of the letter, together with the brochure for Mali's exhibition at the Horizon Gallery[32] were sent to, amongst others, Her Majesty the Queen, the Arts Council of Great Britain, the Commonwealth Institute, the Indian Arts Council, and the Minister for the Arts. Mali may have been additionally irked by *India Weekly*'s description, in its Nehru Gallery announcement, of M.F. Husain as 'India's most famous contemporary artist', perhaps feeling that such a designation more rightfully belonged to him (or at least, that others were more befitting of such status).

The Significance of the 1970s

The 1970s was, in so many ways, a critical bridge, or decade of transition. Black-British artists ended the decade occupying a decidedly different sort of space to the one they had occupied at its beginning. Perhaps because of the recent occurrence of immigration to Britain from the countries of the British Commonwealth, foreign-born artists still tended to cluster around enforced, assumed and designated labels of national background, *vis-à-vis* their identity. To this end, the 1970s saw a marked use of terms such as 'Afro-Caribbean', 'West Indian', 'African', 'Asian' and so on, to describe, label or identify exhibiting artists. And within artists signified as 'Africa' or 'Asian', there were often more specific labels of nationality, such as 'Nigerian', 'Ghanaian', 'Ceylonese', 'Indian', and so on. With increasingly rare exceptions, the mixed exhibitions that characterised the profile of artists such as Bowling, Chandra and Williams were already becoming a matter of history and for history. Over time, Black artists found the particularities of their ethnic and racial identities counting for more and more, in an art world seemingly increasingly reluctant to accord them full respect as unique and individual practitioners. By the time the 1970s came to a close, only a very small number of Black artists were exhibiting, on occasion, outside of racially or ethnically specific exhibition contexts.

The reasons for this were several-fold. Firstly, these artists pretty much had nowhere else to go, and no other umbrellas under which to exhibit. Secondly, the societal status quo that had emerged in Britain by the mid 1970s was one in which Black people were, at best, assigned the status of societal *problem*. With the wider society apparently reluctant to accept Black people as equals, it was perhaps not surprising that the art world was to follow suit in such emphatic fashion. Other reasons were perhaps tied to those already mentioned. Foreign-born artists were increasingly drawn to the strategy of coming together as self-identifying groups, demarcated by

ethnicity, cultural heritage, or nationality. They tended to do so, not for reasons of ethnic chauvinism but for reasons of mutual support and with the idea of perhaps more effectively contributing to the society of which they were now a part.

As mentioned in the previous chapter, in the late 1970s a group of Indian-born painters came together to form IAUK, which cited 'its members' efforts during their individual struggle for recognition'[1] as one of the principal reasons for its establishment. In supporting IAUK, the Commission for Racial Equality stressed that:

> they formed themselves into a group more for reasons of mutual support than because they constitute an identifiable 'school' of painting. They believe that if they approach the issues concerning them collectively they stand a better chance of making a positive contribution to the arts and culture of the country they have made their home.[2]

But there were also external, or decidedly international factors that contributed to the extent to which Black artists in Britain were, by the 1970s, starting to cluster around designations of ethnicity as a means of advancing their own practice. In 1977, Nigeria, the West African giant, mounted an ambitious festival of arts, music, dance, literature and culture, called *Festac '77*. This was the second Black and African Festival of Arts and Culture, an extravaganza that brought together artists, writers, performers and others from the Black and African world, in an African-centred programme of events, performances, activities and exhibitions, for the most part taking place in the then Nigerian capital of Lagos.

An exhibition purportedly representing 'The work of the artists from the United Kingdom and Ireland' was sent to *Festac'77*. In reality, all of the artists were London-based, and the list now provides us with a fascinating snapshot of the Black artists and photographers, drawn from different parts of the world, who had, by the mid 1970s, made London their temporary or permanent home. These artists were Winston Branch, Mercian Carrena, Uzo Egonu, Armet Francis, Emmanuel Taiwo Jegede, Neil Kenlock, Donald Locke, Cyprian Mandala, Ronald Moody, Ossie Murray, Sue Smock, Lance Watson and Aubrey Williams.

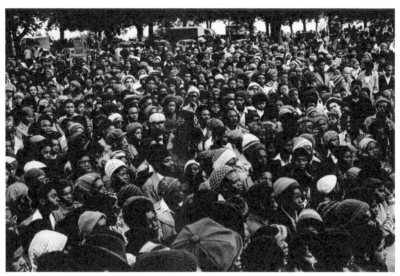

7. Vanley Burke, *Africa Liberation Day* photograph (1977).

The artists each represented different types of art practice, from the demonstrations of abstraction that lay at the heart of the paintings of Branch and Williams, through the pronounced manifestations of African cultural identity in the work of Nigerian artists Egonu and Jegede, to the ecological and environmental concerns frequently manifest in the work of Ronald Moody. The group of artists, with a comprehensive range of formal concerns, came together as practitioners of the Black, African and Pan-African worlds. In the catalogue produced to accompany the exhibition, Yinka Odunlami, Exhibition Officer of UKAFT (UK African Festival Trust), London, sought to locate the group within the aspirations of what he called 'a common humanity'.

The works of artists from the United Kingdom and Ireland Zone who are represented in this exhibition as a substantial contribution to the 2nd World Black & African Festival of Arts and Culture are not just a collection of nostalgic frolic. They are an appreciation of artists originally from widely varying backgrounds; their present human, cultural and environmental conditions focus on the direction of their future development. The concept of Black Art in this exhibition, whilst insisting on the unique contribution of traditional African Art to the general scene, is also committed to the projection of a new image based

on the understanding of a common humanity, hope and struggle of people everywhere. It would therefore be wrong to brand this theme racial.[3]

By the mid 1970s, there was only one dominant context in which the work of Black-British artists was being located, and that was 'ethnic arts'.

The establishment of the term and the construct of 'ethnic arts' could be traced back to a report titled *The Arts Britain Ignores* written by Naseem Khan in 1976.[4] 'Ethnic Arts' tended to define and regard the arts and cultural expressions of Black (or, more specifically, non-white) people in somewhat fixed terms. 'Culture' was regarded as something of a fixed self-referencing entity that the darker peoples of the world carried with them for all time, as part of a historic continuum. One of the biggest problems with this pathology is that it was unable to establish any sort of rapport or interaction between Black people and the main currents of modern and contemporary art. Instead, 'ethnic arts' tended to conjure up associations of ancient cultures embedded in the souls of Black people, whilst white artists were never regarded as embodying such historical continuums, thereby rendering them more suited to modern and contemporary art practices. As far as ethnic arts critics such as Rasheed Araeen were concerned, the dislocation between ethnic arts and the main currents of contemporary art was a 'fact'. Furthermore, 'our cultural traditions are now being seen and are being offered to us as the limits of our artistic or creative potential.'[5]

By the mid to late 1970s, the political and cultural manifestations of the Black presence in Britain was beginning to undergo seismic and traumatic shifts, reflecting the somewhat pained transition from 'West Indian', to 'Afro Caribbean' to 'Black British'. At this time, immigrants from the Caribbean self-identified (and were given the label of) *West Indian*, reflective of their somewhat tenuous hold on British citizenship. The label and self-identification of Caribbean immigrants as 'West Indian' was arguably not as problematic as the telling assigning by British society of the same term to the British-born and British-raised children of these immigrants. The use of the term 'West Indian' to describe Black British youngsters continued well into the 1980s, further emphasising a considerable fissure between Blackness and Britishness. Black Britons bridled against the constraining and alienating designation of themselves as West Indian and it was in this context that the term *Afro-Caribbean* gained both currency and favour as the 1970s progressed.

Notwithstanding the increasing traction of ethnic arts, (and its attendant description of Black Britons as an ethnic minority), the 1970s gave rise to a pronounced and new tendency on the part of Black Britons to embrace the designation of 'Afro-Caribbean'. And this was reflected, not only in much Black artists' practice and exhibitions of the period, but in wider cultural manifestations as well. No single image of the 1970s summed up the cultural spaces to which young Black Britain was gravitating more than Vanley Burke's majestic, panoramic photograph, taken in Handsworth Park, Birmingham, at an Africa Liberation Day rally in the late 1970s. Perhaps counter-intuitively, Burke made the focus of the photograph not the people addressing the multitude, but the multitude itself. In this sense, though the focus of the gathered throng's attention is located somewhere beyond, or outside of, the right side of the image, Burke chose to make the attentive crowd the subject of his picture. To successfully photograph large numbers of people gathered together in one place is one of the most difficult tasks for a photographer. And yet, within this image, Burke produced a compelling and remarkably cogent document of a particularly culturally and politically charged moment in the history of Black Britain.

Nearly all – to a man, to a woman – of the large number of people in the magnificent, commanding photograph betrayed about them or their person some evidence of the influence of Rastafarianism, the hugely empowering and counter-cultural movement that had emerged amongst Black people in Jamaica earlier on in the twentieth century. In Burke's photograph, dreadlocks abound, as do tams, wraps and numerous other signs of Rasta. As with all great photographs of crowd scenes, we see not so much a crowd, or a multitude, but a group of individuals. And in beholding or appraising individual people *en masse*, Burke in effect created a singular study of such things as the facial expressions, body language, and clothing that make each of the photographed people distinctive, particular, and in one or two instances, idiosyncratic or eccentric.

Around the time Burke's Africa Liberation Day photograph was taken, an important exhibition of *Afro-Caribbean Art* took place at a gallery in London. This was the open submission exhibition referenced in the Introduction, held between April and May 1978 at the Artists Market. Artists represented in the exhibition included Mohammed Ahmed Abdalla, Frank Bowling, Reynold Duncan, Merdelle Irving, Emmanuel Taiwo Jegede, Donald Locke, Cyprian Mandala, Siddig El N'Goumi, Adesose Wallace, and Lance Watson.

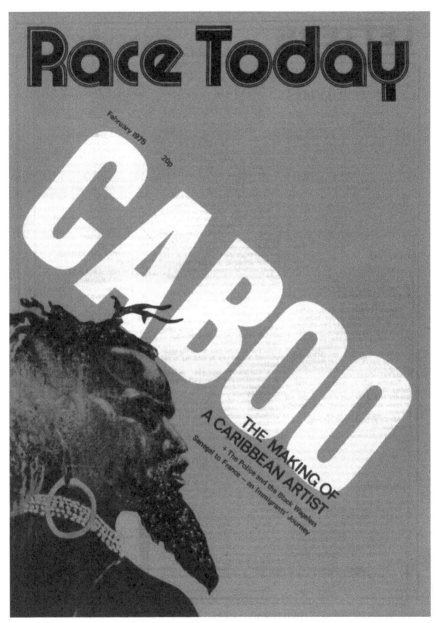

8. *Caboo*, *Race Today* magazine cover (1975).

The exhibition was important for several reasons. Firstly, the staging of the exhibition reflected the sorts of cultural strategies to which a number of Black-British artists were gravitating by the late 1970s. The exhibition was organised by Drum Arts Centre, very much an arts centre in the making, rather than one already fully formed. Secondly, the exhibition effectively reflected a number of the strands of artistic practice then being pursued by Black artists within the capital. And thirdly, the critique of the exhibition by Rasheed Araeen offered what he considered to be substantial pointers to the limitations of cross-art form exhibitions that had as the criterion for their existence the supposed racial or ethnic commonality of the exhibitors. Cross-art form group exhibitions of work by Black artists represented a knotty contradiction. On the one hand, these exhibitions represented an apparent marginalising, or separating, of these artists from the mainstream. Simultaneously, however, the bringing together, within one exhibition of all manner of art works emphasised the degree to which the exhibitors perhaps had little in common beyond shared ethnicity or related ethnic identities.

Like the artists assembled for the *Festac '77* exhibition that took place a year earlier, the coming together of the artists in *Afro-Caribbean Art* enacted a strategy of cultural empowerment, in the face of British societal hostility and entrenched art world indifference. (Indeed, several artists were represented in both exhibitions). The artists themselves (involved in these particular types of exhibitions) were untroubled by their somewhat eclectic content. Painting was exhibited alongside sculpture, printmaking alongside ceramics, and drawings alongside mixed-media works. Whilst mainstream exhibitions had long since gravitated towards displays characterised by a similarity of media, grassroots initiatives, in which Black artists themselves were often closely involved in the organising, were, by way of marked contrast, displays that often showcased a variety of mediums. Indeed, artists drew strength from their coming together as practitioners across the divides of art practice, and in some instances, nationality. It was for others (notably Araeen) to predict or identify the fissures that would, in years to come, bedevil certain exhibitions of Black artists' work.

The only substantial references to this exhibition are a review by Rasheed Araeen, contained in a 1978 issue of his *Black Phoenix* magazine[6], and a review by Emmanuel Cooper, contained in *Art & Artists*, July 1978[7].

Araeen began his review with a disinterested summary of the exhibition, followed by a quote from an introduction to the exhibition. Having dispensed

with the formalities, he then laid into the exhibition and what he perceived to be its contradictions and weaknesses. He wasted little time in getting to the nub of his argument:

> But what is Afro-Caribbean Art? is *the* question one cannot help asking after seeing the exhibition. And in fact one wonders if there really is such a thing as Afro-Caribbean Art. The question can be answered in two different ways, affirmatively as well as negatively, depending on how one would like to look at such things. Whether one is just happy to see *some* black artists exhibiting together under *some* title, or one is seriously concerned about the nature and content of the work beyond liberal sympathy and sentimentality.
>
> The reality which qualifies an art as 'Afro-Caribbean Art' has to be there. Just because an art is produced by somebody who is of Afro-Caribbean origin, or for that matter from Africa or the Caribbean, does not itself lend to that art an Afro-Caribbean particularity unless that particularity is expressed in the work itself, unless the work reflects upon or deals with a reality which in turn necessitates the work to be called 'Afro-Caribbean Art'.[8]

Araeen continued his relentless critique in similar vein, oscillating between a spirited fault-finding of the exhibition's structural weaknesses, as he perceived them, and a critique of the artists' contributions themselves. At one point he even went as far as referring to some Black artists as having 'produced compromisingly third to fifth rate works.' Perhaps the most surprising sentiments in Araeen's review were to be found amongst his references to Frank Bowling. Ten years after Araeen wrote this commentary on the exhibition *Afro-Caribbean Art*, he included Bowling in his important Hayward Gallery exhibition, *The Other Story*. In 1978, however, employing the majestic plural, or the royal 'we', Araeen's comments on Bowling were decidedly uncharitable:

> Three works by Frank Bowling, who is supposed to be internationally known, might have impressed us twenty years ago. In fact we would have certainly credited him if he had innovated this method of throwing paint directly on the canvas or contributed further to its development. Now one has to be ignorant, or pretend ignorance to appreciate what

is no more than a decorative pastiche of the outmoded styles of post-Abstract Expressionist period in New York. They might look beautiful in somebody's house or office but have nothing to say.

For good measure Araeen embellished his criticisms by linking Bowling with artists 'who are dabblingly pursuing a kind of formalist mannerism merely in the interests of careerism.'

The measure of the extent of the problems that Araeen laid out in his arguments about *Afro-Caribbean Art* could be seen in his own exhibition programming and several of the group exhibitions in which he was represented during the 1980s. In 1986, Araeen put together an exhibition he titled *Third World Within*. Held at Brixton Art Gallery,[9] it was described as an 'exhibition of the work of AfroAsian Artists in Britain'. Apart from Araeen himself, the exhibition featured Saleem Arif, Avtarjeet Dhanjal, Uzo Egonu, Mona Hatoum, Gavin Jantjes, Keith Piper and Kumiko Shimuzu. Within the exhibition, it was not possible to identify which characteristics, sensibilities or aesthetics reflected Araeen's designation of the artists as AfroAsian (a term he preferred over, or used instead of, 'Black'). Two years later, Araeen's altogether more monumental affair, *The Other Story*, featured a broad range of artists from different ethnic backgrounds (excluding white) whose practices ranged from the explicitly political though to the esoteric, from the highly figurative to the abstract and formalist. He found room in *The Other Story* for several artists whose work had been in *Afro-Caribbean Art*, namely Lubaina Himid, Donald Locke and Frank Bowling, about whom, in his review of *Afro-Caribbean Art*, Araeen had expressed such withering sentiments. In part, Araeen's curatorial thesis proposed that the 24 artists in *The Other Story* had been marginalised from dominant narratives of twentieth century British art history and that he wished to see them more fully integrated into such narratives. In effect, this amounted to a mirroring of Mapondera's introduction that Araeen had quoted at the beginning of his *Afro-Caribbean Art* review.

Elsewhere, at other times during the 1980s, Araeen contributed work to exhibitions such as *From Two Worlds*, held at the Whitechapel Art Gallery in 1986.[10] Whilst more than two decades earlier Frank Bowling had aspired to exhibit alongside his white peers (with whom he shared an extensive affinity) in *The New Generation* exhibition (from which he felt himself to have been excluded), *From Two Worlds* represented a bringing together of an

eclectic, or diverse, range of practitioners sharing precious little more than degrees of non-white pigmentation or ethnicity. It was this that led Keith Piper, one of the artists included in the exhibition, to report, some time after the exhibition had closed, that it represented 'an insensitive lumping together of a hotch-potch of art objects apparently linked only by the 'non-European-ness' of their makers.'[11]

More than anything, Araeen's critique of *Afro-Caribbean Art*, and the ways in which his own interventions were themselves not free from the same critiques, point to the formidable extent to which dominant art world pathologies were wreaking havoc with the aspirations of Black-British artists. Exhibitions of Black artists' work often came about as a consequence of, or a reaction to, the exclusion of the artists from both integrated gallery program-ming, or substantial solo exhibitions. By the mid to late 1970s, the sorts of integrated programming and solo exhibitions that Frank Bowling and Aubrey Williams had enjoyed in the early 1960s were pretty much things of the past. Instead, the only platform intermittently available to Black artists was the Black group exhibition, which was sometimes presented as a plea for greater respect and acknowledgement from the mainstream. Unfortunately, discrim-inatory pathologies of the art world were ultimately unaffected and untrou-bled by such exhibitions. A decade after *Afro-Caribbean Art*, those organising such exhibitions were, on occasion, still reaching for 'Afro-Caribbean' as a designation or signification of artists' work. In one such example, several of the artists were born in the UK, and one, Uzo Egonu, was born in Nigeria. Even so, the 'Afro-Caribbean' label was freely applied.[12]

The exhibition was organised by Drum Arts Centre, a would-be arts centre dedicated to the arts of practitioners and performers of the African Diaspora. The Drum Arts Centre in question is not to be confused with the centre of the same name that opened in Birmingham in 1998, though the ventures could be said to have had similar mission statements. In early 1975, Drum Arts Centre (London) declared itself to be 'A new arts complex theatre, gallery and audio visual workshop to be created in Central London for the promo-tion of black actors, artists, dancers, musicians and writers.'[13] One of the important aspects of the exhibition *Afro-Caribbean Art* was that it was a visual arts undertaking meant to showcase some of the possibilities of what a Black arts centre for London could offer. What made the exhibition such a singular undertaking was that Black arts centres in the UK have largely privileged performance, theatre, poetry, music, and literature above the visual

arts. Indeed, for a variety of reasons, the UK's Black arts centres have, with rare exceptions, tended to ignore the visual arts or to keep visual artists at arm's length from what these centres regard as their core programmes of activities.

The Keskidee Centre in Kings Cross was perhaps an exception to this, as it hosted artists' residencies and was the venue for talks on artists. An indication of the significance of the Keskidee Centre's role as a venue committed to nurturing, supporting and celebrating Black visual artists can be elicited from a sentence in the Preface to the Caribbean arts journal, *Savacou* issue 9/10, written by John La Rose and Andrew Salkey:

At the time of writing, the most recent medium session, held at the Keskidee Centre, on Friday 10th March 1972, was *A Tribute to Ronald Moody*, a historical exposition, illustrated with slides of the Jamaican sculptor, arranged and presented by Errol Lloyd, the Jamaican painter.[14]

The Keskidee Centre also hosted a long-term residency by an intriguing Trinidad-born, London painter going by the name Caboo. The February 1975 issue of *Race Today* magazine featured a substantial feature on the painter, entitled, 'Caboo: The Making of a Caribbean Artist.' Not only did the feature run across some four pages and include two reproductions of Caboo's work, he also had the cover of the magazine, with his name rendered in bold and large typography, together with an image detail. In the text itself, Caboo stated that

in the last 9 months coming to work here at Keskidee gives me the opportunity to hold a studio, hold some materials and start working seriously. So that what you see at the recent exhibition is the beginning of my painting career as such.

The exhibition took place at the Keskidee Centre which is the black community centre in North London. A lot of young people attended. I paint with them specifically in mind.[15]

Within these references to Keskidee Centre, Caboo pointed to the nurturing, facilitating and enabling role of the centre in providing valuable studio space and generating audiences. In that regard, Keskidee was particularly noteworthy, and several years later it was a meeting held at Keskidee that saw

the launch of an intriguing new initiative known as the Rainbow Art Group. Briefly, the history of the group was as follows:

> In the Spring of 1978 MAAS (Minorities' Arts Advisory Service) held its second London conference. This conference, which took place on the 14th April 1978, summoned together people from ethnic groups living in London who were involved with the arts of London's ethnic groups [...] The visual artists recognised the main problem that exists in relation to the work and aspirations of all ethnic minorities in the art world, including their own. This is the difficulty that all find in getting their work considered seriously and supported through established channels. They therefore decided, at the Conference, to form an organisation with the aim of promoting their work and, by joint efforts, to make a positive contribution to the cultural life of the country. In this way they hope eventually to create a climate of knowledge and appreciation that will allow the work of the future generation to be admired and sought after on its own merits and not simply because it happens to be the work of an ethnic minority. The first tasks were to find a name, qualify aims and objectives and work out a constitution. At the group's second meeting, held on the 24th June 1978 at the Keskidee Centre, the members agreed that the group should be named 'Rainbow Art Group' thereafter.[16]

The group consisted of Indira Ariyanayagam, Uzo Egonu, Lancelot Ribeiro, Taiwo Jegede, Errol Lloyd, Yeshwant Mali, Gordon V. de la Mothe, Durlabh Singh, Suresh Vedak, Ibrahim Wagh, and Mohammad Zakir. Rainbow Art Group undertook several exhibitions during the time of its existence.

Throughout the 1960s and into the 1970s, Caribbean migrants responded to the hostility of British society and the treachery of Britain's political class by setting up their own institutions, from churches to Saturday schools, from cricket and football teams to alternative banking systems, from youth clubs to reggae sound systems. All these things were manifestations of Black people's need to set up their own alternatives, in response to the neglect, indifference, hostility or outright racism demonstrated to them by British churches, banks, schools, social clubs, etc. It was in this context of British societal hostility and entrenched indifference on the part of London's institutions of arts and culture that a group of individuals, enacting the strategy of

cultural empowerment mentioned earlier, came together with the hopes of establishing a dedicated Black arts centre, which they envisaged should be called the Drum Arts Centre.[17]

A feature by Taiwo Ajai on Drum Arts Centre titled *Drum Call for Black Britain* appeared in Africa magazine in April 1975.[18] The text pointed to a number of the elements that reflected the strategies for enhancing visibility being pursued by some Black artists and their advocates. By now, it was taken as a given, amongst certain people, that separate provision was the only way to go. Wrote Ajai, 'There is undoubtedly a need for a Black arts centre in London and a serious, well-planned attempt to establish one is long overdue.' Significantly, Ajai also made mention of the country's apparently 'deteriorating racial situation' and assumed a correlation between that and the funding of Black cultural activity. One of the most unvarnished sentiments expressed in the text was that 'professional Black artists wishing to 'integrate' have been faced by an almost total lack of employment opportunities.' Over time, Ajai's dispiriting observation would prove itself to be something of an enduring sentiment.

The 'deteriorating racial situation' of which Ajai had made mention took a particularly vehement turn not much more than a year after *Drum Call for Black Britain* was published, when violent disturbances involving Black youth and the police erupted at the annual Notting Hill carnival. That year, 1976, saw a dramatic escalation in the numbers of police officers assigned to patrol the event. This was significant because thereafter, much of the mainstream media structured its coverage of Notting Hill carnival around the supposed links between carnival, the apparent criminality of *racial* sections of carnival-goers, and an apparent need for the said criminal elements to be policed. By this time, Black youth, primarily males, were finding themselves to be the increasing focus of the police's attention, through the operating of the notorious stop and search (*Sus*) law. The effective swamping of the Notting Hill carnival by large numbers of police officers, and the attendant feelings of intimidation felt by some carnival-goers was memorably captured in a key work by Dominica-born British artist Tam Joseph within a few years of the cataclysmic events of 1976[19].

In one of her concluding paragraphs in the *Africa* magazine feature, Ajai posited that:

A hopeful sign is that, in a deteriorating racial situation, the British establishment also sees the justification for funding Black cultural activities if only the organisational failures which have bedevilled them in the past can be overcome. The survey on minority arts at present being carried out by Ms Naseem Khan and funded by the Arts Council, the Community Relations Commission and the Calouste Gulbenkian Foundation, is evidence of this.

As mentioned in the introduction to this book, 'Black artists', as a self-declared, and self-identified body of practitioners did not emerge in the UK until the early 1980s. As late as the 1970s there was a presupposition that being Black and being British were mutually exclusive states of being, hence the use of terminology such as 'minority arts'. Before the emergence of the Black-British artist there were, instead, 'Afro-Caribbean' artists, 'West Indian' artists, 'African' artists, 'Asian' artists and so on. And within artists signified as 'African' or 'Asian' there were often more specific labels of nationality, such as 'Nigerian', 'Ghanaian', 'Ceylonese', 'Indian', and so on. Without exception, none of these artists referred to themselves, or their practice, as 'Black', preferring instead umbrella terms such as 'Afro-Caribbean'. Interestingly, though the notion of Black arts was gaining some traction, the notion of Black art, as a specific type of art practice had not yet manifested itself. But by the late 1970s, the emergence of *Black art*, and the *Black artist* was just around the corner.

The 1970s found, or left, Black artists in something of an invidious position. The terms of reference used to discuss or locate the practices of Black artists tended to be somewhat separate from those used in relation to their white counterparts, even though the 'Britishness' of both sets of artists was, year on year, becoming ever more factual and apparent. Though certain groups of artists were regarding their separateness, or distinctiveness, through a prism of political or cultural empowerment, there was perhaps no mistaking the extent to which the notions of 'British' art that were being promulgated at home and abroad tended to cluster around white artists only. Araeen summed up this situation as follows:

> While white painters and sculptors, among them many third-rate mediocres, are sent around the whole world to keep the flag of British art achievements flying, black artists, no matter what

they have achieved in their work and how important they are historically, cannot even get into mixed shows here in Britain.[20]

As noted in this chapter, both the emergence of 'ethnic arts' as the dominant framework for understanding the practices of Black artists, and the clustering of artists under umbrella terms such as 'Afro-Caribbean' were challenged vociferously by Araeen, who had emerged, during the course of the 1970s, as one of the most important and influential figures in the development of Black visual arts practice in mid-late twentieth century Britain.[21] He was one of the first significant London-based figures to acknowledge and critically engage with the new generation of Black artists such as Keith Piper. An accomplished and widely exhibited artist and sculptor, Araeen was also well known for his work as a writer, curator and editor. It was in his capacity of editor that he brought into existence the journal, *Third Text*, which he edited for a considerable number of years. His earlier work as a writer and editor centred on the publication *Black Phoenix*, three issues of which were published towards the end of the 1970s. These issues were hugely important documents, reflecting pronounced counter-cultural arguments and thinking about art, culture, and politics at this critical period in British and international politics. Within these issues were heard not only Araeen's voice, but also the voices of a range of people, coming from, as well as addressing, different highly charged international locations. Further, these issues of *Black Phoenix* gave substantial clues and pointers as to the nature of Black artists' practice of the time. Particularly important in this regard was Araeen's review of the 1978 exhibition of *Afro-Caribbean Art* discussed in this chapter.

But this was more than just an exhibition review. Araeen took to task some of the assertions and assumptions that he felt underpinned the exhibition. In so doing, Araeen was to rehearse (or presciently anticipate) many of the issues that were to dominate discussions of Black-British artists' practice over the course of the following decade and beyond. *Black Phoenix* – perhaps aptly, given its name – was resurrected, reborn, and relaunched by Araeen as the predominantly theoretical and reflective art journal *Third Text*. For significant periods of its history *Third Text* paid attention to contemporary visual arts practice in the UK by reviewing exhibitions and by publishing other features – interviews, biographical texts, and so on. In this regard, *Third Text* contributed much to the process of chronicling visual arts activity, not just in the UK, but internationally as well.

Araeen was instrumental in curating an exhibition that sought to clarify and resolve what, in time, could be summarised as the 'what is Black art?' argument. This exhibition was *The Essential Black Art*.[22] The exhibition was conscious of problematic aspects of the recent history of Black visual arts practice in Britain and how that practice was perceived and defined by sections of the wider community and the art establishment. As such, *The Essential Black Art* was consciously positioned as an attempt to negotiate a number of impasses or look again at a debate that had, to an extent, reached what Keith Piper termed 'a consensus of pluralism', particularly after South Asian visual arts practice had to some extent managed to incorporate itself into broadly accepted definitions of 'Black' visual arts activity by the close of the 1980s.

Araeen's arguments concerning the definition of 'Black Art' were articulated in the introductory notes for *The Essential Black Art* catalogue. His view was that:

> The term 'black art' is now being commonly used by the black community as well as by people in Britain in general. But this common usage is often a misuse, as far as the work that might be called 'black art' is concerned. It may be a convenient term to refer to the work of black artists, but it also implies that their work is or should necessarily be different from the mainstream of modern culture.

Araeen's thesis was that '"Black Art", if the term must be used, defined specific historical development within contemporary art practice and had emerged directly from the joint struggle of Asian, African and Caribbean people against racism, and the art work itself explicitly refers to that struggle'[23]. In his view, any other definition or understanding of *Black art* (that merely regarded it as the visual creativity of any and all non-white people) was erroneous and had its basis in ignorance. Such thinking and assertions by Araeen marked him out as being an important critical voice. His views and comments influenced the direction taken by Black art into the 1980s and beyond.

Uzo Egonu and Contemporary African Art in Britain

As mentioned in Chapter Two, the opening in 1962 of the Commonwealth Institute and its galleries, particularly the main one, provided an important exhibiting venue for African, Asian and Caribbean artists based in London, as well as their counterparts in other parts of the world. There were two gallery spaces at the Commonwealth Institute, which was centrally located in the heart of London, on Kensington High Street. The main space opened with an inaugural exhibition, *Commonwealth Art Today*, on 7 November 1962.[1] Her Majesty the Queen opened the Institute, at which time she met a number of artists, including Francis Newton Souza. A second space, known as the Bhownagree Gallery, occupying a passageway/corridor, also existed within this modern architectural complex that operated to promote the arts, culture, and other aspects of the countries of the Commonwealth. The Commonwealth Institute hosted a considerable number of important exhibitions, over a period of nearly four decades. These exhibitions included both solo shows and group shows, by artists from, or with significant links to, the countries of the Commonwealth. The inaugural exhibition, *Commonwealth Art Today*, provided an invaluable series of snapshots of contemporary art practice as it existed across extensive parts of the world and within the capital. For example, Frank Bowling and Aubrey Williams represented Guyana (then known as British Guiana).

Nearly a decade later, the Commonwealth Institute hosted an exhibition of *Caribbean Artists in England*.[2] Again, this was an venture of great importance, offering as it did a substantial and high-profile opportunity for artists with links to the Caribbean, temporarily resident in England, to exhibit alongside other Caribbean artists who had made their homes in the nation's capital. The exhibiting artists were Althea Bastien, Winston Branch, Owen R. Coombs, Karl Craig, Daphne Dennison, Art Derry, Errol Lloyd, Donald Locke, George Lynch, Althea McNish, Ronald Moody, Keith Simon, Vernon

Tong, Ricardo Wilkins, Aubrey Williams, Llewellyn Xavier, and Paul Dash (though he was unlisted).

Like their counterparts from the South Asian countries of India, Pakistan and Ceylon, young artists from across the African continent were settling in London and establishing careers for themselves, often following periods of study at London's art schools. From the 1950s onwards, these artists, resident in London and elsewhere in the country, were joined by other African artists whose time in London was much briefer and was often linked to exhibitions of their work at venues such as the Commonwealth Institute and Camden Arts Centre. Perhaps the most significant pioneering African artist to settle in London and contribute to the British art scene was Uzo Egonu, born on 25 December 1931 in the Nigerian city of Onitsha. Like Frank Bowling some years later, Egonu came to the UK whilst still in his early teens. He was very much 'an African artist in the West',[3] as Olu Oguibe described him. Indeed, so acculturated was Egonu to life as a British artist that he was one of the 11 practitioners whose work was sent from London to Lagos for *Festac '77: The work of the artists from the United Kingdom and Ireland.* As mentioned earlier, *Festac'77* was an international festival of arts and culture from the Black world and the African Diaspora. All of the artists were London-based, and Egonu exhibited in the company of another Nigeria-born artist, Emmanuel Taiwo Jegede, and other artists from the United States and the Caribbean who had made London their home.

Egonu had the distinction of being, as Araeen put it, 'perhaps the first person from Africa, Asia or the Caribbean to come to Britain after the War with the sole intention of becoming an artist.'[4] In this regard, Guyana-born painter, author and archaeologist Denis Williams should perhaps also be considered, his early promise as a painter having won him a two-year British Council scholarship to the Camberwell School of Art in London in 1946. Egonu also takes his place alongside another important pioneering Nigerian artist, Ben Enwonwu (1917 or 1921–1994)[5], described as:

> One of the most well known African artists to have trained and exhib-
> ited in Britain during the period between the wars, Born, [like Egonu]
> in Onitsha, Nigeria, Enwonwu studied at Goldsmiths, Ruskin College
> at Oxford and the Slade School of Fine Art at University College
> London before returning to Nigeria and embarking on an international
> career in art.[6]

9. Uzo Egonu, *Piccadilly Circus* (1969).

Egonu was introduced to art at an early age and was painting in Nigeria before coming to the UK. Within a few years of his arrival he had completed his schooling in Norfolk, before going on to study fine art, design and typography from 1949 to 1952 at the Camberwell School of Arts and Crafts in London. (This was the art school to which Denis Bowen had won a scholarship in 1946.) Egonu was, from a young age, a prolific and gifted painter and his work consistently reflected a distinctive fusion of modernist influences and aesthetics derivative of his West African heritage. Despite, or possibly because, Egonu left his native Nigeria at such a tender age, the influence, or the *memory* of Nigeria was a recognisable aspect of his practice. Like other artists from Africa, Asia and the Caribbean, Egonu's work was in essence a blend of the abstract, the figurative and the representational. As Oguibe observed, 'For Egonu it was only proper that African artists should not lose themselves in the fiction of a universalist modernism. Instead, they should define a place for themselves within modernism whilst also registering the specificities of their origins.'[7] This pronounced reluctance on Egonu's part to immerse himself uncritically in the language of Modernism had been observed some years earlier. 'But Egonu resisted the common danger for the

African artist of creating an art that was European and derivative without the authentic roots of a personal experience.'⁸ Such sentiments were, however, not entirely unproblematic. The pathology in which artists of Africa were constantly assessed according to notions of *authenticity* remained a fiendishly stubborn criterion by which artists were judged.

Egonu had a remarkable ability to render landscapes and cityscapes as compelling and fascinating geometrical configurations, each of his paintings being very different in its representational aspects. In the mid 1990s one curator pointed to the profound range of influences that could be ascertained in Egonu's work:

Drawn from his studies of African masks, Nok sculpture, Igbo murals, the work of Parisian modernists and a wealth of other sources, Egonu's lyrical paintings and prints thematically investigate diasporic movement, isolation and exile for immigrants in the West, philosophical ruminations on war, nationalism and other concerns.'⁹

A quarter of a century earlier, the breadth of Egonu's practice had been couched in the following terms: 'Egonu is preoccupied with world affairs and his recent themes reflect a search for peace and security; he has also done a series of paintings of London.'¹⁰ In many ways, Egonu's strength as an artist lay in the abiding integrity of his painting. He was, for over half a century of artistic practice, unswayed by the fashions or indeed the vagaries of the art scene. Olu Oguibe, who authored a monograph on Egonu published shortly before the artist died in 1996, noted this. Referring to Egonu's practice, Oguibe observed that 'its greatness lies in the artist's general disregard for movements and prevailing aesthetic strategies, and in his pursuit of techniques appropriate for his own vision and circumstances.'¹¹

But the artist who could paint scenes from his homeland with such empathy and affection, such as *Northern Nigeria Landscape* (1964), was the same artist who could, simultaneously, turn his attention to depicting the freneticism, spirit and the decidedly different architecture of London, the city that was home to Egonu for half a century. Not surprisingly, London was affectionately depicted in Egonu's work, no more so than in paintings such as *Trafalgar Square* (1968) and *Piccadilly Circus* (1969). If ever a painting represented the exuberance and frenetic spirit of the swinging 60s, it was *Piccadilly Circus*

(reproduced here), a painting that is a veritable vortex of movement, architecture, transport, and people on the move.

Though Egonu was resident in London for half a century, he remained primarily identified with the country of his birth and early childhood, rather than the country to which he migrated, as a child. This tendency to keep such artists at arm's length from inclusive notions of British art was counterbalanced by a willingness, desire, or need on the part of artists themselves to maintain a close notional association with the countries and continents from which they had emigrated. On occasion, artists such as Egonu exercised greater traction, or leverage, exhibiting as *African* artists, rather than as the *British* artists they plainly were. Nearly a quarter of a century after he settled in London, Egonu was one of a number of artists to be included in an important exhibition of *Contemporary African Art* held at Camden Arts Centre. This large exhibition was significant for a number of reasons. Firstly, the exhibition's catalogue (for which Egonu provided the cover illustration, stretching over the front and back cover), repeatedly stressed sentiments such as, 'The exhibition has been carefully prepared to include as many artists as possible – to the point that it constitutes the first attempt at a comprehensive view of the contemporary African scene.'[12] The exhibition had at its core a deliberate and concerted attempt to present the artists as very much occupying a modern world, in contrast to the dominant mindset which tended to regard Africa's best art as somehow located in a somewhat ancient yet timeless, mythic past.

[V]ery few are sufficiently concerned to look at contemporary works, much less take them seriously. It is sufficient to notice that most books on African art close abruptly after a presentation of the heads of Ife, the Bambara antelopes, the Baule masks, the Fang statuettes, the Kota reliquaries, the Lega ivories [...] all the well known examples of 'good' African art. As long as we condemn Africa to the past, the numerous exhibitions of traditional art will introduce us to nothing more than a universe of tribal images seasoned in myths – carefully conserved, interpreted and distributed by the Western intellectual.[13]

Elsewhere in the catalogue, another introduction let it be known that 'This Exhibition will present the public with its first opportunity to see the work of modern African artists in its full range and variety, from Dakar to Zanzibar

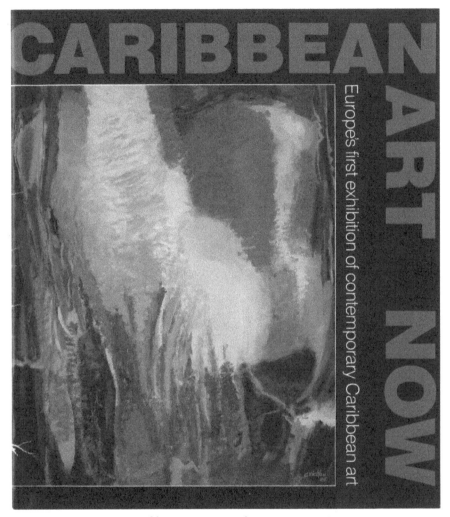

10. *Caribbean Art Now* catalogue cover (1986).

and from the Blue Nile to the Reef.'[14] This was to be the first of a number of periodic attempts to introduce the work of contemporary African artists to London and British audiences. Each new attempt revisited the above sentiments, in the hopes of disabusing the notion that contemporary art and Africa were somehow mutually exclusive. A quarter of a century after *Contemporary African Art*, London galleries played host to an ambitious series of exhibitions and other events that went under the banner of *africa 95*.[15] One of the centrepieces of the project was *Seven Stories About Modern Art in Africa*.[16] The Director of Whitechapel Art Gallery (which hosted the exhibition) wrote in her catalogue foreword that the exhibition

has been organised with the confidence that, by listening first to the personal viewpoints of distinguished African artists and curators, attention will be directed to the serious achievements of artists, both those working as individuals and those who have contributed to movements.'[17]

One of the exhibition's co-curators, Clémentine Deliss, wrote in her introductory essay that when the exhibition was devised several years earlier, it proposed 'to provide a series of personal interpretations, by artists and historians from Africa, of specific movements or connections which have significantly qualified twentieth-century modern art in Africa.'[18] Towards the end of her essay, Deliss opined that 'In their personal styles, the *Seven Stories* together display the diversity of artistic expression in the visual arts of Africa in this century, introducing audiences to the artists' own understandings of their recent histories.'[19]

A decade later, the whole *africa 95* enterprise was reprised as *Africa 05*. On this occasion, the key exhibition aimed at introducing the work of contemporary African artists to London audiences was *Africa Remix*.[20] The Preface to the *Africa Remix* catalogue opened with the boast that this was 'the largest exhibition of contemporary African art ever seen in Europe'.[21] In his Introduction, Roger Malbert suggested that, '*Africa Remix* should be thought of [...] as an anthology or compilation, serving to introduce a selection of significant artists to a wider public largely unfamiliar with them.'[22] The size and scale of the exhibition was clearly important to Malbert, who went on to say 'One distinction of *Africa Remix* is that it is the first large-scale exhibition to embrace the whole continent, north and south, from Cairo to Cape Town.'[23] Seven years later, another such exhibition took place. *We Face Forward: Art from West Africa Today* was shown at venues in Manchester during the summer of 2012.[24] The exhibition challenged its imagined audience to:

Forget everything you think you know about African art; embrace all that you don't yet know about the art, culture and creativity of West African artists today. Major new sculptural installations, painting, photography, textiles, video, sound and fashion ask us to consider global questions of trade and commerce, cultural influence, environmental destruction and identity.

Challenging and humorous, curious, noisy, elegiac and electric – this is the dynamism of West African cultures today.[25]

Predictably, one of the introductory essays in the catalogue for *We Face Forward: Art from West Africa Today* reprised the stock motivations that apparently lay behind exhibitions of work by contemporary African artists – the twin agendas of countering ignorance and facilitating greater exposure to these artists' work.

While Manchester's collections are rich with the history of art and craft from West Africa – the legacy of colonialism – we know almost nothing about the contemporary cultural scene across the Anglophone and Francophone countries of West Africa. *We Face Forward: Art from West Africa Today* was born out of a desire to remedy this.[26]

A paragraph or two later, the writers state that

Our most pressing wish was to explore the incredibly diverse and dynamic art being made by artists from West African countries, not as an exhibition of work that is 'separate' from the global art scene, or defined through ethnographic or geographic containment, but as a body of work that is actively engaged in shaping and challenging how that world is configured.

During the 1980s, Caribbean Art found itself similarly constructed as a panacea for ignorance of the wider cultural dynamism of the region. *Caribbean Focus '86* set itself up as a model for ventures such as *africa 95* and *Africa 05*. Utilising the admonition, 'Widen Your Vision, Sharpen Your Focus', *Caribbean Focus* took place between 'March to November all over the country' and presented 'music, theatre, exhibitions, education, ideas, dance and debate'. One of the centrepieces of the programme was *Caribbean Art Now*, which dubbed itself 'Europe's first exhibition of contemporary Caribbean art' and was held at the Commonwealth Institute over the summer of 1986.[27] The exhibition's press release boldly stated, 'FIRST EUROPEAN EXHIBITION OF CONTEMPORARY CARIBBEAN ART' and opened with

The western world has seen remarkably little of contemporary art from the Caribbean. The Commonwealth Institute's major exhibition, 'Caribbean Art Now' is therefore both an important artistic event and an opportunity for international exposure for the artists concerned. [28]

Another significant feature of Camden Arts Centre's 1969 exhibition, *Contemporary African Art* was that it reflected the extent to which London art schools were, in the 1950s and 60s, the destinations of choice for many young African artists wishing to pursue their studies. Catherine Lampert reiterated this important factor in her foreword for the *Seven Stories About Modern Art in Africa* catalogue. 'Since the fifties, ambitious young African artists have arrived at foreign art schools; those from Anglophone countries were linked especially to the Slade, the Royal College and Goldsmiths.'[29] Many of the artists gathered together for the *Contemporary African Art* exhibition had associations with London arts schools.

Several years after the Camden Arts Centre exhibition, Egonu was still being regarded as a painter of the African continent. Together with Cyprian Shilokoe, Tito Zungu, Louis Maqhubela and Ahmed Louardiri, Egonu was a prizewinner in an annual competition, by then in its fifth year, run by *African Arts* magazine. The announcement of the 1972 prizewinners formed the basis of one of several features on Uzo Egonu that appeared in the magazine over a span of several years. This piece was in the winter 1973 issue.[30] A work by Egonu, *Hair Plaiting*, appeared on the cover of the magazine. A number of colour and monochrome plates of work by the artists illustrated the piece. At the front of the magazine the feature was introduced as:

Our fifth annual competition is again proof of the abundant and diverse creative talents to be found in Africa today. While the individuality of each artist is displayed in the subject matter, style and media, all of the prizewinners are nonetheless united by elements which mark each work as distinctly African.[31]

About Egonu, the text stated (in part):

Uzo Egonu will be known to readers of *African Arts* from the illustration of his prizewinning painting that achieved the distinction of first

prize in the BBC African Art Contest, as was described by George Bennett in *African Arts*, Volume 5, Number 1. He [Egonu] is now living in London and during the last ten years has built up a major reputation as an artist in Europe. He has had a series of one-man showings in London and other British towns – Leicester, Brighton, Edinburgh and Stroud – besides having made a large number of contributions to group exhibitions in major galleries such as the Royal Institute, and exhibitions such as the Camden Exhibition of African Art.[32]

Whilst a particularly nuanced attachment to the land of his birth could be discerned in much of Egonu's practice, he was at the same time somewhat detached from his homeland, as evidenced by a sentiment in a feature on him that appeared in *African Arts* magazine in 1973. 'My other ambition is to be in Africa one day, where I will be very much involved with others making vital contributions to solving problems of contemporary African art.'[33]

As alluded to in the previous two chapters, the 1960s saw the entrenching of exclusionary and somewhat discriminatory attitudes towards Britain's Black artists. Their apparent pointed exclusion from mainstream exhibitions informed a need on the artists' part to come together for the purpose of mutual support. In his Egonu monograph, Oguibe summarised this moment, particularly as it related to the artist.

While the Whitechapel Gallery's annual 'New Generation' exhibitions between 1964 and 1966 predictably excluded non-white artists, inter-cultural fringe and avant-garde groups such as Signals initiated and ran their own independent events and shows. The Indian Artists Group and later, the Caribbean Artists Movement (CAM) sprang up alongside community and political organisations. Although Egonu operated largely outside these developments – he later flirted with CAM and was a founding member of a short-lived African parallel – his career gained momentum through them, especially from 1964 onwards.[34]

The prospect of Egonu joining CAM is truly tantalizing. Had he become an active member, his involvement would have made CAM a broader cultural initiative centred on artists of the African Diaspora, more so than the pronounced Caribbean framing of the movement. CAM was an important and influential cultural initiative, centred on the work, the dialogues, and

interconnectedness of a number of key Caribbean-born writers and artists of the 1960s and 1970s. CAM began in London in 1966, reflecting the extent to which London, (as mentioned in relation to a number of the artists exhibiting in the Camden Arts Centre show of 1969), had become an important destination and focal point for ambitious, creative people from the Caribbean and countries in Africa and South Asia. At its core, CAM was a forum for the exchange of ideas relating to the role, and the work, of Caribbean-born writers, artists, scholars and activists.[35] Barbadian doctoral candidate Edward Kamau Brathwaite and Trinidadian publisher John La Rose were responsible for the formation of CAM. Anne Walmsley observed that 'Brathwaite and La Rose each knew and admired the other's poetry. When they met they found each other to be nurturing a similar idea: an organization of Caribbean writers and artists.'[36] Amongst the influential body of Caribbean writers, visual artists, poets, dramatists, and cultural/educational activists associated with CAM were Ronald Moody, Aubrey Williams, Errol Lloyd, Andrew Salkey, as well as its initiators, Edward Kamau Brathwaite and John La Rose.

The early to mid 1960s were heady days for the people of the Caribbean. Cuba, the predominantly Spanish-speaking giant of the Caribbean, had emerged from a violent, protracted revolution that culminated in 1959 with the establishment of a radically altered country, founded on socialist, and, subsequently, communist ideals. Thereafter, the political and cultural complexion of the entire region was transformed. Two of the Caribbean's largest English-speaking countries, Jamaica, and Trinidad and Tobago became independent in 1962. Barbados followed a few years later. What would independence mean for the peoples of the region, including its artists, poets, novelists, and thinkers? What role(s) could such individuals play in contributing to the lives of the region's people? What role(s) could the artists of the region play in the enterprise of nation building? Should the artist remain at arm's length from the new governments that were taking power across the islands and countries of the Caribbean? To these questions were added other, equally pressing concerns. How could the artists and writers of the region best establish themselves in the challenging environments of cities such as London? How could they contribute to the arts, culture, and literature of the country to which they had migrated? What should be the concerns of the Caribbean artist? In the light of seismic changes in the region, how could Caribbean history be understood, or reinterpreted? Looming large over these questions was the perhaps inevitable consideration of what the specificities

of Caribbean art and identity were. Such were the concerns and questions that concerned and challenged those associated with CAM.

A hugely important consideration for CAM was the way in which it was, remotely, able to contribute to notions of Caribbean art. In the region itself, artists were grappling with this weighty issue, and the Caribbean artists living in London during the 1960s and beyond were able to make significant contributions to the debate through CAM activities. In the introduction to her essay 'The Caribbean Artists Movement, 1966–1972: A Space and a Voice for Visual Practice', Anne Walmsley, herself deeply involved in the development and work of CAM, emphasised CAM's importance in words that resonate with the themes of this book.

> I can't remember when I last felt so proud as I do tonight, catching a glimpse of Caribbean art,' said Aubrey Williams in London in June 1967, to a roomful of fellow artists, writers, critics, actors, musicians, students, teachers, housewives, and other variously employed people. Like Williams, most were from a Caribbean country recently independent from British colonial rule; others were from West Africa, Australia, and other Commonwealth countries, or from Britain. They had just seen Ronald Moody show slides and comment on his sculpture; Althea McNish on her fabric designs; Karl 'Jerry' Craig, and Errol Lloyd on their paintings. This 'Symposium of West Indian Artists' had been organized by the Caribbean Artists Movement (CAM). Never before had these artists had a chance to share their work with each other, and with fellow Caribbean viewers of their work.[37]

The artists involved with CAM had created for themselves an invaluable forum of support and the exchange of information and ideas about their practice. According to Brathwaite:

> [CAM] was to be essentially an artists' co-operative. Our primary concern was to get to know each other and each other's work and to discuss what we were individually trying to do as frankly as possible, relating it, whenever this seemed relevant, to its source in West Indian society.'[38]

A measure of CAM's success could be gleaned from Brathwaite's statement that:

> It was clear from the outset that [CAM] was something that these artists had been hoping and waiting for. News of the group spread rapidly along the grapevine; and from seven the Movement grew to twelve to twenty and by February 1967, when we held our first public meeting, we were fifty strong and had an audience of over a hundred.[39]

But CAM also set itself the task, or agenda, of dialoguing with like-minded individuals from beyond the Caribbean. Consequently, in his text on the origins of CAM, Brathwaite cited its interactions with key personalities such as Ulli Beier, who had an important role in developing literature, drama and poetry in Nigeria, and James Ngugi [Ngũgĩ wa Thiong'o] 'the well known Kenyan novelist.'[40]

Furthermore, the journal *Savacou* was started as a literary vehicle for CAM, enabling literary, scholarly and artistic contributions, as well as CAM' activities in Britain, the Caribbean, and elsewhere in the world to be documented and given published form. An indication of *Savacou*'s longstanding commitment to nurturing, supporting and celebrating Black visual artists and other cultural activity can be elicited from a sentence written by John La Rose and Andrew Salkey in the Preface to *Savacou* issue 9/10: 'At the time of writing, the most recent medium session, held at the Keskidee Centre, on Friday 10th March 1972, was *A Tribute to Ronald Moody*, a historical exposition, illustrated with slides, of Jamaican sculpture, arranged and presented by Errol Lloyd, the Jamaican painter.'[41] Artists such as Williams and Moody were able to make important contributions to *Savacou*. Ronald Moody was responsible for the *Savacou* motif, *Carib War Bird*, which appeared on the magazine's flyleaf. The motif was instantly recognisable as Moody's work, as it closely reflected and referenced his own *Savacou* (1964) – both the maquette and the public sculpture itself, located on the campus of the University of the West Indies Mona Campus in Kingston, Jamaica. (A press photograph of Moody, standing alongside the work, is reproduced in this book). The *Savacou* issue referred to above featured a cover illustration by Williams, *Jaguar* (1972).

During the late 1960s CAM held a significant number of exhibitions at venues across London and indeed, beyond the capital. Artists such as

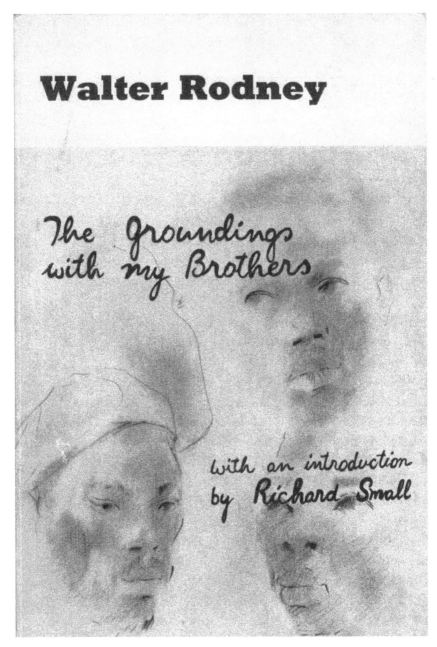

11. Errol Lloyd, *The Groundings with my Brothers* book cover (1969).

Williams, Moody and Errol Lloyd maintained a familiar presence in such exhibitions. Other personalities committed to contributing included Althea McNish, Art Derry and Karl Craig. The exhibitions took place at venues as diverse as the Theatre Royal, Stratford, the West Indian Students Centre, and the House of Commons, Westminster. Several CAM-related exhibitions took place alongside its conferences held at University of Kent at Canterbury, where Anne Walmsley, a key figure in the history of CAM, earned her doctorate. Reflecting on the success and significance of CAM's first conference in particular, Brathwaite recalled, '[The] cosmopolitan aspect of CAM was most brilliantly in evidence at our first Conference on Caribbean Arts held residentially at the University of Kent over the weekend September 15–17 [1967]. Over ninety people attended.'[42]

Born in Jamaica in 1943, Errol Lloyd was one of the younger Caribbean artists associated with CAM. A painter and illustrator, Errol Lloyd has for a considerable number of decades been a staunch advocate of the advancement of Caribbean art in the UK. To this end, he distinguished himself, as indicated earlier, as a friend and supporter of artists such as Ronald Moody. Lloyd came to London as a young man of just 20 years of age, for the purposes of pursuing a career in the law. Switching interests, he subsequently had a substantial and distinguished career as an artist, book illustrator, writer, editor and arts administrator. He was for a considerable period of time involved with the Minority Arts Advisory Service (MAAS), an early incarnation of official attempts to nurture British-based 'minority' artists or otherwise attend to their needs and agendas. Similarly, Lloyd was for a time editor of *Artrage* magazine, the organ of MAAS that was published for the best part of 15 years, from the early 1980s onwards. Within *Artrage* and in other forums, Lloyd reflected, with great clarity, on the practice and conditions of Black artists in Britain.

A self-taught artist, Lloyd provided the cover illustration for an early edition of Walter Rodney's seminal work, *The Groundings with My Brothers*, first published by Bogle L'Ouverture in 1969 and reprinted in the mid 1970s, a number of years before Rodney's assassination. The illustration depicts the faces of several Black men, sensitively drawn, exuding a gentle humanity but simultaneously a steely determination that hinted at the book's noteworthy contents. Complementing the deceptively simple pencil drawings was the title of the book (together with a reference to the book's introduction) reproduced in the style of handwriting, as if to emphasise the singular way in which the

book contained, quite literally, messages from Walter Rodney, one of the African Diaspora's most original and important academics, thinkers, writers and activists.

Gifted with an ability to capture likenesses in a range of creative and engaging ways, Lloyd has been responsible for a number of portrait commissions of leading Black and Caribbean males who have excelled in their respective fields over the course of the twentieth century. These portraits include Sir Alexander Bustamante (1884–1977), who together with Norman Manley was the chief architect of Jamaican independence and the founder of one of the country's main political parties, the JLP (Jamaica Labour Party); Sir Garfield Sobers (b. 1936), the legendary Barbadian cricketer; John La Rose (1927–2006) the Trinidadian intellectual, campaigner, activist, trades unionist, publisher, poet and, as mentioned earlier, one of the initiators of CAM; C.L.R. James (1901–1989) also a Trinidadian, the hugely important historian, writer, theorist, and journalist; and Grenadian David Thomas Pitt (Lord Pitt of Hampstead, 1913–1994), the renowned medical practitioner, politician, and campaigner.

By the mid 1970s, those artists and writers closely identified with CAM were pursuing their interests in other directions, though they remained faithful to their visions and agendas of fostering the integrity of their respective practices. They remained in close contact with each other and this contact resulted in a number of initiatives and was reflected in many others. One particularly fascinating event, which brought together Williams and Lloyd, in the company of other artists, a number of whom were significantly younger, was a forum titled 'Seeking a Black Aesthetic'. The event took place during what was to be the last of four open exhibitions organised by Creation for Liberation, the cultural wing of the Race Today Collective, of which Darcus Howe was the figurehead and indeed, editor of *Race Today*, the Collective's publication. The open exhibitions took place during the summer months of 1983, 1984, 1985 and, finally, 1987. They were held in a variety of venues in Brixton and 1987 was the second year in which the exhibition was held at St. Matthew's Meeting Place. The Creation for Liberation open exhibition had, that year, been selected by several artists, including Chila Kumari Burman and Eugene Palmer. Discussion events related to the exhibitions were a regular feature of these undertakings and in 1987 it was the elder statesman-like Aubrey Williams who was approached to stimulate a discussion on the selected work and issues relating to the then practices of Black artists in

London. Anne Walmsley concluded her essay on CAM with a paragraph on the significance of the event.

In 1987 Williams addressed and Lloyd chaired the forum 'Seeking a Black Aesthetic,' which accompanied 'Art by Black Artists,' an open exhibition in Brixton organized by Creation for Liberation, the cultural wing of the Race Today Collective. Twenty years after CAM began, the artists showing work and attending the seminar were markedly different in their sense of identity, in their direction, and concerns from those in CAM. They included Sonia Boyce, Chila Kumari Burman, [and] Keith Piper: [...] all born in Britain of people who had come from the Caribbean, Africa, or from Asia, technically British, but consciously 'black' in self-image and visual practice. In Britain, at least, the concept of a Caribbean artist and the need for a Caribbean aesthetic was already outdated and gone. But, interest in the work of the artists in CAM and in CAM itself, especially in what it gave to its visual artists and what it gained from them, is alive and well.[43]

The Earliest Black-British Practitioners

As stated at the beginning of Chapter Three, the 1970s was, in so many ways, a critical bridge, or decade of transition. In addition to the reasons already posited, the 1970s was the decade that saw the emergence and establishment of a new peer group of painters and sculptors, younger than the pioneering generation of Moody and Bowling, but older than the body of practitioners that was to emerge during the course of the 1980s. These artists were in almost all instances brought up in this country, their education culminating in first or second degrees from British art colleges. Amongst this new generation of artists were painters Saleem Arif, born in Hyderabad, India; David Medalla, born in the Philippines, and Caribbean-born artists such as Winston Branch (St Lucia), Denzil Forrester (Grenada), Tam Joseph (Dominica), George Fowokan Kelly and Eugene Palmer (Jamaica), Althea McNish (Trinidad) and Bill Ming (Bermuda).

Born in 1947, Tam Joseph came to London at the age of eight, eventually going on to fractious, unsatisfactory periods of study at London art colleges in the late 1960s. He has, since the end of that decade, maintained and developed his practice as a visual artist and sometime sculptor. This makes him, on the one hand, too young to be linked to major figures of Caribbean and African art who made London their home in the decades immediately following the end of World War Two. For example, Ronald Moody was born in 1900, Aubrey Williams in 1926, Frank Bowling in 1936 and Uzo Egonu in 1931. In time, these artists came to be respected as elder statesmen, but Tam Joseph was too young to be included in their number. But Joseph's age, on the other hand, makes him too old to be properly linked to the fiery, boisterous young Black artists, typified by Keith Piper (born 1960 in Malta, and not in Britain as is frequently and erroneously claimed) and Donald Rodney (born 1961) whose brand of 'Black Art' emerged in Britain in the early 1980s. Quite possibly, it is for this reason that Tam Joseph is very much

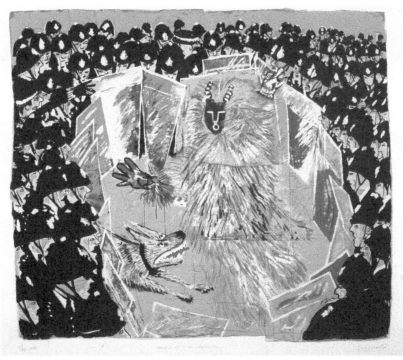

12. Tam Joseph, *Spirit of the Carnival* (1988).

his own man, his own painter, standing somewhat askance from the type-casting beloved of the art world.

Whilst Joseph's *oeuvre* has been somewhat eclectic compared to the practices of other artists discussed in this book, he has nevertheless, in his time, contributed a number of memorable paintings that locate themselves at the centre of social and political commentary, often doing so in ways that reflect the artist's characteristic wit, humour, cynicism and perceptiveness. Typical in this regard are paintings such as *Spirit of the Carnival* and *UK School Report*, both works dating from the early to mid 1980s. The latter piece, sub-divided into three portraits, shows the passage of a Black youngster through time and the British non-education system. Though unambiguously witty, the painting effectively addresses the miserable experiences of many Black youngsters at school. In the first portrait, the neat and tidy lad is noted as being 'good at sports'. In the second portrait, the best that his teachers can say about him is that he 'likes music'. The third is inevitable: a few years of under-achievement at school have put him on the wrong side of society and now he 'needs surveillance'.

If a Black boy is prejudicially labelled 'Good at sports', that child is linked to that almost primeval strand of racism that frequently suggests and sometimes insists that Black people are more physical in their abilities than they are intellectual; that whatever skills they possess lie not in any intellectual capacity, but in their physical attributes. *UK School Report* lamented the ways in which the educational aspirations of so many Black-British school children have been choked off, in favour of supposedly inevitable athletic prowess or excellence. Though the painting is about the often frustrating and negative experiences of Black boys in the British school system, *UK School Report* also serves as a general commentary on the often-compromised positions of Black people in Britain. Whilst the red, white and blue colours used in the painting clearly evoke, or reference, the Union flag of Great Britain, it is perhaps the painting's compartmentalising which gives it its greatest social relevance. The three portraits reflect a profound inability of the youngster to avoid or escape being compartmentalised by his teachers. This in turn reflects, or points to, an equally debilitating inability of many Black people in Britain to effectively function outside of societal constraints and prejudices.

Like Vanley Burke's photograph of the gathered throng discussed in Chapter Three, *UK School Report* points to the extraordinary extent to which the culture of Rastafarianism had found its way into the lives and the affections of young Black Britain as it came of age in the mid to late 1970s. The dreadlocked hair of the boy in Joseph's painting exists as a marker of disaffection, alienation, and more positively, *resistance*. By the mid to late 1980s, Rastafarianism, and its attendant *dread* culture had loosened its grip on Black Britain, and other forms of music besides reggae, and other forms of countercultural positioning were beginning to reflect the identities of Black youngsters. *UK School Report* in that sense reflects both a moment in time for Black Britain, and an ongoing marker of the formidable societal constraints placed on Black people in Britain.

As mentioned in Chapter Three, what one journalist had described as the 'deteriorating racial situation'[1] took a particularly vehement turn when violent disturbances involving Black youth and the police erupted at the annual Notting Hill carnival of 1976. The carnival of that year had seen a dramatic escalation in the numbers of police officers assigned to patrol the event, and it was perhaps of little surprise when simmering tensions between the police and Black youth erupted as they did. The effective swamping of the Notting Hill carnival by large numbers of police officers, and the attendant feelings

of intimidation felt by some carnival-goers was memorably captured in a key work by Tam Joseph, *Spirit of the Carnival* within a few years of the cataclysmic events of 1976.

Tam Joseph's *Spirit of the Carnival* is an important work that reflected the experiences of those on the receiving end of state-sanctioned, police-orchestrated violence and intimidation. The 1984 work is a poignant, piercing commentary on the seemingly ever-increasing, ever-conspicuous police presence at the annual Notting Hill carnival, though the events of 1976 lay behind its making. The painting depicts a lone masquerader being penned in on all sides by a menacing sea of riot-ready police officers. On all sides of the figure, police with riot shields advance on the carnival reveller, as if seeking not to merely contain or arrest him, but to silence and obliterate him. For good measure, a ferocious police Alsatian strains on his handler's leash, snarling at the masquerader, having previously drawn blood. And yet, the solitary masquerader is resilient, unbowed, unintimidated. In the face of this relentless hostility and aggression, the reveller continues to play *mas*.[2] It is this spirit of resilience and fortitude that enables the masquerader to embody 'the spirit of the carnival'.

The work (here illustrated in its print version) is seen from something of an aerial perspective, as if the viewer is somehow slightly elevated above the scene and is thus given a vantage point, to see the police brutality and intimidation that is either hidden from plain view, or has become so normalised as to be almost mundane and less visible. But the painting simultaneously celebrated Black cultural and political resistance and resilience. The body – be that body collective or individual – can be attacked and wounded, perhaps even mortally so. But the spirit, when strong, is unbreakable. The painting also effectively functions as commentary on the ways in which carnivals (and by extension, Black people themselves) are regarded within much of the British population and mainstream media as being synonymous with criminality. Each year, media reports of Notting Hill Carnival centre on, or are accompanied by, tallies of alleged criminal incidents, carrying the unambiguous implication that where and when Black people gather in numbers, criminality, delinquent behaviour and trouble of the most extreme kind are never far away, and that only the presence of overwhelming numbers of police officers can deter troublemakers or maintain law and order.[3]

Another artist born in the Caribbean was the painter Winston Branch. Born in 1947, he achieved notable levels of success and exposure during the

1970s. He attended the Slade School of Fine Art in London in the late 1960s, graduating in 1970. A few years later, he was a recipient of a prestigious DAAD Fellowship, from which came one of Branch's most substantial catalogues. Further recognition was to come, in 1979, when the Arts Council bought one of Branch's paintings for its collection.[4] Branch had a number of other paintings acquired for public collections, including *West Indian* (1973), *Yellow Sky* (1970), *Ju-Ju Bird* (1976), and *Ju Ju Bird No.2* (1974).

Though Branch has yet to be the subject of substantial critical attention,

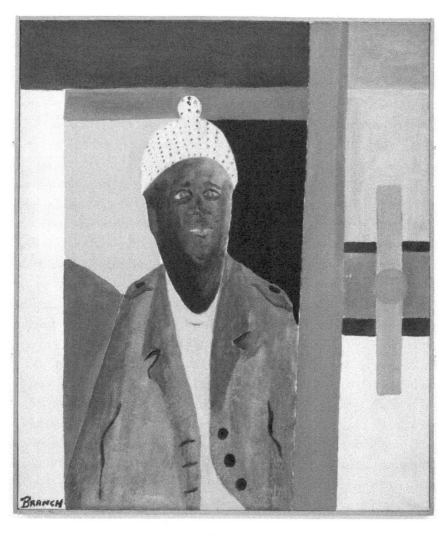

13. Winston Branch, *West Indian* (1973).

a very useful and notable feature on the artist appeared in the magazine *BWIA Caribbean Beat*, November/December 1995. In it, the writer reflected that

> after a very brief stint as a portrait painter in his early days, his work
> is now purely abstract. Art critic Carlos Diaz Sosa describes his paint-
> ings as 'abstract canvasses in cool, cloudy colours that have a quality
> which allow the viewer to explore the depths of the mind. Branch also
> uses paint like a symbol, a purely aesthetic language, an illustration of
> spirit.[5]

Branch's paintings were often strange, and strangely compelling works, which critics sometimes struggled to describe. During the 1970s his paintings were frequently rendered in the form of a triptych. The central rectangular panels, the most painterly of the three, were invariably flanked on either side by more frugal, but no less dramatic panels. The flanking panels – similarly rectangular but slightly narrower in width – often contained seemingly abstract marks, determinedly made, against an imposing background of black that worked well in their endeavours to counterbalance the central panels of these triptych paintings. These black backgrounds effectively create an impression of organic, natural forms – plant life and such – dramatically depicted against the night sky.

In 1978, Branch was the subject of a feature in *Black Art: an international quarterly*.[6] A work of Branch's adorned the cover of the magazine, in addition to which two page-wide reproductions of his paintings were included in the appreciation. Several substantial photographs of the artist at work in his studio also embellished the text. The writer, David Simolke, offered the view that 'A momentary glance gives a viewer the feeling that little compositional variation exists in Winston Branch's series of monuumental works. Each painting is dominated by tripart modular units.'[7]

Whilst Branch is frequently associated with non-figurative painting, his work *West Indian* stands out as a marked exception. Against a background that was perhaps reminiscent of elements of colour field painting, Branch painted a portrait of a Caribbean man, casually dressed, wearing a distinctive pink bobble hat on his head. The gentleman in question seems very much at home amongst the assortment of colours and shapes and it appears as though he is leaving one room, the walls of which are colourfully decorated, and entering another, even more flamboyantly decorated space. The bobble atop

of the *West Indian*'s hat appears to be centred by the lintel under which he is emerging. Though the figure is in some respects frugally presented, being rendered in Branch's own painterly manner, there is nonetheless, an enormous sense of persona about the character, and his workaday, yet stylish appearance casually but absolutely, evokes the spirit, dress sense, visual culture and sensibilities of the early 1970s.

Like a number of Black artists discussed in this book, such as Frank Bowling and F N Souza, Branch made his home in the US, a country perhaps more receptive to what artists such as these had to offer. In 1973, early in his post-college career, he undertook a residency at the famous, historically Black centre of learning Fisk University, in Nashville, Tennessee. Out of that came an exhibition titled *The Recent Paintings of Winston Branch*, shown at the university's Carl Van Vechten Gallery, 14 October – 9 November 1973.

Born in Grenada in 1956, Denzil Forrester was one of only a few Black artists to gain an MA in fine art (painting) from the Royal College of Art in the early 1980s. For several decades, he worked out of a studio in Islington Arts Factory, Holloway, North London, from where he produced some of the most arresting and distinctive painting by any artist of his generation. Historically, Forrester took as his subject the twin themes of reggae/dub dance hall and the music, sights, sounds, and movement of carnival. At times, his work touched on other themes, such as deaths in police custody. His canvases – often large, oversize affairs – ranged from dark, brooding and sometimes menacing works, through to vivid, liberated paintings that resonated with bright and vibrant colours. Sometimes, the scenes he depicted were located in low light, almost tomblike or nocturnal environments. On other occasions, much like carnival itself, Forrester took the focus of his attention to the streets, allowing the sun and copious amounts of light into his paintings. In the words of art critic John Russell Taylor 'The something that Forrester's paintings are about is distinctive and unmistakeable. From the time when he first encountered the clubs, their dancing and their dub music, they have provided the basic scene for his large paintings.'[8]

Like Joseph and a number of other Black-British artists, Forrester painted consistently from the late 1970s onwards, his work being featured in a number of exhibitions, both solo and group, from the early 1980s onwards. In this regard, one of his most significant exhibitions was *Dub Transition: A Decade of Paintings 1980–1990*, which was originated by Harris Museum and Art Gallery and toured to venues in Newcastle and Lincoln. Forrester benefited

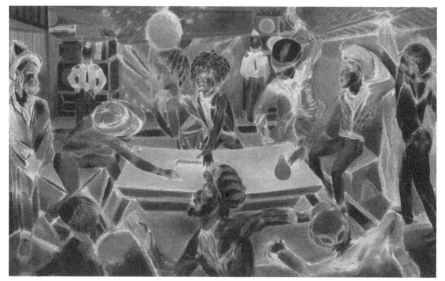

14. Denzil Forrester, *Police in Blues Club* (1985).

from a Rome scholarship and a Harkness scholarship, which took him to New York for a period of time. These scholarships gave Forrester opportunities to develop his practice, though he maintained his interest in, and attachment to, the themes mentioned earlier. Publicity material relating to one of his exhibitions stated that:

> Denzil has evolved a style which combines the expansive vivacity and glowing colour of his Caribbean roots with a highly effective translation of traditional and modernist European painting. The staccato fragmentation of forms, and dynamic jagged planes which articulate compositions like *Carnival Dub* and *Night Strobe* suggest the influence of Italian Futurism, and of German Expressionist painters such as Beckmann.[9]

Perhaps one of the most important features of Forrester's work was the way in which, inadvertently perhaps, it created a series of historical documents related to the making of Black Britain. The late 1970s and early 1980s saw the burgeoning of the British sound system – mobile, counter-cultural reggae enterprises characterised by dub music, MCs, DJs, and fiercely partisan followings of young Black people, primarily males. The clubs and other venues in which sound systems operated were graphically depicted in Forrester's paintings. Similarly, much like *Spirit of the Carnival*, Forrester's paintings

15. Eugene Palmer, *Our Dead* (1993).

captured the tension and the menace of the intrusive and unwelcome policing that was often a feature of how society viewed Black cultural expressions, particularly those influenced by Rastafari and the attendant 'dread' lifestyle. In his painting *Police in Blues Club* (1985), (reproduced on page 81) Forrester depicted a club scene, complete with prancing revellers and carousing youth. The painting's unsettling elements took the form of two motionless police officers, positioned in the background of the painting, silently and with no apology conducting surveillance; the embodiment of menace. Places and spaces in which Black youth could gather, to be themselves, and to express themselves, were few and far between. But Forrester was able to illustrate that even the blues club, beloved of so many alienated Black youth was, or could be, contested territory.

Painters such as Joseph, Forester and Eugene Palmer were new kinds of Black-British artists. Though they were all born in the Caribbean, their upbringing in Britain meant that, alongside the Black diasporic influences they laid claim to, their work also reflected the British visual culture they

were a part of, and of which they availed themselves at the art schools they each attended. This duality was observed by one critic, who offered the view that, 'Denzil's respect for tradition is a manifestation of the will to find an identity within two cultures, Afro-Caribbean and European, for both have played a vital role in his process of maturing as an artist.'[10] This impulse of Forrester's towards synthesis was something shared by a number of other artists, albeit a synthesis that was, on many occasions, overstated by critics.

Eugene Palmer was another painter who emerged into practice during the period of the late 1970s to early 1980s. Born in Kingston, Jamaica in 1955, he completed an Art Foundation course in Birmingham in the mid 1970s, before going on to secure a BA (Hons) from Wimbledon School of Art in 1978. This was followed, a few years later, by other qualifications, including an MA in painting from Goldsmiths College, in the mid 1980s. A significant period of solo shows then followed, at venues such as Bedford Gill Gallery (which was to be the venue for Yinka Shonibare's debut solo exhibition the following year), 198 Gallery, and the Duncan Campbell Gallery, a commercial gallery with which Palmer maintained a relationship for a number of years. In the late 1970s Palmer's work was twice included in *The New Contemporaries*, and his paintings were included in a number of group exhibitions, including *Caribbean Expressions in Britain* in the mid 1980s and, a couple of years later, *Black Art: Plotting the Course*, which looked at the nature of Black artists' issue-based practice in the closing years of the 1980s.

Palmer's earliest works were excursions into the terrain of form, colour, composition and shape – non-figurative practice. In time, however, Palmer moved towards figuration, firstly in a fairly loose form, but increasingly, over the years, towards a tighter, more pronounced and explicit type of highly figurative painting. Within his work of the late 1980s, Palmer offered absorbing assessments and interpretations of Britain, Empire, history, and Black identity. As such, his practice was reflective of his own background, having been born in Jamaica at a time in which the island was, along with others in the Caribbean, a Crown colony. Within seven years of Palmer's birth, Jamaica was to secure its independence, but the links with Britain – political, sporting, cultural, amongst others – would continue through the artist's lifetime, albeit in changing forms. To this end, the image of the British flag figured time and again within Palmer's paintings of this period.

One of the most interesting developments in Palmer's work came in the early 1990s, with the introduction of classical elements into his painting. This

intriguing juxtaposition of Black people as subject matter and the employment of classically derived aesthetics resulted in a new body of work that was wholly unique amongst Britain's Black artists. This singular body of work included a series of imposing, oversize portraits of Black people, including archival photographs of the artist's family members. The scale, posture and composition of the portraits drew heavily on the historical tradition of the sorts of grand portraits of landowners, and other such figures, in the manner perhaps of Gainsborough. Thus Palmer was able, within these fascinating works, to give his Black subject matter a dignity and status that simultaneously resonated with debates about land, landscape, identity, citizenship, and belonging.

It was at this time that Palmer came across the photography of the American Richard Samuel Roberts (1880–1936). Roberts was a contemporary of James VanDerZee, though the two photographers lived and worked in different parts of the US: VanDerZee operated in and around the Harlem district of New York, while Roberts operated in Columbia, South Carolina. Roberts photographed the African-Americans of his community, particularly those who had achieved degrees of affluence and economic stability in their lives. A significant number of Roberts' portraits were brought together and published in an important document of his work and the times in which he lived.[11] Fascinated by some of the book's portraits of the economically secure, fashionable and self-assured African-American middle class, Palmer used a number of these portraits in his work of the mid 1990s. One such work, based on one of Roberts' photographs, is reproduced here. Palmer moved on to explore the use of the repeated image in his paintings, particularly those of family members such as his father and his daughters. Commenting on one of these series of portraits, *Six of One* (1999) Richard Hylton noted that it

> was painted in serial form. It is perhaps unavoidable when looking at such works that we inevitably seek out the subtle differences between them, to arrive at some sort of hierarchy of originality. Yet whilst we might revel in the [supposed] accuracy of skin tone in one, the slightly darker [or indeed, lighter] tone of another casts doubt over our previous judgement. Being drawn to one painting over another or, thinking one better over another, becomes, as much of a game as it is an almost fruitless exercise.'[12]

In considering the paintings of Palmer one can clearly discern over a period of several decades a clear maturing and growth. Palmer's work was able to combine artistic skill with new and refreshing ways of rendering the Black image, particularly the ways in which the archival image, be that familial or anonymous, intersected with issues of art history and contemporary identity.

Saleem Arif (or Saleem Arif Quadri as he came to be known) is also of that generation of primarily Caribbean and South Asian-born artists who are younger than the pioneering generation of Uzo Egonu, Rasheed Araeen and others, but significantly older than the younger generation of artists that included the likes of Keith Piper and Sutapa Biswas. Born in the Indian city of Hyderabad in 1949, some two years after that country's independence, Arif came to the UK in his late teens. Within a few years he went to study sculpture at Birmingham College of Art, going on, a couple of years later, to study painting at the Royal College of Art, London. Arif is perhaps best known for producing beautiful, poetic interpretations of natural forms and animal/bird life, rendered in silhouette, in a restrained palette of flat areas of colours. He has been, for periods of time, a prolific artist whose work has been exhibited widely and has found its way into a number of art collections.

Particularly noteworthy in this regard is the 2001 acquisition by the Tate Collection of Arif's *Landscape of Longing* (1997–9), a sizeable mixed media work on composite panel. Instantly recognisable as an Arif work, the piece featured wall-mounted sections that have the appearance of something fragmented; something whole being pulled apart, or something fractured being uneasily or tentatively pushed back together. Such works spoke of Arif's dual training as first a sculptor and then a painter, as *Landscape of Longing* oscillated between the two dimensional and the three dimensional, in the mind, or to the eyes, of the viewer. As Arif himself recalls, or explains on his website:

Since 1990, all my paintings have been on a versatile wood support, which stands half an inch away from the wall. This device articulates and enhances my new concepts of 'volumetric' and of 'pregnant space', as the paintings appear to float away from the wall surface, adding a third dimension to my pictorial language.[13]

For the most part, *Landscape of Longing* is rendered in a muted shade of white, though each of the shapes is emphasised or embellished by what at first glance resemble incomplete or tentative borders, rendered in quiet or

subdued earthy shades of brown. Though somewhat abstracted, the work's fragmented sections speak of nature, or of natural formations.

In 1983, Arif had a solo exhibition at the Midland Group, Nottingham. The venue was, at the time, (together with Birmingham's Ikon Gallery) one of the leading Midlands venues for contemporary art. Within the exhibition, Arif explored his interest in Dante's *Inferno*, the first part of Dante's *Divine Comedy*, written by the Italian Dante Alighieri in the early fourteenth century. Whilst many people have heard of, or might know of, Dante's *Inferno*, Arif declared himself as having a pronounced interest in the allegorical work, which tells of the writer's journey through the inferno, or hell, shown the way by the Roman poet Virgil. In contrast to heaven above, in Dante's *Inferno*, hell is represented as nine circles of suffering; hell located below, underneath, or encased inside the earth. Within the epic poem that is the *Divine Comedy*, the central narrative represents the allegorical journey of man's soul towards God. According to Rasheed Araeen, Arif's interest in Dante's *Inferno* was not simply academic or disinterested:

It is clear that Arif was preoccupied with the search for a cultural identity. During this time [circa late 1970s/early 1980s] he was also reading Dante's *Inferno* and his research uncovered much evidence to support the growing notion that Dante must have known Islamic literature.[14]

Araeen then goes on to quote from Arif's exhibition catalogue for his Midland Group exhibition: 'He [Arif] discovered documents showing that certain passages in the *Divine Comedy* are virtually direct quotes from Islamic tales. Fired by these inter-connections between east and west, past and present, Saleem was ever more determined to travel.'[15] It was perhaps this perceived interplay, or exchange, between *East* and *West* that led to Arif being included in the important *From Two Worlds* exhibition held at the Whitechapel Art Gallery in 1986.[16] In the summer of 2008 Saleem Arif Quadri was honoured in the Queen's Birthday Honours, receiving an MBE. As such, he was one of a growing number of visual artists of African, Caribbean or South Asian background to be similarly honoured for their endeavours and contributions.[17]

Chila Kumari Burman, though of the generation of artists discussed thus far in this chapter, differed from them in at least one important respect. Whilst Joseph, Forrester, Palmer and Arif were all born in countries of the Caribbean

or South Asia, Burman was born in Liverpool in 1957. She was one of the first of a British-born generation of diaspora artists to complete her art school education, first with a BA from Leeds Polytechnic, then graduating with an MA in printmaking from the Slade in 1982. She took printmaking as her preferred medium, moving from the more traditional forms of the medium, such as etchings, lithographs and screen prints, through to more recent forms which utilise modern technology such as colour photocopying. Her work

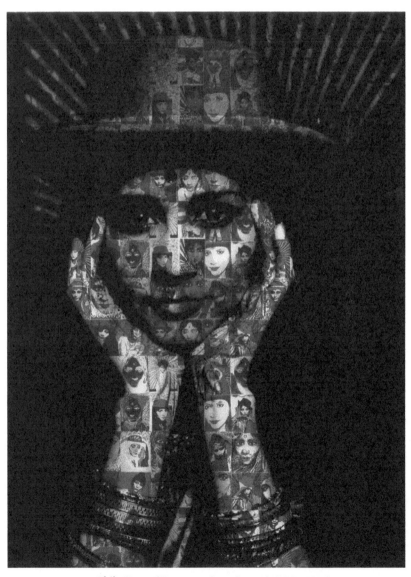

16. Chila Kumari Burman, *Auto-Portrait* (1995–2014).

became distinctive for its consistent embrace of photography and the photo-
graphic image, ranging from self-portraiture to found images. Writing in 2001,
Solani Fernando touched on Burman's significance:

> Gaining a first class honours degree in printmaking in 1979 and
> completing her Masters degree at the Slade School of Fine Art in 1982,
> Burman has been instrumental in opening some of the foremost British
> art institutions to a politicisation around race and gender. One of the
> first Black women artists in this country to produce political work.[18]

Burman's work was further characterised by an unswerving commitment to
a range of social and political narratives. To this end she produced some of
the most compelling work that is reflective of the frustrations and the aspira-
tions not only of Burman's own generation, but also her parents' generation
of immigrants. Typical in this regard was her 1980s print *You Allow Us to
Come Here On False Promises*, in which a range of images, symbols and texts
were montaged to form a protest against what the artist regards as punitive
institutional discrimination, particularly in the realm of immigration policies
and employment practices. The print featured John Bull as Margaret Thatcher
(or Margaret Thatcher as John Bull). From Thatcher's mouth comes a speech
bubble with her infamous words of 1978 in which she speaks of a 'fear' of
the country being 'swamped'.[19] For good measure and effect, Burman included
in the screen-printed collage an image of the white South African runner Zola
Budd, given British citizenship by Thatcher's government to enable her to
compete for Britain in the then upcoming 1984 Olympics.[20] Such a gesture
was interpreted by many as a slap in the face for those Black people (many
of whom were Commonwealth citizens) denied entry, or harassed at the point
of entry, to the UK. Budd's treatment also implied tacit support for South
Africa's apartheid system.

In the mid 1980s Burman was one of a number of Black artists who
undertook several mural commissions in London. One was executed as part
of the project to rehabilitate the Roundhouse in North London as a Black
arts centre.[21] The other was executed in collaboration with Keith Piper as
part of the GLC's *Anti-Racist Mural Project*. Their mural, painted on boards,
was intended to reflect something of Southall's important history as a site of
resistance and struggle. Burman took part in several of the pioneering exhibi-
tions of Black women's work that were such a distinguished feature of Black

visual arts activity in 1980s Britain. A passionate advocate of the rights and demands of Black women artists, Burman was responsible for an important essay that functioned as a manifesto in defence of what she regarded as an often maligned and marginalised group of practitioners. The essay was *There Have Always Been Great Black Women Artists*.[22] Burman's text reflected many of the sentiments expressed a few years previously in the Combahee River Collective's, communiqué, 'A Black Feminist Statement', in *All the Women are White, All the Blacks are Men, but Some of Us are Brave: Black Women's Studies*.[23] Burman's was a bold text that provocatively referenced Linda Nochlin's seminal essay of the early 1970s, 'Why Have There Been No Great Women Artists?'[24]. With respect to issues of absence and discrimination relating to women artists, this was one of the most significant articles ever published; it also addressed matters that would, in time, be referred to as 'feminist art history'.

It could be asserted that the keystone of Burman's argument was that the mixed fortunes of Black women artists are not a result of any objective deficiencies in the range of work these artists produced, but rather a result of systemic institutional prejudice and practical obstacles that have hindered these practitioners. Further, Burman's text prompted considerations of what precisely it was about patriarchal society, a prejudiced art world, and the nature of 'Black art', as apparently advanced by some Black male artists, that prevents Black women artists from realising more fully their creative potential. Provocatively, Burman's text challenged dominant discourses of feminist art history by asking what is it about such texts that prevent a fuller acknowledgement of the question of race and its interplay with sex and gender. A quarter of a century after Burman's essay was written, it still contains a range of relevant and clear sentiments relating to the multiple practices, challenges and experiences of Black woman artists. Early on in the text, Burman set out her stall:

This paper, then, is saying Black women artists are here, we exist and we exist positively despite the racial, sexual and class oppressions which we suffer. However, we must first point out the way in which these oppressions have operated in a wider context – not just the art world, but also in the struggles for Black and female liberation.[25]

Burman goes on make mention of the struggles that have

a lot to do with many second generation British Black women reclaiming art; first, as a legitimate area of activity for Black women as a distinct group of people, second, as a way of developing an awareness of ourselves as complete human beings, and third, as a contribution to the Black struggle in general.[26]

Burman's text was researched and written at a time of some debate, in certain quarters, about the sorts of sensibilities that Black artists ought to be prioritising within their practices. The notion that Black artists' work could and should have some sort of active social agency that directly benefited Black people and their struggles was a sentiment that had gained traction in the United States at several points during the twentieth century, and was being somewhat reprised, in a British context, during the 1980s. Burman's essay gave voice to women who felt that such a position privileged masculine aesthetics and a particularly masculinist approach to art-making and activism. Burman's work has, latterly, evolved from the two-dimensional into the realm of installation/performance, centring on her innovative use of an ice-cream van to animate aspects of her family history.

This chapter has discussed the earliest Black-British artists, and previous chapters have considered artists whose roots lie in West Africa, the Caribbean and South Asia, but still to be examined are those artists who were born in East Africa.

South Asian Stories

An important, hitherto unmentioned aspect of the history of Black artists in Britain is the presence and practice of artists of South Asian background who were born in the East African countries of Kenya, Tanzania and Uganda. Such artists include the likes of Said Adrus, Zarina Bhimji, Juginder Lamba, and Shaheen Merali. Lamba, a sculptor, was one of the most senior figures amongst this group of artists, having been born in the Kenyan capital of Nairobi in 1948. Durlabh Singh, a self-taught artist based in London, was also born in Nairobi in the mid 1940s. Merali, an artist, writer, curator and archivist, was born in 1959 and came to London in 1970 at the age of 11. He was born in Tanganyika – now known as Tanzania – in what was then known as 'British East Africa', which comprised Tanganyika and the two countries on its northern borders, Uganda and Kenya. Like Zarina Bhimji, Symrath Patti, Alnoor Mitha, Said Adrus and many other artists, Merali's family had arrived as part of the British colonial project to import large amounts of South Asian labour to its East African possessions. Such workers – frequently indentured labourers – were used on infrastructure projects such as the building of the strategically and economically important railways through Britain's East African possessions towards the end of the nineteenth century.

The former British colonies in many parts of Africa contain varying numbers of citizens of South Asian descent. In the main, their forebears were brought to these countries by the British Empire, in effect being moved from one part of the British Empire to another. Taken from British India, they were utilised to undertake governmental clerical work, or the low-skilled or semi-skilled manual labour required for construction projects or agricultural work. This movement of labour occurred most notably in the 1890s, when, as mentioned, labourers from British India were shipped to East Africa under indentured labour contracts to work on the construction of the railways. As

with other patterns of economic migration, significant numbers of these labourers returned to India, but others remained in East Africa and thereafter came to constitute a new presence in Africa, particularly in those countries controlled by Britain, from East through to southern Africa.

Subsequently, many of the descendants of these diasporic Asians established themselves in a range of professions, as well as becoming, in effect, the merchant class across much of Kenya, Tanzania and Uganda. Many of them went into sectors such as banking or businesses such as tailoring, serving firstly British expatriates and colonial workers and, subsequently, indigenous African markets. In this context, East Africa's Asians acted as, and were perceived as, a dominant merchant and professional class, distinctly apart from, and indeed, above African peoples. East Africa's Asians came to be regarded, in certain quarters, as a legacy of Britain's colonial adventures and strategising.

Like their African and Caribbean counterparts, immigrants of South Asian background seeking to come to Britain were sometimes subject to not only draconian immigration policies enacted by governments, but also the often punitive whims, vagaries and prejudices of consular officials and immigration officers.[1] Migrants arriving from the countries of South Asia frequently had to run the gauntlet of societal, political and media prejudices. But those arriving in the early 1970s from Uganda were prone to specific and quite distinct additional pressures. Firstly, they found themselves affected by the particularly retributive attentions of Uganda's leader, Idi Amin Dada, who undertook to expel many of the country's Asian residents. Secondly, though these Asians tended to be holders of British passports, they were subject to vociferous and quite explicit British racism, which sought to dissuade those expelled from Uganda from regarding Britain as a viable destination. Beyond this, the perfectly legal and perfectly reasonable arrival of these new immigrants acted as a fillip to those British politicians and political parties that expressed pronounced anti-immigrant sentiments.

It was against this particularly charged political backdrop that South Asian immigrants of East African background took their place in the UK alongside their counterparts who had arrived directly from the countries of South Asia. In time, a number of South Asian people of East African background would establish substantial careers as visual artists, and the multiple episodes of migration that were such a pronounced aspect of their histories and their identities would, on occasion, show up in their art practice.

Shaheen Merali, of East African/South Asian background, is one such hugely important artist who emerged in the 1980s. Over the course of several decades his visual arts practice evolved, and he simultaneously developed particular interests in curating, education, arts management, and archiving. In the early years of his practice, Merali's preferred method of art production was batik. His batik work of the time was astonishing, for a number of reasons. At a time when the demarcations between what was regarded as 'art' and what was regarded as 'craft' were deeply entrenched, Merali effectively made them redundant by utilising what was commonly considered a 'craft' medium in a decidedly 'fine art' context of artistic practice and gallery exhibitions. Furthermore, Merali wrestled batik away from its rigid associations with decorative *tribal* or *ethnic* arts, and its general synonymity with certain non-European ethnicities. Similarly, with batik being widely considered to be women's work, Merali singularly dismantled such a gender demarcation. The other hugely important significance of his batik work was that he used the medium, with enormous effect, to comment on a range of personal, social and political narratives, thereby downplaying or questioning batik's primary association with the purely decorative. His batik portraiture conveyed important political messages.

One such batik was a work from the mid 1980s, based on an old family photograph that showed a group of Merali's family members as they were about to embark on their own epoch-making journey from India to Dar es Salaam, the capital of Tanzania. (*From Ragula to Dar-es-Salaam* (c. 1986) batik) Merali utilised this photograph and rendered it with enormous effect and sensitivity as a sizeable batik. Instead of rendering the family portrait in colour, Merali remained faithful to the monochromatic values of the original photograph by executing the batik in shades of brown. The artist's decision to remain true to the original, and avoid colour, ensured that the work maintained – and indeed, may well have accentuated – the clearly discernible moods of apprehension and uncertainty on his relatives' faces, as they were about to embark on their journey of economic migration. Behind the group, the aeroplane to carry them stands, a symbol of the travel, relocation, upheaval, displacement and exodus which has played such a significant part in world history and the history of nations, millennia or centuries ago, as much as within more recent decades and indeed, up to the present day. Within this work, Merali offered compelling and engaging commentary on the conditions, experiences and consequences of migration

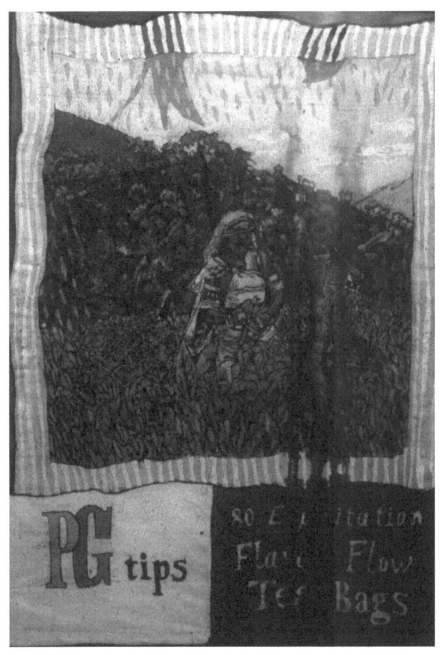

17. Shaheen Merali, *PG Tips: 80 Exploitation Flavour Flow Tea Bags* (1989).

and diaspora for his own family. Within the piece, Merali illustrated something of the physical strains and turbulence caused by his family's history of migrations from India to East Africa, to Britain years later, then on to Canada. Such histories of multiple migrations have exercised Merali and other artists such as Said Adrus, whose own family was caught up in similar patterns of multiple migrations and uprootedness.

Another of Shaheen Merali's fascinating batiks was *PG Tips: 80 Exploitation Flavour Flow Tea Bags*. The work featured, in somewhat disturbing rendering, the familiar and decidedly benign image of a young, sari-adorned Indian woman picking tea in an Indian tea plantation. The image, one of the most iconic of British food packaging and advertising, provides a comforting and reassuring vision of the diligence with which tea is picked for the British consumer. Concurrently, the image provides a reassurance of economic provision and stable employment for women such as the picker, in what might otherwise be a life of poverty and hardship. The image is of course a myth, a fiction, almost an untruth, that masks – some might say deliberately – the hardships of tea-pickers' work. In some ways, Merali's critique of the PG Tips tea-picking imagery mirrors the sorts of critiques of cotton-picking and the sharecropper existence of African-Americans in the agricultural South, in the decades of the early to mid twentieth century. At a first glance at Merali's piece, the viewer might not notice or realise the unequivocal judgement and condemnation of the piece and its text: *PG Tips: 80 Exploitation Flavour Flow Tea Bags*. The way the piece reworked and subverted the familiar PG Tips packaging was both a damning testament to the tea industry's exploitative practices, and a tribute to Merali's skill as an artist. Within a few years, he would once again return to the subject of the largely unseen ways in which tea cultivation and production had a part to play in the violent histories of South Asia.

For a time he collaborated with Allan deSouza, whose family history was not dissimilar to Merali's, the two of them setting up the arts initiative Panchayat, a word literally meaning 'assembly' when used in the countries of South Asia such as India. Panchayat focused its programme of exhibitions and related activities around the work of South Asian artists in Britain, as well as practitioners elsewhere in the South Asian Diaspora. One of Panchayat's most significant undertakings was the exhibition *Crossing Black Waters*, which toured to galleries in Britain in 1992. This was a major touring exhibition that originated at the City Gallery, Leicester. It featured Said Adrus, Anand Moy Banerji, Arpana Caur, Allan deSouza, Nina Edge, Sushanta

Guha, Bhajan Hunjan, Manjeet Lamba, Shaheen Merali, Quddus Mirza, Samena Rana, Anwar Saeed, and Sashidharan. A number of the contributors – Adrus, deSouza, Hunjan, Lamba, and Merali – were born in East Africa; a similar number were born in either India or Pakistan, whilst Nina Edge was British by birth.

This was a bold endeavour which sought to present interconnected strands of South Asian diasporic narratives, very much within the twin contexts of contemporary art practices and British societal constructions. Many previous larger-scale exhibitions of work by South Asian artists had tended to exist along lines of national identity, such as *Six Indian Painters*, presented at the Tagore India Centre, London, in 1964[2], through to *India: Myth and Reality – Aspects of Modern Indian Art*[3], presented, nearly two decades later, at the Museum of Modern Art, Oxford. Here, though, was an attempt to stress the interplay, commonality, or points of dramatic contrast that might be ascertained when a decidedly mixed group of practitioners, all within reach of the designation 'South Asian' were brought together.

During the course of 1992, *Crossing Black Waters* was exhibited at galleries in Leicester, Oldham and Bradford. This programming reflected either a concerted attempt by Merali and deSouza to reach South Asian audiences in towns in which such a presence was relatively substantial; or it reflected an ongoing pathology in which such exhibitions could only find exhibition spaces in towns such as these.

Said Adrus, one of the artists in *Crossing Black Waters*, was born in 1958, in Kampala, Uganda, in what was known as 'British East Africa'. This seemingly straightforward biographical detail contains many pointers to the artist's practice. His family arrived as part of the British colonial project to import large amounts of indentured South Asian labour to its East African possessions. Years later, in the early 1970s, Idi Amin Dada, Uganda's military leader, was to dramatically 'expel' many of the descendants of these indentured labourers. This expulsion created large numbers of refugees and displaced peoples, a number of whom came to the UK, whilst a number went to other countries. Within this sketchiest of outlines we can perceive a layering of conflicting identities for an artist, or a person, such as Adrus. Born in East Africa at a time when it was controlled by the British, represented a coexisting, or a fractious colliding of British, Asian, and African identities, which were to be compounded by the sudden imposition of a largely unexpected refugee or displaced person status. As Adrus himself recounted: 'my own father had

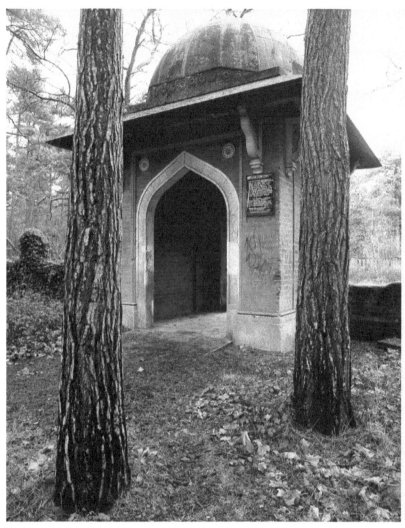

18. Said Adrus, photograph from *Lost Pavilion* (2007/08).

been part of the British Army in Kenya during the Second World War.'⁴ Such service, or selective 'Britishness' would ultimately count for little or nothing in the eyes of sceptical Britain, which viewed with suspicion and alarm the prospect of Amin's exiles seeking to come to Britain.

Adrus had lived, and continues to live, something of a fragmented life, dividing time between residencies and home in the UK and projects and home in Switzerland (where he has family) and other countries of Europe. In this regard, the realties of his life in effect add layers of complexity to Adrus's

biography and it is these layers of complexity that provide the artist with such fertile material from which to draw, in the making of his work.

His earlier pieces tended to be two-dimensional and relied heavily on the use of image and text. The self-portrait, in a variety of forms, was a recurring feature of this work. As such, the self-portrait was not so much a declaration of self, but more of questioning of self, or perhaps more accurately, a means of critiquing the ways in which society 'labelled' and brutalised those it regarded as 'Other'. Adrus's work of the 1980s spoke out against racism, discrimination and the interplay between imposed identities and one's sense of self. In this earlier work, he consistently discussed his political identity and his previous status as a refugee. For him, the royal coat-of-arms, as it appears on the 'British' passport, offered itself as a perplexing, mocking and ultimately offensive symbol. In turn, the British passport became an icon of the transparently racist restrictions placed on those Ugandan Asian peoples who found that the 'British' passports they held were effectively worthless in terms of allowing them unhindered or welcoming entry into Britain.

Over time, Adrus turned increasingly to mixed media ways of working. Thus, the moving image, on screen and projection, became a central part of his gallery work. With ever more sophisticated ways of presenting his work and ideas came ever more sophisticated ways of reading and mining his own history. Typical in this regard was Adrus's more recent work, which took as its starting point the Muslim Burial Ground in Woking, Surrey, a Grade II listed site located in a corner of Woking's Horsell Common. Enclosed within ornate brick walls, the cemetery has a domed archway entrance reflecting the design of the nearby Shah Jehan Mosque, said to be Britain's first purpose-built mosque, established in 1889. The Muslim Burial Ground was apparently built during World War I to receive burials of Indian Army soldiers who, having fought and been wounded fighting for the British Empire, died at the dedicated hospital established for them in Brighton Pavilion. During the 1960s, the bodies of the fallen were exhumed and reinterred in the Military Cemetery at Brookwood, about 30 miles from London. According to Adrus, the work exists, in part at least, to highlight 'issues about War, Empire, and Islamic Architecture in the South East of England and notions of contemporary landscape in the Home Counties.'[5]

By far the most successful and prominent British artist of South Asian/ East African background is Zarina Bhimji, who was born in 1963 and moved to Britain just over a decade later. Whilst many of her contemporaries

produced work with explicit social narratives, Bhimji preferred to pursue oblique, discrete, often furtive artistic investigations that avoided precise meanings or readings. Bhimji's work often had an unnerving effect on its audiences, accustomed as they sometimes were to approaching certain artists' work with a definite and fixed expectation of dialogue and narrative. Bhimji's work certainly contained much in the way of dialogue and narrative, but such concerns required her audiences to approach and appreciate Bhimji's practice on its own terms. Her practice was particularly intriguing insofar as her photographs, sculpture, and later, her films, strongly resonated with meaning, but precise meanings were elusive, and it seemed, ultimately illusory. In the words of a press release for one of Bhimji's exhibitions, her work 'conveys a psyche of decay, loss, stillness and unspoken histories, but the translation of the artist's tender, almost lyrical, visual language and the works' elusive titles [...] are left to the viewer.'[6]

Bhimji's earlier work consisted of poignant photographs of a certain fragmentary quality. The images resonated with absence as much as presence, and what was depicted frequently intimated at loss, violence, trauma and an often-disconcerting partiality. At a time when a number of Black artists were using text as a bold strategy for accentuating meaning and for the communication of messages within their work, Bhimji employed text to confound, rather than to support, an expectation on the viewer's part of unequivocal social sentiments and 'messages'. Furthermore, the titles of her works were similarly intriguing, prompting the viewer to further consider, or question, what he/she was looking at. One of Bhimji's earliest works to reflect her artistic singularity was an installation titled *She Loved to Breathe – Pure Silence*, which was included in several group exhibitions of the late 1980s. The work consisted of a number of photographic images, and text, both elements at once precise and imprecise, encased within sandwiched panels of plexi-glass, suspended from the gallery ceiling. As was the case with pretty much all of Bhimji's subsequent works, the viewer had to work particularly hard to piece together the disturbing narratives that the artist sought to present. One admirer of Bhimji's work discussed the work in the following terms:

A new artist had emerged from silence; an artist working with language, film-like pictures, raw and manufactured materials (some stating an Indian origin), with mixed media, performance, memory, anecdote,

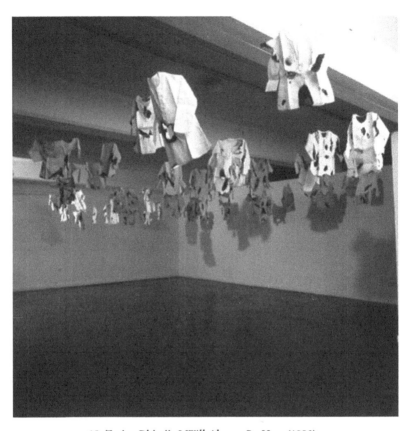

19. Zarina Bhimji, *I Will Always Be Here* (1992).

telling tales of immigration and humiliation, of mothers and daughters, of private and public, of anger and loss. The artist wrote in 1989: 'I am drawn towards the challenge of my own people. I fight them and I fight for them.' And in 1988: 'I want to create, communicate new meanings by bringing Indian languages, objects, memory, dreams, conversations from East African and Indian backgrounds, as well as my experience of western culture, to play in between two realities'. Zarina Bhimji's work relies on intuition – hers and ours – and speaks with courage, vulnerability and pride . . . Zarina Bhimji works from her own identity, history and sense of community, framing questions which history in general and her own personal history have forced upon her. She was eight when civil war erupted in Uganda and her family spent two years behind closed curtains.[7]

As much as it did anything else, Bhimji's work unsettled, disturbed and, on occasion, terrified the viewer. Typical in this regard was Bhimji's installation of little white shirts, hung, *en masse*, from the gallery ceiling. Each shirt bore distinct evidence of violence, destruction, and desecration, in the form of the partial burning to which each shirt had been subject. It was not difficult for the viewer to associate the shirts with the children or young boys for whom the garments might have been manufactured. Certainly, that was the effect that the artist herself strove for. 'I made from delicate cotton shirts with disturbingly beautiful burnt marks. They deal with loss and the experience and language of pain, both of which have been important concepts to my work.'[8]

Bhimji's work was, quite simply, something different. Whilst many artists, including significant numbers of Black practitioners, clung to art forms such as painting, sculpture, printmaking and so on, Bhimji's work was decidedly mixed media, though an attachment to the photographic image lay at the core of her exhibitions. Her work reflected the extent to which her concerns were most effectively explored, not through linear or explicit narratives, but rather through an assemblage of images and text in which meaning was implied rather than explicit, coded rather than unequivocal, and the viewing experience being experiential rather than merely visual. The readings of trauma and damage elicited from Bhimji's practice were made stronger by their reliance on what the viewer brought to the work.

As time went on, Bhimji's practice increasingly reflected an apparent intent to seek to come to terms with her childhood in Uganda. Within her practice, the Ugandan aspect of her identity loomed large in ways that were perhaps unresolved. There had always been, within her work, an element of conscious incompleteness, of unfinished business and within her work, these impulses grew ever more insistent. Bhimji's attempts to come to terms with a disrupted, fragmented, damaged and conflicted history found a particularly arresting form in her film *Out of Blue*, shown, to great critical acclaim, at Documenta 11[9], the major exhibition of international contemporary art which has, since 1955, taken place every five years in Kassel, Germany.

Zarina Bhimji's *Out of Blue*, one of the most critically celebrated artist's films of recent years, is an abstracted narrative of guilt, mourning, and loss, rooted in specific geopolitical, historical, and autobiographical facts. An artist of Indian descent, Bhimji was eight years old and living

in Uganda with her family in 1972, the year General Idi Amin expelled tens of thousands of South Asians from the country. As a filmmaker, Bhimji registers impressions of present-day Uganda through light, colour, and texture to bear witness to the recent past.[10]

In Chapter Four mention was made of the extent to which African art, and Caribbean art in the UK reached its most intense periods of relative visibility when these umbrella art forms were filtered through the lenses of 'festivals'. As discussed in that chapter, the stock motivations that apparently lay behind such exhibitions were the twin agendas, inevitably declared by the festival curators and directors themselves, of countering ignorance and facilitating greater exposure to these art forms and artists' work. The same pathology has been applied to British artists of South Asian background for whom the most intense period of relative visibility to date came through a four-month long *South Asian Contemporary Visual Arts Festival* (SAVAF) which took place in galleries across the West Midlands, beginning in September 1993. The festival was principally the work of Juginder Lamba, the Kenya-born sculptor mentioned earlier, who had made his home in Shropshire, in the West Midlands. In his capacity as festival director, he gathered together in excess of sixty contemporary artists whose backgrounds lay in the South Asian countries of Bangladesh, India, Pakistan and Sri Lanka. The work of these artists was shown in a number of exhibitions across some 20 museums and gallery venues throughout the West Midlands region.

Lamba was keen to facilitate not only greater appreciation of the work of contemporary British artists of South Asian background, but also dialogue amongst the artists, or involving the artists. To this end, one of the features of SAVAF was a South Asian Contemporary Visual Arts Festival Conference held on 29 September 1993, presented in association with Sampad, a Birmingham-based arts agency that existed to promote South Asian arts. The one-day conference took place at a venue known as 'mac' – an abbreviation of its original name of Midlands Arts Centre. The declared aim of the conference was to provide a platform for individuals, organisations, and artists involved in the practice, promotion, and education of South Asian visual arts in Britain, to discuss and debate the issues affecting the development of South Asian visual arts in a national and international context. Conference attenders heard contributions from Lamba, the festival director, and a number of other exhibiting practitioners. SAVAF's stated focus was to demonstrate the high

calibre of work by British and British-based artists of South Asian origin and to seek greater acknowledgement of their contributions to national and international developments in mainstream art. In this regard it echoed the stated intentions of *Caribbean Focus* before it, and the *africa 95* and *Africa 05* festivals that were to follow it, notwithstanding SAVAF's particular artistic focus. Lamba stated in the Festival Programme introduction that:

> It is hoped that the high profile the Festival will give to South Asian artists and issues affecting their visual culture will have lasting effects through documentation, education and publication. Additionally, the Festival will act as a catalyst for long term provision of opportunities in the programming of art venues, as well as expanding and developing ways to involve communities of South Asian people in their visual culture.[11]

Lamba secured funding from a range of bodies that included Birmingham City Council, the Foundation for Sport and the Arts, West Midlands Arts and the national funding body for the arts, the Arts Council. The SAVAF exhibitions featured paintings, sculpture, craft, video, film, photography, live art and performing art and took place at venues across the West Midlands, in towns and cities such as Birmingham, Coventry, Sandwell, Shropshire, Stafford, Stoke, Walsall, Warwick, Wolverhampton and Worcester. Two of the biggest SAVAF curatorial undertakings were *Transition of Riches*, at Birmingham Museum and Art Gallery, which featured Sarbjitt Natt, Nilofar Akmut, Symrath Kaur Patti, Anuradha Patel, Amal Ghosh, Jagjit Chuhan, Chila Kumari Burman, and Said Adrus, 2 September – 14 November 1993; and *Beyond Destination: film, video and installation by South Asian artists*, at Ikon Gallery, Birmingham, which featured, Maya Chowdhry, Sutapa Biswas, Alnoor Dewshi, Khaled Hakim, Shaheen Merali, Sher Rajah, Alia Syed, and Tanya Syed, 16 September – 19 October 1993.

One of the biggest problems with festivals such as *Caribbean Focus* and SAVAF was that, in the long run, they provided only the briefest of respites from a systemic under-representation of certain artists from the galleries of the country. Now, two decades after SAVAF took place, it exists as little more than a near-obscure, pretty much forgotten series of exhibitions, unknown to current generations of art students and young artists, unremembered within narratives of late twentieth century British art history. This certainly was how

the undulating profile of African art had come to exist in Britain; years of under-representation, or no representation at all, punctuated by brief, intense 'festivals', in which African art could be seen in a number of important venues. A significant number of Black artists found themselves at the mercy of a habitual and chronic undulation, in which they achieved relatively substantial exhibition opportunities and funding, within the context of occasional festivals. Such exhibitions reflected the problematics of the ways in which so many Black artists had come to be framed. It appeared that integrated programming, as an inevitable and *normalised* part of the curatorial landscape, lay beyond the reach of the vast majority of Black artists.

Some years after SAVAF, a key publication, *Beyond Frontiers: Contemporary British Artists of South Asian Descent*, was issued.[12] Edited by Amal Ghosh and Juginder Lamba, the book sought to offer, and indeed succeeded in offering, a nuanced, somewhat interlinked series of narratives about the artists who had been brought together for SAVAF, and the wider history of the presence of South Asian artists in the UK. When set in the context of the passage of time, however, the book's stated intentions, presented on its back cover, of unsettling 'once and for all, pat assumptions about the meaning and significance of ethnic origin to artists' contribution to contemporary culture and experience' remains something of an unfulfilled hope or aspiration.

Beyond Frontiers featured contributions from a broad range of individuals, some of whom made several contributions to the publication. Some contributors were academics and writers, though the majority of them were artists.[13] For the most part, the presence of most of these individuals in *Beyond Frontiers* and other such publications and catalogues contrasted, somewhat problematically, with their absence from a great deal of other books and catalogues that purported to have contemporary British art as their focus. It was, as suggested earlier, only in publications such as *Beyond Frontiers* that many of these contributors were able to express themselves and be represented.

The 'Black Art' Generation and the 1980s

The 1980s was an unprecedented period of activity for Britain's Black artists. The previous decade, the 1970s, had seen a number of important visual arts initiatives involving Black artists. These practitioners, for example Emmanuel Taiwo Jegede and Ronald Moody, were immigrants who had come to Britain from countries of the British Empire (or the Commonwealth). The 1980s, however, produced a new generation of artists, for the most part British-born, the majority of whom were art school graduates. The decade was significant for two reasons. Firstly, it produced many professional artists who went on to make important contributions within Britain and further afield. Sonia Boyce, Sokari Douglas Camp, Denzil Forrester, Rita Keegan, George Fowokan Kelly, Veronica Ryan, Eugene Palmer, Bill Ming, Ingrid Pollard and others all established reputations for themselves during the course of the decade. Secondly, the 1980s delivered many new opportunities for Black artists to have their work included in the group exhibitions that frequently took place within galleries and other venues across the country.

Until a new generation of practitioners emerged in the early 1980s, Black artists had been somewhat reluctant to name their practice with a racialised or politicised prefix. They were similarly reluctant to explicitly place social or political narratives at the core of their practice. John Lyons hinted at the profound changes that the profile of Black artists in Britain went through, between the early 1970s and the early 1980s. In Chapter Four it was noted that an important exhibition of work by Caribbean artists in England was held at the Commonwealth Institute in 1971.[1] It was this exhibition that Lyons contrasted with a markedly different type of Black artists' practice, a decade or so later:

Caribbean artists and writers like the Barbadian poet, Edward Kamau Brathwaite, the Jamaican novelist Andrew Salkey and John La Rose,

the Trinidadian activist and poet, came together in 1966 to form the
Caribbean Artists Movement. It was a coterie which, in the fostering
of mutual respect and support, created confidence by maintaining
cultural identity in a Eurocentric milieu fraught with numerous dangers
of misappropriation. It also attempted to establish for Caribbean peoples
in Britain a point of cultural reference. The Caribbean Artists Movement
brought together a group of artists in an exhibition 'Caribbean Artists
in England' mounted in the Commonwealth Institute Gallery in 1971
[...] What started in 1971, significantly in the Commonwealth Institute
Gallery, as relatively benign self-assertion was, within a decade, super-
seded by exhibitions of works of a politically rhetorical character by
young Black artists of the generation born in England as British citizens.
Unlike their parents and grandparents, whose illusion of England as the
mother country was shattered by the stark realities of racism, these
young Black British artists had the right by birth to claim England as
their home.[2]

The genesis of this activity is often traced back to the early 1980s to a series
of exhibitions mounted and organised by a group of young artists and art
students who had grown up in the West Midlands. Chief amongst these
practitioners was Keith Piper, who came to symbolise a new generation of
younger Black artists whose work was characterised by what was, in a British
context at least, a new attachment to social and political narratives, expressed
through styles that drew heavily on the influence of Pop Art, found imagery,
readymades and the use of mechanical forms of image making, such as the
photocopy. Other artists utilised more traditional techniques of painting and
drawing to comment on the Black experience. These artists, Claudette Johnson
and Donald Rodney amongst them, took as their subject matter the history,
culture, tribulations and aspirations of Black people throughout the world.
Piper and others embraced and advocated the American ideology of 'Black
Art' that had emerged in the late 1960s and early 1970s (that is, a socially
dynamic visual art practice, closely aligned to militant political and cultural
agendas of progress for Black people). To this end, these artists' work touched
on the experiences of Black people in the United States, South Africa, and
flash points of tension closer to home, such as Brixton.

Not only were these artists able to articulate themselves in their various
practices, they were also able to express themselves in the various modest

publications that often accompanied their exhibitions. Witness for example Keith Piper, in a statement for *Black Art an' done*, one of the first exhibitions that heralded this new generation of Black Art practitioners. During his time at art school as an undergraduate student, Piper wrote:

> To me, the black art student cannot afford the luxury of complacency as enjoyed by many of his white counterparts. These people, finding little worth responding to in their decadent lives of leisure and pleasure seek out ever more obscure playthings amongst the self indulgent vogue of art 'for arts sake'. The black art student, by his very blackness finds himself drawn towards the epicenter of social tension. He is forced to respond to the urgency of the hour. The aspirations of the Black British are ripe, and our time is 'NOW'. So let us in our work undersign the logical mechanics of our greater struggle. Let us strive by any means to raise the revolutionary consciousness of each other as to the form and functioning of the social, political and economic barriers which this man has placed all around us, and within our very minds.[3]

Within this statement, Piper was referencing not only the urgency of the hour, as regards the political agendas of Black people, he was also resisting the dominant approach to art school education. This approach insisted that students should concern themselves with no more than matters of academic learning – still-life drawing and painting, sketching nude models, perspective, colour, and other such areas. Students were discouraged from applying any explicit social and political narratives to their work. Piper and others breezily disregarded, or even challenged, such an approach, and insisted on a practice that had a pronounced social relevance and responsibility at its core.

In part, the press release for the first *Black Art* exhibition read:

> The exhibitors all share a common preoccupation with the culture and civil rights of Black people in this country and abroad . . . they are concerned with the propagation of . . . Black Art within the wider sphere of modern Black culture. The group believes that Black Art – which is what they call their art – must respond to the realities of the local, national and international Black communities. It must focus its attention on the elements which characterise . . . the existence of Black people. In so doing, they believe that Black Art can make a vital contri-

bution to a unifying Black culture which, in turn, develops the political thinking of Black people.[4]

In the chronology contained in *The Essential Black Art* catalogue, Rasheed Araeen suggested (regarding the *Black Art an' done* exhibition) that 'This is perhaps the first time the term 'Black art' has been used in Britain in relation to a contemporary art practice.'[5]

It might now seem extraordinary that a group of young artists, none of them older than 20, could or should set themselves a collective agenda aimed at developing 'the political thinking of Black people.' But at that time, the development of race-based identity politics presented itself as a credible agenda of the moment. These young artists were mesmerised by the opinions of the US's Black Art advocates such as Larry Neal and Ron Karenga, and Piper and his contemporaries were in effect either quoting from them verbatim, or passing their words off as their own. For example, Ron Karenga had, ten years earlier, written in a manifesto called *Black Cultural Nationalism*[6] that 'Black art, like everything else in the Black community, must respond positively to the reality of revolution . . . Black art must expose the enemy, praise the people, and support the revolution.'[7] He continued in that vein, concluding with, 'Let our art remind us of our distaste for the enemy, our love for each other, and our commitment to the revolutionary struggle that will be fought with the rhythmic reality of a permanent revolution.'[8]

Politically, these were heady and difficult days for Black people. Piper knew how to visualise the trauma and dynamism of the times and to this end, he produced some remarkable work. One particular example was his 1981 mixed media piece, *13 Killed*. 1981 was the year of an event that became known, in certain quarters, as the *New Cross Massacre*, in which 13 Black youngsters, attending a birthday party, lost their lives in a suspicious house fire. The party took place in the home of one of the victims, whose birthday was being celebrated. This was a horrific incident that galvanised the Black community, acutely increasing its sense of identity and purpose.

In *13 Killed*, Piper cut up and collaged one of the very few newspaper reports of the tragedy, overlayering image and text on a powerful background that consisted of a re-creation of a burned and charred wallpaper and skirting board reminiscent of a typical *West Indian* domestic environment.[9] Using found materials in such a strikingly original and emotive way, Piper gave form to Black people's tragedy, grief and outrage. This was a work of the

most profound empathy, in which Piper paid homage to lives lived and lives lost. Using plain household postcards, Piper penned messages to each of the fire's victims, naming them all and attaching portraits of them to each message. This effectively restored to each victim a humanity and an individuality that seemed robbed from them, not only by the fire itself but by the subsequent apparent indifference. The party at which the tragedy occurred was being held to celebrate the birthday of 16-year-old Yvonne Ruddock. Piper's message to her read 'SEND THIS ONE BACK TO THE PEOPLE! SISTER YVONNE SURVIVED 15 YEARS WITH US IN BABYLON. ON THE DAWN OF HER 16TH YEAR BABYLON SNUFFED HER OUT. SEND THIS ONE BACK TO THE PEOPLE + LET THEM DEMAND AN ANSWER!' Similar messages were penned for the other victims: Humphrey Brown, 18, Peter Campbell, 18, Steve Collins, 17, Patrick Cummings, 16, Gerry Francis, 17, Andrew Gooding, 14, Lloyd Richard Hall, 20, Rosalind Henry, 16, Patricia Denise Johnston, 15, Glenton Powell, 15, Paul Ruddock, 22, and Owen Thompson, 16. An infamous episode of history occurred in January 1981. Piper benchmarked that history with a truly remarkable piece of work. Furthermore, the aesthetics of the work decisively pointed to a rebuttal of the art school ethos, whilst simultaneously pointing to the perceived social responsibility of the Black art student.

A measure of Piper's significance as an artist was the purchase, for the Arts Council Collection, of his work *(You are now entering) Mau Mau Country*.[10] Painted in 1983, the piece was included in the Mappin Art Gallery, Sheffield exhibition of the following year, *Into the Open*, and was purchased in 1984, making it one of the first works by the new generation of Black artists to enter a major public collection.

Another important young artist of the period was Donald Rodney who, on arriving at Trent Polytechnic in 1981, met Keith Piper who was a year ahead of him. Rodney, a British artist of African-Caribbean background, was born in Smethwick, Birmingham, England in 1961.[11] Embracing both the aesthetics of Pop Art and the ideology of 'Black Art' (that is, a socially dynamic visual art practice closely aligned to militant political and cultural agendas of progress for Black people), Piper's practice even as a student was, as evidenced previously, sharp, powerful and engaging. Piper had argued that the work of Black artist/art student should speak to 'the Black experience'. To this end, Piper's work touched on the experiences of Black people in the United States, Africa, and elsewhere in the world. Rodney found himself

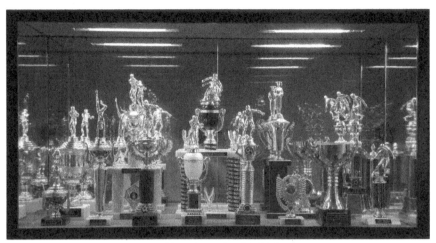

20. Donald Rodney, *Doublethink* (1992).

charmed and persuaded by Piper's position and practice, the two going on to collaborate on a number of occasions. The work and the exhibitions they produced together represented a decisive meeting of minds. In 1987, they issued a statement called 'Piper & Rodney On Theory'. Its opening paragraph read:

> In Britain's art schools, where the mythology of individual self-expression is held at a premium, collaborative activity is discouraged. Apart from throwing a spanner into bureaucratic machinery geared to assess the virtuoso, collaborative activities begin to counter many of the negative effects of an individualism which leaves the art student isolated and vulnerable. Supporting collaborative activity has therefore never been in the interest of the art school hierarchy, as many students expressing an interest in working collaboratively have learned to their cost.[12]

Donald Rodney, like Keith Piper, paid particular attention in his work to the harsh realities of the lives and histories of Black people.[13] In this regard, Rodney was one of the first Black artists of the 1980s generation to pay particular, considered and deeply penetrating attention to the iconography of slavery. One of the most consistently innovative, resourceful and intelligent artists of his generation, he battled with sickle-cell anaemia – a frequently debilitating disease of the blood, from which he suffered – until he succumbed to the condition, dying in March of 1998. Rodney's work, from his earliest

days as an art student at Trent Polytechnic, in Nottingham, in the East Midlands, through to his final one-man show at South London Gallery, some six months before he died, had consistent and distinctive qualities that marked him out as a practitioner of unique ability and sensitivity. In a gesture that was typical of his devastating intellect, Rodney made a seemingly simple, yet profound work that utilised the familiar, everyday box of household matches, England's Glory. Manufactured by Bryant and May, the boxes of matches were commonly used by smokers, householders, and anyone else who needed to strike a light. The trademark on the front of the box of matches, garlanded by the words ENGLAND'S GLORY, was a lithograph of a sea-going vessel, above and below which, the words MORELAND GLOUCESTER appeared, a reference to the Gloucester match maker S. J. Moreland and Sons, a firm who made and sold matches under the trade name *England's Glory*, and was taken over by Bryant and May early in the twentieth century. In a simple yet brilliant act, Rodney replaced the familiar image of the vessel with an equally familiar, but altogether different ship, the Brookes of Liverpool, which infamously depicted captured and shackled Africans. With this singular montage, Rodney effortlessly parodied England's glory, and in so doing advanced the proposition that England's glory was more accurately, England's shame.

Rodney's work, even those pieces that touched on issues of slavery, sometimes contained a marked and distinctive humour, and were always executed with considerable intelligence. His work of the early 1980s consisted largely of loose, exuberant paintings on canvas and wall-mounted assemblages, such as *100% Cotton, the South's Favourite Cloth*, a large diptych which depicted a white lady and a military gentleman of the Confederate South, waltzing at a ball, their faces twisted in grotesque, manic grins. No images of slave ships, no images of brutalised Black people. Yet the painting's messages were clear and its readings were strong. Two figures – her ball gown puffed out by folds of cotton canvas – used to comprehensively reference the whole wretched enterprise of American slavery and its attendant legacies and manifestations of racism. To some, *100% Cotton* may at first have seemed harmless enough, playful even. Others, more perceptively, could see the menace of its subtext that lay immediately beyond the humour of the painting and the effective, seemingly effortless ways in which it parodied *Gone with the Wind* and the frequently troubling nostalgia that the film evoked in certain quarters.

Late in 1985 Rodney had his first solo exhibition. Alluding in part to the

forthcoming 'festive season', the exhibition was titled *The First White Christmas and Other Empire Stories*. It was held at one of Birmingham's community arts centres, Saltley Print & Media, commonly and affectionately known by its acronym, S.P.A.M.[14] The exhibition was in effect an installation of works, a number of which were executed directly on to the walls of the spaces it occupied. The dominant motifs used in the exhibition related to slavery and the slave trade. Rodney's thoughtful engagement was with not only the legacies and consequences of slavery but, just as importantly, the ways in which we navigate or read the troubling yet on occasion curiously sanitised images relating to slavery that are to be found in no end of history books.

The exhibitions in which the likes of Piper and Rodney played a part took place between 1981 and 1984 and featured an ever-changing line-up of artists.[15] By the mid 1980s, these young Black Art advocates had begun to drift away from their pronounced embrace of the ideology. They would, in effect, leave it to the likes of Shakka Dedi and Rasheed Araeen, to champion their own respective positions on, and interpretations of, Black Art.[16] By the end of the decade, Keith Piper, who had been the most articulate of the early 1980s exponents of Black Art, opined on the dramatic changes his practice went through in the middle of the decade. In 1990 he declared himself to be interested in:

> the open-ended and contradictory puzzle of elements thrown into a heap in order to tease and irritate the spectator, rather than the presentation of the closed and logical arguments with their honourable aims of 'education' and 'upliftment' so favoured by myself and my compatriots in earlier, more lucid days.[17]

In reality, Piper's work had always reflected a multi-layered sophistication and a dynamic grasp, utilising various art historical narratives.

Meanwhile, Creation for Liberation, a group of cultural activists based in Brixton, took a pronounced interest in Black artists' work and organised a series of open exhibitions that attracted the work of a great many artists. The first such exhibition was held in 1983 and others followed throughout the course of the decade.[18] Within these open submission exhibitions, the work of lesser-known and newly emerging artists was hung and shown alongside professional and established painters, printmakers and sculptors, thereby

giving many artists important exposure that had traditionally been denied to them by many of the country's art galleries. The profile of Black British artists received a further and major boost with the opening (again, in 1983) of The Black-Art Gallery in Finsbury Park, North London.[19]

During the course of the 1980s, Black artists were able to open up another front of important activity when a number of the country's municipal museums and independent galleries took an interest in their work, exhibiting it in often large-scale group exhibitions. The first such exhibition was *Into the Open*, held at Mappin Art Gallery Sheffield in 1984.[20] Selected by Lubaina Himid and Pogus Caesar, *Into the Open* featured a mix of artists, some familiar, some less so, who were exhibited together in what was to be become one of the landmark exhibitions of the decade. Many other such exhibitions were to follow, the most high profile of which was *From Two Worlds*, held at the Whitechapel Art Gallery just over two years later, in 1986.[21] Important though such exhibitions were, they tended to present Black artists as somewhat generic or homogenised groups of practitioners, rather than as individual artists befitting of more substantial attention. Nevertheless, these exhibitions, which took place at galleries in Bradford, Manchester, Leicester and elsewhere in the country, often represented valuable, albeit relatively fleeting, opportunities for Black artists. It was during this period of the mid 1980s that the GLC took something of a pronounced interest in Black artists, and worked with a number of them on exhibitions and murals.[22]

Fittingly perhaps, the decade of the 1980s ended with a substantial exhibition curated by Rasheed Araeen and hosted by London's Hayward Gallery. Araeen had had the idea for *The Other Story* a number of years earlier, but it was not until the late 1980s that he was able to realise the project. *The Other Story* showcased the work of African, Asian and Caribbean artists working in postwar Britain.[23] The exhibition generated unprecedented levels of press attention and did much to give credibility to the notion of a tangible history of Black-British artists' practice.

The Rise and Fall of
The Black-Art Gallery

By the early 1980s, strategising around the material needs of Black-British artists had evolved, even as debates about the nature of artists' practice were likewise evolving. An astonishingly varied range of strategic responses to the needs of Black-British artists was developed during the course of the 1980s. These included large-scale open submission exhibitions organised by Creation for Liberation, and curatorial interventions made by artists themselves (for example, by Lubaina Himid), who were in effect acting as independent advocates for Black artists, in a range of environments. To such strategies can be added the hugely important one of creating and providing dedicated gallery spaces in which Black artists could have their work exhibited in a range of solo, group, open submission or themed exhibitions. During the 1980s, there were two such gallery spaces in London, The Black-Art Gallery, in Finsbury Park, across from the iconic Rainbow Theatre, and the Horizon Gallery, located in the heart of central London. The Black-Art Gallery, for much of its existence, worked with artists of African and Caribbean backgrounds, whilst the Horizon Gallery exhibited the work of artists of South Asian background.

These were not the only two gallery spaces in London in which the work of Black artists could be seen. As mentioned in Chapter Four, the Commonwealth Institute, located in the upscale shopping district of Kensington High Street, provided two exhibition spaces – the main gallery and a secondary exhibition area – in which Black artists, including those with secondary, rather than primary, links to the Commonwealth, could have their work seen. Elsewhere, in another highly fashionable district of central London, Covent Garden's Africa Centre was an additionally hugely important venue that put a wide range of Black artists' work within relatively easy reach of the general public and gallery-going audiences alike. If/when certain Africa Centre exhibitions were reviewed or highlighted in London listings magazine *Time Out*

(and, while it existed, its rival, *City Limits*), the exhibitions in question were assured of an increased audience, often people for whom a Covent Garden detour presented no challenges whatsoever. Across London, the long-running October Gallery, in Holborn, had established itself as a faithful friend of artists such as Aubrey Williams, as well as artists with links to many different countries of the world, and those whose practice it termed *transvangarde* – that is, the trans-cultural avant-garde. But whilst such central London locations could be regarded as an asset, there were perhaps ways in which some regarded these locations as being something of a liability. That was certainly the opinion of Shakka Dedi, the founding director of The Black-Art Gallery, who opined that a gallery space for Black artists that was located in much closer proximity to recognisable Black communities and neighbourhoods was an altogether more credible prospect.

One significant characteristic of all of these venues, including The Black-Art Gallery and the Horizon Gallery, was a handy proximity to the underground 'Tube' train network. Simply put, these venues (notwithstanding Dedi's cynicism) were all easy to get to. Another noteworthy exhibition space to establish itself around the needs of otherwise under-represented artists (and indeed, audiences) was the People's Gallery, in Camden, North London, located pretty much alongside another legendary London performance venue, the Roundhouse.

Apart from the ways in which these London galleries contributed to an enhanced proximity between a range of Black artists and a range of audiences, their other significance was the extent to which they were able to often contribute to the documenting, and the historicising, of Black artists' work. The catalogues that these galleries tended to produce may, for the most part, have been modest affairs, but they were nevertheless invaluable documents that did much to cement the notion that Black artists were, or could be, practitioners of note, merit and credibility. In addition to the catalogues produced, these galleries frequently circulated posters, opening view cards, press releases and other materials that served to draw greater attention to what Black artists were doing.

Born in the US in 1954, and given the name Melvyn Mykeal Wellington by his parents, (though eventually changing his name to the more Afrocentric Shakka Gyata Dedi), Dedi was a British poet, graphic designer, artist, and the first director of The Black-Art Gallery in North London. Dedi was one of the founders of the group responsible for establishing and running the

gallery, the Organisation for Black Arts Advancement and Leisure Activities (OBAALA); subsequently, the world 'Learning' replaced the word 'Leisure'. Located within the borough of Islington, the gallery received its core funding from Islington Borough Council. In the wake of the inner-city riots of 1980 and 1981 that disturbed both British society and Britain's political leadership, certain types of attention were being paid to the somewhat fractious existence of significant sections of young Black Britain. A number of causes of the riots were advanced, though the causes which tended to dominate social commentary were Black youth's complaints of unemployment, under-employment and poor prospects for social mobility, together with, perhaps most immediately pressing, persistent accusations of police harassment. The riots brought into sharp focus the extent to which so many young Black men were seemingly unable to escape the miserable clutches of unemployment, a situation made all the more wretched by educational under-achievement and the over zealous, somewhat lopsided policing they were subject to.

In the wake of the riots of the early 1980s, a particularly substantial estab-lishment view emerged that the provision of social and cultural amenities could go some way to alleviate the disproportionate pressures Black youth were experiencing. Politicians with direct responsibilities for the wards, constituencies and boroughs that witnessed the most pronounced bouts of rioting gave their backing to a number of schemes and initiatives reflecting the view that, if the police could be somewhat reformed and if Black youth were given places to go and things to do, perhaps future rioting could be prevented. It was in this context that capital schemes were initiated in places such as St Paul's, Bristol and Brixton, South London. The inner-city district of St Paul's, Bristol, which was home to significant numbers of Caribbean migrants and their families, had witnessed a pronounced bout of rioting in 1980.[1] One commentator, speaking of what he called 'reckless anger', summa-rised the events as follows:

> Sooner or later, some confrontation between the police and young blacks was almost inevitable. On 2 April 1980, a riot broke out in the St Paul's district of Bristol with such ferocity that the police withdrew for four hours, leaving hundreds of exuberant black youths to an unre-strained display of reckless anger. Thirty-one people were reported injured.'[2]

Envisaged as a multi-purpose community resource, a St Paul's neighbourhood community centre was built in the early 1980s, following the riots, for the primary purpose of providing social, recreational, educational and entertainment facilities to the inhabitants of St Paul's and its surrounding areas.[3] Brixton, likewise home to significant numbers of Caribbean migrants and their families, was also to witness significant bouts of rioting a year or so later, in 1981. And again, the institutional response was to include the provision of new social amenities.

The Brixton Recreation Centre, built following the Brixton riots, opened in 1985. It was in this context – of social provision for what were widely accepted to be disadvantaged communities – that Islington Borough Council made monies available to OBAALA to establish, maintain and run The Black-Art Gallery. Under Dedi's directorship, a significant number of Black artists had their first London solo exhibitions, which came with catalogues, posters, opening view cards, press releases and so on. In that regard, the gallery did much to present the work of a wide range of artists of African background and origin in a professional environment. Early solo exhibitions included ones by Keith Piper, Donald Rodney and Sonia Boyce.

The gallery described itself as 'a permanent venue for the works of Afrikan artists world-wide to be exhibited, seen, appreciated, shared, developed, bought, sold, etc.'. Beyond that, the gallery was to be 'a permanent place to inspire you' In its publications and other publicity material, the gallery made available notes on the history of the venture, written by Shakka Dedi:

Shakka Dedi and Eve-I Kadeena developed the original idea for the gallery in 1981. It came about as a response to the scarcity of space and lack of opportunities for Black artists to exhibit their work. It was recognised that there were very few venues where work by Black artists could be exhibited on a regular basis. The few venues that did exist, such as the Commonwealth Institute, Africa Centre, and at one time, the Keskidee Centre, were not well situated or suited to attract the audiences that many Black artists wished their work to reach. Some artists had tried to get their work exhibited in the established commercial art galleries – which are dominated by white, private enterprise. Owners of these establishments argue that they can only handle work that is commercially viable, and that the work produced by Black artists does not fall into this category. When they do display any interest, it

is only in the stereotypical images of what they expect and believe Black art to be – i.e. palm trees, beaches, smiling fruit-women, etc. Others [other Black artists], aware of the way in which British society views Afrikan peoples and their culture, spared themselves the frustrations of seeking exhibition space in the private gallery arena.[4]

These notes by Dedi/OBAALA reflected a certain frustration on the part of a number of Black artists themselves of not having their work taken seriously by the gallery sector. Dedi alluded to the consequences of this neglect, before going on to posit that The Black-Art Gallery should be seen as being a positive development for Black artists and Black communities alike:

> This lack of exhibiting venues and opportunities had the effect of stifling artistic expression – thus, preventing its development and progress. Many artists and potential artists ceased to produce work, having little motivation in this dead-end situation. OBAALA intends The Black-Art Gallery to act as a catalyst, and provide an incentive for artists to continue and to take up producing work. [...] Importantly, the idea for The Black-Art Gallery evolved not simply as a response – albeit a positive one to a negative situation. It arose too out of the conscious recognition that Black people need to establish institutions and structures in Britain, which they are seen to administer and control – in order to best suit the needs and demands of the community.[5]

A passionate believer in the potential of 'Black Art' to be a driving, guiding and illuminating force in the lives and destiny of Black African (or, as he himself preferred, Afrikan) peoples, Dedi and his colleagues created one of the first British manifestos of Black Art, which appeared in the catalogues accompanying several early exhibitions at The Black-Art Gallery, beginning with *Heart in Exile*, the gallery's opening exhibition in the autumn of 1983.[6] From this point onwards, for the next six years, The Black-Art Gallery was in a position to impact on the ongoing debate about the nature, relevance and validity of 'Black Art' in Britain. OBAALA's view of Black art was to some extent a reworking of the Black art manifestos offered ten to 15 years earlier by the African-American poets and prophets.

We believe that Black-Art is born and created out of a consciousness based upon experience of what it means to be an Afrikan descendant wherever in the world we are. 'Black' in our context means all those of Afrikan descent: 'Art'; the creative expression of the Black person or group based on historical or contemporary experiences. It should provide an historical document of local and international Black experience. It should educate by perpetuating traditional art forms and by evolving and adapting contemporary art forms to suit new experiences and environments. It is essential that Black artists aim to make their art 'popular' – that is expression that the wide community can recognise and understand.[7]

One of the ways in which OBAALA strove to maintain what it considered to be a clear position was in the naming of the gallery. Whilst some artists and activists were starting to shy away from the term 'Black Art', OBAALA mounted a spirited defence of the term by calling their gallery space 'The Black-Art Gallery'. This was not meant to be just a 'Black' gallery. It was meant to be a unique exhibition space, dedicated to the promotion of 'Black-Art'. Capital B, hyphen, capital A. The gallery refused to use or recognise any variation of this. The first exhibition organised and presented at The Black-Art Gallery was *Heart in Exile*, which featured the work of 22 artists. All of the practitioners were of African-Caribbean origin. For almost a decade, the gallery maintained its 'Afrikan-Caribbean' position and no other artists were exhibited there. It was perhaps with good reason that Allan deSouza, a British South Asian artist, of East African background, made mention in an essay of 'the rigidly Afrocentric nature of much Black art theory and practice.'[8] In addition to the stringent criterion that 'Black' equates to African and African-Caribbean applied by The Black-Art Gallery, non-figurative or abstract painting was also conspicuously absent from the gallery exhibition programme; for fear that such work could be seen as being 'elitist or pretentious'.

Like other exhibition spaces, The Black-Art Gallery was not without its critics and detractors. Nevertheless it established a reputation for showing a variety of interesting work, closely allied to the essentialist 'Black-Art' manifesto of the gallery and its director. Dedi had studied graphic design at Canterbury College of Art and was continuing to work as a graphic designer of film posters, record sleeves, and so on. In seeking to publicise the gallery's

exhibitions, Dedi brought into play his graphic design skills, serving his core belief that the work of the Black artist should at all times seek to educate (in the widest sense of the word), inform and strengthen the political and cultural identities of 'Pan-Afrikan' peoples. During his tenure, Dedi placed great emphasis on the exhibition poster, seeing it as not just a publicity tool, but a piece of work in its own right, embracing and reflecting his beloved principles of Black-Art. Dedi wanted his gallery's exhibition posters to have a life of their own. Such was the success of his posters that it could, perhaps unkindly, be said that some of them were more successful than the exhibitions they sought to promote. He frequently designed the posters himself. But on occasion, he was happy for the artists themselves to take charge of this work.

Over the course of a decade of exhibition programming, The Black-Art Gallery hosted a wide range of exhibitions that, as mentioned earlier, took the form of solo, group, open submission or themed presentations. These included *Conversations: An Exhibition of work by Sonia Boyce*. Publicity for the exhibition stated:

> Childhood memories of home and family life have formed the basis of many of Sonia's creations. Concentrating on the Afrikan-Caribbean experience, there is little reference to 'white society' in her work. A constant theme running through Boyce's work is the personal as public and the specific made general. The work is often full of warm inviting images beckoning the viewer to enter. Once comfortably inside, you are confronted with some of the harsher aspects of Black life. Sonia has recently acquired a studio space after much struggle. This is a major achievement for a Black artist outside the 'old boys' network which is usually closed to us. From her new studio she intends to explore new directions and subjects. The show at The Black-Art Gallery will be her first solo show.[9]

Though The Black-Art Gallery had, as mentioned, a number of detractors, it nevertheless had what it regarded as a core mission to nurture a community of practitioners. One such artist was Joseph Olubo, who exhibited in the gallery's 1983 debut exhibition. Born in 1953, Olubo was aged 30 at the time of *Heart in Exile*, though he was to pass away seven years later, in April of 1990. As a way of marking Olubo's premature passing, The Black-Art Gallery mounted *'Ask me no Question.... I tell you no lie'*, an exhibition of painting

and sculpture which it described as being 'Dedicated to the memory of Jo Olubo'.[10] Amongst the gallery's many other exhibitions were *Sight•Seers: Visions of Afrika and the diaspora*. This was one of a two part exhibition of 'Afrikan Women's Photography' which featured Afia Yekwai, Elizabeth Hughes, Ifeoma Onyefulu, Jheni Arboine, and June Reid. By this time (late 1987), the gallery was somewhat obliged to acknowledge the recent, albeit relatively brief, escalation of the profile of a number of London's Black artists, who had been exhibited in shows at the ICA (the *Thin Black Line*) and the Whitechapel Art Gallery (*From Two Worlds*). The *Sight•Seers* brochure referenced these exhibitions, but cautioned against complacency by flagging up seemingly perennial challenges:

> Today, the work of Black artists has become slightly more visible, and with the recent breathtaking stream of interest being shown by white administered art establishments, Black-art in Britain has moved into a new phase. Issues of access to white venues, and the visibility of Black visual art share the discussion arena alongside others. Some [issues], such as the relevance and political nature of Black artists' work were always part of the debate. Other [issues] are now being forcefully vocalised and fighting for space on the agenda. The even greater problem of Black women artists' invisibility is one such issue being seriously challenged by Black women artists. Our policies and programme will seek to encourage and support these important debates and developments.[11]

The gallery sought to present a varied programme of exhibitions that included woodburning, ceramics, and textiles. *The Potter's Art*, an exhibition of ceramics by Chris Bramble, Jon Churchill, Tony Ogogo, and Madge Spencer,[12] was one such exhibition. Alongside this curatorial programme, the gallery sought to generate debates about aspects of the nature of Black artists and their practices. One such event, scheduled for Saturday 28 June 1986, was titled *So Anything Goes?*. This was Dedi's attempt to re-assert his particular notion of the ways in which Black artists' practice should, in effect, reflect and address a particular type of diasporic vision. The event was billed as 'A Reasoning on Black Visual Arts Practise [*sic*] and Presentation' and was described as 'An opportunity for practicing Black artists and other members of the Black community to come together and discuss the issues of content, quality, audience and presentation.'[13]

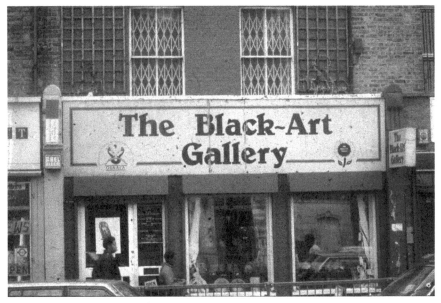

21. The Black-Art Gallery, street view (1986).

It was not until 1992 that Asian artists were able to exhibit at The Black-Art Gallery. From the start of her time as director (taking over from Dedi in the early 1990s), Marlene Smith made it clear that she had little regard for the exclusively African/African-Caribbean remit of her predecessor Dedi. Her first exhibition was an emphatic rebuttal of The Black-Art Gallery's previous agenda. The exhibition, called *Colours of Asia*,[14] featured work by 11 artists of Asian origin. Inadvertently or deliberately, the Black-Art hyphen came to be dropped under Smith's tenure, and the space was referred to as The Black-Art Gallery. It was the London venue for Zarina Bhimji's exhibition *I Will Always Be Here*, on tour from the Ikon Gallery, Birmingham.[15] Smith also overturned Dedi's unwritten employment policies and employed a staff member of South Asian origin to work at the gallery.

By the autumn of 1992, relations between The Black-Art Gallery and its principle funder, the London Borough of Islington, had deteriorated significantly. So much so that, according to the *Weekly Journal* newspaper, 'The Finsbury Park-based gallery's main funder Islington Borough Council suddenly axed its £92,000 grant in September [1992] creating protest from artists and supporters at its "underhand tactics".'[16] The story, titled 'Black arts put on the shelf', was written by Lorraine Griffiths and was front-page news in the *Weekly Journal* of Thursday 28 October 1992. A campaign was

launched to keep the gallery open, but despite letters of support from directors and other senior staff of a number of galleries such as Camerawork, The Photographers' Gallery, Camden Arts Centre, Bluecoat Gallery, and Walsall Museum & Art Gallery, and letters of protest sent directly to Margaret Hodge (then Leader of Islington Borough Council, and currently a senior Labour Party politician), The Black-Art Gallery closed its doors for the last time in 1993.

Ultimately, the reasons for the demise of The Black-Art Gallery were multi-factored. The exhibition landscape for Black artists changed markedly during the decade in which the gallery operated. In 1983, exhibitions by Black artists in the full range of mainstream gallery spaces were still something of an exception and a rarity. In 1983, when The Black-Art Gallery first opened, none of the major survey exhibitions of Black artists' work had yet taken place. The GLC had not yet begun its piecemeal engagement with Black artists and no major publications featuring these artists had yet been produced. By the late 1980s, Black artists' work had been exhibited in major galleries such as the Mappin Art Gallery in Sheffield and the Cornerhouse in Manchester, both regarded, at the time, as important *national* venues. Black artists had also featured in celebrated exhibitions at the ICA, the Whitechapel Art Gallery, and the Hayward, all important London galleries. Exhibitions had also taken place at venues such as the Chisenhale Gallery, and Lubaina Himid had mounted a self-initiated venture, a one-off exhibition at a temporary space near Borough Tube station. Major touring exhibitions of Black artists' work were taking place around the country. All this mid-to-late 1980s exhibition activity, and much more besides, meant that The Black-Art Gallery became, in time, only one of the spaces in which Black artists' work could be seen.

During its decade of existence, The Black-Art Gallery had not cultivated (or had not been successful in cultivating) relations with the national funding body for the arts, the Arts Council. (Though the gallery did secure some funding from London Arts Board, the regional arts board for London.) Had the gallery secured revenue funding, or otherwise accessed Arts Council monies, its fate might have been somewhat different. Instead, when Islington Borough Council let it be known that its funding was to be summarily withdrawn, The Black-Art Gallery had, in effect, no friend or allies amongst the country's funding bodies to which it could turn for support. By the early 1990s, the fabric of the gallery was looking decidedly shabby, as precious

little money had been raised for the upkeep of the building on Seven Sisters Road, or precious little of the gallery's budget had been spent on maintenance and refurbishment. The gallery looked tired.

The history of Black arts projects in the UK shows the vulnerability of such projects to the vagaries and/or prejudices of funding bodies. Generally speaking, when Black projects got into financial difficulties or otherwise fell out of favour with funders, their funding was withdrawn, forcing the projects to close or collapse. In contrast, when a number of 'white' arts projects ran into financial difficulties or experienced other potentially chronic problems, they were often bailed out or given financial reprieves.

There were other respects in which Black projects were susceptible to the vagaries of funders. By the early 1990s, the riots of the early and mid 1980s had already passed into history, and the Black presence in the country, and in London in particular, was assessing itself, and being assessed against other criteria, such as the brutal and horrific murder, in 1993, of the young Black Londoner Stephen Lawrence. In effect, the institutional and local governmental responses to the riots of the early to mid 1980s were a thing of the past. So much so, that many of the capital projects and other initiatives launched in the wake of the riots had, by the end of the decade, run into similar problems to those of The Black-Art Gallery. In short, the landscape had changed. A new institutional venture backed by the Arts Council, going by the acronym INIVA – the Institute of New International Visual Arts – was in its early ascendancy and was rapidly becoming the only game in town that purportedly catered to the notional needs of cultural diversity in the visual arts. For these reasons, and indeed others, The Black-Art Gallery effectively found itself, to use a chess analogy, in checkmate.

For several years, from the mid 1980s onwards, The Horizon Gallery distinguished itself as a substantial exhibition space, located in central London, in which visitors could expect to see work by practitioners of primarily South Asian background. The gallery was run by, and home to, a body known as the Indian Arts Council. The gallery hosted a number of important exhibitions by artists of South Asian background raised in the UK, including *Sutapa Biswas: Recent Paintings*, 17 June – 11 July 1987. Located at 70 Marchmont Street, in London's West End, the Horizon Gallery offered a consistent programme of exhibitions which frequently came with modest, but nonetheless important, exhibition brochures.

By far the most important curatorial intervention made by Horizon Gallery

came in early 1990, during the course of *The Other Story* exhibition on show at the Hayward. As mentioned in the Introduction, important and monumental though the exhibition was, it nevertheless elicited a number of critical responses that brought out into the open divergent and sometimes discordant voices. The most conspicuous critics were those who declined Araeen's invitation to participate, fearing that to contribute to such an exhibition was tantamount to pigeon-holing themselves along constrained lines of ethnicity, race, cultural identity, and so on. The effective refusal of high-profile artists Shirazeh Houshiary, Anish Kapoor, Kim Lim, Dhruva Mistry, and Veronica Ryan cast something of a shadow over the exhibition, and was seized on by certain critics as evidence or confirmation of the exhibition's supposedly peripheral status. Amongst the exhibition's sternest critics were those who charged that it overlooked or omitted significant women artists, particularly those of South Asian background, who were arguably conspicuous by their absence from the exhibition.

It was an attempt by the Horizon Gallery to address what it saw as *The Other Story*'s omissions that led the gallery to hastily organise a series of exhibitions that were, despite that haste, important curatorial interventions. The exhibitions were called *In Focus* and comprised four consecutive exhibitions, each one featuring work by four artists of South Asian background. Bhajan Hunjan, Chila Kumari Burman, Shanti Thomas, and Jagjit Chuhan were in the first of the exhibitions. Mumtaz Karimjee, Zarina Bhimji, Nudrat Afza, and Pradipta Das were in the second. Mali, Shaffique Udeen,[17] Sohail, and Shareena Hill were in the third, and Suresh Vedak, Amal Ghosh, Prafulla Mohanti and Ibrahim Wagh were in the fourth and final show.[18]

The press release bristled with a certain indignation at the perceived failings of *The Other Story* and an apparently pressing need to address these short-comings:

We have identified an urgent need to mount an exhibition in conjunction with the Hayward show, 'The Other Story'. From our discussions with various Asian Artists, three distinct groups have emerged. These groups reflect different political and social realities, which are inevitably reflected in their art. The relationship between these artists, their work, their position in British society and the influences of their background and culture, is different, depending on the circumstances and reasons for living in Britain. These groups are: The older generation who came

between 1950 to 1970, some of whom formed the Indian artists collective in 1964; to redress the lack of recognition in mainstream art in the West, the [second group is] Asians who were compelled to leave Africa and [the third group is] Asians born in Britain.

Additionally, in all three categories, but mainly in the final category, 'Asians born in Britain' are Asian women artists. This important group is not represented in the Hayward show.

The exhibitions are designed to give a representative view of the work of Asian artists living in Britain. [...] The exhibition [...] will consequently make a considerable contribution both to the exposure of Asian artists in Britain and the longer term documentation of their work.

It is an appropriate time to assess and analyse the input of Asian artists and to evaluate them in relation to main stream art practices.[19]

Hurriedly put together these exhibitions may have been, but they nevertheless represented by far the most important curatorial intervention made by Horizon Gallery. Whilst *The Other Story* drew large amounts of press attention, *In Focus* drew comparatively little. Artist Veena Stephenson wrote one of the most significant appraisals of the series of exhibitions:

The Horizon Gallery in London organised 'In Focus' in response to the more widely publicised exhibition, 'The Other Story', at the Hayward Gallery. Their response was not only swift but was achieved with minimal financial help from the usual funding bodies. The aim was to address some of the failings of the Hayward show and the result was a selection of work by sixteen South Asian artists spread over four consecutive exhibitions.

Particular emphasis was given to the women artists who comprise exactly half the exhibitors. All but one are in the first two shows – the significance of this arrangement, it seems, was to highlight the much talked about omission of South Asian women artists in the Hayward show. In fact, this was one of the main motivations for mounting this series of exhibitions.[20]

When the Horizon Gallery closed in 1991, a well-located venue, dedicated to showing the work of artists with, frankly, limited exhibition options, was lost.

Within a couple of years of the Horizon Gallery closing, The Black-Art Gallery, in Finsbury Park, also closed its doors for the final time, having had its funding withdrawn by Islington Borough Council. Whilst neither of these galleries were without their critics, for periods of about five and ten years respectively they provided exhibition opportunities for significant numbers of artists, albeit practitioners representing demarcated constituencies. Notwithstanding the subsequent establishment of Rivington Place, the gallery-based home to INIVA and Autograph, the closure of the Horizon Gallery and The Black-Art Gallery effectively meant that two particular venues were lost, and were never replaced.

CHAPTER NINE

The Emergence of Black Women Artists: Arguments and Opinions

During the period of the early to mid 1980s the distinct, specific entity of the 'Black woman artist' emerged alongside the more general (and non-gender-specific) presence of the 'Black' artist. By 1986, the impact and importance of this development was widely acknowledged, resulting, temporarily at least, in the significant raising of the profile of Black women artists such as Sonia Boyce and Maud Sulter, by sections of the art establishment. In 1988 Sonia Boyce achieved the distinction of being the first British-born Black artist to have had a solo exhibition at the Whitechapel Art Gallery[1] and Maud Sulter was awarded the Momart Fellowship at Tate Gallery, Liverpool in 1990–1991. In an overview of Black visual arts practice in Britain, from the 1950s through to the mid 1980s, Errol Lloyd noted that 'Women are now stepping out, and for the first time in Britain black women artists are exhibiting together, as well as exploring issues of common concern and creativity together, without the sometimes stifling intervention of men.'[2]

This emergence was centred on three particular exhibitions organised and curated by Lubaina Himid which signalled the newly conspicuous presence of Black women artists. These were the first exhibitions of Black women artists in Britain to be labeled as such. The first of these exhibitions was *Five Black Women Artists*,[3] which took place at the Africa Centre, a venue that had increasingly come to be used by a newer, younger generation of practitioners whose links with the African continent most frequently existed via the diaspora. The exhibition featured Sonia Boyce, Lubaina Himid, Claudette Johnson, Houria Niati, and Veronica Ryan. Whilst Boyce and Johnson were British-born, and Himid, Niati and Ryan were born in Zanzibar, Algeria and Montserrat respectively, these artists typified the profile of new Black artists in Britain. They were educated in Britain, art school-trained, and adept at using the languages and devices of modern and contemporary art, to make the work they wanted to make.

Two other vitally important factors in the practices of these artists were their critical approaches to art history and the extent to which they were referencing ongoing debates about the specificities of the identities and struggles of Black women. During the course of the late twentieth/early twenty-first century, a new generation of Black artists made work that critiqued and interrogated dominant notions of art history. These artists, having received BA and, in some instances, MA degrees from the country's art schools, were well placed to appreciate the extent to which dominant notions of the Western art historical canon excluded, as a matter of course, artists such as themselves. These Black artists were keenly aware of the ways in which art history had failed them, and were determined that this willful failure would not go unremarked or unchallenged. Consequently, their work frequently resonated with references to the manifestation, consequences, and implications of this exclusion. But this was not simply a strategy of critique and critical engagement. Artists such as Himid took art history to task, partly as a way of inserting themselves into its narrative.

The other factor that frequently informed the work of these women artists was the new articulations of the specificities of Black women, which were being voiced during the course of the early 1980s. The African-American feminists of the Combahee River Collective authored a statement arguing that Black women experienced a particular form of oppression because, as Black women, they stood in polar opposition to the normative, as defined and prescribed by the white masculinist hegemony.[4] It was to a great extent the articulation of such sentiments that provided a blueprint for statements subsequently made by Black women artists in the UK, for example:

> The most general statement of our politics at the present time would be that we are actively committed to struggling against racial, sexual, heterosexual, and class oppression and see as our particular task the development of integrated analysis and practice based upon the fact that the major systems of oppression are interlocking. The synthesis of these oppressions creates the conditions of our lives. As Black women we see Black feminism as the logical political movement to combat the manifold and simultaneous oppressions that all women of color face.[5]

Very much reflecting these bold and precise new articulations, Claudette Johnson, whose work was a consistent feature of the Black women artists'

exhibitions of the 1980s, summarised the challenges facing Black women as artists (and provided a context in which her work and the work of other Black women artists could most effectively be read). This summary appeared in her statement for *The Image Employed*[6] catalogue:

> Within the term 'Art', the work, experiences, culture and values of the Black artist are too often ignored, obscured, devalued, misrepresented, or misunderstood. This is perhaps inevitable in a society where the criteria that have defined and controlled the production of Western art are blindly applied to the work of artists whose cultural heritage is Asian, African or Caribbean. The work of the Black artist involves the expression of her or his life experience. Here in Britain that experience includes institutionalised racism and class oppression. Any assessment of Black art which fails to fully acknowledge these factors is at best superficial and at worst invalid.[7]

Johnson went on to identify what she considered to be the unique position of the Black woman, in simultaneously experiencing both racism and sexism:

> The White woman, whose creativity and human potential are forcibly limited, distorted or aborted, by male definitions of her sexuality, experiences sexism. The Black man, who is subtly and brutally degraded by a skein of lies and violence designed to maintain and perpetuate his position of economic vulnerability, where his labour is cheap and abundant, experiences racism.
>
> Whilst the Black woman experiences oppression on the grounds of her sex, sexuality and race, there is not yet a word that properly describes the specific and deliberate nature of the oppression. She does not experience sexism exactly as the White woman nor racism exactly as the Black man. The quality, nature and forms [of her oppression] relate to her specifically as a Black woman with a history and struggle of her own. This is the present, out of which the Black woman artist creates her future.'[8]

Following on from the Africa Centre exhibition was the numerically larger group exhibition *Black Woman Time Now*.[9] The exhibition featured Brenda Agard, Sonia Boyce, Chila Kumari Burman, Jean Campbell, Margaret Cooper,

Elizabeth Eugene, Lubaina Himid, Claudette Johnson, Mumtaz Karimjee, Cherry Lawrence, Houria Niati, Ingrid Pollard, Veronica Ryan, Andrea Telman and Leslee Wills. Two years later, another group exhibition was curated and organised by Himid. This exhibition, *The Thin Black Line*,[10] was to be her single most high-profile curatorial undertaking of the decade, taking place in the ICA, at the time one of the most important, prestigious and well-located galleries in central London. On account, in part, of its location, *The Thin Black Line* garnered significant amounts of press attention which offered both new insights and old prejudices.

Lubaina Himid was one of the most important and accomplished women artists to be identified with the 1980s emergence and development of Black artists in Britain. Alongside her studio practice as a painter and creator of mixed media pieces, she established a reputation as a curator of Black artists' exhibitions, both gender-specific, such as the exhibitions referenced above, and non-gender-specific.

Himid was born in Zanzibar, Tanzania in 1954, coming to England shortly after her birth. A degree in Theatre Design was awarded to her in 1976 after a period of study at Wimbledon School of Art. It was in 1979 that Himid began to organise exhibitions. She started by showing work in a central London restaurant, though it was not until 1983 that Himid organised the first of several widely respected exhibitions of work by Black women artists. Himid's preface to *The Thin Black Line* exhibition catalogue summarised the curatorial position she adopted for these exhibitions:

> All eleven artists in this exhibition are concerned with the politics and realities of being Black Women. We will debate upon how and why we differ in our creative expression of these realities. Our methods vary individually from satire to storytelling, from timely vengeance to careful analysis, from calls to arms to the smashing of stereotypes. We are claiming what is ours and making ourselves visible. We are eleven of the hundreds of creative Black Women in Britain. We are here to stay.[11]

Himid was a wide-ranging artist whose work embraced and could be divided into a number of themes: satirising white society and white/European cultural orthodoxies; celebrating the creativity and resourcefulness of Black people and Black women; and challenging the skewed ways in which dominant notions of art history exist. But Himid's work did more than simply satirise,

celebrate or critique. Through her paintings she sought to challenge dominant and oppressive versions of history and in so doing, continually sought to rescue Black historical figures from an ever-threatening obscurity. Typical in this regard is her 1987 work, *Scenes from the Life of Toussaint L'Ouverture* (watercolour and pencil on paper, 15 sheets). In this series, which echoed and recalled Jacob Lawrence's magnificent work of 1938, his *Toussaint L'Ouverture Series*, Himid depicted assorted scenes from the life and legend of Toussaint L'Ouverture – *This Gilded African*,[12] the eighteenth century military commander and revolutionary who occupied such a respected position in Black history (among those who were aware of him). On one such sheet, beneath stylised renderings of the warrior statesman and a partial view of his mount, Himid offered the following sentences: 'Toussaint was known as The Centaur of the Savannahs he rode 125 miles a day. He could jump on a horse at full speed and was still a fine rider at 60'.[13]

Himid's work also had the aim of challenging and undermining patriarchal systems and patriarchal modes of thought and behaviour. To this end, she regularly employed humour, often producing caustic renderings of her tormentors in the form of wooden cut-out figures. One such figure depicted a white man as a facile clown, chasing, or seeking to lure, a Black woman with a carrot on a stick. Another earlier piece showed a white man masturbating over himself with an enormous penis in one hand. Out of his penis ejaculated the filth of the world: warfare, destruction, pornography, exploitation and so on.

For a period of time Himid worked closely, in a number of ways, with the Glasgow-born artist Maud Sulter (who died in 2008, still in her forties). Together they were responsible for the only British-produced book dedicated to examining and celebrating the work of Black women artists. Their publishing company, Urban Fox Press, published *Passion: Discourses on Blackwomen's Creativity* in 1990.[14] As mentioned, Himid's work was included in the landmark exhibition *The Other Story: Afro-Asian artists in post-war Britain*, Hayward Gallery, London, 1989. This allowed Himid and Sulter to contribute a text – *A Statement from the Elbow Room*, 'Freedom and change: she who writes her story rewrites history' – in the 'Other Voices' section of *The Other Story* catalogue.[15]

It was a testament to the appeal of Himid's work that it was used to illustrate the covers of several publications that sought to chronicle the Black British presence. These include *Black British Cultural Studies: A Reader*,

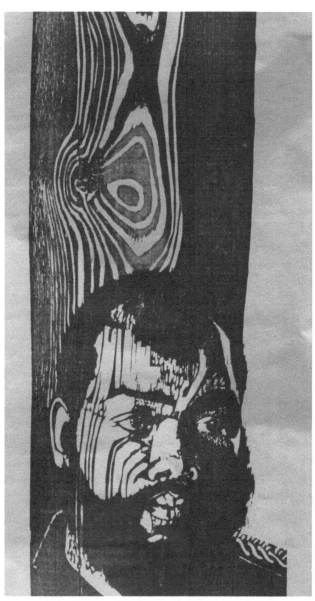

22. Sue Smock, *The General* (detail), (1970).

published by Chicago University Press in 1996, and, five years later, *Companion to Contemporary Black British Culture*, published by Routledge in 2001. In similar regard, a detail of one of Himid's installations, *Naming the Money* (2004) graced the cover of *Imagining Transatlantic Slavery*. More recently, Himid's work was used in the publicity for the major Tate Britain exhibition, *Migrations: Journeys Through British Art*, 31 January – 12 August 2012. Himid's image was *Between the Two my Heart is Balanced* (1991).

As stated earlier in this chapter, the three most significant exhibitions that signalled the newly conspicuous presence of Black women artists were all the work of Lubaina Himid, and the most complete overview of the nature and impact of Himid's 1980s curatorial work was provided in 'A statement from The Elbow Room' in *The Other Story* catalogue. In 1986, the *Elbow Room* was the name given to a space within a largely unoccupied shell of a building near Borough tube station in London. Himid used this space for one exhibition that she organised – *Unrecorded Truths*.[16] Subsequently Maud Sulter joined Himid in her organising and curatorial work, and the site of the Elbow Room became a terraced house in Martello Street, Hackney, London. For a while thereafter, the Elbow Room maintained a status as a non-building-based operation, centred on the curatorial activities of Himid and Sulter.

The effect of Himid's three women-only exhibitions and their ensuing debates was that by the mid 1980s, an increasing number of people were able to confidently discuss the work of Black women artists as a recognisable entity. During the course of the twentieth century, African-American women artists, alongside their male counterparts, had struggled for visibility. By the end of the twentieth century, the Black woman artist had become an increasingly recognised (though to some extent, still very much challenged) component of the US art scene. The closing decades of the twentieth century saw Britain's Black women artists engaged in similar struggles, with the same partial outcomes. Perhaps the most positive legacy of the emergence of Black women artists is the existence of a number of texts that attempt to illustrate and define those particular aspects and components of Black artists' work. Whereas before 1985 there was little or nothing (in writing) that dealt with the specifics of the Black woman as artist, by the end of the decade several key texts were in print. One such text was the Chila Kumari Burman essay touched on in Chapter Five, 'There Have Always Been Great Blackwomen Artists'.[17] Another such text is Gilane Tawadros's 'Black Women in Britain: A Personal & Intellectual Journey'.[18] Lubaina Himid also provided several

such essays, including 'Mapping: A Decade of Black Women Artists'.[19] As noted earlier, Himid and Sulter, who established a publishing company, Urban Fox Press, as an extension of their Elbow Room activities, were responsible for producing *Passion: Discourses on Blackwomen's Creativity*, the only book (thus far) devoted entirely to the work of Black women artists in Britain during the 1980s. During the 1990s, several monographs on Black women artists were brought into existence.[20]

One reviewer of *The Thin Black Line* concluded her review by stating that 'as a showcase for the work of black women artists [the exhibition] will no doubt inspire and encourage similar exhibitions.'[21] This was indeed the case, as the next few years witnessed a significant number of exhibitions of work by Black women artists. This growth in exhibition activity (together with the existence of a number of texts that attempt to illustrate and define Black women artists' work) was Lubaina Himid's legacy.

Elsewhere, in another text, Sutapa Biswas and Marlene Smith underlined the argument about the historical non-recognition of Black women as artists:

Within the context of current art criticism the nineteenth century view of Black people as 'other' is still dominant. On the right, mainstream art has failed to acknowledge the work of Black artists. The left on the other hand has framed us within an anthropological context.[22]

Biswas and Smith could derive little or no comfort from the writings of white feminist art historians. They continued, 'similarly, feminist art critics have evaded issues of race. For example, in *Framing Feminism, Art and the Women's Movement 1970–85*, Black women's work is dealt with as an adjunct to the main thesis.' This pathology of treating certain artists as almost an afterthought, or an addendum to a supposedly central thesis, was evidenced in other publications.[23]

The problem, as artists and writers such as Kumari Burman, Smith and Biswas saw it, was that assorted academics, art historians, curators and activists, both men and women, representing different constituencies, had all overlooked or ignored the specificities and the contributions of the Black woman artist. The Ghanaian writer Kwesi Owusu was also criticised by Biswas and Smith for apparently not dealing adequately with issues of gender in his work. Biswas and Smith had both been included in *The Thin Black Line*, and a year later, Owusu's book *The Struggle for Black Arts in Britain*[24]

commented on this show as a successful, triumphant undertaking. Using street-wise terms of approval that were Jamaican in origin and were popular at the time his book was written, Owusu described the exhibition as being 'big, broad and massive' and as bringing to the fore 'Fresh evocations of Black experience and collective identities, complemented by challenging and accessible visual arts discourses.'[25] However, Owusu's approval of the exhibition cut little or no ice with Biswas and Smith. They dismissed his book with the sentiments:

> Conversely in *The Struggle for Black Arts in Britain*, the issues of gender are not dealt with.
>
> This is not to imply that by simply naming Black women artists these texts would improve. Their problem lies beyond the ability to list Black women's exhibitions or reproduce their images. Their theories need to be revised to make the issues of both race and gender central and connected.
>
> There is a failure to recognise the full significance of the developing discourse on race/gender and cultural production.[26]

Himid and other Black women artists had also argued that (before, during and subsequent to the conspicuous emergence of 'the Black woman artist' and their attendant exhibitions), the practice of Black Art, as defined and reported by Black men, was aesthetically, intellectually and politically cramped. Himid considered that Black women artists were still being comprehensively ignored and, like Biswas and Smith, she saw no room for complacency:

> There can be no survey, no overview, no clear picture of art in the twentieth century without the work, the theory and the philosophy of the Black woman artist. We are still left gasping however at the unrelenting omissions by galleries, archivists, historians and indeed fellow artists.[27]

It was, though, not so much the case that prior to the 1980s there was an absence of Black women practicing as artists. Artists such as Merdelle Irving and Sue Smock were actively exhibiting during the 1970s.[28] Rather, the problem lay in their apparent *invisibility* or marginalisation as exhibition

organisers, curators, art critics and artists. The exhibition from Britain that
went to *Festac' 77*[29] featured work by twelve men and only one woman (Sue
Smock). We do not know to what extent Black women artists of the 1960s
and 1970s voiced displeasure at their limited representation in exhibitions
such as *Festac '77*, but within less than ten years the issue of 'representation'
had taken centre stage and Black women artists were not only vocalising their
frustration, they were also building for themselves platforms of visibility and
dialogue. Beyond this, certain Black women artists were, briefly, recipients
of a pronounced level of interest from art critics and the art establishment
during the 1980s.

But the emerging issues of 'representation' that Black women artists were
addressing did not simply relate to Black artists' undulating profiles and
fortunes. Black women artists (during the 1980s) began to level the charge
of discrimination at those responsible for high-profile *Black* exhibitions.
Black artists, men and women, were increasingly coming to express the view
that they simply *had* to be represented in major exhibitions organised and
curated by white people. So too Black women artists were increasingly
coming to express the view that there simply was no excuse for them being
kept out of major Black exhibitions. Despite the extent to which representa-
tion became a visible issue in the 1980s, there was still, by the close of the
decade, a perceived failure of Black male artists (working as critics and cura-
tors) to acknowledge to a greater degree the existence and contributions of
Black women artists.

This failure was, according to some Black women artists, no more apparent
than in *The Other Story* exhibition.[30] Despite the broad curatorial brush
strokes of the exhibition (it claimed to indicate and represent key works
reflecting the presence of Asian, African and Caribbean artists in postwar
Britain), there was within the show a complete absence of contributions by
Black women artists of the older generation. And, so it was charged, even
women artists of the younger generation were sparingly represented. Biswas,
one of those not included in the exhibition, hung much of her *The Other
Story* review around the issue of exclusion: 'Araeen [curator of the exhibition]
jeopardises [the exhibition] by . . . neglecting what would have been the
show's major strengths, particularly the contribution of black women'.[31]

Biswas chastised Araeen for 'cleverly' deflecting attention away from the
apparently limited representation of women in the exhibition by hanging the
work of those women who were included in 'isolated categories', implying

that a 'women's section' would have been more appropriate. In case Araeen needed any advice as to which women he could have/should have included, Biswas went on to write '. . . he has deliberately missed out the work of artists like Houria Niati, Marlene Smith, Claudette Johnson, Sokari Douglas Camp, Nina Edge, Bhajan Hunjan, Shanti Thomas, Ingrid Pollard, Zarina Bhimji, Amanda Holiday, and so on.'[32]

By the early 1990s, what appeared to be a 'consensus of pluralism'[33] could be discerned in a number of exhibitions of Black artists' work. Not only were Black women artists being represented in exhibitions in relatively greater numbers, but other signifiers of diversity – such as sexuality – were beginning to appear as a pronounced strand within Black artists' practice and exhibitions. In this regard, the work of those Black photographers and film-makers who have located gay politics and Black homosexual identity at the centre of their creativity must be referenced. One of the most striking characteristics of the development of Black visual arts activity from the late 1980s onwards has been the emergence of film-makers such as Isaac Julien and photographers such as Rotimi Fani-Kayode, Sunil Gupta and Ajamu.[34] These artists have all dealt with issues of homosexuality and its relationship to culture, race, nationality, identity and, just as importantly, its relationship to those activities and that counter-cultural stance of activism generically and historically referred to as 'the struggle'.

Spaces for these artists and these types of work were opened up and made possible by the endeavours and the struggles of Black art practitioners and Black curatorial activity of early-mid 1980s Britain, particularly the activist work of Black women artists. Post-riots 1981 Britain saw Black ideas of 'difference' and political demands for space, representation and resources becoming more defined and articulated. The emergence of work by Black photographers and film-makers who have located gay politics, Black homosexual identity and the Black male body at the centre of their creativity has been a continuation of this process.

Historically, certain people had argued that 'the struggle' had been located around 'masculinist' sensibilities, policed by heterosexual Black men.[35] In this scenario, heterosexual Black women were cast as not much more than a supportive and tangential component, relegated to realms of domesticity or 'women's issues'. Homosexual Black people, of both sexes, were assigned no role or visibility. Mirroring shifts in other spheres, gay Black artists moved the terms of reference irreversibly when they insisted that homosexual iden-

tity had a valid and central place within Black artists' exhibitions, as well as within debates about what 'the struggle' was and along what lines it should/could be conducted. These artists and activists similarly argued that the dominant activism around homosexuality and gay rights was problematic, lacking, so it was argued, due considerations of issues of 'race' and racism'.

The mid to late 1980s manifestation of a 'consensus of pluralism', incorporating as it did disparate notions of sexuality as well as a questioning and critiquing of notions of nationality, race and gender was summarised and celebrated by Sunil Gupta in his 1993 book and exhibition, *Disrupted Borders*.[36] Within this book and exhibition, Gupta sought to bring together strands from his assorted projects as a curator, artist and cultural activist that he had undertaken from 1986 onwards. In his introduction to the book, Gupta wrote:

> Since 1986 I have been involved in organising exhibitions around a variety of specialist themes to bring targeted audiences into the gallery. There have been lesbian and gay shows, Black and Asian shows, now I want to bring these issues not only into context with each other but also to confront the failure of modernism to take into account the wide variety of constituencies for the production and consumption of art on a world-wide scale.[37]

Pioneering practitioners such as Merdelle Irving, Sue Smock and, later, Sunil Gupta, helped immeasurably to advance the causes of a wide range of artists who emerged in subsequent decades.

Sonia Boyce and Other Black Women Artists

Sonia Boyce was one of the most important artists associated in large part with the emergence of Black artists in 1980s Britain. She was further identified – along with Lubaina Himid and others – with the emergence and development of curatorial and critical contexts addressing the practice of Black women artists of that decade. Boyce was born in London in 1962 to parents from the Caribbean countries of Barbados and Guyana. She received her art school training at Stourbridge, graduating in 1983, and then returned to London, where she has continued to live and work.

Boyce was, during the early to mid 1980s, producing wonderful, engaging large-scale pastel drawings, semi-autobiographical works that were reflective of her feminist, and indeed her *womanist* impulses. She became something of a household name in Britain's art scene; it was the first time for several decades that a Black artist was represented in mixed exhibitions in which their work was seen alongside that of their white counterparts, as those of Frank Bowling and Aubrey Williams had been. Boyce was one of five artists in *Room at the Top*, a mixed group exhibition curated by Waldemar Januszczak that took place at Nicola Jacobs Gallery, London.[1] The other artists included in the exhibition were Gerard de Thame, Mary Mabbutt, Paul Richards, and Adrian Wiszniewski. The exhibition was one of the very few such undertakings, during the 1980s, in which the work of a Black artist was exhibited alongside work by white artists. Boyce was for a while an artist with whom Januszczak, (at the time visual arts reviewer for the *Guardian*), was particularly impressed. Following Boyce's presence in group exhibitions such as this, a few years would elapse before a new generation of Black artists, for example Chris Ofili, would again be embraced in mixed exhibitions such as *Room at the Top*.

Boyce was one of the first Black British-born artists to have work included in *The British Art Show* (in 1990). Likewise, she was, as mentioned in the previous chapter, the first Black British artist ever to have a solo exhibition

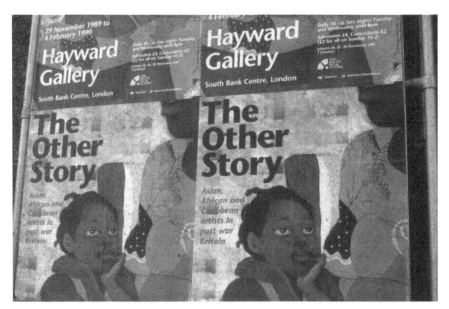

23. Sonia Boyce, *Big Woman's Talk*, 1984, exhibition poster, *The Other Story* (1989).

at the Whitechapel Art Gallery.[2] Boyce is primarily known for her work as a visual artist, but over the years she has also worked as an archivist, editor, lecturer and tutor. Her work, together with that of artists such as Keith Piper, was widely exhibited in a range of exhibitions during the 1980s and beyond. These exhibitions began with the initiatives developed by Lubaina Himid such as *Black Woman Time Now* at Battersea Arts Centre and *Five Black Women Artists* at the Africa Centre, referenced in the previous chapter. From these exhibitions, Boyce went on to many other group exhibitions, among them *Into the Open* and *Unrecorded Truths* (again, both of these exhibitions featured the curatorial input of Lubaina Himid). She also had several important solo exhibitions, perhaps the most important being her 1986 show at the Air Gallery, London.[3]

Boyce is known and celebrated for her wonderful oil pastel drawings that explored a range of personal and social narratives, touching on an astonishingly wide range of subjects: the ambiguities of Christianity and its troubling and troubled relationship with Black people; the legacies and the consequences of the British Empire; predatory and sexually abusive behaviour (from supposed close friends of the family) that often remain hidden from view; the importance of memory. All these topics and many others have

featured in Boyce's earlier work. From the late 1980s onwards, her work began to change markedly. She began to move away from her distinctive oil pastel drawings towards ways of working that utilised photography, montage, and colour photocopying. From this work, Boyce progressed to performance, installation, and other ways of working that were largely reflective of contemporary art practices of the 1990s. Her work was the subject of a monograph written by Gilane Tawadros[4] and as an artist, illustrator and editor, her name is linked to a range of publications.

The most enduring work by Boyce has been her oil pastel drawings of the early to mid 1980s, evocative of a range of narratives centred on aspects of her identity as a Black woman of Caribbean heritage, growing up in Britain, and the multiple dimensions of those experiences. Typical in this regard is *Lay Back, Keep Quiet and Think of What Made Britain so Great* (1968). At a stroke, Boyce's sampling of the phrase *Lie back and think of England* evoked both British military expansionism during the days of the British Empire and, simultaneously, hardships, discomforts or privations that had to be endured by colonials and expatriates in the name of, or for the sake of, this expansionism. At the core of this is a grim understanding by Boyce that whilst the phrase, in one of its original contexts, might have been somewhat jovially applied to wives needing to do their conjugal duty, the realities of sexual submission to colonials and expatriates by indigenous people, particularly women, were, during the centuries of the British Empire, of an altogether more menacing, abusive and coercive nature.

This is a profoundly empathetic work by Boyce, in which she finds common cause with those on the receiving end of the British Empire's military, political and colonial aggression. Within the work, a Black woman – Boyce perhaps – stares out directly at the viewer, thereby putting herself directly in the mix, whilst simultaneously seeking to implicate the viewer in this unsavoury history, the consequences of which are still being played out today in many parts of the world.

The importance and success of another of her key works, *Big Woman's Talk* (1984) was such that a detail of the work was used, to dramatic effect, on the poster for *The Other Story* exhibition. The work typified much of Boyce's concerns during this particularly fertile period of her practice. It depicts a young girl, sitting with her elbows in her mother's lap, seemingly staring into space, as the formidable frame of her mother fills much of the picture. Though her mother's head is cropped at the top of the picture, we

see enough of her face and mouth to know that she speaks to, or converses with, an unseen friend, neighbour or family member, out of frame, to the left side of the picture. We notice immediately several important aspects, almost trademarks, of Boyce. The woman and her young daughter (and presumably the unseen conversationalist) are sitting in a domestic environment. Here Boyce again pays loving and lavish attention to depicting the domestic environment of Caribbean homes as being important, culturally enriched spaces, the décor of which reveals much about the tastes, aspirations and lifestyles of its occupiers.

The West Indian front room[5] has now been cast as a recognisable familial space, with its own aesthetic integrity. Many Caribbean homes during the 1960s and 1970s and indeed beyond, had a room – often a front room – that was regarded as a special environment, full of the best furniture, pictures, books, ornaments, etc. The room reflected the aspirations of the homeowners or occupiers, for whom these spaces existed as special places in the home that were ordinarily off-limits, until such time as esteemed guests visited. In a world in which many Caribbean migrants had little or no access to special places or spaces, these people, very simply, constructed their own prestigious environments, irrespective of how modest their incomes might be or how pressing a need there might be for space within often large and active families. The woman and child in Boyce's drawing are located in such a space and Boyce has, typically, lavished an almost inordinate amount of care, attention and detail on the room's wallpaper. Instead of executing gestural marks, to indicate wallpaper, Boyce has, as it were, created the wallpaper herself, and to this end, every bit of the background of *Big Woman's Talk* is covered in Boyce's own lavish wallpaper, evocative of the Arts and Crafts movement.[6] Boyce was highly skilled at depicting supposedly simple scenes or scenarios that were in fact hugely layered and detailed in both their composition and meanings. The mother sits in an armchair or sofa, green in colour, and the viewer can see a section of the antimacassar – the small, sometimes embroidered pieces of rectangular cloth placed over the backs or arms of chairs, or the head or cushions of a sofa, to prevent soiling of the permanent fabric, by hands, the backs and sides of heads, and so on.

The woman's mouth (or what we can see of it) is open, indicating conversation. A small, discreet, but perfectly placed element of the woman's head is the earring she wears. The mother's dress gives more than a passing nod to the African-American tradition (amongst women) of patchwork quilting.

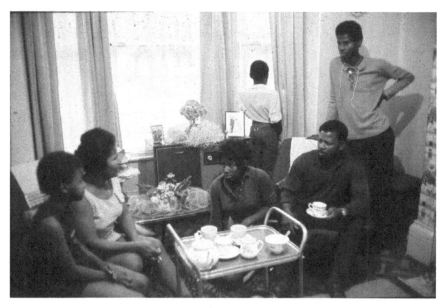

24. Romano Cagnoni, *West Indian Front Room*, photograph (1971).

The woman's open mouth conveys salacious tales of who (within the conver-
sationalists' shared group of friends, relatives or acquaintances) did what, to
whom. It is this conversation, peppered with juicy titbits, on which the young
girl eavesdrops, her apparently absent facial expression acting as a cheeky but
successful foil.

Though familial dirt is being dished, in reality the woman's utterances,
coupled with the astonishingly strong cultural resonances of the piece, mean
that *Big Woman's Talk* is in effect about the communication, not of salacious
details, but of *culture* itself, and its familial transferences. Such work quietly
but studiously celebrates the resilience, the importance, the significance of
the Black woman. Astonishingly perhaps, such work was, until the arrival of
artists such as Boyce and Claudette Johnson, relatively unusual. Perhaps the
most substantial evidence of Boyce's status was the way in which she came
to act as something of a role model for a slightly younger generation of Black
women artists. Like Boyce herself, artists such as Simone Alexander, Amanda
Holiday and Mowbray Odonkor created a range of compelling works that
located images and experiences of Black women, like themselves, their friends,
their mothers, their sisters, at the core of their practice.

Claudette Johnson is an artist who trained in Fine Art at The Polytechnic,

Wolverhampton, graduating in the early 1980s. Born in Manchester, Johnson is a contemporary of artists such as Lubaina Himid and Sonia Boyce, with whom she exhibited in several exhibitions in the early to mid 1980s. Johnson first began exhibiting with the Midlands-based group of art students and young artists that included the likes of Marlene Smith, Keith Piper and Donald Rodney. Later, Himid included Johnson in the *Five Black Women Artists* exhibition at the Africa Centre in 1983, *Black Woman Time Now*, at Battersea Arts Centre some months later, and *The Thin Black Line*, the important exhibition that took place at The ICA in London midway through the 1980s. Johnson's work also featured in mixed gender exhibitions such as *Into the Open* at Sheffield's Mappin Art Gallery in 1984 and *The Image Employed*, which took place at the Cornerhouse, Manchester, in 1987. In addition, Johnson has had a number of solo exhibitions.

A gifted artist with a marked ability to capture the *personality* of her subjects and sitters, like Boyce was to do for a period of time, Johnson has traditionally taken as her subject the image of the Black woman. In so doing, her work is inscribed with bold attempts to both counter widespread negative portrayals of the Black woman and to combat what effectively amounts to their lack of visibility in assorted arenas. Correspondingly, Johnson's work sought to create a range of depictions of the Black female body that were free from, or resisted, objectification. As mentioned in the previous chapter, in her catalogue statements Johnson spoke eloquently about what she saw, felt and understood to be the Black woman's specific experiences of racial and gender politics. According to Johnson, the Black woman suffered racism in ways that were different from the ways in which Black men suffered racism. Likewise, the Black woman suffered sexism in ways that were different from the ways in which white women suffered sexism. It was within the peculiarities of the Black woman's space, framing and treatment that Johnson's work germinated and produced such spectacular results. In this regard, Johnson's work, like Boyce's, could be thought of as reflecting distinctly womanist, rather than feminist, sensibilities.[7] Johnson articulated her concerns as follows:

> The experience of near annihilation is the ghost that haunts the lives of [Black] women in Britain daily. The price of our survival has been the loss of our sense of ownership of both land and body. The ownership of our ancestors' bodies was in the hands of slave owners. The horrors

of slavery and racism have left us with the knowledge that every aspect
of our existence is open to abuse [...] This is reinforced by the experi-
ence of a kind of social and cultural invisibility [...] As women, our
sexuality has been the focus of grotesque myths and imaginings.[8]

Johnson's women tended to be monumental in scale. Oversize drawings on
heavy art paper, rendered in her preferred medium of oil pastel. These portraits
were imposing pieces that demanded the viewer's attention, as well as their
respect. The Black women Johnson depicted were drawn from a variety of
contexts. Some were friends or otherwise known to the artist. Occasionally,
her subjects would be taken from photographs. Some would be drawn
clothed, some unclothed, some would be young, and some would be decid-
edly elderly or matriarchal. Some would be pregnant, a testimony to the
importance of the Black woman in giving birth to, as well as nurturing,
successive generations. Some were taken from, or located within, Caribbean
contexts. Some were clearly located within African contexts. And some were
located within domestic environments. Some were rendered in colour, others
in more muted palettes, or in monochromatic form. Some had bodies (and
occasionally faces) that were, to varying degrees, abstracted; though for the
most part, Johnson's women were highly figurative in representation. And
all were, in Johnson's world, her *sisters*.

One of her most significant solo exhibitions was at The Black-Art Gallery
in Finsbury Park, London, whilst the venue was under the directorship of
Marlene Smith.[9] Its accompanying catalogue featured a fetching portfolio of
images of Johnson's women, an emphatic rebuttal to their perhaps wider
marginalisation, objectification and invisibility. When a young Steve McQueen
– then a student at Goldsmiths College, going by the name Steven McQueen
– reviewed this exhibition, he was palpably animated in his praise for John-
son's work. McQueen's feature on Johnson appeared in a 'grass-roots'
community newspaper, *African Peoples Review*, which described itself as 'A
Monthly Journal of Reviews of Publications and the Creative Arts of Peoples
of African Descent.' McQueen wrote:

On walking into the Black-Art Gallery in Finsbury Park, London, I
was amazed to see images of black women staring at me from all angles
– some looking at me, some through me, and some past me. This
reminded me of a photograph of my grandfather on the wall of my

grandmother's house when I was a child. Whenever I tried to hide from the glance of my grandfather's gaze, it always found me! The works one sees in the exhibition, *In this Skin*, are overwhelmingly arresting. They invite, and envelope the viewer to mediate in the enquiring and exploratory space of Johnson's immensely imaginative and absorbing mind. Claudette Johnson's tools are more than just paper and charcoal. What she does is to bring out the soul, sensuality, dignity, and spirituality of the black woman as she crafts away on drawing board, and far beyond.[10]

Towards the end of the piece – part of which was an interview McQueen conducted with Johnson – McQueen wrote:

Claudette Johnson's art is rooted in her African heritage. Her talent is as powerful as it is obvious. We can only guess with delightful anticipation what Johnson has in stock for us all when next her works are exhibited.[11]

As mentioned earlier in this chapter, there were several practitioners, within a slightly younger generation of Black women artists, for whom Boyce came to act as something of a role model. Mowbray Odonkor was one such artist. A British artist of Ghanaian parentage, she trained at Wimbledon College of Art, London, 1984–7. Her work was exhibited in a number of group exhibitions including the 1991–2 Norwich Gallery touring exhibition *History and Identity*.[12] Along with other women artists such as Amanda Holiday and Simone Alexander, Mowbray Odonkor seemed destined to follow in and indeed emulate the successes achieved by Sonia Boyce during the 1980s and on into the 1990s. Odonkor's work was characterised by a singular attachment to highly figurative painting and drawing. For the most part, she took as her subjects the condition of Black women of the diaspora, identity politics, and the legacies of history. To this end, she was responsible for some of the most compelling and articulate paintings and drawings produced by artists during the 1980s.

One of her key pieces, *Self-portrait with Red, Gold and Green Flag* (c.1988, otherwise known as *Onward Christian Soldiers*) was acquired by the Arts Council Collection, a reflection of its significance and importance as a prime example of Odonkor's concerns and artistic style. Time and time again,

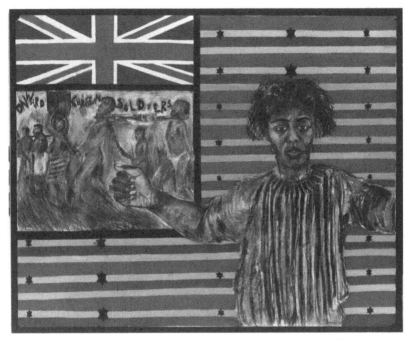

25. Mowbray Odonkor, *Self-portrait with Red, Gold and Green Flag* (1987).

Odonkor embraced the vehicle of the self-portrait as a means of expressing herself and her ideas. Indeed, even those works which were not, in a direct sense, self-portraits, reflected such a profound empathy on Odonkor's part for the struggling Black women of the world that they were, to a great extent, very much a part of her body of self-portraiture.

Odonkor was one of the *Seven Painters* included in the early 1990s exhibition, *History and Identity*. She was represented by two drawings; *Eeny Meeny Miney Mo, Now You See Me Now You Don't* (c.1988) and the previously mentioned *Self Portrait with Red Gold and Green Flag*. In *Eeny Meeny Miney Mo, Now You See Me Now You Don't*, one of Odonkor's beloved self-portraits, the artist drew herself not once but six times, each portrait noticeably different from the other five. The composition challenges the viewer to identify the real Mowbray Odonkor: it almost shows her as being six different people. In actuality, the portraits present her in six different ways, or guises, reflecting the extent to which the way Black women style their hair has such a profound effect on how they are perceived and visually evaluated. In this piece of work, Odonkor was attempting to challenge the often biased or prejudicial initial evaluations people make on the basis of the

style of hair, mode of dress, etc. of those they encounter. And though certain types of people are more likely than others to be on the receiving end of this tendency to be sized up, it was clear that the work had as much to do with intra-communal hierarchies of appearance as it did with notions of wider societal prejudices. In regard to the latter, there is perhaps more than a playful reference to a children's rhyme in the title Odonkor has chosen, evoking the N word, as it so ofen does.

Commenting on *Eeny Meeny Miney Mo Now You See Me Now You Don't*, Odonkor herself said:

This piece of work addresses stereotypes. Using self-portraiture it addresses the way we are all too often solely judged by our outward appearance. For example the way in which a person styles her hair is often used as a criterion for judgement, resulting in assumptions that can be totally misleading. We need to look further than outward appearances and stop making rash judgements which pigeonhole people through dress. Appearances can be deceptive.[13]

Onward Christian Soldiers stands as a compelling, layered testament to the potency and intricacies of Odonkor's history and identity. Presented in the manner, perhaps, of the Asafo flags of Ghana, the piece shows the artist standing, arms horizontally extended, in front of a flag of repeated lateral bands of red, gold and green. Perhaps reflective of the Ghanaian flag, the flag is embellished with stars that recall the six pointed Shield of David. Thus within the work Odonkor evokes the distinctly Pan-African, or Diasporic sensibilities of a Black British culture influenced to the nth degree by the sensibilities and the aesthetics of Rastafarianism. In one corner of the flag there is a monochrome drawing of a slave coffle – that is, those manacled and shackled groups of captured African forced to march (often many miles) to the coast or through the desert, shortly after their nightmare of enslavement began. The monochromatic nature of the slavery tableaux contrasts markedly with the colour of the rest of the piece. Directly adjacent to the slavery tableaux Odonkor has placed a Union flag, thereby boldly and directly implicating Britain in the sordid history of the transatlantic slave trade.

Odonkor declared the memory of slavery to be an integral part of her history and identity. Not only that, but the memory of slavery existed, for the artist, as an ongoing affliction, or burden. There were profound overtones

of the sacrificial within the piece. With her arms extended as if nailed or bound to an unseen cross, it was almost as if Odonkor has been crucified by slavery. Slavery was her stigmata. Such profound assemblage of ideas, motifs, and symbols is rare, and through this work, Odonkor declared herself to be one of the most important artistic voices to emerge during the 1980s.

Simone Alexander was another British artist who, like Odonkor, trained at art school in London during the mid 1980s. Like her peers, Alexander's work was characterised by a notable attachment to figurative painting and drawing. For the most part, again like a number of her contemporaries, Alexander took as her subjects the condition of Black women of the diaspora, identity politics, and the legacies of history. To this end, together with artists such as Sonia Boyce, Mowbray Odonkor, and Claudette Johnson, she was responsible for some of the most interesting paintings and drawings of the Black woman, in a multiplicity of guises, personas and contexts, produced by Black women artists themselves during the 1980s.

Time and time again, like other Black women artists before and alongside her, Alexander embraced the vehicle of the self-portrait as a means of expressing herself and her ideas. But she did not merely or simply embrace the self-portrait. She emphatically transformed it into something wholly shorn or void of introspection. Alexander's self-portraits were dramatic and arresting vehicles for critiquing such things as the male gaze, the objectification of women, and the vacuous and empty-headed world of fashion and perfumery. Similarly, Alexander used the self-portrait to express solidarity with the people of South Africa in their struggle against apartheid. Like Odonkor, even those works of Alexander's which were not in a direct sense self-portraits reflected such a profound empathy on her part for the struggling Black women of the world, that they were, to a great extent, very much a part of Alexander's body of self-portraiture.

In this regard, one of Alexander's most remarkable pieces is *Sharpeville, Paris, London, New York* (c.1990) in which Alexander subverts the popular mechanism used within the fashion and perfumery worlds to indicate international sophistication and chic, by signifying, as part of their advertisements, the major destinations or international locations where their products have a home and are marketed. Within such adverts, New York – Paris – London – Milano – Tokyo are frequently flagged as glamorous locations, reflective of equally glamorous products with which the purchaser can avail themselves, at least notionally, of said glamour. These are international destinations reflec-

tive of the world of Prada, Gucci, Donna Karan and Dolce & Gabbana. Yet in Alexander's piece, Sharpeville, the South African township, was inserted and repeated in the background of her self-portrait. In March of 1960 the township was the scene of what became known as the *Sharpeville Massacre*, when South African police began shooting into a crowd of Black protesters. The incident became more than a grim and bloody episode in the struggle against apartheid: it became instead a rallying cry, a renewed focus, for the anti-apartheid struggle, in much the same way as, a decade and a half later, the murder of Steve Biko and the Soweto uprisings would. Within this work, Alexander extends profound empathy to apartheid's victims and thereby acknowledges another generation of struggle and resistance. Not only that, but she also posits cities such as Paris, London and New York as sites of struggle, alongside Sharpeville.

As for the self-portrait itself, it features Alexander, in faux glamorous pose, sternly but ambiguously returning the gaze and presenting an image of herself on her own terms, an image which is in essence the antithesis of the world of fashion and its obsession with notions of beauty and body type that often verge on the tyrannical. Scattered over the large picture are motifs, or paintings, of roses and rose petals. The flower, deeply symbolic, was used by other Black women artists such as Val Brown, Mowbray Odonkor, and Sonia Boyce as a means of illustrating the specificities of themselves and the Black women of the world. Here, Alexander was similarly attracted to the rose, boldly using it to add humanity, love, and beauty to the stridency of the piece's messages. Within *Sharpeville, Paris, London, New York*, the figure of a second Black woman can clearly be seen, departing the frame, or at least, looking out of it. In a text written in 1986, Alexander paid homage to those women of Africa (in this instance, Kenya) for whom frivolities such as what type of perfume to purchase were a world away from their daily hardships of survival: 'These women were absolute because theirs was a world without superficial values [...] because unlike us who have nothing constructive to do with ourselves, for these women there is always the question of survival.'[14]

During the 1980s, several Black artists made work in response to rioting that was, in turn, a response to the maiming of one Black woman and the death of another in 1985. Marlene Smith was one of these artists. She produced a sobering, nuanced and deeply empathetic work called *Bless This House* (c.1986) in recognition of the horrific injuries sustained by a Black woman named Cherry Groce. On Saturday 28 September 1985, Mrs Groce was shot

during a police raid on her home in London and was subsequently paralysed. Groce was allegedly shot in her bed by a member of a team of armed police officers who were looking for her son. Another, divergent account, has it that

> a team of armed officers went to the home of Mrs Cherry Groce in Brixton, South London, to arrest her son, Michael, who was wanted for [allegations of] armed robbery. In fact, Michael Groce, no longer lived there. The officers smashed down the door with a sledge-hammer and then an inspector rushed in shouting "armed police". Mrs Groce says the officer suddenly rushed at her, pointing a gun at her. She tried to run back but he shot her. She is now paralysed and confined to a wheelchair.[15]

Groce's maiming sparked rioting in the vicinity of Brixton, a district of South London which had witnessed extensive rioting four years earlier, in 1981. The sense of Black Britain being a community under siege and on the unanswered receiving end of casual but deadly state-sanctioned violence was further heightened within a matter of days of Groce's injuries being sustained. On Sunday 6 October 1985, just over a week after Groce sustained her horrific injuries, another Black woman, Mrs Cynthia Jarrett died of a heart attack during a police search of her Tottenham home.[16] (Again, it was allegations against her son that lay at the centre of this police action.) During this period of the mid 1980s, there were many other such personal tragedies that ultimately spoke of the Black-British presence being somewhat fractious or ill at ease. It was during the 'rioting' on the Broadwater Farm estate, sparked by news of Mrs Jarrett's death, that PC Blakelock was isolated from his fellow police officers and set upon and killed by what was commonly referred to at the time, by the press and media, as a 'mob'.[17] In keeping with the times, there was much about Black artists' practice during the 1980s that inculcated and declared multiple senses of opposition, alienation and protest.

Bless This House was the title of a long-running British sitcom of the 1970s. There was, though, nothing remotely comical about Smith's piece, a multimedia work that depicted a robed Black woman, in the unsuspecting comfort of her own home. The woman – rendered in three dimensions – stands in front of a family photograph that hangs on the wall behind her. The framed photograph is typical of any given number of such photographs

in households throughout the land, depicting as it does a group of Black people, including youngsters, at a party or celebration, such as a wedding reception. Within the deceptively frugal construction, Smith evokes the sort of domestic stability that emanates, almost as a matter of routine, from households that bore witness to the presence of matriarchal figures such as Cherry Groce. It was this somewhat comforting sense of domestic stability that was so violently intruded upon on that fateful morning in September 1985. The work is made within and across the space where two boards of wall met, positioned at an angle, as if to suggest a corner. This sense of Groce, and indeed the family members depicted in the photograph, being almost literally cornered is a device that adds further substance to this grave and weighty piece of work. Across the corners of the assemblage, Smith has written on the walls, in capital letters: 'MY MOTHER OPENS THE DOOR AT 7 A.M. SHE IS NOT BULLETPROOF'.

Another artist of great importance to emerge during the course of the 1980s was Sutapa Biswas, born in India but who had lived in Britain since a young age. Like many of her contemporaries, Biswas was university trained, having studied at the University of Leeds from 1981 to 1985, at the Slade School of Fine Art from 1988 to 1990, and at the Royal College of Art between 1996 and 1998. She became a regular contributor to a number of the important exhibitions of women's work that took place during the 1980s. Her work at the time revealed Biswas to be a singular and most original artist. In her paintings and drawings she fused decidedly contemporary manifestations of her identity as a young, British-Asian woman with compelling aspects of her cultural heritage. Biswas' astonishing work of the 1980s boldly challenged, head on, stereotypes of Indian women as demure and submissive whilst this work, simultaneously, unapologetically investigated and recalled, with great clarity, aspects of religious and cultural identity evocative of Biswas' ancestral home of India. Typical in this regard is one of Biswas' most powerful works of the decade, *Housewives with Steak-Knives* (1985).[18]

In the mixed media painting, Biswas depicts a young Asian woman –herself perhaps – in the form of the deity Kali, the very recognisable and somewhat terrifying Hindu goddess associated with empowerment. Reflective of the multiple resonances of traditional images of Kali, her persona is also associated with darkness, time, and death; hence her perennial depiction as evoking that which is dark and violent. Kali – instantly recognisable by her multi-limbed upper torso – is traditionally depicted as an annihilator of evil forces,

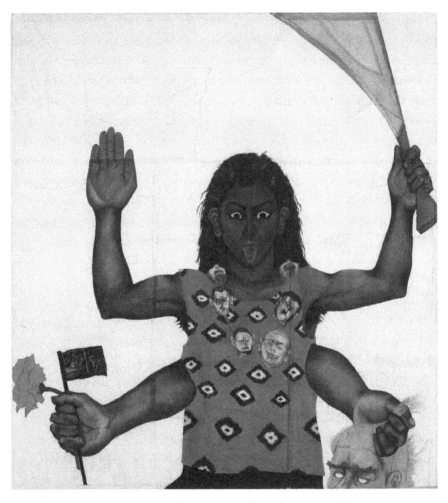

26. Sutapa Biswas, *Housewives with Steak Knives* (1985).

a retributive vanquisher of wrongdoers, who holds in her several hands not only the tools of annihilation such as knives and other weapons, but also the severed heads of her victims. Kali is also frequently depicted as wearing around her neck a garland of the reduced heads of those she has, literally, put to the sword. Biswas' painting was no less terrifying and awe-inspiring. Her Kali, however, wears a sleeveless summer patterned frock, or top; red, with decorative diamonds shapes. Like traditional depictions of Kali, the whites of her eyes signify retributive intent, as does her tongue, which protrudes violently from her mouth. Lest there be any doubts as to the extent to which this modern embodiment is at polar opposites to the media-stoked

stereotypes of Asian feminine submission, this particular modern-day Kali has the hairiest of armpits, an emphatic rebuttal of the grooming seemingly imposed on women and symptomatic of the ways in which they are expected to do battle with their own bodies, by the vigilant removal of under-arm body hair.

All four hands of the avenging goddess are stained with the red blood of her slain foes. One hand holds a fearsome, somewhat oversized steak knife, itself bearing evidence of the carnage it recently inflicted. Another hand holds the decapitated head of one of her victims, whilst around her neck hangs a ghoulish, bloody garland of heads – those of white males, here cast as her vanquished tormentors. The fourth hand holds what are perhaps the most intriguing of objects. A red rose, or some such flower, and a small flag on a stick. The flag bears images reflective of Biswas' art historical training, and her resulting keen awareness of the ways in which paintings and images can be read. Within the flag's depiction of Artemisia Gentileschi's version of *Judith Beheading Holofernes* (a reddened photocopy of the work, in miniature) Biswas invites the viewer to consider connections between the Hebrew heroine, Judith, the Goddess Kali, and Biswas herself, and the ways in which they are each here presented as wrestling with and indeed conquering their respective gendered tormentors. *Housewives with Steak-Knives* was intended to be hung in an elevated position, with the top of the painting significantly away from the wall, thereby creating, or intensifying, a sense of dread in the viewer who, having been placed in an obligatory position of deference and respect, had no choice but to literally *look up to* the painting and its fearful depiction.

Much like Boyce's practice, Biswas's work began to change markedly. She began to move away from her distinctive paintings and drawings, which often celebrated the political struggles of Asian women and Asian communities in Britain, towards ways of working that utilised photography and other media, largely reflective of contemporary art practices of the 1990s.

Meanwhile, another group of artists were using sculpture to explore ideas and concerns that, on occasion, echoed the considerations framed by Boyce, Biswas and their contemporaries.

Substantial Sculpture: The work of Sokari Douglas Camp, Veronica Ryan, and Permindar Kaur.

Alongside those Black women artists emerging during and following the 1980s whose practice reflected a range of explicit social narratives were other Black women artists whose practices reflected other concerns. The work of these artists was, interestingly, primarily sculptural, and ranged from investigations into shapes and forms evocative of the natural world and the sculptural qualities of materials, through to work that reflected notions of cultural heritage, with a similar and attendant interest in the sculptural qualities of materials. One of the most prolific sculptors to emerge during the 1980s, working at the same time as Lubaina Himid, Sonia Boyce and their contemporaries, was Sokari Douglas Camp. Born in Rivers State, Nigeria in the late 1950s, Douglas Camp was educated at California College of Arts and Crafts, Central School of Art and Design, London (from where she obtained a First Class Honours degree, as Keith Piper was to do in the same year). Like Piper, Douglas Camp went on to graduate from the Royal College of Art in the mid 1980s.

Reflective of the complexities and enigmatic singularity of her work, Douglas Camp was cast, by alternating degrees, as either a Nigerian/African artist, or as a late twentieth century artist, making a new and decidedly different kind of work. In reality, her work occupied its own particular aesthetic and sculptural space, a space in which the different elements of her upbringing and art school training merged, with often dramatic results. Douglas Camp came to be known and celebrated for the pronounced sculptural qualities of her work and the ways in which the work often challenged gendered perceptions of what a woman sculptor could produce. Her creations were often large, oversize and decidedly strange figures, made of welded shapes, strips, and other pieces of metal. Alongside her figures, which often evoked the substantial frames of formidable African matriarchs and other women, Douglas Camp also created wonderful boat-like structures and other

strange constructions. Her sculpture often related to masquerades and festivals evocative of certain parts of her native Nigeria. It was perhaps this type of work that critics and curators most easily latched onto. But Douglas Camp's sculptures also resonated with investigations into form, shape, space and balance, sometimes with aural dimensions. In this regard, work regarded as being culturally specific or culturally evocative took its place alongside very different types of sculpture, equally culturally nuanced, but in very different ways.

A measure of the formidable constraints, and indeed prejudices, brought to bear on Black artists was evidenced in an interview with Douglas Camp that appeared as one of her exhibition brochures in 1988. The interviewer begins by asking, 'How do you feel about being regarded as a black artist?'[1] Nothing within Douglas Camp's own pronouncements suggested that she was wedded to any sort of inevitable prefix to her identity as an artist. And

27. Sokari Douglas Camp. *Iriabo (Woman and child)* (1987).

yet the interviewer, like so many others cut from the same cloth, chose not to frame Douglas Camp as an artist making her own dramatic contributions to late twentieth century contemporary sculpture, but (in this instance) as 'a black artist', a cramped and somewhat uninspiring tag. To be sure, other practitioners of the period advanced textured, socially assertive identities as *Black* artists, but Douglas Camp most assuredly was not amongst them. The tendency to collapse a broad range of art practices and positions into the monolithic construct of the 'black artist' was reflected not only in the inter-viewer's opening question, but also in a number of the large-scale group exhibitions that dominated during this period. By the summer of 1988 Douglas Camp was being regarded as 'a young artist who has already achieved consid-erable critical acclaim' and, further, that she 'must be acknowledged as one of the most exciting sculptors working in Britain today.'[2]

> Her return visits to the Niger Delta have provided a constant source of inspiration for her work, through which she seeks to re-invent Kala-bari Culture, specifically the movement, vitality and spiritual signifi-cance of its masquerades at Festival Time (Alali). Whilst not offering a literal representation of the masquerades, the sculptures incorporate recognisable elements from them, realised with great formal ingenuity and employing a range of materials and processes, an approach which owes much to Western sculptural conventions. Drawing on and fusing these distinct cultural traditions – one African and one Western – Sokari Douglas Camp's work succeeds however in operating independently as a unique sculptural expression, which we hope will reach a wider audi-ence through this exhibition.[3]

Douglas Camp made the most arresting of sculptures. Sometimes, her work was kinetic; her strange welded steel mannequins, when made to 'play' metal instruments, created a discordant but dramatic metal-on-metal rhythm. At other times, her imposing metal figures stood silent, and once encountered by audiences could not be ignored. Like several other celebrated female sculp-tors of the twentieth century, Douglas Camp challenged the dominant percep-tions of what work such an artist might be expected to make. But welding pieces and shapes of metal, to create figures with a powerful sense of gravitas, was something that Douglas Camp did, almost as a matter of course. Time and again, however, a somewhat hackneyed notion was employed to introduce

her work. Another critic equating Africa with the past and Europe with the present, wrote:

> Although she received her artistic training in California and London, her work is not that of an artist alienated from her culture. Coming as she does from Nigeria, with its rich sculptural tradition, she has been inspired by the art of her ancestors without being overwhelmed by it as so many modern African sculptors have been, with the result that their work is at best derivative, at worst purely imitative, Sokari Douglas Camp straddles the cultural divide between past and present, Africa and Europe, with apparent ease. As this present combined exhibition of her sculpture and the Kalabari masquerades, Sekiapu, which have provided inspiration for so much of her work, so clearly demonstrates.[4]

Though Douglas Camp may have bridled against the West versus Africa or Europe versus Africa amalgamation that her work was said, by critics, to reflect, the critics themselves found it hard to write their texts on her without reference to these types of dichotomies and amalgamations. In 1990 Douglas Camp made a series of near-theatrical carts that would be rickety, or should be rickety, were it not for the decidedly structurally solid materials with which these comic, playful, yet quite grounded or anchored contraptions of movement were constructed. Furthermore, this sense of the playful consistently manifested itself in her imposing figure sculptures, which ranged from depictions of regular people out shopping through to wonderful masqueraders, evocative of her native Nigeria. The materials from which such works were created gave these figures a profound sense of grounding, and of self. For example, *Rose & Vi* (1993), a representation of two women out shopping, complete with trolley for their groceries, was constructed of steel and copper. Douglas Camp was however not averse to introducing the lightest of materials into her figure sculptures, almost as if to emphasise a sense of contrasting materiality. Consider, in this regard, *Big Masquerade with boat and household on his head* (1995), which was constructed from steel, wood and feathers. *Big Masquerade* was in its own ways wonderfully reminiscent of the effigy of Joseph Johnson, discussed in the Preface to this book.

Another, but decidedly different sculptor who emerged into notable visibility and prominence during the 1980s was Veronica Ryan, who was born in Montserrat, in the Caribbean. She availed herself of opportunities to study

at various institutions, including Bath Academy of Art, the Slade School of Fine Art and the School of Oriental and African Studies. The 1980s was a particularly fertile decade for Ryan, who had a number of prestigious exhibitions of her work at venues such as Riverside Studios, London (19 October – 13 November 1988) and Kettle's Yard, Cambridge (19 November – 8 January 1989). Veronica Ryan is best known for her sculpture that is evocative of shapes, forms and objects from the natural world, giving her work a distinct sense of the *organic*. Ryan's work has made its way into a number of important collections of British art, making her one of the most important sculptors of her generation.

Her sculptures often sat on the gallery floor, or positioned at ground level outdoors. In a number of instances, this placing emphasised the association of her work to natural forms, literally growing up from or at ground level, as well as hinting at domesticated or other beasts that eat from ground level troughs. Typical in this regard was Ryan's work of 1988, simply titled *Trough*. Made from cast bronze, the work resembled a farmyard trough, made from a very soft metal that had grown misshapen through many years of use, but was nevertheless holding its shape. A certain sense of vulnerability and fragility in Ryan's work was offset by the decidedly weighty materials she used in the making of work such as *Trough*. In turn, this unmistakeable sense of solidity and physical presence was offset by the use of such things as dried flowers, again (and perhaps self-evidently) evocative of plant life and the natural world. The two compartments of *Trough* were generously filled with still-beautiful remnants of desiccated flowers, which though long dead, resonated with a sense of bounty, and a dreadful exquisiteness and splendour. Such was the sense of things living, things growing, things dying, and things being preserved, that Ryan's work evoked.

> Veronica Ryan's works, comprised of [*sic*] seed-like forms, also evoke a sense of location, dislocation and dispersal, through metaphysical allusions to birth, death and decay. Ryan's enigmatic forms, scattered like seeds, appear frozen in transitional states of development amongst landscapes offering sustenance and potential fruition, as seen in her sculpture *Territorial* (1986).[5]

The work in question, here described by Mora Beauchamp-Byrd (and contained in the Arts Council Collection), resembled a terrible but fascinating mutant

form of vegetation resonating with those plants capable of inflicting damage and death on its hapless victims. Again, despite the solidity of the materials used to make the work (in this instance, plaster and bronze), *Territorial* resembled nothing so much as a giant vegetative land mine, capable of devouring anything that flew too close, or came too close. The work did indeed conjure up notions of the territorial, with the sculpture's triffid-like qualities.

A particularly successful work of public art executed by Ryan was a work called *Boundaries* (c.1985). In its title, and in other respects, it echoed *Territories*. Located in a relatively remote grassy area of Peterborough Sculpture Park, this pair of sculptures created an intriguing relationship with the wider surroundings. Set within concrete ground-level plinths, the work had a remarkable ability to evoke decidedly different things to different people, depending on which angle it was viewed from, what distance it was viewed from, and the prevailing light or weather conditions at that particular moment. Not only that, but as with other such pieces of work in the open air, the metal of which *Boundaries* was made gradually altered its appearance in response to the attention it received from the sun and the rain, the frost and the dew, the wind and the snow. Metal thieves stole the work in early January of 2012

On occasion during the 1980s, when Ryan exhibited in the company of other Black women artists, her work would be cast by critics as contrasting favourably with the perceived or apparent strident tone of the other exhibited work.[6] Ryan was one of the 11 artists in Lubaina Himid's *The Thin Black Line* exhibition. Whilst the other ten artists had their work displayed in the corridor area and stairwell within the ICA, Ryan's sculpture was displayed in a separate, upstairs room in the building. Reviewing the exhibition, the *Guardian* art critic pointed to the 'gentle sadness which emerges in the splendid sculpture of Veronica Ryan'.[7] Januszczak discerned a particularly contemplative aspect of Ryan's work that did indeed resonate with a sense of melancholy, rupture, and sense of self. In this regard, he was particularly prescient, as in years to come, Ryan was to make more work that resonated with particular sentiments of loss, yearning and remembrance.

Writing in the *From Two Worlds* catalogue, Adeola Solanke made mention of Ryan's sculptures as

sculptural forms which convey a still, unhurried and yet insistent being. Her forms have a characteristic aura which is conducive to and induces

a feeling of contented being. Pillows and pods with undulating surfaces in which various smaller forms rest; pods with compartments which act as home to a family of smaller creations. These suggest a completeness and peace like that of a foetus in a welcoming womb.[8]

These were perceptive comments by Solanke, who also reported in the same text that Ryan 'insists her work is figurative, not abstract, but has the qualities that incorporate both modes of reflecting on reality.' Ultimately however, it was Stella Santacatterina who provided possibly the safest judgement on Ryan's work when she suggested that 'To look for absolute concepts capable of embracing Veronica Ryan's works is a difficult, if not impossible task.'[9]

Ryan created work using a variety of materials, in a number of different locations, sometimes working as a result of a residency. In addition to the work in the Arts Council Collection referenced previously, she also had worked acquired for the Tate Collection: *Quoit Montserrat* (1998) and *Mango Reliquary* (2000). It was from the former piece in particular that a 'gentle sadness' could be seen to emerge. The piece was in some respects a memoriam for Ryan's native Montserrat, which had recently been traumatised by a volcanic eruption.

Like a number of Black artists, for example Frank Bowling and Francis Newton Souza, Ryan moved to New York at the beginning of the 1990s, to an environment perhaps more suited to what artists such as these had to offer. Other artists similarly moved to the US, for example Donald Locke and Winston Branch lived in Atlanta and the San Francisco Bay Area, respectively.

Although of a slightly younger generation (having been born in Nottingham in 1965), Permindar Kaur is another British sculptor of substantial repute. Of South Asian origin, she was born to Punjabi parents in Nottingham and emerged into visibility and practice during the course of the 1990s. She is a sculptor whose work has been featured in a significant number of solo and group exhibitions both at home and internationally. Her practice was characterised by an enigmatic use of materials, scale, and symbolism. Despite its considerable ambiguity of meaning, highly charged cultural and religious symbolism has often been a feature of Kaur's work. In 1991 she made a community of miniature, but sizeable transparent plate glass houses for the exhibition *Four x 4* at the Arnolfini in Bristol.[10] The houses were filled with handmade clay domestic implements, cultural objects and religious symbols, by far the most potent of which was the Khanda, the emblem of the Sikhs

that is such an instantly recognisable symbol adorning the Gurdwara, the Sikh place of worship. In the mid 1990s, Kaur's contributions to *The British Art Show* included *Innocence* (1993), a religiously specific piece of work consisting of a child's dress made of a rich orange-coloured material – the same coloured material that swathes Gurdwara flagpoles, crowned with the Khanda. Tucked into a sash, draped across the dress, is a khanda or khanja, a double-edged sword that often symbolises the kirpan, one of the five K's of the Sikh religion.

For Kaur, who secured her MA from Glasgow School of Art, such symbolism took its place alongside other equally dramatic devices and elements central to her sculpture. Perhaps the most consistent dramatic device employed by Kaur has been her extraordinary use of scale. For the 1990 self-portrait exhibition, *Let the Canvas Come to Life With Dark Faces*,[11] Kaur made a large oversize head, well over two metres high. The head was made from short metal rods, painstakingly welded together to form a work that successfully referenced the artist's own distinctive facial features. Successful work on such a scale, requiring as it did copious amounts of patience and technical expertise, is rare indeed. But the head was also a cage-like construction, packed with brightly coloured wooden objects that resembled children's toys. Disconcertingly, the artist had put attractive and innocent objects within what was in effect a caged structure, notwithstanding the structure's representation, in such a painstaking way, of Kaur's own face and head. Throughout much of her practice, Kaur has continued to be fascinated with what might be regarded as disturbing and unsettling questions.

One of Kaur's most substantial British exhibitions was *Cold Comfort*, in in which her ongoing interest in questions of scale was abundantly apparent.[12] The centrepiece of the exhibition was a work of three steel-framed beds, constructed to stand high above the viewer. Each bed came complete with attached ladders, enabling viewers to imagine themselves literally 'climbing into bed'. Elsewhere in the exhibition, a pair of chairs similarly dwarfed the viewer. Perhaps one of the most disconcerting things about these particular pieces was that they did not necessarily look like the eccentric or slightly odd creations of an artist. They were polished, highly finished pieces of furniture that had a showroom-like quality, making them all the more unnerving.

Permindar Kaur's work continued to be enigmatic; time and again critics and curators picked up on Kaur's ability to use distinct and particular materials such as glass and steel to make work that resonated with no end of

associations. That much, at least, was clear to Mora Beauchamp-Byrd, who wrote:

> Nationality – the concept of belonging to a country or an actual geographical space – is a subject addressed by many of Britain's contemporary artists. Permindar Kaur's installation *Arrival* (1991), metaphorically references the transmission and shifting nature of ides and culture. Sheets of glass, set atop tall metal rods with arrow-like points at the bottom, stand positioned at various points along the installation floor. Their points form map-like configurations, charting geographical points of residence and transitory movement as well as cultural reference points.[13]

Alongside personal or domestic narratives, Kaur's sculpture contained much in the way of references to Sikh/Indian identity and culture. Like Sokari Douglas Camp before her, Kaur was also vulnerable to the suggestion that her work 'is a synthesis of the different cultural experiences that she is simultaneously immersed in. [...] She may think of herself as both an Indian and a British woman'.[14] In many ways, a more plausible reading of Kaur's work would acknowledge that all sorts of 'cultural' influences (if one can determinedly speak of such things) are discernible within her work. As to what, if any, national identity (again, if one can determinedly speak of such things) she subscribes to, her audiences do not know, because, very simply, she has not told them – either through her sculpture or by other means.

Like several other artists referenced in this book, Kaur was able to wrestle herself free of the sometimes constraining ways in which she was regarded and her work perceived, simply by relocating to another country – in her case, to Spain, and Barcelona, in the early 1990s. Though the writers of the following text were somehow able to conjoin British-born Kaur to 'non-Western artists', they nevertheless offered a useful summary of the benefits of Kaur's temporary international relocation.

> On completing her MA in 1992 she spent several years in Barcelona. This presented her with more cultural and aesthetic complications in her daily life – another language, another culture, another place to get to know. The experience has been a positive force in her work.

28. Permindar Kaur, *Innocence* (1993).

Working in Britain the artist felt a pressure to make work referring specifically to her Indian culture, and the struggles that many non-Western artists face, when working in this country.

One of the many foreign artists in Barcelona, she felt that these expectations were lifted and her work began to develop in other directions. As a result Kaur has felt freer to make more emotional work and experiment with various themes.[15]

Permindar Kaur was one of a relatively select number of British artists of African or Asian origin to be included in *The British Art Show*, the National Touring Exhibition organised every five years by the Hayward Gallery for Arts Council England, which sets out to survey British art. It was *The British Art Show 4*, of 1995/1996 that included Kaur's *Innocence*.

Art critic Richard Cork, writing in The *British Art Show* catalogue, discussed Kaur's work in the following terms:

Remembrance of childhood fuels the art of Permindar Kaur, but these

recollections have the capacity to haunt it as well. Her finest work seems to have been made by a woman who ruminates, time and again, on the insecurities in a child's mind. The objects she produces often resemble toys and they are notable for their vulnerability. There is nothing playful about them. Rather do they appear ominous, as if gifted with the power to foresee the future. In *Untitled* (1995), a costume made of green fabric dangles from the wall. Its legs terminate in copper boots, while an equally burnished crown beaten from the same material caps the head. But the costume remains empty. Loose folds run down its surface and the owner's absence seems fateful. Although it could simply be an item in a child's dressing-up cupboard, this inert form also says something about the ultimate futility of an adult's lust for aggrandisement.[16]

Kaur's work relentlessly played on feelings of vulnerability, and effectively questioned societal attitudes towards childhood and adulthood. A particularly revealing comment by Kaur appeared in an interview Claire Doherty conducted with her. Kaur commented:

When I take part in discussions or give talks [about my work], I find that the audience want to know more about the personal nature of the work, but to do this they have to reveal something of themselves, which they are far more reluctant to do. The fact that the work can be intimate while at the same time reticent is unnerving.[17]

The complex tensions that Kaur alluded to in this statement were similarly present in the work of a range of practitioners who emerged during the course of the 1990s.

Black Artists of the 1990s Generation

During the course of the 1990s, other important and original new artistic voices entered the sphere of contemporary British art. The challenges and successes of each of these artists reflected much of the complicated space that so many Black artists came to occupy during the 1990s. Some achieved particular successes in the international arena, undertaking residencies and exhibitions in countries beyond Britain. On occasion, they would avail themselves of residency or exhibition opportunities offered by an important new presence in the London art scene, the Arts Council-sponsored Institute of International Visual Arts – or INIVA, as it became known.[1] Sometimes they were able to break free of exhibition contexts that unambiguously signified them by race, ethnicity, skin colour and so on. At other times, some of these artists seem to have been periodically set to one side, in ways that their more successful white counterparts were not.

Amongst these artists were Hurvin Anderson, Godfried Donkor, Mary Evans, Kimathi Donkor, and Barbara Walker. Godfried Donkor was born in Kumasi, Ghana, in the mid 1960s, around the same time that Kimathi Donkor (no relation) was born in Bournemouth, England, Mary Evans was born in Nigeria, and Hurvin Anderson and Barbara Walker were born in Birmingham. Each of these artists made fascinating, compelling work that addressed the dual concerns of excavating or re-excavating history, whilst concurrently opening up understandings and considerations of the contemporary social, political and cultural presence of Black people in Britain, and elsewhere in the world. A sign of the changing times for Black artists could be discerned in the respective profiles of each of these artists. It might be a sign of problems, or it might be a sign of progress, that these six artists kept very little in the way of curatorial company with each other. During the 1980s, the overlap in the varied profiles of Black artists was apparent, as a number of

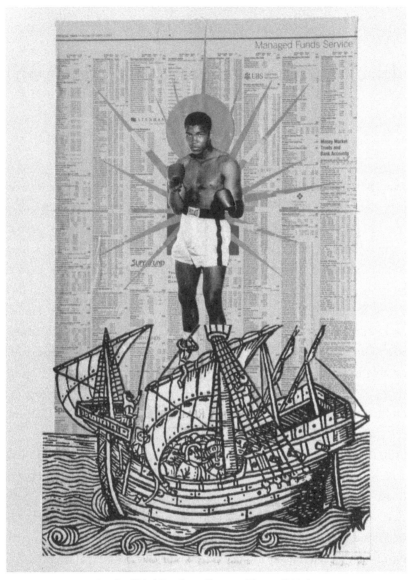

29. Godfried Donkor, *Slave to Champ* (2007).

them showed up, time and again, in the same sorts of exhibitions. Not so this 1990s generation of practitioners.

One of Godfried Donkor's most engaging series of work, begun in the mid to late 1990s, was his *Slave to Champ* paintings. This series featured near-iconic depictions of Black boxers, some from the earliest days of the entry of Black boxers into that particular sport, others from more recent eras

of the sport. Donkor's *Slave to Champ* paintings and montages often took the form of images of Black boxers apparently standing on, or emerging from, enlarged reproductions of lithographs of slave ships, depicting their human cargo packed below deck like so many sardines in a tin. The origins of these drawings of slave ships and their contents dated back to the abolitionist movements of the late eighteenth and early nineteenth centuries. The abolitionists had seized on this simple but effective graphic device as a means of driving home the horrors that had to be endured by captured Africans during the middle passage – the nightmarish journey by sea that took captured Africans from their homelands to slavery and death in the 'New World'. As one historian has noted: 'Of all the details of the slave trade that appalled anti-slavers, the most immediate – because the easiest to visualise – were those of how the human cargoes were stowed. The arrangements were made widely known in drawings'[2]

But these powerful lithographs would in time take on a significance that went way beyond their propaganda value of their day. The passage of time did little or nothing to diminish the memory of slavery on the collective and individual psyche of new world Africans and their descendants. Indeed, a century and a half after the abolition of slavery by the British, plans of laden slave ships were starting to become iconic shorthand graphic signifiers for the miserable, wretched history of slavery and the myriad ways in which that history spawned a thousand Black liberation struggles. There were those who might regard slavery as something from the dim and distant past, but Donkor's work declared that for many Black people the experience of slavery had seared itself on their psyche in a way that few non-Black people could understand. This was one of the most profound ways in which slavery had, for many people of the African diaspora, become a signifier of identity. Donkor's use of the slave ship motif encapsulated and signified much in the way of Black history. The signifiers of enslavement, exploitation, bondage, torture and death were in any case never far from many Black people's readings of the slave ship image. Nor, for that matter, were the redemptive signifiers of survival, perseverance and the struggle for humanity.

As one commentator noted, Donkor 'places his black boxer towering aloft like a giant above a cross section of a slave ship, which recurs as a diagram from painting to painting.'[3] That particular commentator, Everlyn Nicodemus, went on to summarise her particular take on these paintings:

30. Kimathi Donkor, *Coldharbour Lane 1985* (2005).

If we look closer at the history of this Black Atlantic track, we find that history supports his choice by confirming a basic fact about how those blacks, who have a background related to slavery, have been allowed to become visible. Their only legitimate field of expression has been as popular entertainers, to whom boxers belong. And the successful way of becoming successful entertainers has been to play the game of the whites, complying with their worst prejudices and skilfully manipulating them them to their own advantage.[4]

But there was, within Donkor's portrayals of his boxers, warmth, humanity, and the perseverance of an almost righteous and spiritual struggle for manhood. Consider the incessant demonisation of Mike Tyson, and the ways

in which, time and time again, he has been portrayed within the media as being a mindless brute, a thug, and an animal.[5] Within Donkor's depiction of Tyson we see the 'Champ', laden with world title belts, but looking anything but menacing.

There is of course much room within readings of these pieces to raise some other critical questions, reflecting or extending the questions asked by Keith Piper's video, *The Nation's Finest*.[6] Within this video, Piper, exploring the social construct of the Black British athlete, asked the probing question, 'stadium or enclosure?' In other words, does the running track or the boxing ring exist as an environment in which finely honed and well-trained athletes can demonstrate their physical excellence and a range of gladiatorial and non-gladiatorial skills? Or, on a more disturbing and profound level, does the running track or the boxing ring exist as a formidable physical and psychological enclosure? This was Nicodemus' take on Donkor's *Slave to Champ* paintings. Little should perhaps be taken away from Nicodemus' assertion. After all, the racist notion that Black people were gifted with physical much more than intellectual abilities was apparently an enduring pathology. Notwithstanding Nicodemus' assertion, one should perhaps be careful in accepting her assertion that Donkor's work 'cannot avoid running the risk of confirming certain prejudices, especially the stereotype about the black male as merely a body, strong and potent, the personification of a mindless brute.'[7] A more considered look at these *Slave to Champ* paintings would reveal that Donkor's work, in subtle and sensitive ways, sought to undermine these stereotypes by accentuating the humanity of the boxers.

Mary Evans was another artist to make particularly engaging use of the slave ship motif. One of the works in question was *Wheel of Fortune*, produced by the artist in 1996. Within the sobering, imposing, and engaging work, Evans painstakingly cut out of dark-coloured paper, three times, the distinctive shapes – patterning even – of the plan of the slave ship. This was patient, painstaking work that one could imagine involved Evans developing a particularly empathetic relationship with each individual outline of a slave (and of course, the slave ship itself), as she took her time extricating whole fragile, delicate plans of slave ships from the pieces of paper she started with. For the three *positive* outlines Evans secured for herself, she was left with three corresponding *negative* pieces of paper. Evans then took these six pieces of paper and alternately placed them on a wall, forming a wheel of fortune, each ship with its bow located within the epicentre of the wheel

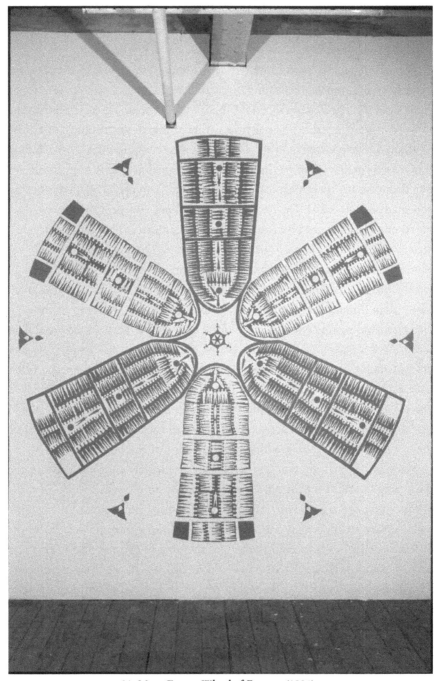

31. Mary Evans, *Wheel of Fortune* (1996).

of fortune, with an equal spacing between the sterns of the six slave ship cutouts. Evans wrote: 'I wanted to make something decorative out of that particular image. The images at 2 o'clock, 4 o'clock and 10 o'clock are the leftover cuttings from the other images which were cut first. This made positive and negative brown and white figures.'[8]

Within this work, Evans explored the idea of chance and slavery. The historic wheel of fortune, laden with fatal consequences for some, is spun, and x number of Africans are chosen for capture and enslavement, their lives, the lives of their communities, families and indeed, their descendants, forevermore transformed through the horrific experiences of the transatlantic slave trade. The title of Evans' work, *Wheel of Fortune*, referenced a long-running American television game show in which contestants competed to solve word puzzles, such as those used in another word game, Hangman, to win money and other prizes supposedly determined by spinning something akin to a giant carnival or funfair wheel. Hardly deviating from its long-running format, *Wheel of Fortune* was said to be the longest-running syndicated game show in US television history. By titling her piece as she did, Evans introduced a pointed, almost macabre, gallows humour into her commentary on history, fate, and enslavement. The cheery notion of a game show wheel of fortune, complete with its elements of chance, when coupled with an insistent and quite disturbing patterning of the slave ship, acted as a foil for what was a brave and almost audacious piece of work. If the historical shoe had been on the other foot, perhaps it would have been the white people who would have suffered, endured, and had to find ways of surviving the death, destruction and disruption the Atlantic slave trade caused. Whilst certain Africans of all ages and both genders were captured into slavery, the effects of slavery deeply affected much of the African continent, the ramifications and effects of which are still being felt today. Amongst other things, Evans' work invited its audiences to consider what the world would be like if Africans had systematically enslaved Europeans over a period of several hundred years, rather than the other way around.

Chapter Eight made mention of the riots that took place in London and elsewhere in the country in the early 1980s. Likewise, Chapter Ten referenced the riots that erupted in Brixton and Tottenham as a response to, respectively, the maiming of Mrs Cherry Groce by armed police and the death from a heart attack of Mrs Cynthia Jarrett during the course of a police search of her home. Several artists had made work in response to these riots of the mid

1980s. Some two decades after the events themselves Kimathi Donkor painted scenes that recalled both the death of Mrs Cynthia Jarrett and the riots that took place in Brixton in the aftermath of the maiming of Mrs Cherry Groce, a testament to the enduring significance of the events for Black Britain. In Donkor's painting that recalled the 1985 Brixton riots, the essential elements were the brutalist and brutalising housing which signified social deprivation, and the attempts to repel the neighbourhood of Brixton's uniformed invaders.

Along with Railton Road, Coldharbour Lane had over the course of the middle to late twentieth century developed or acquired near-iconic status as one of the original 'frontlines', indicating the contested territory where the police and Black youth regularly clashed or otherwise came into confrontational contact with each other. On a map, Coldharbour Lane is one of the main thoroughfares in South London that leads south-westwards from Camberwell into Brixton. Although the road is over a mile long, being a mixture of residential, business and retail properties, the stretch of Coldharbour Lane depicted in Donkor's painting centres on a few blocks, not too far from Brixton Market and nearby shops, bars and restaurants, where Coldharbour Lane meets Acre Lane in central Brixton. Donkor's painting recalls a time when Brixton was very much, and very much regarded, as a Black (as in, distinctly African-Caribbean) neighbourhood. True to the 'frontline' nature of Coldharbour Lane, Donkor's painting showed three ghetto defenders, each in various stages of hurling rocks at their tormentors, located outside of the frame of the canvas, some distance to the right of the depicted rock-throwers. In point of fact, we do not know for certain what the first rioter is about to hurl, as his hand and weapon are located beyond the left side of the artist's canvas. Rock, half-brick, petrol bomb, whatever the weapon, the first rioter, and the one closest to us, is about to let it fly. One of the extraordinary strengths of the painting is its aspect of animation, the ways in which Donkor composes a sequence of steps and movements for each of his ghetto youths. The bodies of each of the three figures are depicted in different stages of movement, creating what is in effect an animation. In this regard, the three figures – despite differences in clothing – become one, carefully choreographed by the artist to provide and create a unity of movement and purpose. Standing as something of a dramatic backdrop to the group of three is an anonymous housing block, its façade of muted colour effectively pock-marked by what seem to be impossibly small windows, making the building more reminiscent of a prison, or a low rent

ministry of truth[9] than a building made up of homes in which Londoners are expected to live.

Coldharbour Lane 1985 was characteristic of Donkor's style of painting. He confidently tackled key, dramatic, monumental moments of African diaspora history, but did so with a painterly preciseness that bordered on aesthetic frugality. Despite the animated scene depicted, *Coldharbour Lane 1985* resonated with an almost deafening silence, almost as if the riot was taking place with the environmental volume turned right down, or muted altogether. As such, the painting stood in marked and salutary contrast to the shrill, hysterical and sensationalist tones that normally accompanied television reports of urban disturbances, reports that by their nature offered more in the way of heat than light on the causes and anatomies of a riot.

Elsewhere in the country, Birmingham-based artist Barbara Walker was also concerned with documenting the presence of Black Britain. At times, she sought to present a settled community looking to go about its various activities in peace. At other times, she documented a decidedly fractious community, ill at ease with the perceived draconian policing it was forced to endure. Walker did more than simply *paint* her community, her friends, her family and herself. She was in effect a chronicler, a faithful and friendly documenter of the lives and culture of African-Caribbean people around her in her native Birmingham. Her work was, however, not merely illustrative, or merely social documentation, important though social documentation is. Walker's work effortlessly exuded a warmth, a familiarity and a humanity seldom within reach of even the most accomplished and empathetic photographer. Walker had grown up in, as well as grown out of, the community that she took as her subject matter. In her early work, like several other Black painters, Walker took as her subject matter the barbershop, itself such an important social focal point in Black communities in Britain, and indeed further afield.

Walker had, over the course of the late twentieth and into the twenty-first century, emerged as one of the most talented, productive and committed artists of her generation. She respectfully painted the experiences, rituals and spaces that bond and characterise so many aspects of African-Caribbean identity. From rituals like those practiced within majority-Black churches, such as baptism by total emersion, through to affirmative and communal spaces used by Black men, such as the barbershop. Her work – painting and drawing – was marked by its profound empathy for its subject matter as much as its

32. Barbara Walker, *Solomon* (2005).

distinctive style. There was, within her pictures, great honesty, an honesty that spoke of (as well as to) the human condition in many of its forms. Like the great African-American artist Charles White, Walker's pictures were 'images of dignity' and because her work was highly figurative, audiences had an uncommon access to its multiple and pronounced social narratives.

For one particular exhibition, Walker produced a body of work that unflinchingly and intelligently explored the impact that *stop and search* has had, and continues to have, on her son, Solomon, as well as on herself as a mother. The exhibition *Louder Than Words*[10] consisted of a series of deeply engaging drawings that directly addressed the personal, social and political implications of the police obsession with stopping and searching those hapless young Black men deemed to be suspicious in appearance or behaviour. As a parent, artist, and life-long resident of Britain's second city, Birmingham, Walker used her formidable drawing ability to explore the impact of *stop and search* on her son Solomon who had, on a number of occasions been stopped by the police, questioned and searched.

The resulting work was a series of portraits of her son, or drawn views of her neighbourhood, rendered on enlarged copies of stop and search carbon copies with which he had been issued at the end of each encounter with the police. With this startling and original device, Walker effectively alluded to the sinister and intrusive nature of stop and search, and the ways in which one's neighbourhood was a menacing and sinister space, rather than a nurturing space of comfort, community and safety. The work also referenced the extent to which certain British people, on account of no more than their skin colour, were subject to constant and unapologetic surveillance. There was a marked and salutary contrast between the juxtaposition of Walker's precise, confident drawings and the impersonal, bureaucratic compartmentalising of information about human beings reflected by the state's issuing of these stop and search records, on which these drawings were rendered.

Birmingham had given rise to a number of significant and influential artists of Caribbean background, amongst them Vanley Burke, Keith Piper, Donald Rodney, Barbara Walker and Hurvin Anderson. Anderson is one of the most accomplished painters of his generation, known and respected for the uniqueness of his vision and practice, who emerged into notable prominence during the course of the 1990s. In the years since then he has garnered notable attention in the international arena. Some of his paintings are singular constructions which somehow manage to achieve the – in some respects unlikely – combination of being investigations into colour, shape and form, and unsentimental explorations of cultural and socially charged spaces such as the Black barbershop, and places in Jamaica, the Caribbean island from which his parents had emigrated. Typical in regard to Anderson's extraordinary investigations into the Black barbershop is *Jersey*, a painting of 2008

33. Hurvin Anderson, *Peter's Sitters II* (2009).

now in the collection of the Tate. *Jersey*, like other paintings characteristic of Anderson, is a study of the interplay between figurative and non-figurative elements, and the fascinating results that can ensue when the painter's brush-strokes are used to create what are in effect *collages*. *Jersey* (from one of the artist's celebrated series of paintings) depicts a barbershop, in which two empty barbers' chairs – perhaps recently vacated of their customers – occupy a decidedly unusual type of environment. The notable presence of abstraction within the painting decisively prevents it from being merely or simply a painterly study of a space of congregation and conversing for Black males, who often found themselves with few other social spaces to gravitate to. The painting is dominated by a wall the colour of light blue, onto which, or in front of which, have been placed rectangles of assorted sizes and colours. With this startling device, Anderson created an astonishingly ambiguous depth of field, rendering the viewer uncertain as to whether the barbershop had a wall or whether it was instead located in a kind of infinitesimal space in which the rectangles of colour floated, as if in some sort of neverending void.

Like several artists before him, it was in some regards the *space* of the Black barbershop that Anderson sought to commemorate or illustrate in paintings such as *Jersey*. In so doing, Anderson produced a remarkable and wondrous body of work. *Jersey* embodied a certain luminous and optimistic disposition, with its combination of a bright, light pastel blue, and the rectangular shapes of lilac and other colours that resembled small patches of colour painted or affixed to a wall rather like those homemakers might live with before they decide on a final colour scheme for this or that room in their home. In this regard, with its partial emphasis on decorative elements, *Jersey* effectively displaced or troubled dominant societal notions of African-Caribbean males. In referencing elements of the modernist grid, colour field painting, and Black male grooming, Anderson was producing singular work of pronounced sophistication, capable of telling no end of stories. There was an insistent oscillation between abstraction and figuration in Anderson's work, consequently imbuing it with a wealth of painterly, visual art, as well as cultural and historical narratives.

Faisal Abdu'Allah was born in London in 1969, and graduated from the Royal College of Art in the early 1990s. A number of the artists discussed in previous chapters and the current one – Bowling, Forrester, Arif, Piper, Anderson – had all studied at this important London graduate art college. A

34. Faisal Abdu'Allah, *Fuck da Police*, (1991).

measure of the Royal College of Art's significance in narratives reflecting the presence of Black artists in Britain was indicated in the exhibition, *RCA Black*, which took place at the Royal College of Art, Henry Moore Galleries, London, 31 August – 6 September 2011. The exhibition celebrated the work of a number of Black artists who, over the course of the last half a century, had been able to study at the institution.

Abdu'Allah's work was emphatically reflective of the cultural and political influences that have shaped a generation of Black British people for whom Black urban American street style, language, aesthetics and music were profound and critical influences as they came of age. In looking at Abdu'Allah's work, Black Atlantic and other diasporic sensibilities were consistently discernible.

His first exhibition, titled *Censored! From Nigger to Nubian*, took place at the 198 Gallery, in South London, in 1993.[11] It consisted of a series of works – screen prints on etched steel – that were, for a while, to become something of his trademark. One particularly imposing series consisted of five full-length portraits of young Black men, printed on oversize sheets of steel. The work was at once gritty and contemporary, and, despite the unquestionable power and strength of the portraits, was simultaneously enigmatic and understated. In this regard, steel was a singularly original and appropriate medium on which to screen-print the images. Steel is a material that in its making is quite literally forged in the fire, and yet upon manufacture can acquire a cool, minimal, and decidedly modernist aesthetic. The images of

the young Black men all provocatively engaged with, or oscillated between, rap iconography and the objectification of young Black males as having a close proximity to criminality, deviance, and threat. Within this work, the artist appropriated iconography from popular culture in an attempt to question particular pathologies – both spoken and unspoken – relating to media and other representations of the young Black male.

A particularly photogenic and media-savvy personality, Abdu'Allah carved out for himself a substantial place in the landscape of visual arts practice in twenty-first century London. The intellectual depth, integrity, and consistent originality of his work marked him out as a hugely important and relevant artist. The role of Black people in society, in history, in art, and in numerous other spheres, is of central importance to Abdu'Allah. Another of his much-celebrated works (*Last Supper*, 2003) is a sizeable reworking of the symbolism of the image of the Last Supper. In Abdu'Allah's reworking, commissioned by Autograph, the by now long-running Black photographers' agency, the figures have been made over to reflect the artist's own identity as a Muslim, as well as his critique of the ways in which Black people – both men and women – have been largely excised from mainstream (including biblical) narratives. Like much of his work, his rendering of the Last Supper (in two different versions) boldly challenged the viewer, as well as presenting its audiences with masterfully executed, intriguing, grand visual narrative.

Another artist to decisively make a name for himself during the course of the 1990s and on into the new millennium was Hew Locke, who was born in Edinburgh, Scotland in 1959 but lived from 1966 until 1980 in Georgetown, the capital of Guyana, the country of his father's birth.[12] He gained a BA in Fine Art from Falmouth School of Art (having studied alongside another significant young practitioner, Alistair Raphael) and an MA in Sculpture from the Royal College of Art, London, in 1988 and 1994 respectively. Locke's distinctive work was widely celebrated for what sometimes appeared at first glance to be offbeat and slightly eccentric sculptural forms. Frequently, during the early years of the twenty-first century, these sculptural forms were renditions of prominent members of the British royal family. Closer inspection of his work revealed, for some, much more intellectually textured and heavily nuanced readings.

Locke achieved considerable success and recognition by the middle of the 2000s and his work was exhibited in substantial group and solo exhibitions in the UK and internationally. Locke is one of only a limited number of

35. Donald Locke, *Trophies of Empire* (1972–1974).

Black British artists to have their work included in the *British Art Show*[13] – in Locke's case, in the sixth manifestation of the exhibition, which toured to venues in Gateshead, Manchester, Nottingham and Bristol in 2006. He had a major solo exhibition at the New Art Gallery Walsall in 2005.[14] The lavish and sizeable publication that accompanied the exhibition included a substantial and useful essay on Locke's work, 'King Creole – Hew Locke's New

Visions of Empire' written by Kris Kuramitsu.[15] The publication also contained 'A Sargasso Sea-Hoard of Deciduous Things... Hew Locke and Sarat Maharaj in conversation', in which Maharaj shed much calm, reflective and perceptive light on the nature and complexity of Locke's practice. The conversation opened with Maharaj reflecting:

> For me the singularity of your work springs from its wit – its humour and sense of play. These qualities are at odds with the earnest tonals and high seriousness of concepts like 'postcolonial, trans-national, commonwealth, creole' – even if they do throw keen light on your ways of seeing and making. The wit seems to resist and short circuit blanket categories that claim to 'explain' the shape of your thinking and practice.[16]

Indeed, these sentiments could, perhaps, be applied to many of the artists who stamped their imaginative and thought-provoking impressions on the 1990s.

The Triumphant Triumvirate: Yinka Shonibare, Chris Ofili, and Steve McQueen.

Towards the end of the millennium, a new younger generation of ambitious and media-savvy Black artists, typified by the likes of Chris Ofili, Yinka Shonibare and Steve McQueen[1] began to take centre stage, arguably reflecting multiple shifts in race and representation and (cultural) politics, relating as much to wider communities of Black people in Britain as to Black artists themselves. The media profile and career success of these artists was simply unparalleled in the history of Black artists in Britain. This chapter examines the trajectories of these artists' successes. Arguably, their successes lay in their abilities to create work that was perceived to be somewhat comfortably in step with what might be called a post-yBa[2] moment.

Yinka Shonibare was born in London in the early 1960s, but grew up in Nigeria. Returning to London to continue his art school education, he completed an undergraduate degree before going on to Goldsmiths College for postgraduate study.[3] It was at this time – the late 1980s and early 1990s – that he was making some of his most interesting and successful work. His paintings at the time were acrylic canvasses that brought together studies of African art pieces – often depicted were wooden caryatid figures –juxtaposed with all manner of consumer items, readily available on high streets and other retail outlets. What may at first have seemed like incongruous pairings or groupings were in reality bold declarations that challenged often unthinking assumptions about the nature of African cultures and the suppositions that an untroubled African way of life somehow existed separate from the late twentieth century world of technological development and consumerism. With titles such as *Caryatid Figures Rafia Colour Motif with Viscount* [telephone] *from British Telecom* (c.1989), Shonibare's paintings were remarkable affairs. Several years after their making, Elsbeth Court described them as follows: 'In 1989 he divided the plane of a single canvas into three sections, each containing figurative imagery of an 'icon' such as a Lega stool or global

designer telephone.'[4] Elsewhere, Shonibare's paintings from this period were described as

> the diametric opposite of cultural taxidermy. Juxtaposing images of African carved figurines, advertising logos, entomological illustrations, small electrical appliances, and Chinese calligraphic characters, Shonibare disregards any hierarchical arrangements other than those dictated by his compositional choices. The canvasses of the artist often suggest an almost haphazard collage of museological specimen charts and modern advertising billboards.[5]

Steering clear of the occasional didacticism that had not been uncommon amongst certain Black British artists' practice, Shonibare attempted to fashion new languages, new dialogues, and new terms of reference to describe the peculiarities of his life and his identity in late 1980s London. The decade had given rise to several Black artists who, like Shonibare, were also seeking to utilise painting as more than introspective formalism, and more than the merely illustrative. Instead, they approached painting for its potential to communicate and embody new ideas and new ways of framing elements of the world around them. Particularly noteworthy in this regard were Denzil Forrester, Eugene Palmer and Tam Joseph, discussed earlier in chapters of this book.[6] Whilst a number of other artists had long since moved away from painting and other practice-based media, Shonibare kept faith with the act of painting, even as he critiqued its history and its legacies. In so doing, he was to go on to make an extraordinary, penetrating work. Following two years of postgraduate study at Goldsmiths College, Shonibare was included in the prestigious Barclays Young Artist Award, 1992, held at the Serpentine Gallery in London.[7] Elsbeth Court, in her review of his work in the exhibition, claimed that Shonibare was, 'the first non-European selected to be a finalist.'[8] There was great significance in Shonibare's inclusion in the exhibition. More than a decade and a half after the Barclays Young Artist Award, 1992, Shonibare was asked to describe what his big breakthrough was. He replied: 'Winning a Barclays Young Artist award in 1992. It got me noticed.'[9]

Within his practice, Shonibare was at pains to stress that his work was a critique of, and challenge to, seemingly indelible or fixed notions of Africa and African art. Furthermore, though he was not minded to exhibit in Nigeria, the country he grew up in, Shonibare was nevertheless a clear beneficiary of

a new art-world status quo, in which precious few biennales and other inter-
national mega-exhibitions were considered complete without the presence of
one or more practitioners deemed in some way or another to represent or
reference 'Africa'. Steve McQueen was another beneficiary of the ways in
which Black artists, including those from Britain, were increasingly embraced
by the biennale circuit during the course of the 1990s.[10]

Shonibare's headway was aided by another particularly fortuitous sequence
of events – the meteoric coming into view of the so-called yBa generation
who have in many ways dominated all curatorial narratives governing British
art practice from the mid 1990s onwards. Such was the new hegemony that
the yBa grouping represented that by the mid 1990s they were in the words
of Michael Bracewell, 'well on their way to becoming the new establishment
of British art.'[11]

Having studied at Goldsmiths College, the undisputed home of the yBa
generation, and graduating from there in the early 1990s, Shonibare was well
placed to be identified with these artists and to be noticed, in time, by both
influential and impressionable curators, gallery directors, critics, and collec-
tors from far and wide. Ofili (though not a Goldsmiths graduate) and
McQueen (another Goldsmiths graduate) were likewise beneficiaries of the
unprecedented levels of curatorial and other types of attention paid to the
yBa generation that included the likes of Damien Hirst, Sam Taylor-Wood
and Tracey Emin.

The work that Shonibare exhibited in the Barclays Young Artist Award
was groundbreaking. Elsbeth Court, whose review appeared in *African Arts*,
provided the most substantial appraisal of Shonibare's work in the Serpentine
exhibition, which was titled *Installation*: 'On adjacent walls Shonibare
composed an asymmetrical array of four-sided color field objects prepared
from textiles stretched over a frame, like the traditional canvas, and painted.
Stunning in appearance and significance, *Installation* is a watershed for
contemporary African art.'[12]

Following on from *Installation*, one of Shonibare's next works was *Double
Dutch*,[13] which consisted of several rows of small rectangular paintings. The
paintings were executed on the fronts or the sides of the canvasses, though
the canvasses were, in turn, stretched pieces of faux African fabric. The fabric
acted as a leitmotif of Shonibare's own existence and identity. This was irrev-
erent, brassy work. Referencing the modernist grid, the work existed as a
critique of Modernism and wider art histories, even as it simultaneously acted

as a mechanism through which Shonibare could find a way into these same narratives, and, in effect, create a space for himself within art history. The canvasses were mounted on a wall that was a shocking shade of bright pink in colour, thereby driving a coach and horses through the sacrosanctity of the white cube gallery aesthetic. The work was also an exuberant investigation into the process of painting, in which the paint on the fronts or the sides of the canvasses was applied in luscious, generous quantities, to create shapes, patterns, symbols that were evocative of such things as cultural identity, the occasional eccentricity of fabric design, and investigations into the ways in which paint can be applied to fabric.

Concurrent to Shonibare's stock rising, an intriguing young artist – not yet into his thirties – crowned off a successful year with a coveted Turner Prize nomination. Chris Ofili was the first British-born Black artist to be nominated. Indeed, Ofili went to on win the Turner Prize, thereby signalling the triumphant arrival of a bold, new, media-savvy talent whose work was characterised in large part by (and indeed, arguably primarily noticed for) its distinctive and liberal use of balls of elephant dung. As Julian Stallabrass observed, 'He achieved prominence at a genuinely young age, only six years out of art school when, in 1998, he won the Turner Prize and in the same year had a solo show at one of London's foremost venues, the Serpentine Gallery.'[14] Stallabrass proceeded to make mention of other Ofili successes, before noting that 'his work arrived swiftly at the official centre of the British art world, and may indeed be seen as a manifestation of the [then] British state's new self-image.'[15] As mentioned earlier, Ofili, together with Shonibare and McQueen were to an extent fortuitous beneficiaries of the unprecedented levels of curatorial and other types of attention paid to the yBa generation. But other factors were at play in Ofili's success. Stallabrass opined, 'The prodigious success of Ofili is however a sign of shifts in the art-world view of black art, one connected with a change in government [...] and with larger and deeper changes in the global art world as a whole.'[16] There could be no question that the late 1990s was Ofili's time. Rachel Newsome, in a feature on Ofili published in November 1998, on the eve of his Turner Prize triumph, summed up the artist's relevance and timely emergence in a handful of words: 'it's a late '90s thing.'[17]

In his perceptive review of Ofili's 1998 touring exhibition, Richard Dyer briskly reminded, or made the reader aware of, the artist's rapid rise to success and good fortune:

Since graduating from the Royal College of Art in 1993 with an MA
in painting, Ofili has been courted by the upper echelons of the art
establishment – Victoria Miro, Charles Saatchi, the Serpentine Gallery
– and starting even while still at college he was a prize winner in the
Whitworth Young Contemporaries, an exhibitor in the BP Portrait
award and later in the prestigious John Moores Liverpool Exhibition.[18]

Ofili's rise to fame and success owed much to his timely and emotive painting
of a woman taken to approximate Mrs Doreen Lawrence, *No Woman No
Cry* (1998), which was purchased by the Tate in 1999.

In April of 1993, 18-year-old student Stephen Lawrence was stabbed to
death in a vicious and unprovoked attack that was widely regarded as a racist
murder.[19] In the immediate years following the murder, no convictions were
secured for this death and allegations persisted that the London police were
ultimately indifferent to racist violence against Black people. Worse, that
incompetence, corruption, and racism may have played a part in the lack of
convictions.[20] The New Labour government of 1997, sensing the palpable
mood of outrage and injustice at Lawrence's death and the attendant failure
of the police and judicial system to secure satisfactory prosecutions, commis-
sioned a report by Sir William Macpherson which, when published in
February 1999 became known as *The Macpherson Report*.[21] With its damning
verdict that police forces such as the Metropolitan Police were affected by a
culture of 'institutional racism', the report was seen as evidence that under
New Labour, Black victims of crime, including racial violence, would be
taken seriously and that the police would work to eradicate racism from their
ranks. Notwithstanding the importance of the report, its findings, and its
recommendations, the public mood (articulated within sections of the press
and media, and elsewhere) took the form of outrage at the wanton violence
perpetrated against someone framed as a decent, upstanding, hardworking
young man, and sympathy for the Lawrence family, particularly the teen-
ager's parents. Doreen and Neville Lawrence were regarded as dignified
people who, though burdened with an unimaginable grief, carried themselves
in a way that was inspirational. Like their son, they were perceived as decent
people, who wanted nothing more and nothing less than justice for their
beloved son. Few racist murders had in the past generated this level of
sympathy. Indeed, much of the media and the wider society had appeared
apparently indifferent to the deaths of no fewer than 13 Black youngsters,

in a suspicious house fire, at the beginning of the 1980s.[22] But on this occasion at least, things were different and there was a palpable sense of society-wide sympathy for Lawrence's parents and respect for their dignified manner.

When Chris Ofili was shortlisted for the Turner Prize exhibition of 1998, held at Tate Britain from late October 1998 to early January the following year, he became the first British-born Black artist to be so honoured. The other shortlisted artists – Sam Taylor-Wood, Cathy de Monchaux, and Tacita Dean – were also of the yBa generation who had come, and indeed would continue, to dominate Turner Prize shortlists.[23] The award was, in due course, made to Ofili 'for the inventiveness, exuberance, humour and technical richness of his painting, with its breadth of cultural reference, as revealed in his solo exhibition at Southampton City Art Gallery and in *Sensation* at the Royal Academy, London.'[24] It is certain that his painting, *No Woman No Cry*, the star of his display, helped him to achieve this recognition.

Ofili's *No Woman No Cry* was a sentimental portrait of a tearful woman, widely taken to be Mrs Lawrence, or a woman the viewer can surmise might be representative of Mrs Lawrence. The theatricality of the elephant dung which had catapulted Ofili to stardom was present within the painting – in the form of a pendant worn by the woman, and as two props on which the painting (and indeed, many of his paintings which use the material) rested. But, sentimentality and predictable or inevitable use of elephant dung aside, the painting was widely recognised and it was no surprise when the Tate purchased it in 1999. As Virginia Button noted in her history of the Turner Prize, *No Woman No Cry* 'was widely admired by the press.'[25] The woman in Ofili's portrait appeared behind a decorative, latticework type grid, almost a funeral veil. Not a harsh grid that trapped her, but an ornamental patterning that reflects the figure's gentle humanity. With her hair plaited, and her eyes gently closed in sorrow, the painting was perhaps a timely embodiment of sympathy felt towards Mrs Lawrence and the high esteem in which she and her husband were held. The woman in Ofili's painting cried gentle tears and within each droplet, those who cared to look closely enough could see a portrait of the murdered, the martyred, Stephen Lawrence. Reflecting as it did something of the nation's sympathy, it was difficult to imagine Ofili's *No Woman No Cry*, as the centrepiece of his display, not winning 1998's Turner Prize, once Ofili had been shortlisted.

Despite the pronounced, supposedly playful and somewhat mannered nature of the found imagery and the pick and mix approach to Black popular

culture that characterised Ofili's work, its strongest and most dominant aspect was in many ways not the content itself, but the paintings' luxurious, indulgent, decorative nature. These were beautiful, crafted, layered affairs in which the somewhat gimmicky elephant dung acted as a foil for what were clearly painstakingly assembled mixed media paintings. Stallabrass described something of Ofili's technique:

> Ofili started making quasi-abstract paintings of a very complex, decorative nature, composed of many layers. Typically his paintings will contain, from bottom layer to top, under-painting in sweet colours, collage material from magazines, glitter, drips and slashes of resin, and finally dot painting and dung.[26]

In Ofili's early paintings, technique was everything and content, such as it was, ultimately counted for little or nothing beyond its supposed playfulness. In this respect, *No Woman No Cry*, notwithstanding its tendency towards mawkishness, was something of an exception, in that it brought together something approaching more substantial content and medium. Only Ofili's earliest, non-figurative pictures, (which had no references to the sexual organs or other body parts that characterised many of Ofili's *dung* paintings) such as *Painting With Shit on It*, were as successful.[27] That particular painting, one of Ofili's first to make use of elephant dung, established the artist's trademark. As Stallabrass bluntly put it, 'Shit was Ofili's logo, and he did what he could to brand both himself and the product he had created.'[28]

As was the case for the most successful of the yBa coterie, in what seemed like no time at all Ofili had acquired a tangible celebrity status, the trappings of which included a documentary on him broadcast on television,[29] a medium which had previously done little to nothing in the way of providing substantial focus on a Black British artist. Like other artists alongside him, some of Ofili's press and media coverage presupposed an understanding of, or familiarity with, Ofili's practice, thereby enabling other aspects of his life to be brought to the public's attention. The *Guardian* newspaper was a particular admirer of Ofili, providing consistent coverage on him and his work over an extended period of time. Going beyond his art practice, the Guardian's *Weekend* magazine of 25 November 2000 included a lifestyle and interior decoration feature that focussed, in part, on Ofili's London home.[30]

Within two years of leaving Goldsmiths College as Steven McQueen,[31] Steve McQueen was in a group exhibition at the ICA, then one of London's most prestigious visual arts venues.[32] By 1997, McQueen's career was already being described as 'formidable'.[33] He had already been included in a number of important exhibitions and had shown work in a number of prestigious galleries, and greater success clearly lay ahead. Remarkably, McQueen's career was launched on the back of barely half-an hour's worth of 16mm film and video projects. But such was the special and arresting quality of McQueen's work that curators, gallery directors and art critics all took notice of it. In a piece written towards the end of 1997 for an American publication, Michael Rush, clearly impressed, wrote that:

> Steve McQueen, a twenty-eight-year-old Black British media artist, has already forged a formidable career with less than thirty minutes worth of video and films. This year alone he has had solo exhibitions at documenta X, the Johannesburg Biennale, the Stedelijk Museum, Marian Goodman Gallery, and now at the estimable Projects Room at MoMA.[34]

Time and time again critics found themselves voicing surprise at the speed with which McQueen established himself. An *Artforum* review, again of late 1997 began with:

> I liked Steve McQueen's first New York show, and then I found that he has an exhibition history rather fatter than either the thin number of years he has been practising or the slender body of art he has made.[35]

Glowing reviews and press adulation followed McQueen from his earliest work onwards. Within little more than a decade and a half of graduating from Goldsmiths, *Art Review* magazine summarised McQueen's stellar achievements: 'The only person on the planet to have been awarded both the Turner Prize and the Caméra d'Or (for best first feature at the Cannes film festival) is also representing Britain at the 53rd Venice Biennale.' The magazine ran a feature on the artist, whose portrait appeared on the cover of one of its issues. Perhaps not surprisingly – and perhaps with good reason – the cover introduced McQueen as 'The Most Relevant Artist in Britain'.[36]

Shonibare had his faux African fabric, Ofili had his elephant dung. What got McQueen noticed was his apparent seriousness and the depth of his

practice and vision. His film work acted as something of an antidote to the knowing, ironic, supposedly self-deprecating, post-modern frivolity and froth that was, even then, starting to grate and wear a little thin in some of the work of the yBa generation. McQueen's films, such as his 1995 works, *Bear* and *Five Easy Pieces*, and his 1997 work *Deadpan*, came as a blessed relief to those looking for substance. As Chris Townsend noted in his book, *New Art From London*:

> The best artists of the new generation are distinguished by a seriousness and by a thoughtfulness about their work that has not been a significant feature of British art for many years. (The decision to award the 1999 Turner Prize to Steve McQueen for his self-reflexive videos suggests an early manifestation of this return to art as a serious topic, where concentrated attention is paid to the content and rhetorical forms of the art work, rather than to excess publicity or media interest in the artist.)[37]

McQueen's characterisation as a *serious* artist may have been a device to differentiate him from the other Black Turner Prize winner of the period, Chris Ofili. The body of paintings for which Ofili had secured his nomination included titles such as *Popcorn Tits*, *Captain Shit and the Legend of the Black Stars*, and *Seven Bitches Tossing Their Pussies Before the Divine Dung*. Such titles reflected a contrived and grating hilarity, which contrasted poorly with McQueen's framing as an assiduous and visionary technician, not given to frivolity and mirth.

It appeared that McQueen had found the holy grail for which many Black artists had searched, seemingly since time immemorial. What large numbers of Black artists had earnestly pursued or sought after was what one might call a largely non-racial reading of the Black image. In a world in which the white image stood for the general and the Black image stood for the racially or ethnically or culturally specific, McQueen's work seemed to challenge this debilitating and constraining pathology. McQueen seemed able to use, or construct, the Black image in ways that, whilst not exactly transcending race or difference, were able to wrestle it free from the limited range of readings that historically seemed to plague the Black image. To be sure, it was difficult to characterise or caricature McQueen's work according to explicitly racial narratives, even though the Black image (or perhaps more correctly, images of Black people) was often central to the crafted, filmic narratives and

sequences of his earlier work. McQueen may have been Black and a film-maker, but he most assuredly was not a Black filmmaker. The significance of this cannot be overstated. Others before him may have been Black, and artists, but almost irrespective of their practice or their intentions, they would, whether they liked it or not, invariably find themselves caricatured or catego-rised as Black artists. McQueen seemed able to break that coupling of the words Black and artist, even though, as mentioned earlier, his camera lens at this time had the Black image as its unswerving focus.

Earlier generations of Black artists who utilised the Black image in a range of social narratives had developed mechanisms for dealing with art world indifference or creating platforms of visibility for their work. These included Black exhibitions and other self-initiated visual arts projects. As time went on, a number of these Black artists found sporadic exposure through actions and approaches that had explicit racial or anti-racist agendas. But other Black artists, whose practice eschewed pronounced or didactic Black symbolism, also fell victim to the art world pathology of perceiving overt racial narratives – in artist or in art – where such narratives did not necessarily exist. Most damning of all, generations of Black painters whose practice was characterised by notably non-figurative elements similarly found themselves kept at arm's length by an art world largely unconvinced or uninterested in their practice. Much of this changed with the arrival of this new late 1990s grouping of artists, McQueen, Ofili and Shonibare. Of the three, it was perhaps McQueen who has been most feted for the quality of his work, its vision and its depth. Rush was not alone in observing that McQueen was 'an assured craftsman for whom simple, often straight-on, bold camera shots can enact an entire scenario in less than five minutes.'[38] and that, 'McQueen's characters to date are powerful, living sculptures, at once enigmatic, erotic, and solitary.'[39]

It was clear that McQueen was a new type of Black artist, one for whom the substantial exhibitions and other recognition just kept stacking up. Signif-icantly, as mentioned earlier, McQueen became (in 1999) the first Black British artist ever to have a solo exhibition at the Institute of Contemporary Art in London.[40] Nearly a decade and a half earlier, Lubaina Himid had occupied the ICA concourse gallery (in effect, corridor walls) and an upper room with her *The Thin Black Line* exhibition.[41] Discussed in Chapter Nine, this was a critically well-received exhibition that nevertheless took place in something of a marginal and marginalised space, albeit within a prestigious central London venue. A decade on, and David A. Bailey, working with Catherine

Ugwu, presented *Mirage: Enigmas of Race, Difference & Desire* within the main gallery spaces of the ICA.[42] This was the first time in the venue's history that it had given itself over to such an exhibition, featuring as it did Caribbean-born, Black British and African-American practitioners. Within a couple of years of *Mirage*, McQueen made a triumphant return to the ICA, occupying its gallery spaces with a universally celebrated exhibition. It was this exhibition, and his show of the same year at Kunsthalle, Zurich that gained McQueen his Turner Prize nomination and subsequent win.[43]

The New Generation

As mentioned in the Introduction, every chapter of this book could have been titled *Problems and Progress*, because either an entrenching of ongoing challenges, or the creation of new ones, has invariably accompanied each step that Black artists have taken towards greater visibility. The history of Black artists in Britain reflects a steady and often predictable pattern, in which the fortunes of individual artists undulate, whilst the majority of practitioners have to settle for either fleeting visibility, or no visibility at all. Each of the decades studied in this book has produced remarkable artists whose practice is both in step with the times and simultaneously something unique, something different, something fresh. But Britain has yet to learn to keep hold of its most gifted Black artists. Time and again, the country has seen its most successful Black artists either reach for more appreciative environs, or turn their backs on a country which had long since turned its back on them. At times, the individuality of the practitioners seemed to count for very little. Instead, the British art scene seemed capable of dealing with Black artists only en masse, as it were, such as in the group exhibitions that proliferated in the 1980s and beyond. As time went on, and the face of cultural politics changed, Black artists in Britain increasingly found that their most substantial opportunities took the form of initiatives linked to festivals, or other projects that had community engagement or notions of racial/social uplift at their core.

In some ways, the Arts Council-sponsored Institute of International Visual Arts was an intriguing new presence in London from the early 1990s onwards, but INIVA's relationship to the country's Black artists has always been a decidedly unstraightforward affair. Furthermore, a gallery space (as currently exists) supposedly dedicated to engaging with a plurality of practitioners has implications that are spectacularly troubling.

Nevertheless, a new generation of Black artists is functioning in London,

and doubtless new practitioners will continue to emerge over time. Among the new artists to emerge in the twenty-first century can be listed the likes of Lynette Yiadom-Boakye, Grace Ndiritu, Samson Kambalu and Zenib Sedira. In April of 2013, when the shortlist for the 2013 Turner Prize was announced, the inclusion of Lynette Yiadom-Boakye's name was perhaps not a particular surprise. Not only had she been making waves in the UK, with significant attention from the art press,[1] but she had also been the subject of an important exhibition at the Studio Museum in Harlem, a leading New York gallery that had also shown a number of other Black British artists such as Yinka Shonibare, Hurvin Anderson, and Chris Ofili.[2]

Yiadom-Boakye distinguished herself by producing the most enigmatic of portraits. She tended to take as her subjects Black people not drawn from life but instead taken – assembled, almost – from a variety of secondary material. The significance of the successes achieved thus far by Yiadom-Boakye cannot easily be overstated. It appears that, like Steve McQueen before her, she has found ways to present a largely non-racial reading of the Black image. As mentioned in the previous chapter, in a world in which the white image stood for the general and the Black image stood for the racially or ethnically or culturally specific, McQueen's work seemed to challenge this debilitating and constraining pathology. Likewise, Yiadom-Boakye seems able to use or construct the Black image in ways that, whilst not exactly transcending race or difference, are able to wrestle it free from the limited range of readings that historically seemed to plague the Black image. And like McQueen, Yiadom-Boakye seems able to break what had been, for so many practitioners, a somewhat debilitating coupling of the words *Black* and *artist*, even though her portraits reflect an unblinking examination of Black portraiture.

The men and women presented in Yiadom-Boakye's portraits are often decidedly dark-skinned and as such represent an almost over-determination of Blackness. In some portraits this is achieved by the visibility of the whites of the subjects' eyes. In others, this sense of over-determination is achieved by the showing of the subjects' teeth. There is also the use of the decidedly dark backgrounds or overall environments in which the artist locates her subjects. For a Black artist to be able to paint Black people and to draw positive attention from the art world is rare indeed.

Grace Ndiritu is another young artist who came to attention in the first decade of the twenty-first century as a result of her striking practice. Of

36. Lynette Yiadom-Boakye, *Any Number of Preoccupations* (2010).

Kenyan parentage, Ndiritu is celebrated for work that came to be referred to as *Handcrafted videos* or *Video Paintings*. At a time when a number of artists were known and celebrated for the use of textiles within their work, Ndiritu distinguished herself by her remarkable use of textiles in the video works she creates. Typical in this regard is her video, *The Nightingale* (2003). In a perhaps deceptively simple film, Ndiritu continuously wraps and unwraps her head and face with a piece of fabric. But this is not simply a now-you-see-me-now-you-don't video self-portrait. Not only is the fabric used highly nuanced, evocative of Islamic patterning, but the almost bewildering variety of ways in which Ndiritu reveals and/or conceals herself each carries pronounced associations in the mind of the viewer. One moment the cloth is wrapped in the manner of a hastily applied death shroud, in the next Ndiritu wraps her face as if mimicking the headgear of rock-throwing young Palestinians of the Intifada, at pains to mask their faces to prevent subsequent identification. One moment, the cloth signifies the covering of a woman's hair or face to preserve modesty, at other times, Ndiritu wraps herself as if mimicking the do-rag, with all its pronounced references to strands of hip hop and

African-American culture. At times, the fabric appears as a shawl, evoking piety, at other times, it appears as if Ndiritu's removing herself from view assumes altogether more different associations of one having been silenced, or one whose visibility had been questioned or compromised. This was astonishing work, which was duly noted as such. Running to just over seven minutes,

> *The Nightingale* is a powerful video concerned with projected identity and miscommunication. Originally based on a story of unrequited love – the title making reference to the bird famous for its beautiful, sad song – it has become more fixated on the disconnection between the East and West, global separation and cultural stereotyping.[3]

A number of artists discussed in this book relocated to other countries; but this migration was, however, very much a two-way process, and a number of artists from other parts of the world continued to move to London, pretty much as they had done for many decades. One such was Zenib Sedira, who moved to London from Paris in the mid 1980s. Very much a multimedia artist, Sedira's early work was marked by its investigations into issues of language and storytelling, and familial relations, within the context of her family's experience of immigrating to France from Algeria, Sedira's subsequent growing up in Paris and, subsequent to that, her move to the UK in the mid 1980s. With France's fractious relation to one of its biggest (ex)-colonies, and the protracted and bloody war for independence as such potent aspects of her family background, Sedira's work struck a variety of chords in the ways in which it mined history and identity. Black artists in Britain, of the 1980s in particular, were used to dealing with issues of migration and colonial legacies in their practices. Sedira, however, has brought renewed depth and relevance to her explorations of these issues. Two decades earlier, another London-based artist, of Algeria background, Houria Niati, had also investigated France's colonial legacy in Algeria, though for her the paintings of Delacroix and the medium of paint were her preferred tools in this endeavour.

During the first decade of the twenty-first century, a significant number of new Black artists appeared on the art scene. These included Oladélé Ajiboyé Bamgboyé, born in Nigeria in 1963, who developed his interest in photography during and after his time as a student in Glasgow in the 1980s;

Harold Offeh, born in Accra, Ghana who, like a number of other artists of his generation, worked in a range of media including street performance, video, and photography and sought to reference popular culture and to use humour and parody to engage and confront the viewer with a range of social and cultural concerns; Haroon Mirza, born in London in 1977, whose fascinating, intriguing work combined household objects and repurposed electrical appliances to create decidedly odd, but deeply engrossing work that was both sculptural and aural; Tariq Alvi, born in Newcastle-upon-Tyne, who achieved considerable success with his innovative mixed media explorations of sexuality, territory, identity, and culture; and Janette Parris, an artist concerned more with making interventions than with making objects. Decidedly eclectic in its manifestations, Parris's work embraced video, animation, cartoons, musical opera and performance.

While in the case of artists such as these it might be too early to assess the full extent of their position within British art, there are a number of practitioners who have managed, one way or another, to be represented in certain narratives of British art. The most pronounced manifestation of this occurred in the 2012 Tate Britain exhibition, *Migrations: Journeys into British Art*, an important exhibition that included the work of some 70 artists.[4] The exhibition proposed the view that for the past five centuries or so, Britain itself has been shaped by successive waves of migration, from Europe, from the Caribbean, from Asia, and other parts of the world. Furthermore, that what we know as, or consider to be, *British* art has itself been similarly shaped. The exhibition advanced, or prompted, the question: what is British art? It proposed that genres audiences think of as most typically British, such as landscape painting, were in actuality introduced by artists who had migrated to Britain. Foreign-born artists frequently secured lucrative commissions and many became, in effect, not just *British artists*, but *Britain's artists*. A combination of European painters steeped in an academic tradition and British artists who travelled to study in Italy helped to introduce a neoclassical vocabulary into British painting. Much later, from the mid nineteenth century onwards, a transatlantic dialogue developed between British artists and American artists such as James McNeill Whistler and John Singer Sargent. Throughout history, Paris too existed as a magnet for artists, and French artists such as Henri Fantin-Latour and Alphonse Legros were regular visitors to England.

Fittingly, artists from the first-ever diaspora – the Jewish Diaspora –

featured prominently in the *Migrations* exhibition, and a significant number of early twentieth century artists, including David Bomberg, Jacob Epstein and Mark Gertler figured in the history of British art. These influential practitioners were joined by a number of established artists including Naum Gabo, Oskar Kokoschka, Piet Mondrian and Kurt Schwitters. This latter group were amongst the refugees from the rise of Nazism and Fascism in Europe in the 1930s. Within just a few years of this (indeed, even before this wave of refugee artists), as discussed earlier in this book, artists were making their way to Britain from countries of the former British Empire such as Guyana, India, Pakistan and Jamaica. Such artists included Ronald Moody, Frank Bowling, Rasheed Araeen and Aubrey Williams.

The story of successive periods of migration influencing British art continued in the 1970s with the decidedly international rise of conceptual art involving an intriguing group of artists such as David Medalla, David Lamelas and Gustav Metzger. These artists were both international in their approach to their own practice as well their approach to their own identities. Towards the final, and most recent chapters of the *Migrations* story, the politically and socially charged climate of the 1980s gave birth to a compelling and dynamic range of visual art aligned to social commentary, in the work of Black Audio Film Collective, Keith Piper, Sonia Boyce, and Donald Rodney. The work of these artists effectively explored the duality and the nuances of being both 'Black' and 'British'.

The final sections of *Migrations* reflected the present-day nature of London and other parts of the UK as an international destination of choice for artists from across the globe; the other side of a process that has seen British artists seek to establish themselves in other parts of the world. This dual process has created a fascinating cultural space characterised by a constant process of reinvention and change. Artists such as Peter Doig, Steve McQueen, Wolfgang Tillmans and Tris Vonna Michell networked globally with a speed and effectiveness enabled by plentiful travel opportunities and advances in technological communications. Although not the first project of its kind, *Migrations* told a compelling story of the vital part migration, and the migration of artists, has played in the shaping of what we know as *British* art and culture.

Notes

NOTE

1 Gilane Tawadros, 'Mirage: Enigmas of Race, Difference and Desire,' in *Mirage: Enigmas of Race, Difference and Desire* (London: ICA/INIVA, 1995): 13.

2 Ibid.

3 Gen Doy, 'Introduction' to Doy, *Black Visual Culture* (London: I.B.Tauris, 2000): 9.

FOREWORD

1 Simon Houfe, 'Social Realism 1850–1890', *The Dictionary of British Book Illustrators and Caricaturists, 1800–1914*, Woodbridge, Suffolk, Antique Collectors' Club, 1978: 149.

2 Ibid.

3 *Vagabondiana or, Anecdotes of Mendicant Wanderers Through the Streets of London; with Portraits of the Most Remarkable Drawn From the Life.* London: Published by the Proprietor and sold by Messrs. J. and A. Arch, Cornhill; Mr Hatchard, Bookseller to the Queen, Piccadilly; and Mr Clark, Bond-Street. 1817, pp. v/vi.

4 Ibid, p. v.

5 Ibid.

6 Ibid.

7 Smith described his subject in the following terms:

The succeeding plate displays the effigy of Joseph Johnson, a black, who in consequence of his having been employed in the merchants' service only, is not entitled to the provision of Green-wich. His wounds rendering him incapable of doing further duty on the ocean, and having no claim to relief in any parish, he is

obliged to gain a living on shore; and in order to elude the vigilance of the parochial beadles, he first started on Tower-hill, where he amused the idlers by singing George Alexander Stevens's 'Storm'. By degrees he ventured into the public streets, and at length became what is called a 'Regular Chaunter'. But novelty . . . induced Black Joe to build a model of the ship Nelson; to which, when placed on his cap, he can, by a bow of thanks, or a supplicating inclination to a drawing room window, give the appearance of sea-motion. Johnson is as frequently to be seen in the rural village as in great cities . . . (p. 33)

8 Ibid.
9 Ibid, p. 34.
10 For many years, the fourth plinth at the north-west corner of Trafalgar Square, London, stood empty. In 1999, the Royal Society of Arts (RSA) conceived the Fourth Plinth Project, which temporarily occupied the plinth with a succession of works commissioned from contemporary artists Mark Wallinger, Bill Woodrow and Rachel Whiteread. As the RSA's temporary custody of the Fourth Plinth as a site for contemporary art appeared to be popular with both the public and the media, the Greater London Authority (GLC) assumed responsibility for the fourth plinth and began its own series of changing exhibitions. These included works by Marc Quinn, Anthony Gormley, and Yinka Shonibare, whose *Nelson's Ship in a Bottle* was unveiled on 24 May 2010. *Ship* garnered significant press coverage, and Shonibare was the first Black artist to receive a Fourth Plinth commission.
11 Michael McCarthy, 'Nelson's 'Victory' joins him in Trafalgar Square', The *Independent*, 25 May 2010, p. 16

INTRODUCTION

1 *Afro-Caribbean Art* was a large open submission exhibition organised by Drum Arts Centre, held 27 April – 25 May 1978 at the Artists Market, 52 Earlham Street, London, WC2. The artists were Mohammed Ahmed Abdalla, Keith Ashton, Colin Barker, Lloyd George Blair, Frank Bowling, Linward Campbell, Jan Connell, Dam X, D. Dasri, Horace de Bourg,

Gordon de la Mothe, Daphne Dennison, Art Derry, Barbara Douglas, Reynold Duncan, Anthony Gidden, Lubaina Himid, Merdelle Irving, Siddig El N'Goumi, Anthony Jadunath (his name appeared in the catalogue as Jadwnagh), Emmanuel Taiwo Jegede, Donald Locke, G. S. Lynch, Errol Lloyd, Cyprian Mandala, Althea McNish, Nadia Ming, Lloyd Nelson, Eugene Palmer, Bill Patterson, Rudi Patterson, Shaigi Rahim, Orville Smith, Jeffrey Rickard Trotman, Adesose Wallace, Lance Watson, and Moo Young. (The last artist listed was likely to have been Tony Moo Young, from Jamaica, though the Moo Young listed in the catalogue was listed as coming from Trinidad.) The only substantial references to this exhibition are a review by Rasheed Araeen, published in *Black Phoenix* ('Afro-Caribbean Art', *Black Phoenix*, No. 2 Summer 1978, pp. 30–31), and a review 'In View' by Emmanuel Cooper, contained in *Art & Artists*, Hansom Books, London, Volume 13, No. 3, Issue Number 148, July 1978, p. 50. A feature on Drum Arts Centre, titled 'Drum Call for Black Britain', written by Taiwo Ajai appeared in *Africa* magazine. No. 44 April 1975, p. 43.

2 See, for example, Val Brown's series of photographic portraits, *A British Product* (exhibited in *Black Art: Plotting the Course*, Oldham Art Gallery and touring, 1988). See also *Black People and the British Flag* (a touring exhibition which opened at Cornerhouse, Manchester, 1993). Both exhibitions were curated by Eddie Chambers. In *A British Product*, Brown critiqued and challenged the absence from the traditional notion of the 'English Rose' of women who looked like her. In *Black People and the British Flag*, a number of artists critically engaged with multiple notions of Britishness.

3 This sense of *resistance* to the label of being *British* was explicitly apparent in a substantial feature on a London painter who went by the name of *Caboo*, which appeared in the February 1975 issue of Race Today. Though the Trinidad-born painter had been resident in London since the age of fifteen, and though he had come to art as an adult, the feature introduced him in the following terms: *Caboo: The Making of a Caribbean Artist*. Such distancing, such alienation, from notions of Britishness was in keeping with the times.

4 *Restless Ribeiro: An Indian Artist in Britain*, 24 May – 29 June 2013, Asia House, London.

5 'Backlash, Caboo: the Making of a Caribbean Artist', Rasheed Araeen, and H. O. Nazareth, *Race Today*, March 1975, pp. 67-8.

6 Surprisingly perhaps, Sulter's death passed relatively unremarked, the most substantial obituary appearing in the *Herald*, Glasgow, 22 March 2008, a few weeks after her death.

7 Brenda Agard was born in 1961 and died in 2012. She was a familiar and consistent presence in the exhibitions of the mid 1980s that reflected the emergence of a new generation of Black-British artists. A photographer and artist, her work sought to create affirming images centred on the resilience of the Black woman. An early showing of her work was *Mirror Reflecting Darkly*, an exhibition of work by Black women artists held at Brixton Art Gallery in 1985. Her work was included in the important *The Thin Black Line* exhibition held at the Institute of Contemporary Arts later that year. Agard's work featured in Lubaina Himid's *Elbow Room* exhibition of 1986, titled *Unrecorded Truths*. Agard appeared in the Black Audio Film Collective film, *3 Songs on Pain, Light and Time* (1995), speaking about the artist Donald Rodney.

8 14 October 1997 – 15 March 1998, Studio Museum in Harlem;
 15 October 1997 – 15 March 1998, Bronx Museum of the Arts;
 16 October 1997 – 15 March 1998, Caribbean Cultural Center, the venue for *Picturing England: The Photographic Narratives of Vanley Burke*.

9 Courtney J. Martin, 'Surely, There Was a Flow: African-British Artists in the Twentieth Century', *Flow*, Studio Museum in Harlem, New York, 2 April – 29 June 2008, pp. 63–9, (exhibition catalogue).

CHAPTER ONE

1 The Veerle Poupeye quote is taken from her entry on Ronald Moody in the *St. James Guide to Black Artists*, Detroit, St James Press and New York, Schomburg Center, 1997, pp. 364–5.

2 Cynthia Moody, 'Ronald Moody: A Man true to his Vision', *Third Text* 8/9, Autumn/Winter 1989, pp. 5–24.

3 Guy Brett, 'A Reputation Restored', *Tate International Arts and Culture*, March/April 2003, pp. 78–80. The piece was extensively illustrated, including a dramatic full-page reproduction of *Seated Sarong Figure* (1938). The article related to a display of Moody's work that took place at Tate Britain, 24 March – 30 May 2003.

4 Guy Brett, 'A Reputation Restored', p. 79.

5 Marie Seton, 'Prophet of Man's Hope: Ronald Moody and his Sculpture', *The Studio*, January 1950, pp. 26–7.

6 Ibid p. 27.

7 Ibid p. 27.

8 See Rasheed Araeen's discussion of Frank Bowling in 'In the Citadel of Modernism', *The Other Story*, exhibition catalogue, p. 39.

9 Kobena Mercer, 'Black Atlantic Abstraction: Aubrey Williams and Frank Bowling', *Discrepant Abstraction*, The MIT Press, Massachusetts Institute of Technology, Cambridge, Massachusetts and INIVA the Institute of International Visual Arts, London. 2006, p. 183.

10 Ibid p. 186.

11 Ibid p. 186.

12 The obituary was written by Anne Walmsley and appeared in the *Guardian*, Tuesday 1 May 1990, p. 25.

13 1962 was also the year in which the Arts Council bought a work of Bowling's for its collection, making him among the first Black artists in Britain to be recognised in this way. The work was *Birthday* (1962), oil on canvas, 121.9 x 91.4 cm.

14 G.S.W. [G.S. Whittet], 'Two New Imagists at the Grabowski', *The Studio, International Art*, November 1962, Vol 164, No 835, p. 195.

15 Frank Bowling, quoted in Rasheed Araeen's discussion of Bowling in 'In the Citadel of Modernism', *The Other Story*, exhibition catalogue, p. 39.

16 Ibid p. 40. For more on this, see Mel Gooding, 'Dying Swans and a Spiral Staircase: Images of Crisis', *Frank Bowling*, Royal Academy of Art, 2011, p. 41.

17 *1st Commonwealth Biennale of Abstract Art*, Commonwealth Institute, London, 19 September – 13 October 1963, exhibition catalogue, unpaginated.

18 Martin Gayford, catalogue essay on Frank Bowling, in *Frank Bowling: Bowling on Through the Century*, exhibition catalogue, Bristol, 1996, p. 3. This exhibition was shown at Leicester City Gallery, 11 September – 12 October 1996; Gallery II, University of Bradford, 12 January – 7 February 1997; De La Warr Pavilion, Bexhill-on-Sea, 27 February – 31 March 1997; South Hill Park, Bracknell, 5 April – 10 May 1997; Midlands Arts Centre, 14 June – 27 July 1997 and Herbert Art Gallery and Museum, Coventry, 6 September – 26 October 1997.

19 Frank Bowling, quoted in Rasheed Araeen's discussion of Bowling in 'In the Citadel of Modernism', *The Other Story*, exhibition catalogue, p. 40.

20 Ibid.

21 Kobena Mercer, 'Frank Bowling's Map Paintings', in *Fault Lines: Contemporary African Art and Shifting Landscapes*, edited by Gilane Tawadros and Sarah Campbell, INIVA, London, 2003, p. 140.

22 Rasheed Araeen, *The Other Story: Afro-Asian artists in post-war Britain*, exhibition catalogue, Hayward Gallery London, 1989, p. 40.

23 The exhibition's dates were 28 November 1973 – 13 January 1974.

24 For a discussion of the honours system's embrace of Black-British artists, see Eddie Chambers, *Things Done Change: The Cultural Politics of Recent Black Artists in Britain*, Rodopi Editions, 2012; in particular, Chapter Two, 'Service to Empire'.

25 Edward Brathwaite, 'The Caribbean Artists Movement', in *Caribbean Quarterly*, Vol. 14, No. 1/2, A Survey of the Arts, March – June 1968, p. 58.

26 Guy Brett, 'A Tragic Excitement', *Aubrey Williams* exhibition catalogue, published by the Institute of International Visual Arts (INIVA) in association with the Whitechapel Art Gallery, 1998, p. 24

27 Guy Brett, introduction to *Aubrey Williams*, exhibition catalogue, Shibuya Tokyu Plaza, Japan, 1988, unpaginated.

28 From the entry on Williams in *The Other Story* catalogue (p. 32), taken from Rasheed Araeen, 'Conversation with Aubrey Williams', *Third Text*, Vol. 1, No. 2, Winter 1987–88, pp. 25–52.

29 Guy Brett, 'Aubrey Williams obituary', the *Independent* Tuesday 1 May 1999, p. 15.

30 Gallery-going audiences of a certain age may well have availed themselves of such an opportunity several decades earlier, when Williams exhibited in *1st Commonwealth Biennale of Abstract Art*, alongside painters such as Frank Avray Wilson, Peter Lanyon, Denis Bowen and Victor Pasmore. Scholarship on Williams continues to be published (see for example, Leon Wainwright's 'Aubrey Williams: A Painter in the Aftermath of Painting', *Wasafiri*, issue no. 59, Autumn 2009, pp. 65–79).

31 Guy Brett, 'Aubrey Williams obituary'.

32 *Commonwealth Art Today*, Commonwealth Institute, London, 7 November 1962 – 13 January 1963.

33 The Indian Painters Collective was established in 1963. Though the group was relatively short-lived, it was reborn a decade and a half or so later as IAUK (Indian Artists United Kingdom), a body that had an altogether more substantial, productive and influential programme and profile.

CHAPTER TWO

1 *Commonwealth Art Today*, Commonwealth Institute, London, 7 November 1962 – 13 January 1963.

2 For a discussion of this, see Eddie Chambers, 'Coming in From the Cold: Some Black Artists Are Embraced', in *Things Done Change: The Cultural Politics of Recent Black Artists in Britain*. Editions Rodopi, 2012, pp. 210-11.

3 GALLERY ONE – TEN YEARS, Gallery One, London, 19 August – 6 September 1963, catalogue, unpaginated. This was a hugely important document covering the first ten years of activity of Gallery One.

4 Ibid.

5 Victor Musgrave, in GALLERY ONE – TEN YEARS.

6 Ibid.

7 Reyahn King, *Anwar Shemza*, catalogue essay in Anwar Shemza, Birmingham Museum and Art Gallery, 12 November 1997 – 1 February 1998, p. 6.

8 Ibid p. 4.

9 W. G. Archer, 'Avinash Chandra: painter from India', *The Studio* magazine, Vol. 161, No. 813, January 1961, pp. 4–7. Like the Introduction to Chandra's Hamilton Galleries exhibition of 1965, this article was written by W. G. (William George) Archer, an 'expert' on Indian poetry, culture and art. He was born in 1907 and worked for the Indian Civil Service from 1931 until about the time of Indian independence in 1947. He was, subsequently, Keeper, Indian Section, Victoria and Albert Museum 1949–59. W. G. Archer died in 1979.

10 Ibid p. 5.

11 See GALLERY ONE – TEN YEARS.

12 *Avinash Chandra*, Hamilton Galleries, London, 10–27 March 1965.

13 W. G. Archer, introduction to *Avinash Chandra*, exhibition catalogue, Hamilton Galleries, London, 10–27 March 1965, unpaginated.

14 W. G. Archer, 'Avinash Chandra: painter from India', p. 6.

15 Ibid.

16 Rasheed Araeen, 'In the Citadel of Modernism', *The Other Story*, exhibition catalogue, Hayward Gallery, London/South Bank Centre, 1989, p. 23.

17 Francis Newton Souza, *The Supper at Emmaus*, 1958.

18 Geeta Kapur, 'London, New York and the Subcontinent', *Francis Newton Souza: Bridging Western and Indian Modern Art*, by Aziz Kurtha, Mapin Publishing Pvt. Ltd, Ahmedabad, India, 2006, p. 72.

19 Aziz Kurtha, 'Origin and Influence', *Francis Newton Souza: Bridging Western and Indian Modern Art*, Mapin Publishing Pvt. Ltd, Ahmedabad, India, 2006, p. 57.

20 *India: Myth and Reality Aspects of Modern Indian Art*, Museum of Modern Art, Oxford. The exhibition was selected by David Elliott, Director of Museum of Modern Art, Oxford, Victor Musgrave, and E. Alkazi. The artists exhibited were M F Husain, F N Souza, Satish Gujral, S H Raza, Akbar Padamsee, Ram Kumar, Mohan Samant, Tyeb Mehta, K G Subramanyan, Krishen Khanna, A Ramachandran, Bikash Bhattacharjee, Jogen Chowdhury, Rameshwar Broota, Ranbir Singh Kaleka, Gieve Patel, Sudhir Patwardhan, Nalini Malani, Mrinalini Mukherjee, and Anish Kapoor. The exhibition's dates are not included in the catalogue.

21 Entry on *F. N. Souza*, in *India: Myth and Reality Aspects of Modern Indian Art*, Museum of Modern Art, Oxford, 1982, p. 8.

22 Philip Rawson, text for *Balraj Khanna: Paintings*, October Gallery, London, 16 April – 10 May 1980.

23 Rasheed Araeen, 'In the Citadel of Modernism', p. 43.

24 Rasheed Araeen, 'The Art Britain *really* Ignores', *Making Myself Visible*, London, Kala Press, 1984, p. 102.

25 *Balraj Khanna*, New Vision Centre, 18 October – 6 November 1965.

26 Ahmed Parvez, a Pakistani modernist painter, was born in 1926, in Rawalpindi (then in India, now in Pakistan) and died in 1979. In the words of Rasheed Araeen, writing in *The Other Story* catalogue (page 34), 'Parvez belonged to the first group of artists in Pakistan for whom 'modern art' was everything.'

27 Senake Bandaranayake and Manuel Fonseka, 'An Introduction to the Paintings', in *Ivan Peries: Paintings 1938–88*, Tamarind Books, Colombo, Sri Lanka, 1996, p. 9.

28 *Six Indian Painters*, Gajanan D. Bhagwat, Balraj K. Khanna, Yashwant Mali, S. V. Rama Rao, Lancelot Ribeiro, and Ibrahim Wagh, Tagore India Centre, London, 9 – 28 November 1964.

29 Catalogue flyleaf, *Six Indian Painters*.

30 Brochure (unpaginated) for an exhibition at Burgh House Museum, New End Square, Hampstead, London NW3 of *Exhibition of Paintings by IAUK Indian Artists living in UK*. The exhibition took place 27 January – 24 February 1980, and featured Yeshwant Mali, Prafulla Mohanti, Lancelot Ribeiro, Suresh Vedak, Ibrahim Wagh, and Mohammad Zakir.

31 The letter was copied to this author.

32 *Mali*, Horizon Gallery, London, 29 August – 21 September 1990.

CHAPTER THREE

1 Brochure (unpaginated) for an exhibition at Burgh House Museum, New End Square, Hampstead, London NW3 of *Exhibition of Paintings by IAUK Indian Artists living in UK*. The exhibition took place 27 January – 24 February 1980, and featured the artists above, all of whom were involved with IAUK.

2 Letter from Lionel Morrison, then Principal Information Officer of Commission for Racial Equality dated 6 February 1980 and originally sent to Sheldon Williams, 64 Clissold Crescent, London, N16, drawing attention to *Exhibition of Paintings by IAUK Indian Artists living in UK*.

3 Catalogue for *Festac'77*: 'The work of the artists from the United Kingdom and Ireland. Introduction by Yinka Odunlami, Exhibition Officer of UKAF', London, p. 4.

4 The Arts Council of Great Britain, Calouste Gulbenkian Foundation and the Community Relations Council had commissioned this report. It was published in May 1976.

5 Rasheed Araeen, 'The Arts Britain *really* Ignores', *Making Myself Visible*, London: Kala Press, 1984, p. 101.

6 Rasheed Araeen 'Afro-Caribbean Art', *Black Phoenix* No. 2 Summer 1978, pp. 30–1.

7 Emmanuel Cooper ,'In View', *Arts & Artists*, Hansom Books, London, Volume 13, Number 3, Issue Number 148, July 1978, p. 50.

8 Rasheed Araeen 'Afro-Caribbean Art', originally published in *Black Phoenix* 2, Summer 1978. Reprinted in Rasheed Araeen, *Making Myself Visible*, London: Kala Press, 1984, pp 124–5.

9 *Third World Within*, Brixton Art Gallery, London, 31 March – 22 April 1986.

10 *From Two Worlds*, Whitechapel Art Gallery, 30 July – 7 September 1986, Rasheed Araeen, Saleem Arif, Franklyn Beckford, Zadok Ben-David, Zarina Bhimji, the Black Audio Film Collective, Sonia Boyce, Sokari Douglas Camp, Denzil Forrester, Lubaina Himid, Gavin Jantjes, Tam Joseph, Houria Niati, Keith Piper, Veronica Ryan and Shafique Uddin.

11 Keith Piper, foreword to *The Image Employed: The Use of Narrative in Black Art*, exhibition catalogue, 13 June – 19 July 1987, Manchester, Cornerhouse, 1987, unpaginated.

12 *Double Vision: An exhibition of contemporary Afro-Caribbean Art*, Cartwright Hall, Bradford, 8 November 1986 – 4 January 1987, Franklyn Beckford, Margaret Cooper, Uzo Egonu, Amanda Hawthorne, Lee Hudson Simba, Debbie Hursefield, Tam Joseph, Johney Ohene, Keith Piper, Madge Spencer, and Gregory Whyte.

13 'DRUM ARTS CENTRE', *Race Today*, March 1975, p. 72.

14 John La Rose and Andrew Salkey, preface to *Writing Away From Home*, *Savacou* 9/10, p. 8.

15 'Caboo: The Making of a Caribbean Artist', *Race Today*, February 1975, p. 37.

16 Rainbow Art Group exhibition, *Action Space*, leaflet, London, 22 May – 9 June 1979.

17 Throughout the 1970s and 1980s there were periodic attempts to establish a national Black arts centre for London, most notably, perhaps, the one centred on the Roundhouse in Camden, North London. Ultimately, however, these efforts came to naught, though the Keskidee Centre in Kings Cross, North London operated for two decades, between 1971 and 1991. It was not until the period around the new millennium that a number of new Black arts centres were brought into existence.

18 Taiwo Ajai, 'Drum Call for Black Britain', *Africa* magazine. No. 44 April 1975, p. 43.

19 The work was titled *Spirit of the Carnival* and is further discussed in Chapter Five.

20 Rasheed Araeen, 'The Arts Britain *really* Ignores', p. 104.

21 The following biographical summary on Rasheed Araeen appeared in *Wasafiri*, Volume 23, Number 1, Issue 53, Spring 2008, p. 22. The text, an interview with Araeen conducted by Richard Dyer covering some eight pages, was liberally illustrated with archival images of Araeen's practice. The front cover of the issue featured an archival photograph of Araeen's 'Paki Bastard (Portrait of the Artist as A Black Person)', a live event with slides and sound, first performed at Artists for Democracy, 31 July 1977.

> Rasheed Araeen was born in 1935 in Karachi, Pakistan. Although he first trained as a civil engineer, he later began to work as an artist, first producing figurative work and then abstract painting. Restricted by attitudes to modernity in Pakistan, he moved to England in 1964 after a brief stay in Paris. A year later, he encountered the work of Anthony Caro which was a transformative experience for him and encouraged him to start making his own sculptures. Rather than producing sculpture based on traditional composition or pictorial structures, Araeen argued that 'symmetrical configuration, rather than composition, should be the basis of a new sculpture'. Consequently, Araeen became a pioneer of Minimalist sculpture in Britain, although his contribution was largely unrecognised at the time. Araeen did not discover the New York school of American Minimalism until 1968 when a friend in Paris told him of the work of Sol LeWitt. It was at this time that he also began to devote himself full-time to art. In 1970, Araeen became increasingly politically active, joining both the Black Panthers (later re-named the Black Workers Movement) and Artists for Democracy. Later in the decade, he explored performance art, concentrating on political issues and identity politics. In 1978 he founded *Black Phoenix*, a magazine which dealt with radical contemporary art from the 'Third World'. This was the precursor to *Third Text* magazine which he launched in 1987 and which is one of the leading academic journals of contemporary art and culture today.

Araeen regarded his practice as being reflective of, and having made quantum contributions to, both modernism and post-modernism. (See the artist's exhibition and catalogue, *From Modernism to Postmodernism – Rasheed Araeen: A Retrospective: 1959–1987*, Ikon Gallery, Birmingham, 1988.)

22 *The Essential Black Art*, Chisenhale Gallery, 5 February – 5 March 1988, Rasheed Araeen, Zarina Bhimji, Sutapa Biswas, Sonia Boyce, Eddie Chambers, Allan de Souza, Mona Hatoum, Gavin Jantjes and Keith Piper.

23 Rasheed Araeen, 'The Emergence of Black Consciousness in Contemporary Art in Britain: Seventeen Years of Neglected History', *The Essential Black Art*, exhibition catalogue, Kala Press, London 1988, p. 5.

CHAPTER FOUR

1 *Commonwealth Art Today*, Commonwealth Institute, London, 7 November 1962 – 13 January 1963.

2 *Caribbean Artists in England*, Commonwealth Art Gallery, Kensington High Street, London, 22 January – 14 February 1971. The exhibition featured some 17 practitioners, showing fabrics, paintings, sculpture and ceramics. The list of artists present in the exhibition gives an indication of the extent to which certain practitioners have been susceptible to the vagaries of obscurity. Names such as Althea Bastien, Owen R. Coombs, Daphne Dennison, and Llewellyn Xavier are, by and large, unfamiliar in the present age.

3 Olu Oguibe, *Uzo Egonu: An African Artist in the West*, London, Kala Press, 1995.

4 Rasheed Araeen, 'Recovering Cultural Metaphors', *The Other Story* catalogue, 1989, p. 86.

5 Some sources give Enwonwu's year of birth as 1917, others give 1921.

6 Courtney J. Martin, 'Surely, There Was a Flow: African-British Artists in the Twentieth Century', *Flow*, exhibition catalogue, the Studio Museum in Harlem, 2 April – 29 June 2008, p. 65.

7 Olu Oguibe, *Uzo Egonu*, p. 4.

8 '1972 Prizewinners', *African Arts*, Vol. VI, No. 2, Winter 1973, p. 12.

9 Mora J. Beauchamp-Byrd, 'London Bridge: Late Twentieth Century British Art and the Routes of "National Culture"', in *Transforming the Crown*, exhibition catalogue, New York, Caribbean Cultural Center, 1998, p. 21.

10 'Biographies', *Contemporary African Art*, exhibition catalogue, London, Camden Arts Centre, 10 August – 8 September 1969, p. 34.

11 Olu Oguibe, *Uzo Egonu*, p. 9.

12 Jacqueline Delange and Philip Fry, introduction to *Contemporary African Art*, exhibition catalogue, London, Camden Arts Centre, 10 August – 8 September 1969, p. 5.

13 Ibid.

14 Gerald Moore, 'About this Exhibition', *Contemporary African Art*, exhibition catalogue, London, Camden Arts Centre, 10 August – 8 September 1969, p. 13.

15 africa 95 was founded in 1992 to initiate and organise a nationwide season of the arts of Africa to be held in the UK in the last quarter of 1995. The wide-ranging events included the visual and performing arts, cinema, literature, music and public debate, and programmes on BBC television and radio. africa 95, a registered company with charitable status, was formed in 1993. It was granted patronage by HM the Queen, President Nelson Mandela of South Africa, and President Leopold Sedar Senghor of Senegal. The centrepiece of the season was the Royal Academy of Arts exhibition, *Africa: the Art of a Continent*.

The policy and decision-making body of africa 95 was an Executive Committee chaired by Sir Michael Caine. The offices, with around ten permanent staff, were at Richard House, 30–32 Mortimer Street, London. Over twenty co-ordinators and consultants were engaged in the project. Funding was provided from over 150 sources, with major grants being made by the European Development Fund, the Foreign and Common-wealth Office, the British Council, and the Baring Foundation. Company sponsors included British Airways and Blue Circle Industries. Extensive archival material relating to africa 95 is held by the School of Oriental and African Studies, University of London. See http://archiveshub.ac.uk/features/050527r1.html (accessed 27 February 2013).

16 *Seven Stories About Modern Art in Africa* (Whitechapel Art Gallery, 27 September – 26 November 1995), described by one critic, Jean Fisher, as 'part of a multimedia jamboree called "africa95"', was the first exhi-bition to attempt to provide a historical context for African Modernism'. See Jean Fisher, 'Seven stories about modern art in Africa,' *Artforum*, January 1996, p. 94.

17 Catherine Lampert, foreword to *Seven Stories About Modern Art in Africa*, exhibition catalogue, London, Whitechapel Art Gallery, 1995, p. 9.

18 Clémentine Deliss, '7+7=1: Seven stories, seven stages, one exhibition', *Seven Stories About Modern Art in Africa*, exhibition catalogue, London, Whitechapel Art Gallery, 1995, p. 913.

19 Ibid p. 27.

20 *Africa Remix: Contemporary Art of a Continent*, Hayward Gallery, London, 10 February – 17 April 2005.

21 Roger Malbert, preface to *Africa Remix*, exhibition catalogue, Germany, Hatje Cantz Publishers, 2005, p. 9.

22 Roger Malbert, introduction to *Africa Remix*, p. 11.

23 Ibid.

24 *We Face Forward: Art from West Africa Today*, Manchester City Galleries, the Whitworth Art Gallery and the Gallery of Costume, Manchester, 2 June – 16 September 2012.

25 Publicity, back cover, exhibition catalogue, *We Face Forward: Art from West Africa Today*.

26 Maria Balshaw with Bryony Bond, Mary Griffiths and Natasha Howes, 'Facing Forward: West Africa to Manchester', in *We Face Forward: Art from West Africa Today*, exhibition catalogue, p. 5.

27 *Caribbean Art Now: Europe's first exhibition of contemporary Caribbean art*, Commonwealth Institute, London, 17 June – 4 August 1986.

28 *Caribbean Focus '86,* press release, March 1986.

29 Catherine Lampert, foreword to *Seven Stories About Modern Art in Africa*, p. 10.

30 *African Arts*, Vol, VI, No. 2, pp. 8–13.

31 Ibid p. 4.

32 Ibid p. 11.

33 Adeyemo Adekeye, 'Uzo Egonu of Nigeria', *African Arts* Vol. VII, No. 1, Autumn 1973, p. 34.

34 Olu Oguibe, *Egonu*, p. 29.

35 Anne Walmsley, a distinguished scholar of Caribbean art and supporter and friend of Aubrey Williams, was responsible for a comprehensive appraisal of CAM, *The Caribbean Artists Movement, 1966–1972: A Literary and Cultural History*, published by New Beacon Books, London, 1992. For the *Transforming the Crown* catalogue (1997),

Walmsley supplied the essay 'The Caribbean Artists Movement, 1966–1972: A Space and a Voice for Visual Practice'.

Art in the Caribbean: An Introduction, (London, New Beacon Books, 2011) offered the following biographical summary on Anne Walmsley, who was one of the book's authors:

> [Anne Walmsey is] a British-born writer specializing in Caribbean art and literature. She studied English for a BA at Durham University, African Studies for an MA at Sussex, researched the Caribbean Artists Movement for a PhD at Kent, and was awarded an Honorary DLitt at the University of the West Indies, Mona (2009). She has taught English at a secondary school in Jamaica and an MA course, *Aspects of Caribbean Art*, at the School of Oriental and African Studies, University of London, and has worked for Longman, the publisher, in the Caribbean and in Africa. She contributed a detailed chronology of the life and work of Aubrey Williams to the catalogue of his retrospective at the Whitechapel Gallery, London (1998). Her publications include two anthologies of Caribbean literature, *The Sun's Eye* (1968, n/e 1986) and *Facing the Sea*, with Nick Caistor (1986), *Guyana Dreaming: the Art of Aubrey Williams* (1990), *The Caribbean Artists Movement: A Literary and Cultural History 1966–1972* (1992) and *Art of the Caribbean*, a postcard pack for schools (2003).

36 Anne Walmsley, 'The Caribbean Artists Movement, 1966–1972: A Space and a Voice for Visual Practice', *Transforming the Crown*, exhibition catalogue, New York, Caribbean Cultural Center, 1997, p. 46.

37 Anne Walmsley, 'The Caribbean Artists Movement, 1966–1972', p. 46.

38 Edward Brathwaite, 'The Caribbean Artists Movement', *Caribbean Quarterly*, Vol. 14, No. 1/2, A Survey of the Arts (March – June 1968), p. 58.

39 Ibid.

40 Ibid pp. 58/59.

41 John La Rose and Andrew Salkey, preface to *Writing Away From Home*, *Savacou* 9/10, 1974, p. 8.

42 Edward Brathwaite, 'The Caribbean Artists Movement', p. 59.

43 Anne Walmsley, 'The Caribbean Artists Movement, 1966–1972', p. 52.

CHAPTER FIVE

1 Taiwo Ajai, 'Drum Call for Black Britain', *Africa magazine*, No. 44 April 1975, p. 43.

2 'Mas' is colloquial expression, meaning to actively participate in the carnival.

3 So close is the association between Notting Hill Carnival and criminality that media coverage is frequently centred on either that criminality which has occurred, or that criminality which has been avoided. See for example the following extracts of coverage of the Notting Hill Carnival taken from the *Guardian* newspaper. 'Meanwhile police in London said there was a total of 55 offences committed at the Notting Hill Carnival over the bank holiday and 46 arrests' (Alex Bellos, News in Brief 'Police reveal arrests of rock festival guards' the *Guardian*, August 30, 1995, p. 7). In another edition of that day's *Guardian*, the 55 offences were tallied as 'eight robberies, 15 snatches, 15 pick-pocketing offences, one of grievous bodily harm and four of actual bodily harm.' And 'Despite the worst fears of the police, the Notting Hill Carnival passed off without the robberies and murders that blighted last year's event. Police had launched pre-emptive raids against armed gangs in a bid to stop them disrupting the event, but one senior officer in the Metropolitan police still told the Radio 4 *Today* programme he would not take his children to Carnival' ('Wild West London', The Week in Pictures No. 4, The [*Guardian*] Editor, September 1 2001, p. 13).

And 'Concern over the rising cost of [policing] the carnival led the police to estimate last year's event would cost £4m. The final bill was higher because of the Met's determination to prevent the violence and murders that marred the 2000 event' (Nick Hopkins, Crime Correspondent, 'Policing of Notting Hill Carnival cost £5.6m', the *Guardian*, June 1 2002, p. 9). This same report also claimed that '10,000 officers were deployed over the two days, 1,500 more than the year before.' Elsewhere, the *Daily Telegraph* of Tuesday 29 August 1995 reported that 'Police made 51 arrests and violence marred the closing stages when a man was shot in the arm.' ('Carnival Time', p. 2).

4 *First Light 'For Polly'*, (1979), acrylic on canvas, 87.5 x 364 cm.

5 Caroline Popovic, 'The Precarious Life of Art', ART BEAT, 78–83, *BWIA Caribbean Beat*, No. 16, November/December 1995, p. 83.

6 David Simolke, 'Winston Branch: A Study in Contrast', *Black Art: an international quarterly*, Volume 2 Number 2 Winter, 1978, pp. 4–8.

7 David Simolke, 'Winston Branch: A Study in Contrast', p. 5.

8 John Russell Taylor, 'Denzil Forrester: World Painter', catalogue essay in *Denzil Forrester: Two Decades of Painting*, 4 Victoria Street, Bristol, 4 June – 6 July 2002, Eddie Chambers, Bristol, 2002, unpaginated.

9 Gallery guide, *Denzil Forrester: Dub Transition, A Decade of Paintings 1980–1990* (the exhibition's dates were 14 February – 14 April 1991).

10 John Lyons, 'Denzil Forrester's Art in Context', catalogue essay in *Denzil Forrester: Dub Transition, A Decade of Paintings 1980–1990*, p. 20. The exhibition's first dates, at Harris Museum & Art Gallery, Preston, were 22 September – 3 November 1990.

11 Phillip C. Dunn and Thomas L Johnson, *A True Likeness: The Black South of Richard Samuel Roberts: 1920–1936*, Bruccoli Clark, Columbia, South Carolina and Algonquin Books, Chapel Hill, North Carolina, 1986.

12 Richard Hylton, text for *Eugene Palmer: Index*, exhibition catalogue, Wolsey Art Gallery, Christchurch Mansion, Ipswich, 17 January – 28 March 2004, unpaginated.

13 See www.saleem-arif-quadri.co.uk/ (accessed 3 March 2013).

14 Rasheed Araeen, 'Recovering Cultural Metaphors', *The Other Story*, exhibition catalogue, London, Hayward Gallery/South Bank Centre, 1989, p. 97.

15 Ibid.

16 Nicholas Serota and Gavin Jantjes, *From Two Worlds*, Whitechapel, 1986. *From Two Worlds* was a major undertaking and was at the time the most substantial exhibition of Black artists' work at a major London gallery. Perhaps predictably, it featured the work of a number of relatively prominent Black artists. However, it also featured the work of a number of other artists, thereby representing an intriguing mix of practitioners. The exhibition generated a significant catalogue with an Introduction by Serota and Jantjes, and an essay *Juggling Worlds* by Adeola Solanke. The exhibition, which toured to Fruitmarket Gallery in Edinburgh, garnered a relatively large amount of press coverage.

17 For a discussion of the ways in which Black-British artists were drawn

into the honours system, see Eddie Chambers, 'Service to Empire', in *Things Done Change: The Cultural Politics of Recent Black Artists in Britain*, Rodopi Editions, 2012.

18 Solani Fernando, 'Chila Kumari Burman', in *Beyond Frontiers: Contemporary British Art by Artists of South Asian Descent*, edited by Amal Ghosh and Juginder Lamba, Saffron Books, London, 2001, p. 57.

19 See www.margaretthatcher.org/document/103485 (accessed 3 March 2013). Thatcher's comments came during a 1978 television interview, in which she opined:

> 'Well now, look, let us try and start with a few figures as far as we know them, and I am the first to admit it is not easy to get clear figures from the Home Office about immigration, but there was a committee which looked at it and said that if we went on as we are then by the end of the century there would be four million people of the new Commonwealth or Pakistan here. Now, that is an awful lot and I think it means that people are really rather afraid that this country might be rather swamped by people with a different culture and, you know, the British character has done so much for democracy, for law and done so much throughout the world that if there is any fear that it might be swamped people are going to react and be rather hostile to those coming in.'

What were widely regarded, in certain quarters at least, as vociferously anti-immigrant sentiments did Thatcher and the fortunes of her Conservative Party no harm. 'The effects of the interview, and particularly of that one word 'swamped', were instantaneous. Thatcher received five thousand letters in a week (way above her average of fifty a day), surveys showed increased support for the proposition that there were too many immigrants (in the UK), up from 9 to 21 per cent (of those polled), and the Tories enjoyed a surge in popularity. In Thatcher's own words: 'Before my interview, the opinion polls showed us level-pegging with Labour. Afterwards they showed the Conservatives with an eleven-point lead' (Alwyn W. Turner, *Sense of Doubt: 1976–1979*, 'Race: "I was born here just like you"', chapter in *Crisis? What Crisis?: Britain in the 1970s*. London, Aurum Press, 2008, p. 224). Subsequently, Turner quoted a senior Labour Party figure, as saying, 'The [Labour] party is depressed at the apparent success of Thatcher's exploitation of the race issue,' noted [Tony] Benn glumly.'

20 It was the *Daily Mail* newspaper which espoused Budd's application for British citizenship, on the grounds that her grandfather was British. Such a strategy effectively circumvented the international sporting boycott of South Africa so that she could compete in the forthcoming 1984 Olympics, scheduled to take place in Los Angeles. To the disgust of some, and to the delight of others, Budd's British citizenship was granted in short order, the preferential treatment she received being explicit and unabashed. For many Black people and others, this was a two-fold blow. Firstly, the granting of Budd's British citizenship flagrantly disregarded attempts to isolate apartheid South Africa, and secondly, Budd's preferential treatment further mocked and humiliated those darker-skinned peoples who found themselves at the mercy of an immigration and citizenship system that treated these people with prejudice and disrespect.

21 During the 1980s in particular, efforts were made to turn the Round-house into a leading Black arts centre. Ultimately, these efforts came to naught.

22 Chila Kumari Burman, 'There Have Always Been Great Black Women Artists', in *Charting the Journey: Writings by Black and Third World Writers*, edited by Shabnam Grewal, Jackie Kay, Liliane Landor, Gail Lewis and Pratibha Parmar, London, Sheba Feminist Publishers, 1988, p. 292.

23 The Combahee River Collective, 'A Black Feminist Statement,' in *All the Women are White, All the Blacks are Men, but Some of Us are Brave: Black Women's Studies*, edited by Gloria T. Hull, Patricia Bell Scott, and Barbara Smith. Old Westbury, New York, Feminist Press, 1982, pp. 13–22.

24 Linda Nochlin, 'Why Have There Been No Great Women Artists?', in *Art and Sexual Politics*, edited by Thomas B. Hess and Elizabeth C. Barker. New York: Macmillan, 1973, pp. 1–39.

25 Chila Kumari Burman, 'There Have Always Been Great Black Women Artists', p. 292.

26 Ibid p. 293.

CHAPTER SIX

1 In his introduction for a catalogue accompanying an exhibition by Zarina Bhimji, Mark Haworth-Booth referenced one of the most humiliating, dehumanising and brutal experiences to which Asian women seeking to immigrate to Britain were subject. 'The infamous 'virginity tests' were reported by The *Guardian* frequently in 1979: 'The government has admitted a charge that 34 Indian women who wanted to settle in Britain were given virginity tests'. (Mark Haworth-Booth, 'Introduction', *Zarina Bhimji: I will always be here*, Ikon Gallery, 4 April – 9 May 1992, exhibition catalogue, unpaginated.)

2 *Six Indian Painters*, Gajanan D. Bhagwat, Balraj K. Khanna, Yashwant Mali, S. V. Rama Rao, Lancelot Ribeiro, and Ibrahim Wagh, Tagore India Centre, London, 9–28 November 1964.

3 *India: Myth and Reality – Aspects of Modern Indian Art*, Museum of Modern Art, Oxford, 1982.

4 *Next We Change Earth* exhibition catalogue, New Art Exchange, Nottingham, 2008, p. 64.

5 Quoted in Eddie Chambers, *Next We Change Earth*, Nottingham, 2008, p. 64.

6 Press release, *Archive Season: Zarina Bhimji*, INIVA, London, 28 January – 6 March 2004.

7 Mark Haworth-Booth, 'Introduction', *Zarina Bhimji: I will always be here*, Ikon Gallery, 4 April – 9 May 1992, unpaginated.

8 See www.zarinabhimji.com/dspseries/4/1BW.htm (Accessed 15 August 2013).

9 'Documenta' happens every five years, whereas 'Documenta II' (eleven) specifically took place in 2002.

10 See www.artic.edu/exhibition/zarina-bhimji-out-blue (Accessed 19 March 2013).

11 Juginder Lamba, Festival Director, 'Introduction', *South Asian Contemporary Visual Arts Festival*, September–December 1993, Programme Guide, p. 1.

12 Amal Ghosh and Juginder Lamba, (eds), *Beyond Frontiers: Contemporary British Artists of South Asian Descent*, London, Saffron Books, 2001.

13 Nilofar Akmut, Zarina Bhimji, John Brady, Sutapa Biswas, Chila Kumari Burman, Mohini Chandra, Jagjit Chuhan, Nina Edge, Elizabeth Edwards, Solani Fernando, Amal Ghosh, Tania V Guha, Keith Khan, Pervais Khan, Balraj Khanna, Juginder Lamba, Manjeet Lamba, Shaheen Merali, Partha Mitter, Prafulla Mohanti, Usha Parmar, Anu Patel, Symrath Patti, Jacques Rangasamy, Ian Iqbal Rashid, Sajid Rizvi, Gurminder Sikand, Veena Stephenson, Shanti Thomas, Ibrahim Wagh, and Ali Zaidi.

CHAPTER SEVEN

1 *Caribbean Artists in England*, Commonwealth Art Gallery, Kensington High Street, London, 22 January – 14 February 1971. The exhibition featured some 17 practitioners, showing fabrics, paintings, sculpture and ceramics.

2 John Lyons, 'Denzil Forrester's Art in Context', essay in *Denzil Forrester: Dub Transition, A Decade of Paintings 1980–1990* (the exhibition first shown at Harris Museum & Art Gallery, Preston, 22 September – 3 November 1990, exhibition catalogue p. 17.

3 Keith Piper, 'Artist's Statement', *Black Art an' done*, exhibition catalogue, 1981, unpaginated.

4 Press release, *Black Art an' done*, 1981.

5 Rasheed Araeen, 'Chronology', *The Essential Black Art*, exhibition catalogue. Published by Chisenhale Gallery, London in conjunction with Black Umbrella, London, 1988, p. 20.

6 Ron Karenga, 'Black Cultural Nationalism', in *The Black Aesthetic*, edited by Addison Gayle Jr., Doubleday & Company Inc. New York, 1971, pp. 32–8. It was reprinted as 'Black Art: Mute Matter Given Form and Function', in *Black Poets and Prophets: The Theory, Practice and Esthetics of the Pan-Africanist Revolution*. The book, which described itself as 'a bold, uncompromisingly clear blueprint for black liberation', was edited by Woodie King and Earl Anthony, a Mentor Book, 1972.

7 Ron Karenga, 'Black Cultural Nationalism', pp. 32, 33/4.

8 Ibid p. 38.

9 For references to the *West Indian Front Room*, see Chapter Ten, the paragraphs relating to Sonia Boyce.

10	Keith Piper, *(You are now entering) Mau Mau Country* (1983), acrylic on hessian & canvas, 246.5 x 192 cm, Arts Council Collection, Southbank Centre.

11	For information and material on Donald Rodney, see *Doublethink* (essays by Eddie Chambers and Virginia Nimarkoh), edited by Richard Hylton, Autograph, London, 2003 and Eddie Chambers, 'His Catechism: The Art of Donald Rodney', London, *Third Text* 44, Autumn 1998, pp. 43–54.

12	PIPER & RODNEY ON THEORY, two pages of typewritten text to accompany ADVENTURES CLOSE TO HOME: An Exhibition by Piper & Rodney, the Pentonville Gallery, London, 6 August – 5 September 1987.

13	Both of these young artists had exhibitions at The Black-Art Gallery in London in the mid 1980s.

14	*The First White Christmas and Other Empire Stories*, Saltley Print & Media, Birmingham. The exhibition opened on 9 December 1985.

15	Eddie Chambers, Dominic Dawes, Andrew Hazel, Claudette Johnson, Wenda Leslie, Ian Palmer, Keith Piper, Donald Rodney, Marlene Smith, Janet Vernon. Whilst most of these artists produced work that was reflective of their Black Art manifesto, Wenda Leslie was a ceramicist whose work was not necessarily reflective of the ideas asserted by the likes of Piper and Rodney. Following *Black Art an' done*, there were several exhibitions with *The Pan-African Connection* (or *The Pan-Afrikan Connection)* in the title, each with a slightly differing line-up of contributing artists. These exhibitions took place at venues such as Africa Centre, London; Ikon Gallery, Birmingham; 35 King Street Gallery, Bristol; Midland Group Nottingham; Herbert Art Gallery and Museum, Coventry; and Battersea Arts Centre, London. The group itself was known by different names, at different times; Wolverhampton Young Black Artists, The Pan-African Connection (in which African sometimes appeared as Afrikan), and, towards the end of their existence, perhaps their most distinctive and recognised name of all, the Blk. Art Group).

16	Araeen advanced his own definition of Black Art in an exhibition he assembled, titled *The Essential Black Art*. Held at Chisenhale Gallery, London, 5 February – 5 March 1988 (and touring), it featured Rasheed Araeen, Zarina Bhimji, Sutapa Biswas, Sonia Boyce, Eddie Chambers,

Allan deSouza, Mona Hatoum, Gavin Jantjes and Keith Piper. For the specifics of his arguments, see the accompanying catalogue. Chapter Eight discusses the notion of Black Art advanced by Shakka Dedi and The Black-Art Gallery.

17　Keith Piper, 'Beating the boy', a short text contained in the exhibition catalogue *Distinguishing Marks*: work by Sonia Boyce, Allan deSouza, Shaheen Merali, Pitika Ntuli and Keith Piper, p. 15. This was a mixed media exhibition by five Black artists, who recently had represented Britain at the 3rd Havana Biennale, Cuba. Bloomsbury Galleries, Institute of Education, University of London, London, 22 May – 9 June 1990.

18　*Creation for Liberation, First Open Exhibition of Contemporary Black Art in Britain*, St Matthew's Meeting Place, Brixton, London, 20–30 July 1983; *Second Creation for Liberation Open Exhibition*, Brixton Art Gallery, Brixton, London, 17 July – 8 August 1984; *3rd Creation for Liberation Open Exhibition of Contemporary Art by Black Artists*, GLC Brixton Recreation Centre, Brixton, London, 12 July – 3 August 1985; *Creation for Liberation Open Exhibition: Art by Black Artists*, Brixton Village, Brixton, London, 7 October – 17 November 1987. These exhibitions were large-scale affairs, featuring many artists, some of whom showed just one or two pieces. The 1987 exhibition, for example, included contributions by 46 artists.

19　This is discussed in Chapter Eight.

20　*Into the Open: New Paintings Prints and Sculptures by Contemporary Black Artists*, Clement Bedeau, Sonia Boyce, Eddie Chambers, Pogus Caesar, Shakka Dedi, Uzo Egonu, Lubaina Himid, Gavin Jantjes, Claudette Johnson, Tom (as he was then known) Joseph, Juginder Lamba, Bill Ming, Tony Moo Young, Ossie Murray, Houria Niati, Ben Nsusha, Pitika Ntuli, Keith Piper, Ritchie Riley, Veronica Ryan and Jorge Santos. Mappin Art Gallery, 4 August – 9 September 1984. The exhibition toured to two other venues: Castle Museum, Nottingham, 16 September – 21 October 1984 and Newcastle Media Workshops, 2–30 November 1984.

21　Nicholas Serota and Gavin Jantjes, *From Two Worlds*, Whitechapel, 1986.

22　For a discussion of the GLC's involvement with Black artists, see Eddie Chambers, 'Black Visual Arts activity in England, 1981–1986: Press and Public Responses' (doctoral dissertation, Goldsmiths College,

University of London, 1998), in particular Chapter 6, 'Black Artists and the Greater London Council'.

23 Rasheed Araeen, *The Other Story*, 1989. The artists were grouped into something of a chronological narrative, locating the work of Jamaican-born sculptor Ronald Moody in the first room of the exhibition, and thereafter taking its audiences through artists of the 1950s, 1960s, 1970s and 1980s. The final sections of the exhibition related to those artists who themselves had emerged into practice only a few years earlier, in some cases, well into the 1980s.

CHAPTER EIGHT

1 For more on the riots in Bristol in 1980, see Harris Joshua, Tina Wallace, Heather Booth, *To Ride the Storm: The 1980 Bristol Riot and the State*, Heinemann, 1983.

2 Andy McSmith, 'Inglan is a Bitch', *No Such Thing as Society: A History of Britain in the 1980s*, London: Constable & Robinson Ltd, 2011, p. 91.

3 The community centre is now known as the Malcolm X Centre.

4 *The Black-Art Gallery – It's [sic] Development*, gallery publicity, circa late 1983.

5 Ibid.

6 *Heart in Exile*, 4 September – 2 October 1983. It featured work by Tyrone Bravo, Vanley Burke, Pogus Caesar, Dee Casco, Eddie Chambers, Adrian Compton, Shakka Dedi, Olive Desnoes, Terry Dyer, Carl Gabriel, Funsani Gentiles, Anum Iyapo, George Kelly, Cherry Lawrence, Ossie Murray, Pitika Ntuli, Joseph Olubu, Keith Piper, Barry Simpson, Marlene Smith, Wayne Tenyue and someone going under the name 'Woodpecker'.

7 *A Statement on Black Art and the Gallery*, gallery publicity, circa late 1983.

8 Allan deSouza, 'An Imperial Legacy', in *Crossing Black Waters*, exhibition catalogue, Working Press, London, 1992, p.6.

9 *Conversations: An Exhibition of work by Sonia Boyce*, an announcement about Boyce's then forthcoming exhibition at The Black-Art Gallery, OBAALA Newsletter July/August 1986, Issue No. 2, p. 4. The exhibi-

tion's dates were given as 3 September – 4 October 1986.

10 *'Ask me no Question.... I tell you no lie', An exhibition of Painting &
 Sculpture Dedicated to the memory of Jo Olubo*, The Black-Art Gallery,
 London, 6 September – 20 October 1990.

11 *Sight•Seers: Visions of Afrika and the diaspora. Part Two of Eye-Sis •
 Afrikan Women's Photography*, Afia Yekwai, Elizabeth Hughes, Ifeoma
 Onyefulu, Jheni Arboine, and June Reid, The Black-Art Gallery,
 London, 3–19 December 1987. Exhibition brochure (unpaginated).

12 *The Potter's Art: Ceramics by Chris Bramble, Jon Churchill, Tony
 Ogogo, and Madge Spencer*, The Black-Art Gallery, London, 7 February
 – 24 March 1990.

13 *'So Anything Goes?'* flyer, 1986.

14 *Colours of Asia*, The Black-Art Gallery, London, 1 February – 7 March
 1992. Khulood Da'ami, Bhajan Hunjan, Ka Che Kwok, Keith Khan,
 Farzana Khatri, Walid Mustafa, Julie Potratz, Samena Rana, Tehmina
 Shah, Veena Stephenson and Ali Medhi Zaidi.

15 Zarina Bhimji, *I Will Always Be Here*, The Black-Art Gallery, London,
 27 January – 13 March 1993.

16 Lorraine Griffiths, 'Black arts put on the shelf', the *Weekly Journal*,
 Thursday October 28, 1992, p. 1.

17 The more common spelling of the artist's name was Shafique Uddin.

18 The dates of the four exhibitions were 24 January – 9 February 1990;
 14 February – 2 March 1990; 7–23 March 1990; and 28 March – 13 April
 1990. *The Other Story* itself ran from 29 November 1989 – 4 February
 1990, before touring to galleries in Wolverhampton and Manchester.

19 *In Focus* press release. In the press release, Jagjit Chuhan's name errone-
 ously appeared as Jagjit Thomas.

20 Veena Stephenson, 'In Focus', *Bazaar South Asian Arts Magazine*, Issue
 No. 12, p. 12 (feature on pp. 12/13).

CHAPTER NINE

1 *Sonia Boyce: Recent Work*, New Gallery, Whitechapel Art Gallery,
 London, 13 May – 26 June 26 1988.

2 Errol Lloyd, 'An Historical Perspective', introduction to *Caribbean
 Expressions in Britain*, exhibition catalogue, Leicestershire Museum and

Art Gallery, 16 August – 28 September 1986, pp. 5–6.

3 *Five Black Women Artists*, Sonia Boyce, Lubaina Himid, Claudette Johnson, Houria Niati, and Veronica Ryan. Africa Centre, London, 6 September – 14 October 1983.

4 The Combahee River Collective, 'A Black Feminist Statement,' in *All the Women are White, All the Blacks are Men, but Some of Us are Brave: Black Women's Studies*, edited by Gloria T. Hull, Patricia Bell Scott, and Barbara Smith. Old Westbury, New York, Feminist Press, 1982, pp. 13–22. The distinctive title of this particular publication was celebrated, some years later, by the Black women artists who were assembled for *Some of Us Are Brave All of Us Are Strong*, Jo Addo, Brenda Agard, Simone Alexander, Sonia Boyce, Lubaina Himid, Amanda Holiday, Clare Joseph, Eve-I Kadeena, Mowbray Odonkor, Marlene Smith, Maud Sulter and Audrey West, The Black-Art Gallery, London, 13 February – 15 March 1986.

5 The Combahee River Collective, 'A Black Feminist Statement', p. 13.

6 *The Image Employed: The use of narrative in Black art.* An exhibition of work selected by Marlene Smith and Keith Piper. Simone Alexander, Zarina Bhimji, Sutapa Biswas, Sonia Boyce, Chila Kumari Burman, Eddie Chambers, Jennifer Comrie, Amanda Holiday, Claudette Johnson, Tam Joseph, Trevor Matthison and Eddie George, Mowbray Odonkor, Keith Piper, Donald G Rodney, Marlene Smith, Allan deSouza. Cornerhouse, Manchester, 13 June – 19 July 1987.

7 Claudette Johnson, *Image Employed*, exhibition catalogue, unpaginated.

8 Ibid.

9 *Black Woman Time Now*, Battersea Arts Centre, London, 30 November – 31 December 1983.

10 *The Thin Black Line*, Institute of Contemporary Arts (ICA) London, Brenda Agard, Chila Kumari Burman, Sutapa Biswas, Sonia Boyce, Lubaina Himid, Claudette Johnson, Ingrid Pollard, Veronica Ryan, Marlene Smith, Jennifer Comrie, and Maud Sulter. 15 November 1985 – 26 January 1986.

11 Lubaina Himid, foreword to *The Thin Black Line*, exhibition catalogue, ICA, London, 1985, unpaginated.

12 This description is taken from the title of book by Wenda Parkinson, *This Gilded African: Toussaint L'Ouverture*, Quartet Books, London, 1978.

13 Toussaint L'Ouverture was in fact 59 when he died. *Scenes from the Life of Toussaint L'Ouverture* was acquired for the Arts Council Collection in 1988.

14 *Passion: Discourses on Blackwomen's Creativity*, Urban Fox Press, 1990, edited by Maud Sulter.

15 The Elbow Room, 'Freedom and Change: a statement from the Elbow Room' in *The Other Story*, exhibition catalogue, South Bank Centre 1989, pp. 122–4.

16 *Unrecorded Truths.* An exhibition selected by Lubaina Himid. Brenda Agard, Simone Alexander, David A. Bailey, Sutapa Biswas, Sonia Boyce, Keith Piper, Donald Rodney and Marlene Smith and Allan deSouza. The Elbow Room, London, 16 April – 16 May 1986.

17 Chila Kumari Burman, 'There Have Always Been Great Black Women Artists', in *Charting the Journey: Writings by Black and Third World Writers*, edited by Shabnam Grewal, Jackie Kay, Liliane Landor, Gail Lewis and Pratibha Parmar, London, Sheba Feminist Publishers, 1988, pp. 292–9.

18 Gilane Tawadros, 'Black Women [artists] in Britain: A Personal & Intellectual Journey', *Third Text*, 15, Summer 1991, pp. 71–6.

19 Lubaina Himid, 'Mapping: A Decade of Black Women Artists 1980–1990', *Passion: Discourses on Blackwomen's Creativity.* Urban Fox Press, 1990, pp. 63–72.

20 Gilane Tawadros, *Sonia Boyce: Speaking in Tongues*, Kala Press, London, 1997, and Lynda Nead, *Chila Kumari Burman: Beyond Two Cultures*, Kala Press, London, 1995.

21 Kelly Burton, 'Hemmed In', review of *The Thin Black Line*, *Race Today* magazine, January 1986, p. 26.

22 Sutapa Biswas and Marlene Smith, 'Black Women Artists', *Spare Rib*, No. 188, March 1988, pp. 8–12.

23 In *The Art of Reflection: Women Artists' Self-Portraiture in the Twentieth Century*, Marsha Meskimmon, Columbia University Press, 1996, a limited number of Black women artists are dealt with in a few pages at the end of the book ('Black Women Artists: The Politics of Gender and Race'). Meskimmon refers to these pages as 'this final section'.

24 Kwesi Owusu, 'Notting Hill Carnival: "De road is de stage, de stage is de road"', *The Struggle for Black Arts in Britain*, Comedia Publishing Group, London, 1986, pp. 1–26.

25 Ibid p. 21.

26 Sutapa Biswas and Marlene Smith, 'Black Women Artists', pp. 8–12.

27 Lubaina Himid, 'Afterword', a postscript on p.12 of the reprinted *The Thin Black Line* catalogue, Urban Fox Press, November 1989.

28 Merdelle Irving participated in exhibitions from the late 1960s onwards. See her CV in the catalogue for *Third World Within: An exhibition of the work of AfroAsian Artists in Britain* organised by Rasheed Araeen. Apart from Araeen himself, the exhibition featured Saleem Arif, David A Bailey, Sutapa Biswas, Avtarjeet Dhanjal, Uzo Egonu, Mona Hatoum, Merdelle Irving, Gavin Jantjes, Houria Niati, Keith Piper, and Kumiko Shimizu. Brixton Art Gallery, London, 31 March – 22 April 1986. Sue Smock (also known as Sue M. Smock, Sue Jane M. Smock, Sue Jane Mitchell Smock, and Sue Jane Smock) was an African-American artist (born New Orleans, Louisiana, in 1937) who in the 1970s was living and working in London. She received a BA degree from Oberlin College, Oberlin, Ohio and a Master of Fine Arts degree from Columbia University, New York. Smock was a fascinating artist who is yet to be the subject of substantial art historical and critical attention. She was described in one press article as 'a beautiful girl talented enough to share an art show with two of the most famous names in the world of art – Picasso and Giacometti – and to have her work on exhibit in many museums.' This same feature concluded with: 'For the foreseeable future London will be [her] base.' (See Robert Musel, 'Race prejudice disturbs Smock', the *Baltimore Afro-American*, Baltimore, Maryland), 20 June 1970, p. 15 (reprinted as 'Sue Jane Smock Professes Art is White Controlled', *Palm Beach Post*, (Thursday, 6 August 1970, page D4). A particularly substantial feature on Sue Jane Smock was Timeri Murari, 'Young, Black, Talented and Successful: Timeri Murari talks to Sue Jane Smock, a very rare American and an artist, whose work will be exhibited next month in Geneva side by side with new works by Picasso and Giacometti', The *Guardian*, (Thursday 16 April 1970, p9.)

29 *Festac '77* was the *2nd World Black and African Festival of Arts and Culture*, held in Lagos, Nigeria. An exhibition of British-based Black artists travelled to the festival. The significance of *Festac '77* is discussed in Chapter Three.

30 Rasheed Areen, *The Other Story*, 1989.

31 Sutapa Biswas, review of *The Other Story*, *New Statesman and Society*, 15 December 1989, pp. 40–2.

32 Ibid.

33 A term used by Keith Piper in an essay in his *Step into the Arena* exhibition catalogue, Rochdale Art Gallery, 1991, unpaginated.

34 Isaac Julien's films included *Territories* (1984), *Looking for Langston* (1989) and *Young Soul Rebels* (1991). All these films dealt with issues of homosexuality as concerns that were central to the narratives of the films. Likewise, the photographs of Rotimi Fani-Kayode, Ajamu and Sunil Gupta often depict and employ images of Black bodies/the Black body, located firmly within the arena of Black male homosexual identity, experience and relationships.

35 For a discussion of this, see Keith Piper's essay in his *Step into the Arena* exhibition catalogue, Rochdale Art Gallery, 1991.

36 *Disrupted Borders: An intervention in definitions of boundaries* was a book edited by Sunil Gupta and also an exhibition curated by him. The book was published by Rivers Oram Press, London, 1993. The exhibition contained work by Shahidul Alam, Emily Anderson, Monika Baker, Karl Beveridge, Sutapa Biswas, Kaucyita Brooke, Sheba Chhachhi, Carol Conde, Darrel Ellis, Jamelie Hassan, Doug Ischar, Jorma Puranen, Samena Rana, Renee Tobe and Millie Watson. It was first shown at Arnolfini, Bristol 18 September – 7 November 1993.

37 Sunil Gupta, (ed.), introduction to *Disrupted Borders: An intervention in definitions of boundaries*, Rivers Oram Press, London 1993, unpaginated.

CHAPTER TEN

1 *Room at the Top*, Nicola Jacobs Gallery, 9 Cork Street, 6 February – 9 March 1985.

2 *Sonia Boyce: Recent Work*, New Gallery, 13 May – 26 June 1988.

3 *Sonia Boyce*, Air Gallery, London, 11 December, 1986 – 25 January, 1987.

4 Gilane Tawadros, *Sonia Boyce: Speaking in Tongues*, Kala Press, London, 1997

5 For a substantial look at the West Indian Front Room, see *Front Room:*

Migrant Aesthetics in the Home, Michael McMillan, Black Dog Publishing, London, 2009.

6 Boyce's distinctive approach to rendering her own wallpaper was picked up and admiringly regarded by a number of writers. For example, in Whitney Chadwick's *Women, Art and Society*, (Thames and Hudson, 1990): 'Here [in *Lay Back, Keep Quiet and Think of What Made Britain So Great*] the image of the woman is displaced to the margin as the artist inserts an iconography of colonialism into the foliate forms of a decorative surface that recalls the cheerful domesticity of wallpaper.' (pp. 387/388). Within this book, however, Boyce's *Missionary Position II* was illustrated as being 'from *Lay Back, Keep Quiet and Think of What Made Britain So Great*', when in fact they are two distinct and separate pieces of work.

7 The word *womanism* was coined by American writer Alice Walker in her book *In Search of Our Mothers' Gardens* (London, the Women's Press, 1987) as a means of discussing and addressing the specificities of Black women to which Johnson's statements alluded.

8 Claudette Johnson, 'Issues Surrounding the Representation of the Naked Body of a Woman', *Feminist Arts News*, vol. 3, no. 8, pp. 12–4. Quoted in 'Black Women Artists: The Politics of Gender and Race', part of a chapter, 'The Body Politic', in *The Art of Reflection: Women Artists' Self-Portraiture in the Twentieth Century*, by Marsha Meskimmon, Columbia University Press, 1996, pp. 188–94.

9 *In This Skin: Drawings by Claudette Johnson*, The Black-Art Gallery, 27 May – 11 July 1992.

10 Steven McQueen, 'In This Skin: featuring Claudette Johnson,' *African Peoples Review* (August 1992), p 5.

11 Ibid.

12 *History and Identity: Seven Painters*, Said Adrus, Medina Hammad, Godfrey Lee, Mowbray Odonkor, Eugene Palmer, Tony Phillips and Lesley Sanderson, Norwich Gallery, Norwich, 16 March – 11 May 1991.

13 Mowbray Odonkor, statement in *History and Identity: Seven Painters*, exhibition catalogue, 1991, unpaginated.

14 Simone Alexander, 'Marlene Smith', *Artrage* No. 14, 1986, p. 30.

15 *The Times*, 16 January 1987, quoted in *Policing Against Black People*, London, Institute of Race Relations, 1987, p. 26

16 Kimathi Donkor memorably recreated the scene of Cynthia Jarrett's

tragic death in his painting *Madonna Metropolitan* (2005, oil on linen, 152 x 152cm). *Madonna Metropolitan* depicts a collapsed and dying Cynthia Jarrett, being attended to by one of her distressed daughters, whilst all around them police officers continue to turn the domestic room upside down in their search for whatever incriminating items they hope to find. For good measure, one of the officers is aggressively remonstrating with the daughter, jabbing his finger menacingly in her direction, even while life drains from the heart attack victim.

17 For a discussion of these 'riots' see *A Climate of Fear*, David Rose, Bloomsbury Publishing, 1992. For more on the Broadwater Farm riots, see the entry 'Broadwater Farm riots', in *The Oxford Companion to Black British Culture*, edited by David Dabydeen, John Gilmore and Cecily Jones, Oxford University Press, 2007, pp. 71–2.

18 *Housewives with Steak-Knives*, 1985, acrylic, pastel and Xerox collage on paper mounted on canvas, 274 x 244 cm. Collection: Bradford Museums and Galleries.

CHAPTER ELEVEN

1 'Sokari Douglas Camp in conversation with Lucinda Bredin', brochure for *Alali: sculpture by Sokari Douglas Camp*, Bluecoat Gallery, Liverpool, 28 May – 2 July 1988 and City of Plymouth Museums & Art Gallery, Plymouth, 23 July – 3 September 1988, unpaginated.

2 Bryan Biggs and Sarah Shalgosky, introduction to the brochure for *Alali: sculpture by Sokari Douglas Camp*, Bluecoat Gallery, Liverpool, 28 May – 2 July 1988 and City of Plymouth Museums & Art Gallery, Plymouth, 23 July – 3 September 1988, unpaginated.

3 Ibid.

4 Michael Crowder, *Sekiapu: Nigerian Masquerade With Sculpture by Sokari Douglas Camp*, catalogue text, unpaginated. The Africa Centre, Covent Garden London, 12 June – 2 July 1987.

5 Mora J. Beauchamp-Byrd, 'London Bridge: Late twentieth Century British Art and the Routes of 'National Culture', in *Transforming the Crown: African, Asian and Caribbean Artists in Britain 1966–1996*, exhibition catalogue, The Caribbean Cultural Center, New York, 1997, p. 26.

6 See for example, Waldemar Januszczak, 'Anger at Hand: Waldemar Januszczak on the barely controlled fury of *The Thin Black Line*', the *Guardian*, Arts Section, 27 November 1985, p. 23.

7 Ibid.

8 Adeola Solanke, 'Juggling Worlds', essay in *From Two Worlds*, exhibition catalogue, Whitechapel Art Gallery, London, 1986, p. 12.

9 Stella Santacatterina, 'Veronica Ryan: Compartments/Apart-ments', essay in *Veronica Ryan: Compartments/Apart-ments*, exhibition catalogue, Camden Arts Centre, London, February 1995.

10 *Four X 4* was described in its catalogue as 'an innovative exhibition project that brings together sixteen artists creating installations in four different gallery spaces'. Venues and dates as follows: Harris Museum and Art Gallery, Preston, 8 September – 17 October 1991, Shaheen Merali, Houria Niati, Sher Rajah, and Lesley Sanderson; Wolverhampton Art Gallery, 21 September – 2 November 1991, Oso Audu, Val Brown, Stephen Forde, and Rita Keegan; The City Gallery, Leicester, 9 October – 16 November 1991, Medina Hammad, Richard Hylton, Tony Phillips, and Folake Shoga; Arnolfini, 12 October – 24 November 1991, Permindar Kaur, Virginia Nimarkoh, Alistair Raphael, and Vincent Stokes. A fifth exhibition, featuring several installations presented at the Preston, Wolverhampton, Leicester and Bristol venues, titled *The Four X Retrospective* was shown at the Castle Museum, Nottingham, 18 January – 1 March 1992.

11 *Let the Canvas Come to Life With Dark Faces*. Organised by Eddie Chambers in collaboration with Herbert Art Gallery, April 14 – May 29 1990 and touring.

12 *Cold Comfort* was first shown, in two parts, at Ikon Gallery, Birmingham and Mead Gallery, Coventry, before touring to several galleries, including Bluecoat Gallery, Liverpool, 27 July – 31 August 1996.

13 Mora J. Beauchamp-Byrd, 'London Bridge: Late twentieth Century British Art', p. 26.

14 Roger Palmer, 'Permindar Kaur', a short essay on the artist contained in *Four x 4* (exhibition catalogue, unpaginated). *Four x 4* was 'an innovative exhibition project that brings together sixteen artists creating installations in four different gallery spaces.' Eddie Chambers, Bristol, 1991.

15 Sue Clive and Sarah Derrick, 'Eye openers', *Permindar Kaur Cold*

Comfort, exhibition guide, Mead Gallery, Warwick Arts Centre, University of Warwick, 1996.

16 Richard Cork, 'Injury Time' *British Art Show 4*, exhibition catalogue, Hayward National touring exhibitions, London, England, 1995, pp. 12–32.

17 'Permindar Kaur and Claire Doherty, 'Permindar Kaur Cold Comfort Interview: Claire Doherty', *Transcript: Journal of Visual Culture*, School of Fine Art, Duncan of Jordanstone College of Art, Vol. 2, Issue 2, 1996, p. 23.

CHAPTER TWELVE

1 The Arts Council-sponsored Institute of New International Visual Arts, as it was first known, was launched in the early 1990s. The word *New* would in time be dropped, though the acronym INIVA would remain, albeit in a constantly changing use of upper and lower case letters, such as Iniva and inIVA. Similarly, the words Institute of International Visual Arts appeared in a variety of upper and lower case letters. This book uses the acronym INIVA (upper case letters), as it first appeared in the organisation's publicity.

2 Susanne Everett, *History of Slavery*, London, Bison Books, 1978, p.46.

3 Everlyn Nicodemus, 'Routes to Independence', *Routes*, exhibition catalogue, Brunei Gallery, School of Oriental and African Studies, London, 1999, unpaginated.

4 Ibid.

5 For example, page 15 of the *Observer* of Sunday 2 February 1992 carried a full-page feature on Tyson (who at the time had been accused of, and was on trial for, raping a beauty queen contestant) under the headline 'Sad tale of the beauty and the "beast". Hugh McIlvanney in Indianapolis reports on the trial of former heavyweight boxing champion Mike Tyson (16 stone), accused of raping Desiree Lynn Washington (7 st 10 lb)'. One week later, a similar feature in the same newspaper on Sunday 9 February 1992, page 22, was titled 'The Raging Bull in the bedroom. 'Hugh McIlvanney in Indianapolis watches Mike Tyson launch his fight-back against a rape charge by detailing his foul-mouthed way of wooing.' Elsewhere, *The Sunday Times* of 16 February 1992 captioned a photo-

graph of Tyson with, 'No emotion: Tyson was the mean machine of Brownsville' (James Dalrymple, HARD TIME, *The Sunday Times*, Focus, page 11). Like other Black boxers before him, Tyson had to endure relentless vilification within the white media, which seemed intent on portraying the boxer as a sub-human delinquent beast.

6 Keith Piper, *The Nation's Finest*, video, 7 minutes, 1990. This video work seeks to explore issues of race and citizenship in sport. Available at http://vimeo.com/85809559 (accessed 20 March 2014).

7 Everlyn Nicodemus, 'Routes to Independence'.

8 Undated handwritten note to this author.

9 The Ministry of Truth was where Winston Smith, the main character of George Orwell's *Nineteen Eighty-Four*, worked. In the book, it is described as an enormous pyramidal structure of glittering white concrete rising some 300 metres into the air, containing in excess of 3,000 rooms above ground level. To emphasise the sinister and terror-laden function of the Ministry of Truth, on the outside wall of the building there appear three slogans of the Party: 'WAR IS PEACE,' 'FREEDOM IS SLAVERY,' and 'IGNORANCE IS STRENGTH.'

10 *Barbara Walker: Louder Than Words*, Unit 2 Gallery, London Metropolitan University, 18 November – 16 December 2006.

11 The exhibition ran from 10 June – 10 July 1993 at 198 Gallery and was described on its poster as 'Barber Shop Installation with Screen Prints on Steel'.

12 His father was Donald Locke, a highly accomplished and distinguished sculptor whose work was introduced to new audiences when it was included in Rasheed Araeen's 1989 Hayward Gallery exhibition, *The Other Story*. Donald Locke had for number of years practiced in Britain, before relocating to the US.

13 The British Art Show is a major survey exhibition organised every five years to showcase contemporary British Art. The first one took place in 1979. For more on Black artists and the British Art Show, see 'Coming in From the Cold: Some Black Artists are Embraced', *Things Done Change: The Cultural Politics of Recent Black Artists in Britain*, by Eddie Chambers, Rodopi Editions, Amsterdam and New York, 2012, in particular pages 211, 215.

14 *Hew Locke*, New Art Gallery, Walsall, 29 April – 26 June 2005.

15 Kris Kuramitsu, 'King Creole–Hew Locke's New Vision of Empire',

Hew Locke, exhibition catalogue, the New Art Gallery, Walsall, 2005, pp. 3–7.

16 'A Sargasso Sea-Hoard of Deciduous Things... Hew Locke and Sarat Maharaj in conversation', 2005, p. 8.

CHAPTER THIRTEEN

1 For a discussion of the successes and significance of Steve McQueen, Chris Ofili and Yinka Shonibare, see Eddie Chambers, *Things Done Change: The Cultural Politics of Recent Black Artists in Britain*, Rodopi Editions, 2012, in particular Chapter Three, 'Chris, Steve and Yinka: We Run Tings', from which this chapter draws.

2 The term 'yBa' is used in this book to refer to certain types of practitioners who collectively, and in some instances, rather loosely, came to be known as *young British artists*. The term, which appears as either yBa or YBA, originated in the early 1990s, centred on the work of Damien Hirst and a number of other artists. This book uses the letters yBa, though the term, when quoted, appears as it was originally written. Louisa Buck has offered a useful summary of its origins:

> [Charles] Saatchi had attended [Damien] Hirst's famous Freeze exhibition in 1988, and soon began to bulk-buy this new batch of home-grown talent. He also set about applying his marketing skills to the promotion of these artists and their work, initially in a series of widely publicised exhibitions at Boundary Road [the original home of the Saatchi Gallery, in St John's Wood, London] during 1992–95 under the collective title of Young British Artists. The acronym stuck, and soon any artist of that generation, whether or not they had been to Goldsmiths [College], was branded YBA. (Louisa Buck, 'The Tate, the Turner Prize and the Art World,' in *The Turner Prize and British Art*, London, Tate Gallery, 2007, p. 19).

3 Shonibare's education was at Byam Shaw School of Art, London, 1984–9 and Goldsmiths College, London, 1989–91.

4 Elsbeth Court, 'Yinka Shonibare: Finalist, Barclays Young Artist Award', *African Arts*, Vol. 26, No. 1 (Jan., 1993), pp. 79–81.

5 *Interrogating Identity*, Gray Art Gallery and Study Center, New York University, 1991, exhibition catalogue, p. 132. The exhibition's dates were 12 March – 18 May 1991. It then toured to venues in Boston, Massachusetts, Minneapolis, Minnesota, Madison, Wisconsin, and Oberlin, Ohio, between August 1991 and November 1992. Work by Rasheed Araeen, Rebecca Belmore, Nadine Chan, Albert Chong, Allan deSouza, Jamelie Hassan, Mona Hatoum, Roshini Kempadoo, Glenn Ligon, Whitfield Lovell, Lani Maestro, Lillian Mulero, Ming Mur-Ray, Keith Piper, Ingrid Pollard, Donald Rodney, Yinka Shonibare and Gary Simmons. The artists were drawn from Canada, the United States and the United Kingdom.

6 See the catalogues *Tam Joseph: This is History* (touring exhibition, including Mappin Art Gallery, Sheffield, 7 March – 19 April 1998); *Eugene Palmer* (touring exhibition, originating at Norwich Gallery, 15 November – 17 December 1993); *Denzil Forrester: Two Decades of Painting* (4 Victoria Street, Bristol, June 4 – July 6, 2002).

7 Barclays Young Artist Award 1992, Serpentine Gallery, London, 5 February – 8 March, 1992. Richard Ducker, Janice Howard, Andrew Kearney, Gabriel Klasmer, Joanna Lawrance, Lisa Richardson, Stefan Shankland, Yinka Shonibare and Mari Tachikawa.

8 Elsbeth Court, 'Yinka Shonibare: Finalist', pp. 79–81.

9 'Portrait of the artist: Yinka Shonibare, artist'. Interview by Laura Barnett, the *Guardian G2*, Tuesday 27 January 2009, p. 25.

10 Shonibare was included in the 2nd Johannesburg *Biennale* of 1997, *Trade Routes: History and Geography*, Artistic Director Okwui Enwezor, 12 October 1997 – 18 January 1998. As well as being included in *Documenta X*, exhibition of contemporary art, Kassel 21 June – 28 September 1997, curated by Catherine David, Steve McQueen's work was also included in *Documenta XI*, curated by Okwui Enwezor, 8 June – 15 September 2002.

11 Michael Bracewell, 'Growing Up in Public: The Turner Prize and the Media 1984–2006', in *The Turner Prize and British Art*, Tate, 2007, p.80.

12 Elsbeth Court, 'Yinka Shonibare: Finalist', pp. 79–81.

13 *Yinka Shonibare: Double Dutch*, Centre 181 Gallery, London 2–25 February 1994.

14 Julian Stallabrass, *High Art Lite: The Rise and Fall of Young British Art*, Verso, 1999 (fourth edition, 2006), p. 108.

15 Ibid.

16 Ibid pp. 118–9.

17 Rachel Newsome, 'Afro Daze', *Dazed & Confused*, No 48, November 1998, p. 76.

18 Richard Dyer, 'Chris Ofili', *Wasafiri*, No. 29 Spring 1999, pp. 79–80.

19 For a substantial account of the Stephen Lawrence affair, see Brian Cathcart, *The Case of Stephen Lawrence*, Penguin Books Ltd, Harmondsworth, 2000.

20 It was not until 2012 that two of Lawrence's killers, Gary Dobson and David Norris, were found guilty of his murder.

21 For more on the Macpherson Report, see the entry *Macpherson Report*, in *The Oxford Companion to Black British Culture*, edited by David Dabydeen, John Gilmore and Cecily Jones, Oxford University Press, 2007, pp. 281–2.

22 For an account of the tragedy, see Cecily Jones, 'New Cross fire', *The Oxford Companion to Black British History*, edited by David Dabydeen, John Gilmore and Cecily Jones, Oxford University Press, 2007, pp. 341–2. See also *The New Cross Massacre Story: Interviews With John La Rose*, published by Alliance of the Black Parents Movement, Black Youth Movement And The Race Today Collective, London, 1984 and Peter Fryer, 'The New Generation', from *Staying Power: The History of Black People in Britain*, Pluto Press, London, 1985 pp. 387–99. See also Chapter Seven.

23 See *The Turner Prize 1998*, catalogue published by Tate Gallery Publishing, London, 1998.

24 *The Turner Prize 1998*.

25 Virginia Button, *The Turner Prize*, Tate Gallery Publishing, 1999, p. 142.

26 Julian Stallabrass, *High Art Lite*, p. 109.

27 Chris Ofili, *Painting With Shit on It* (1993), acrylic paint, oil paint, polyester resin, elephant dung on canvas, 183 x 122 cm, British Council Collection.

28 Julian Stallabrass, *High Art Lite*, p. 108.

29 *Chris Ofili*, 1998, director, Sarah Wason, co-producer Augustus Casely-Hayford, an LWT Programme.

30 Jane Withers, 'Within These Walls', *Guardian Weekend*, November 25 2000, pp. 59–66. The *Guardian Weekend* magazine went on to produce

substantial features on Ofili in two further issues. The first featured a detail of a work by Ofili on its cover, together with the cover text *Chris Ofili Paints His Way to Paradise*. The feature, written by Jonathan Jones, was titled 'Paradise Reclaimed' (*Guardian Weekend*, Saturday 15 June 2002, pp. 18–23, 95). The second was a feature by Gary Younge – *Been There Dung That – Why did Chris Ofili turn his back on art? And why make a comeback now?* – titled 'A bright new wave' (*Guardian Weekend*, Saturday 16 January 2010, pp. 24–7). Beyond this, another substantial piece of *Guardian* coverage on Ofili was a full-page feature, in the main newspaper, on his 2010 mid-career retrospective at Tate Britain. Written by Charlotte Higgins, it was titled 'In retrospect, Turner prize winner Ofili has gone from urban jungle to Caribbean vision' (the *Guardian*, 26 January 2010, p. 7). For good measure, the *Guardian G2* supplement of the same issue included a comment piece on Ofili, written by long-time Ofili admirer, Adrian Searle: 'Chris Ofili heads into the shadows. Hip, cool and wildly inventive, Chris Ofili burst onto the scene in the early 90s. Now he's ditching the dung and the glitter, and going some place darker' (the *Guardian G2*, 26 January 2010, pp. 19–21).

31 *Goldsmiths B.A. Fine Art Nineteen 93* catalogue.

32 *Mirage: Enigmas of Race, Difference and Desire*, ICA, London, curated by David A. Bailey and Catherine Ugwu. An ICA/INIVA season, 12 May – 16 July 1995. Lyle Ashton Harris, Sonia Boyce, Nina Edge, Ronald Fraser-Munro, Mario Gardner, Edward George and Trevor Mathieson, Renée Green, Isaac Julien, Keith Khan, Marcus Kuiland-Nazario, Marc Latamie, Susan Lewis, Glenn Ligon, Steve McQueen, Sarbjit Samra and Carmelita Tropicana.

33 Michael Rush, 'Deadpan Appropriation', *Review*, New York, December 15, 1997, p. 1.

34 Ibid. As well as having been included in *Documenta X*, exhibition of contemporary art, Kassel, 21 June – 28 September 1997 (curated by Catherine David), Steve McQueen's work was also later included in *Documenta XI* (curated by Okwui Enwezor) 8 June – 15 September 2002.

35 David Frankel, 'Openings, Steve McQueen', *Artforum* 36, No. 3, November 1997, p. 102.

36 *Art Review*, Summer 2009.

37 Chris Townsend, *New Art From London*, Thames & Hudson, 2006, p. 18

38 Michael Rush, 'Deadpan Appropriation', *Review*, New York, December 15, 1997, p. 1.

39 Ibid p. 5.

40 *Steve McQueen*, Institute of Contemporary Arts, London, 30 January – 21 March 1999. The exhibition also showed at Kunsthalle, Zürich, 12 June – 15 August 1999. It was for this exhibition that McQueen was shortlisted for the Turner Prize in 1999.

41 *The Thin Black Line*, Brenda Agard, Chila Kumari Burman, Sutapa Biswas, Sonia Boyce, Lubaina Himid, Claudette Johnson, Ingrid Pollard, Veronica Ryan, Marlene Smith, Jennifer Comrie and Maud Sulter. Institute of Contemporary Arts (ICA) London, November 15 1985 – 26 January 1986.

42 *Mirage: Enigmas of Race, Difference and Desire*, ICA, London, 12 May – 16 July 1995.

43 *The Turner Prize 1999: An Exhibition of Work by the Shortlisted Artists*, catalogue published by Tate Publishing, 1999.

EPILOGUE

1 This attention included an adulatory review in the *Guardian*, and a substantial feature in *Frieze* magazine, the cover of which featured a work by Yiadom-Boakye. (Jennifer Higgie, 'The Fictitious Portraits of Lynette Yiadom-Boakye', *Frieze*, Issue 146, April 2012, pp. 86–91)

2 *Lynette Yiadom-Boakye: Any Number of Preoccupations*, Studio Museum in Harlem, 11 November 2010 – 13 March 2011.

3 www.luxonline.org.uk/artists/grace_ndiritu/the_nightingale.html (accessed 4 October 2013).

4 *Migrations: Journeys into British Art*, Tate Britain, 31 January – 12 August 2012. Amongst the seventy or so artists in *Migrations*, the exhibition included work by Rasheed Araeen, Black Audio Film Collective, Frank Bowling OBE, RA, Sonia Boyce MBE, Avinash Chandra, Mona Hatoum, Lubaina Himid MBE, Kim Lim, Yuan-chia Li, Steve McQueen OBE, CBE, David Medalla, Ronald Moody, Rosalind Nashashibi, Keith Piper, Donald Rodney, Zineb Sedira, Anwar Jalal Shemza, Francis Newton Souza and Aubrey Williams.

Bibliography

'1972 Prizewinners', *African Arts*, Vol. VI, No. 2, Winter 1973, pp. 8–13.

Adekeye, Adeyemo, 'Uzo Egonu of Nigeria', *African Arts*, Vol. VII, No. 1, Autumn 1973, pp. 34–7.

Ajai, Taiwo, 'Drum Call for Black Britain', *Africa magazine*, No. 44, April 1975, p. 43.

Alexander, Simone, 'Marlene Smith', *Artrage*, No. 14, 1986, p. 30.

Araeen, Rasheed, 'Afro-Caribbean Art', *Black Phoenix*, No. 2, Summer 1978 pp. 30–1.

———— 'The Arts Britain *really* Ignores', *Making Myself Visible*, London: Kala Press, 1984, pp. 100–5.

———— 'Conversation with Aubrey Williams', *Third Text*, Vol. 1, No. 2, Winter 1987/8, pp. 25–52.

———— 'The Emergence of Black Consciousness in Contemporary Art in Britain: Seventeen Years of Neglected History', *The Essential Black Art*, exhibition catalogue, Chisenhale Gallery/Black Umbrella, London: Kala Press, 1988, pp. 5–11.

———— 'Chronology', *The Essential Black Art*, exhibition catalogue, Chisenhale Gallery/Black Umbrella, London: Kala Press, 1988, pp. 12–28.

———— 'In the Citadel of Modernism', *The Other Story*, exhibition catalogue, London: Hayward Gallery/South Bank Centre, 1989, pp. 16–49.

———— 'Recovering Cultural Metaphors', *The Other Story*, exhibition catalogue, London: Hayward Gallery/South Bank Centre, 1989, pp. 82–104.

———— *The Other Story: Afro-Asian artists in postwar Britain*, exhibition catalogue, London: Hayward Gallery, 1989.

Araeen, Rasheed and H.O. Nazareth, 'Backlash, Caboo: the Making of a Caribbean Artist', *Race Today*, March 1975, pp. 67–8.

Archer, William George, 'Avinash Chandra: painter from India', *The Studio*, Vol. 161, No. 813, January 1961, pp. 4–7.

―――― introduction to *Avinash Chandra*, exhibition catalogue, London: Hamilton Galleries, 1965, unpaginated.

Archive Season: Zarina Bhimji, press release, London: INIVA, 2004.

Balshaw, Maria, with Bryony Bond, Mary Griffiths and Natasha Howes, 'Facing Forward: West Africa to Manchester', *We Face Forward: Art from West Africa Today*, exhibition catalogue, Manchester City Galleries and Whitworth Art Gallery, 2012, pp. 5–13.

Bamgboye, Oladele Ajiboye, *Writings on Technology and Culture*, Manchester: Cornerhouse Publications, 2000.

Bandaranayake, Senake and Manuel Fonseka, 'An Introduction to the Paintings', *Ivan Peries: Paintings 1938–88*, Colombo, Sri Lanka: Tamarind Books, 1996, pp. 9–21.

Barnett, Laura, 'Portrait of the artist: Yinka Shonibare, artist', interview, the *Guardian G2*, Tuesday 27 January 2009, p. 25.

Beauchamp-Byrd, Mora J., 'London Bridge: Late 20th Century British Art and the Routes of 'National Culture', *Transforming the Crown: African, Asian and Caribbean Artists in Britain 1966–1996*, exhibition catalogue, New York: Caribbean Cultural Center, 1997, pp. 16–45.

Bellos, Alex, 'Police reveal arrests of rock festival guards', the *Guardian*, 30 August 1995, p. 7.

Bennett, George, 'BBC Art Competition 1970', *African Arts*, Vol. V, No. 1., Autumn 1971, pp. 36–8.

Biggs, Bryan and Sarah Shalgosky, introduction to *Alali: sculpture by Sokari Douglas Camp*, exhibition brochure, Bluecoat Gallery, Liverpool, and City of Plymouth Museums & Art Gallery, Plymouth, 1988, unpaginated.

'Biographies', *Contemporary African Art*, exhibition catalogue, London: Studio International and Africana Publishing Corporation/Camden Arts Centre, 1969, pp. 34–8.

Biswas, Sutapa, 'Review of The Other Story', *New Statesman and Society*, 15 December 1989, pp. 40–2.

Biswas, Sutapa and Marlene Smith, 'Black Women Artists', *Spare Rib*, No. 188, March 1988, pp. 8–12.

Black Art an' done: An Exhibition of Work by Young Black Artists, press release, Wolverhampton Art Gallery, June 1981.

Black Audio Film Collective, London, *3 Songs on Pain, Light and Time*, a film about Donald Rodney by Trevor Mathison and Edward George, colour, sound, Digibeta, 25 mins, 1995.

Bowen, Denis, 'Guyana dreaming in paint', addendum to Aubrey Williams obituary, the *Guardian*, Tuesday 1 May 1990, p. 25.

Bracewell, Michael, 'Growing Up in Public: The Turner Prize and the Media 1984–2006', *The Turner Prize and British Art*, London: Tate Gallery, 2007, pp. 74–85.

Brathwaite, Edward, 'The Caribbean Artists Movement', *Caribbean Quarterly*, Vol. 14, No. 1/2, A Survey of the Arts, March–June 1968, pp. 57–9.

Brett, Guy, introduction to *Aubrey Williams*, exhibition catalogue, Shibuya, Japan: Tokyu Plaza, 1988, unpaginated.

—— 'Aubrey Williams', obituary, the *Independent*, Tuesday 1 May 1999, p. 15.

—— 'A Tragic Excitement', *Aubrey Williams*, exhibition catalogue, London: Institute of International Visual Arts (INIVA) in association with the Whitechapel Art Gallery, 1998, pp. 22–32.

—— 'A Reputation Restored', *Tate International Arts and Culture*, London: Tate Gallery, March/April 2003, pp. 78–80.

Buck, Louisa, 'The Tate, the Turner Prize and the Art World,' *The Turner Prize and British Art*, London: Tate Gallery, 2007, pp. 12–25.

Burman, Chila Kumari, 'There Have Always Been Great Black Women Artists', *Charting the Journey: Writings by Black and Third World Writers*, edited by Shabnam Grewal, Jackie Kay, Liliane Landor, Gail Lewis and Pratibha Parmar, London: Sheba Feminist Publishers, 1988, pp. 292–9.

Burton, Kelly, 'Hemmed In', review of *The Thin Black Line*, *Race Today*, London, January 1986, p. 26.

Button, Virginia, *The Turner Prize*, London: Tate Gallery Publishing, 1999.

'Caboo: The Making of a Caribbean Artist', *Race Today*, February 1975, pp. 36–9.

Caribbean Focus '86, press release, March 1986.

'Carnival Time', *Daily Telegraph*, Tuesday 29 August 1995, p. 2.

Cathcart, Brian, *The Case of Stephen Lawrence*, Harmondsworth: Penguin Books, 2000.

Chadwick, Whitney, *Women Art and Society*, London: Thames and Hudson, 1990.

Chambers, Eddie, 'Black Visual Arts Activity in England, 1981–1986: Press and Public Responses', doctoral dissertation, Goldsmiths College, University of London, 1998.

———— 'His Catechism: The Art of Donald Rodney', *Third Text* 44 London: Autumn 1998, pp. 43–54.

———— *Next We Change Earth*, exhibition catalogue, Nottingham: New Art Exchange, 2008.

———— *Things Done Change: The Cultural Politics of Recent Black Artists in Britain*, Amsterdam and New York: Rodopi Editions, 2012.

Clive, Sue and Sarah Derrick, 'Eye openers', *Permindar Kaur Cold Comfort*, exhibition guide, Mead Gallery, Warwick Arts Centre, University of Warwick, 1996.

The Combahee River Collective, 'A Black Feminist Statement,' *All the Women are White, All the Blacks are Men, but Some of Us are Brave: Black Women's Studies*, edited by Gloria T. Hull, Patricia Bell Scott, and Barbara Smith, Old Westbury: New York, Feminist Press, 1982, pp. 13–22.

Cooper, Emmanuel, 'In View', *Art & Artists*, London: Hansom Books, Vol. 13, No. 3, Issue No. 148, July 1978, p. 50.

Cork, Richard, 'Injury Time', *British Art Show 4*, exhibition catalogue, London: Hayward National Touring Exhibitions, 1995, pp. 12–32.

Court, Elsbeth, 'Yinka Shonibare: Finalist, Barclays Young Artist Award', *African Arts*, Vol. 26, No. 1, January 1993, pp. 79–81.

Crowder, Michael, *Sekiapu: Nigerian Masquerade With Sculpture by Sokari Douglas Camp*, exhibition catalogue, The Africa Centre, Covent Garden London, 1987.

Dalrymple, James, 'HARD TIME', *Focus, Sunday Times*, 16 February 1992, p. 11.

Delange, Jacqueline and Philip Fry, introduction to *Contemporary African Art*, exhibition catalogue, London: Studio International and Africana Publishing Corporation/Camden Arts Centre, 1969, pp. 5–8.

Deliss, Clémentine, '7+7=1: Seven stories, seven stages, one exhibition', *Seven Stories About Modern Art in Africa*, exhibition catalogue, London: Whitechapel Art Gallery, London, 1995, pp. 13–27.

Denzil Forrester: Dub Transition, A Decade of Paintings 1980–1990, gallery guide, Newcastle upon Tyne: Laing Art Gallery, 1991.

deSouza, Allan, 'An Imperial Legacy', *Crossing Black Waters*, exhibition catalogue, London: Working Press, 1992, pp. 6–8.

Douglas Camp, Sokari and Lucinda Bredin, 'Sokari Douglas Camp in conversation with Lucinda Bredin', *Alali: sculpture by Sokari Douglas Camp*,

exhibition catalogue, Bluecoat Gallery, Liverpool and City of Plymouth Museums & Art Gallery, Plymouth, 1988, unpaginated.

'DRUM ARTS CENTRE', *Race Today*, March 1975, p. 72.

Dunn, Phillip C. and Thomas L Johnson, *A True Likeness: The Black South of Richard Samuel Roberts: 1920–1936*, Chapel Hill, North Carolina: Bruccoli Clark, Columbia, South Carolina and Algonquin Books, 1986.

Dyer, Richard, 'Chris Ofili', *Wasafiri*, Issue 29, Spring 1999, pp. 79–80.

—— 'Rasheed Araeen', *Wasafiri*, Issue 53, Spring 2008, pp. 22–33.

Everett, Susanne, *History of Slavery*, London, Bison Books, 1978.

Fernando, Solani, 'Chila Kumari Burman', *Beyond Frontiers: Contemporary British Art by Artists of South Asian Descent*, edited by Amal Ghosh and Juginder Lamba, London: Saffron Books, 2001, pp. 57–63.

Fisher, Jean, 'Seven stories about modern art in Africa,' *Artforum*, Vol. 34, No. 5, January 1996, pp: 94.

Frankel, David, 'Openings, Steve McQueen', *Artforum* Vol. 36, No. 3, November 1997, pp. 102–3.

'Freedom and Change: a statement from the Elbow Room', *The Other Story*, exhibition catalogue, South Bank Centre 1989:, pp. 122–4.

Fryer, Peter, 'The New Generation', *Staying Power: The History of Black People in Britain*, London: Pluto Press, 1984, pp. 387–99.

Gayford, Martin, untitled essay, *Frank Bowling: Bowling on Through the Century*, exhibition catalogue, Bristol, 1996, pp. 3–7.

Ghosh, Amal and Juginder Lamba, (eds), preface to *Beyond Frontiers: Contemporary British Artists of South Asian Descent*, London: Saffron Books, 2001, pp. 11–3.

Gooding, Mel, 'Dying Swans and a Spiral Staircase: Images of Crisis', *Frank Bowling*, London: Royal Academy of Art, 2011, pp. 40–50.

Grewal, Shabnam, Jackie Kay, Liliane Landor, Gail Lewis and Pratibha Parmar, (eds), *Charting the Journey: Writings by Black and Third World Writers*, London: Sheba Feminist Publishers, 1988.

Griffiths, Lorraine, 'Black arts put on the shelf', the *Weekly Journal*, Thursday 28 October 1992, p. 1.

Gupta, Sunil (ed.), *Disrupted Borders: An intervention in definitions of boundaries*, exhibition catalogue, London: Rivers Oram Press, 1993.

Haworth-Booth, Mark, introduction to *Zarina Bhimji: I will always be here*, exhibition catalogue, Ikon Gallery, 1992.

Herbert, Martin and Mark Rappolt, 'Steve McQueen', *Art Review*, Summer 2009, pp. 74–9.

Higgie, Jennifer, 'The Fictitious Portraits of Lynette Yiadom-Boakye', *Frieze*, Issue 146, April 2012, pp. 86–91.

Higgins, Charlotte, 'In retrospect, Turner prize winner Ofili has gone from urban jungle to Caribbean vision', the *Guardian*, 26 January 2010, pp. 7.

Himid, Lubaina, foreword to *The Thin Black Line*, exhibition catalogue, ICA, 1985, unpaginated.

—— afterword to *The Thin Black Line* (reprint), exhibition catalogue, Hebden Bridge: Urban Fox Press, November 1989, p. 12.

—— 'Mapping: A Decade of Black Women Artists 1980–1990', *Passion: Discourses on Blackwomen's Creativity*, edited by Maud Sulter, Hebden Bridge: Urban Fox Press, 1990, pp. 63–72.

Hopkins, Nick, 'Policing of Notting Hill Carnival cost £5.6m', the *Guardian*, 1 June 2002, p. 9.

Houfe, Simon, 'Social Realism 1850–1890', *The Dictionary of British Book Illustrators and Caricaturists, 1800–1914*, Woodbridge, Suffolk: Antique Collectors' Club, 1978, pp. 148–157.

Hull, Gloria T., Patricia Bell Scott, and Barbara Smith, (eds), *All the Women are White, All the Blacks are Men, but Some of Us are Brave: Black Women's Studies*, Old Westbury, New York: Feminist Press, 1982.

Hylton, Richard (ed.), *Doublethink*, essays by Eddie Chambers and Virginia Nimarkoh, London: Autograph, 2003.

—— text for *Eugene Palmer: Index*, exhibition catalogue, Ipswich: Wolsey Art Gallery, Christchurch Mansion, 2004.

In Focus, press release, Horizon Gallery, London, January 1990.

Institute of Race Relations, *Policing Against Black People*, London: Institute of Race Relations, 1987.

Januszczak, Waldemar, 'Anger at Hand: Waldemar Januszczak on the barely controlled fury of The Thin Black Line', the *Guardian*, Arts Section, 27 November 1985, p. 23.

Johnson, Claudette, 'Artist's Statement', *Image Employed*, exhibition catalogue, 1987, unpaginated.

—— 'Issues Surrounding the Representation of the Naked Body of a Woman', *Feminist Arts News*, Vol. 3, No. 8, pp. 12–14, quoted in 'Black Women Artists: The Politics of Gender and Race', *The Body Politic*, in *The Art of Reflection: Women Artists' Self-Portraiture in the Twentieth*

Century, Marsha Meskimmon, New York: Columbia University Press, 1996, pp. 188–194.

Jones, Cecily, 'Broadwater Farm riots', *Oxford Companion to Black British Culture*, edited by David Dabydeen, John Gilmore and Cecily Jones, Oxford: Oxford University Press, 2007, pp. 71–2.

—— 'New Cross fire', *The Oxford Companion to Black British History*, edited by David Dabydeen, John Gilmore and Cecily Jones, Oxford: Oxford University Press, 2007, pp. 341–2.

Jones, Cecily and Ian Jones, 'MacPherson Report', *The Oxford Companion to Black British Culture*, edited by David Dabydeen, John Gilmore and Cecily Jones, Oxford: Oxford University Press, 2007, pp. 281–2.

Jones, Jonathan, 'Paradise Reclaimed', *Guardian Weekend*, Saturday 15 June 2002, pp. 18–23, 95.

Joshua, Harris, Tina Wallace and Heather Booth, *To Ride the Storm: The 1980 Bristol Riot and the State*, London: Heinemann, 1983.

Kapur, Geeta, 'London, New York and the Subcontinent', *Francis Newton Souza: Bridging Western and Indian Modern Art*, by Aziz Kurtha, Ahmedabad, India: Mapin Publishing Pvt. Ltd, 2006, pp. 64–93.

Karenga, Ron, 'Black Cultural Nationalism', *The Black Aesthetic*, edited by Addison Gayle Jr., New York: Doubleday & Company Inc. 1971, pp. 32–8.

—— 'Black Art: Mute Matter Given Form and Function', *Black Poets and Prophets: The Theory, Practice and Esthetics of the Pan-Africanist Revolution: A Bold, Uncompromisingly Clear Blueprint for Black Liberation*, edited by Woodie King and Earl Anthony, New York: Mentor Book, 1972.

Kaur, Permindar and Claire Doherty, 'Permindar Kaur Cold Comfort Interview: Claire Doherty', *Transcript: Journal of Visual Culture*, School of Fine Art, Duncan of Jordanstone College of Art, Vol. 2, Issue 2, 1996, pp. 18–25.

Khan, Naseem, *The Arts Britain Ignores*, The Arts Council of Great Britain, Calouste Gulbenkian Foundation and the Community Relations Council, 1976.

King, Reyahn, *Anwar Shemza*, exhibition catalogue, Birmingham Museum and Art Gallery, 1998.

Kuramitsu, Kris, 'King Creole–Hew Locke's New Vision of Empire', *Hew Locke*, exhibition catalogue, the New Art Gallery, Walsall, 2005, pp. 3–7.

Kurtha, Aziz, 'Origin and Influence', *Francis Newton Souza: Bridging*

Western and Indian Modern Art , Ahmedabad, India: Mapin Publishing Pvt. Ltd, 2006, pp. 12–63.

La Rose, John, *The New Cross Massacre Story: Interviews With John La Rose*, London: Alliance of the Black Parents Movement, Black Youth Movement And The Race Today Collective, 1984.

La Rose, John and Andrew Salkey, preface to *Savacou* 9/10, 'Writing Away From Home', 1974, p. 8.

Lamba, Juginder, introduction to *South Asian Contemporary Visual Arts Festival*, programme guide, 1993, p. 1.

Lampert, Catherine, foreword to *Seven Stories About Modern Art in Africa*, exhibition catalogue, London: Whitechapel Art Gallery, 1995, pp. 9–11.

Legg, Helen, (ed.), *Haroon Mirza: A User's Manual*, Bristol: Spike Island, 2013.

Lloyd, Errol, 'An Historical Perspective', introduction to *Caribbean Expressions in Britain*, exhibition catalogue, Leicestershire Museum and Art Gallery, 1986, pp. 5–6.

Locke, Hew and Sarat Maharaj, 'A Sargasso Sea-Hoard of Deciduous Things . . . Hew Locke and Sarat Maharaj in Conversation', *Hew Locke*, exhibition catalogue, Walsall: the New Art Gallery 2005, pp. 8–16.

Lyons, John, 'Denzil Forrester's Art in Context', *Denzil Forrester: Dub Transition, A Decade of Paintings 1980–1990*, exhibition catalogue, Preston: Harris Museum & Art Gallery, 1990, pp. 16–21.

Malbert, Roger, preface to *Africa Remix*, exhibition catalogue, Germany, London: Hatje Cantz Publishers/Hayward Gallery Publishing, 2005, pp. 9–10.

—— introduction to *Africa Remix*, exhibition catalogue, Germany, Hatje Cantz Publishers, London: Hayward Gallery Publishing, 2005, p. 11.

Mapondera, John, introduction to *Afro-Caribbean Art*, exhibition catalogue, 52 Earlham Street, London: Arts Centre, Artists Market, 1978, unpaginated.

Marsack, Robyn, 'Maud Sulter' obituary, the *Herald*, Glasgow, 22 March 2008, p. 17.

Martin, Courtney J., 'Surely, There Was a Flow: African-British Artists in the Twentieth Century', *Flow*, exhibition catalogue, Studio Museum in Harlem, New York, 2008, pp. 63–9.

McCarthy, Michael, 'Nelson's "Victory" joins him in Trafalgar Square', the *Independent*, 25 May 2010, p. 16.

McIlvanney, Hugh, 'Sad tale of the beauty and the "beast"', *Observer*, Sunday 2 February 1992, p. 15.

——— 'The Raging Bull in the bedroom', *Observer*, Sunday 9 February 1992, p. 22.

McMillan, Michael, *Front Room: Migrant Aesthetics in the Home*, London, Black Dog Publishing, 2009.

McQueen, Steven, 'In This Skin: featuring Claudette Johnson,' *African Peoples Review*, August 1992, p. 5.

McSmith, Andy, 'Inglan is a Bitch', *No Such Thing as Society: A History of Britain in the 1980s*, London: Constable & Robinson Ltd, 2011, pp. 86–110

Mercer, Kobena, 'Frank Bowling's Map Paintings', *Fault Lines: Contemporary African Art and Shifting Landscapes*, exhibition catalogue edited by Gilane Tawadros and Sarah Campbell, London: INIVA, 2003, pp. 139–149.

——— 'Black Atlantic Abstraction: Aubrey Williams and Frank Bowling', *Discrepant Abstraction*, Cambridge, Massachusetts, the MIT Press, Massachusetts Institute of Technology and London: INIVA the Institute of International Visual Arts, 2006, pp. 182–205.

Meskimmon, Marsha, 'Black Women Artists: The Politics of Gender and Race', *The Art of Reflection: Women Artists' Self-Portraiture in the Twentieth Century*, New York: Columbia University Press, 1996, pp. 188–194.

Moody, Cynthia, 'Ronald Moody: A Man true to his Vision', *Third Text* 8/9, Autumn/Winter 1989, pp. 5–24.

Moore, Gerald, 'About this Exhibition', *Contemporary African Art*, exhibition catalogue, London: Studio International and Africana Publishing Corporation/Camden Arts Centre, 1969, p. 13.

Morrison, Lionel, Principal Information Officer of Commission for Racial Equality to Sheldon Williams, letter, 6 February 1980, private collection.

Murari, Timeri, 'Young, Black, Talented and Successful: Timeri Murari talks to Sue Jane Smock', the *Guardian*, Thursday 16 April 1970, p. 9.

Musel, Robert, 'Race prejudice disturbs Smock', the *Baltimore Afro-American*, Baltimore, Maryland, 20 June 1970, p. 15 (reprinted as 'Sue Jane Smock Professes Art is White Controlled', *Palm Beach Post*, Thursday, 6 August 6, 1970, p. D4).

Nead, Lynda, *Chila Kumari Burman: Beyond Two Cultures*, London: Kala Press, 1995.

Newsome, Rachel, 'Afro Daze', *Dazed & Confused*, No 48, November 1998, pp. 74–80.

Nicodemus, Everlyn, 'Routes to Independence', *Routes*, exhibition catalogue, London: Brunei Gallery, School of Oriental and African Studies, 1999, unpaginated.

Nochlin, Linda, 'Why Have There Been No Great Women Artists?', *Art and Sexual Politics*, edited by Thomas B. Hess and Elizabeth C. Barker, New York: Macmillan, 1973, pp. 1–39.

Odonkor, Mowbray, 'Artist's Statement', *History and Identity*, exhibition catalogue, Norwich, 1991, unpaginated.

Odunlami, Yinka, introduction to *Festac'77: The work of the artists from the United Kingdom and Ireland*, exhibition catalogue, London: UKAFT, 1977, pp. 4–5.

Oguibe, Olu, *Uzo Egonu: An African Artist in the West*, London: Kala Press, 1995.

—— 'Egonu: The Life', *Uzo Egonu: An African Artist in the West*, London: Kala Press, 1995, pp. 11–43.

Organisation for Black Arts Advancement and Learning Activities (OBAALA), *The Black-Art Gallery–It's [sic] Development*, gallery publicity, c. late 1983.

—— *A Statement on Black Art and the Gallery*, gallery publicity, c. late 1983.

Owusu, Kwesi, *The Struggle for Black Arts in Britain*, London: Comedia Publishing Group, 1986.

Palmer, Roger, 'Permindar Kaur', *Four x 4*, exhibition catalogue, Bristol, 1991, unpaginated.

Parkinson, Wenda, *This Gilded African: Toussaint L'Ouverture*, London: Quartet Books, 1978.

Parris, Janette, *The Best of Jeanette Parris*, London: Autograph, 2002.

Parry, Jann, 'The New Britons', *Observer* magazine, 28 November 1971, pp. 17–25.

Piper, Keith, 'Artist's Statement', *Black Art an' done: An Exhibition of Work by Young Black Artists*, exhibition catalogue, Wolverhampton Art Gallery, 1981, unpaginated.

—— foreword to Keith Piper & Marlene Smith, *The Image Employed: The Use of Narrative in Black Art*, exhibition catalogue, Manchester: Cornerhouse, 1987, unpaginated.

——— 'Beating the boy', *Distinguishing Marks*, exhibition catalogue, London: Bloomsbury Galleries, Institute of Education, University of London, 1990, p. 15.

Piper, Keith and Donald Rodney, 'PIPER & RODNEY ON THEORY', two pages of typewritten text to accompany *ADVENTURES CLOSE TO HOME: An Exhibition by Piper & Rodney*, London: Pentonville Gallery, 1987.

Popovic, Caroline, 'The Precarious Life of Art', feature on Winston Branch, ART BEAT, *BWIA Caribbean Beat*, No. 16, November/December 1995, pp. 78–83.

Poupeye, Veerle, 'Ronald Moody', *St. James Guide to Black Artists*, Detroit, St James Press and New York, Schomburg Center, 1997, pp. 363–5.

Rodney, Walter, *The Groundings with my Brothers*, London: Bogle L'Ouverture Publications, 1969.

Rose, David, *A Climate of Fear*, London, Bloomsbury Publishing, 1992.

Rush, Michael, 'Deadpan Appropriation', *Review*, New York, 15 December 1997.

Santacatterina, Stella, 'Veronica Ryan: Compartments/Apart-ments', *Veronica Ryan: Compartments/Apart-ments*, exhibition catalogue, London: Camden Arts Centre, February 1995, pp. 3–5.

Searle, Adrian, 'Chris Ofili heads into the shadows', the *Guardian G2*, 26 January 2010, pp. 19–21.

Serota, Nicholas and Gavin Jantjes, introduction to *From Two Worlds*, exhibition catalogue, London: Whitechapel Art Gallery, 1986, pp. 5–8.

Seton, Marie, 'Prophet of Man's Hope: Ronald Moody and his Sculpture', *The Studio*, January 1950, pp. 26–7.

Simolke, David, 'Winston Branch: A Study in Contrast', *Black Art: an international quarterly*, Vol. 2, No. 2, Winter 1978, pp. 4–8.

Smith, John Thomas, *Vagabondiana or, Anecdotes of Mendicant Wanderers Through the Streets of London; with Portraits of the Most Remarkable Drawn From the Life*, London: Published by the Proprietor and sold by Messrs. J. and A. Arch, Cornhill; Mr Hatchard, Bookseller to the Queen, Piccadilly; and Mr Clark, Bond-Street, 1817.

'*So Anything Goes?*', flyer for event, The Black-Art Gallery, Saturday 28 June 1986.

Solanke, Adeola, 'Juggling Worlds', *From Two Worlds*, exhibition catalogue, London: Whitechapel Art Gallery, 1986, pp. 9–13.

Souza F. N., *India: Myth and Reality Aspects of Modern Indian Art*, exhibition catalogue, Museum of Modern Art, Oxford, 1982.

Stallabrass, Julian, *High Art Lite: The Rise and Fall of Young British Art*, London: Verso, 1999 (fourth edition, 2006).

Stephenson, Veena, 'In Focus', *Bazaar South Asian Arts*, Issue No. 12, 1990, pp. 12–13.

Sulter, Maud, (ed.), *Passion: Discourses on Blackwomen's Creativity*, Hebden Bridge: Urban Fox Press, 1990.

Tawadros, Gilane, 'Black Women [artists] in Britain: A Personal & Intellectual Journey', *Third Text* 15, Summer 1991, pp. 71–6.

—— *Sonia Boyce: Speaking in Tongues*, London, Kala Press, 1997.

Taylor, John Russell, 'Denzil Forrester: World Painter', *Denzil Forrester: Two Decades of Painting*, exhibition catalogue, Bristol: 4 Victoria Street, 2002, unpaginated.

Townsend, Chris, *New Art From London*, London: Thames & Hudson, 2006.

Turner, Alwyn W., *Sense of Doubt: 1976–1979*, 'Race: 'I was born here just like you'', *Crisis? What Crisis?: Britain in the 1970s*. London: Aurum Press, 2008, pp. 205–25.

Wainwright, Leon, 'Aubrey Williams: A Painter in the Aftermath of Painting', *Wasafiri*, Issue no. 59, Autumn 2009, pp. 65–79.

Walker, Alice, *In Search of Our Mothers' Gardens: Womanist Prose*, London: The Women's Press, 1987.

Walmsley, Anne, (ed.), *The Sun's Eye: West Indian Writing for Young Readers*, London: Longmans, Green And Co., 1968.

—— *Guyana Dreaming: the Art of Aubrey Williams*, Sydney, Dangaroo Press, 1990.

—— 'Guyana dreaming in paint', Aubrey Williams obituary, the *Guardian*, Tuesday 1 May 1990, p. 25.

—— *The Caribbean Artists Movement, 1966–1972: A Literary and Cultural History*, London: New Beacon Books, 1992.

—— 'The Caribbean Artists Movement, 1966–1972: A Space and a Voice for Visual Practice', *Transforming the Crown*, exhibition catalogue, New York, 1997, pp. 46–52.

—— *A Postcard Pack of Art of the Caribbean*, Upton, Didcot, Oxfordshire: Goodwill Art Service, 2003.

Walmsley, Anne and Nick Caistor, (eds), *Facing the Sea: A New Anthology*

from the Caribbean Region for Secondary Schools, London: Heinemann, 1986.

Walmsley, Anne and Stanley Greaves, in collaboration with Christopher Cozier, *Art in the Caribbean: An Introduction*, London: New Beacon Books, 2011.

Wason, Sarah (director) and Augustus Casely-Hayford (co-producer), *Chris Ofili*, LWT Programme, 1998.

Whittet, G.S., 'Two New Imagists at the Grabowski', *The Studio*, November 1962, Vol. 164, No. 835, pp. 194–5.

'Wild West London', The Week in Pictures #4, the *Guardian*, 1 September 2001, p. 13.

Withers, Jane, 'Within These Walls', *Guardian Weekend*, 25 November 2000, pp. 59–66.

Younge, Gary, 'Chris Ofili: A bright new wave', *Guardian Weekend* magazine, 16 January 2010, pp. 24–7.

EXHIBITIONS

Continuum, Denis Bowen (South Africa), Max Chapman (United Kingdom), Anthony Underhill (Australia) and Aubrey Williams (British Guiana). Grabowski Gallery, London, 18 October – 12 November 1960.

Image in Revolt, Frank Bowling and Derek Boshier, Grabowski Gallery, London, 5 October – 3 November 1962.

Commonwealth Art Today, Commonwealth Institute Art Gallery, Kensington High Street, London, 7 November 1962 – 13 January 1963.

GALLERY ONE – TEN YEARS, Gallery One, London, 19 August – 6 September 1963.

1st Commonwealth Biennale of Abstract Art, Frank Avray Wilson, James Boswell, Denis Bowen, Leslie Candappa, Max Chapman, George Claessen, Kenneth Coutts Smith, William Culbert, John Drawbridge, Bill Featherston, William Gear, Kamil Khan, Peter Lanyon, John Latham, Ken Moore, William Newcombe, David Partridge, Ahmed Parvez, Victor Pasmore, Michael Rothenstein, Ashu Roy, Ron Russell, Viren Sahai, Charles Spencer, Stapleton, Brian Wall, Aubrey Williams, Nancy Wynne-Jones and Bryan Wynter. Commonwealth Institute Art Gallery, Kensington High Street, London, 19 September – 13 October 1963.

Six Indian Painters, Gajanan D. Bhagwat, Balraj K. Khanna, Yashwant Mali, S. V. Rama Rao, Lancelot Ribeiro and Ibrahim Wagh. Tagore India Centre, London, 9–28 November 1964.

Avinash Chandra, Hamilton Galleries, London, 10–27 March 1965 .

Balraj Khanna, New Vision Centre, London, 18 October – 6 November 1965.

Appointment With Six, Aubrey Williams showing alongside Gwen Barnard, Pip Benveniste, Oswell Blakeston, Max Chapman and A. Oscar. Arun Art Centre, Arundel, West Sussex, 19 October – 5 November 1966.

Contemporary African Art, Camden Arts Centre, London, 10 August – 8 September 1969.

Caribbean Artists in England, Althea Bastien, Winston Branch, Owen R. Coombs, Karl Craig, Daphne Dennison, Art Derry, Errol Lloyd, Donald Locke, George Lynch, Althea McNish, Ronald Moody, Keith Simon, Vernon Tong, Ricardo Wilkins, Aubrey Williams, Llewellyn Xavier and Paul Dash (unlisted). Commonwealth Art Gallery, Kensington High Street, London, 22 January – 14 February 1971.

The Recent Paintings of Winston Branch, Carl Van Vechten Gallery, Fisk University, Nashville, Tennessee, 14 October – 9 November 1973.

Frank Bowling, Center for Inter-American Relations, Park Avenue, New York, 28 November 1973 – 13 January 1974.

Winston Branch: Bilder 1976/77, DAAD, Berlin.

Festac'77: The work of the artists from the United Kingdom and Ireland. Winston Branch, Mercian Carrena, Uzo Egonu, Armet Francis, (Emmanuel) Taiwo Jegede, Neil Kenlock, Donald Locke, Cyprian Mandala, Ronald Moody, Ossie Murray, Sue Smock, Lance Watson and Aubrey Williams. Lagos, Nigeria, 1977.

Afro-Caribbean Art, Mohammed Ahmed Abdalla, Keith Ashton, Colin Barker, Lloyd George Blair, Frank Bowling, Linward Campbell, Jan Connell, Dam X, D. Dasri, Horace de Bourg, Gordon de la Mothe, Daphne Dennison, Art Derry, Barbara Douglas, Reynold Duncan, Anthony Gidden, Lubaina Himid, Merdelle Irving, Siddig El N'Goumi, Anthony Jadunath (his name appeared in the catalogue as Jadwnagh), Emmanuel Taiwo Jegede, Donald Locke, G. S. Lynch, Errol Lloyd, Cyprian Mandala, Althea McNish, Nadia Ming, Lloyd Nelson, Eugene Palmer, Bill Patterson, Rudi Patterson, Shaigi Rahim, Orville Smith, Jeffrey Rickard Trotman, Adesose Wallace, Lance Watson and Moo Young. Drum Arts Centre,

Artists Market, 52 Earlham Street, London, WC2, 27 April – 25 May 1978.

Rainbow Art Group, Action Space, London, 22 May – 9 June 1979.

Exhibition of Paintings by IAUK Indian Artists living in U.K, Yeshwant Mali, Prafulla Mohanti, Lancelot Ribeiro, Suresh Vedak, Ibrahim Wagh and Mohammad Zakir. Burgh House Museum, New End Square, Hampstead, London NW3, 27 January – 24 February 1980.

Balraj Khanna: Paintings, October Gallery, London, 16 April – 10 May 1980.

Black Art an' done: An Exhibition of Work by Young Black Artists, Eddie Chambers, Dominic Dawes, Andrew Hazel, Ian Palmer and Keith Piper. Wolverhampton Art Gallery, 9–27 June 1981.

India: Myth and Reality Aspects of Modern Indian Art, M F Husain, F N Souza, Satish Gujral, S H Raza, Akbar Padamsee, Ram Kumar, Mohan Samant, Tyeb Mehta, K G Subramanyan, Krishen Khanna, A Ramachandran, Bikash Bhattacharjee, Jogen Chowdhury, Rameshwar Broota, Ranbir Singh Kaleka, Gieve Patel, Sudhir Patwardhan, Nalini Malani, Mrinalini Mukherjee and Anish Kapoor. Museum of Modern Art, Oxford, 1982.

The Pan-Afrikan Connection (or in some instances, *The Pan-Afrikan Connection)* was title given to, or included in most of a series of exhibitions that took place between 1982 and 1984, each with a slightly differing line-up of contributing artists that included Eddie Chambers, Dominic Dawes, Andrew Hazell, Claudette Johnson, Wenda Lesley, Ian Palmer, Keith Piper, Donald Rodney, Marlene Smith and Janet Vernon. These exhibitions are marked with an asterix.

* Eddie Chambers, Dominic Dawes, Claudette Johnson, Wenda Leslie and Keith Piper. Africa Centre, London, 4 May–4 June 1982.

* Eddie Chambers, Dominic Dawes, Wenda Leslie, Keith Piper and Janet Vernon. Ikon Gallery, Birmingham, 27 June – 18 July 1982.

* Eddie Chambers, Keith Piper and Donald Rodney, Faculty of Art and Design, Trent Polytechnic, Nottingham, 25 – 29 October 25 1982.

* Eddie Chambers, Claudette Johnson, Keith Piper and Donald Rodney. 35 King Street Gallery, Bristol, 17–30 November 1982.

* *Beyond The Pan-Afrikan Connection*, Eddie Chambers and Keith Piper. Hexagon Gallery, Midlands Arts Centre, Birmingham, 7 January – 3 February 1983.

* Eddie Chambers, Claudette Johnson, Keith Piper and Donald Rodney. Midland Group Nottingham, 15 January – 12 February 1983.

* Eddie Chambers, Claudette Johnson, Wenda Leslie, Keith Piper, Donald

Rodney and Janet Vernon. Herbert Art Gallery, Coventry, 20 February – 20 March 1983.

* Eddie Chambers, Keith Piper and Donald Rodney. Africa Centre, London, 4 May – 2 June 1983.

Creation for Liberation, First Open Exhibition of Contemporary Black Art in Britain, St Matthew's Meeting Place, Brixton, London, 20–30 July 1983.

Heart in Exile, Tyrone Bravo, Vanley Burke, Pogus Caesar, Dee Casco, Eddie Chambers, Adrian Compton, Shakka Dedi, Olive Desnoes, Terry Dyer, Carl Gabriel, Funsani Gentiles, Anum Iyapo, George Kelly, Cherry Lawrence, Ossie Murray, Pitika Ntuli, Joseph Olubu, Keith Piper, Barry Simpson, Marlene Smith, Wayne Tenyue and someone going under the name 'Woodpecker'. The Black-Art Gallery, London, 4 September – 2 October 1983.

Five Black Women Artists, Sonia Boyce, Lubaina Himid, Claudette Johnson, Houria Niati and Veronica Ryan. Africa Centre, London, 6 September – 14 October 1983.

Black Woman Time Now, Brenda Agard, Sonia Boyce, Chila Burman, Jean Campbell, Margaret Cooper, Elizabeth Eugene, Lubaina Himid, Claudette Johnson, Mumtaz Karimjee, Cherry Lawrence, Houria Niati, Ingrid Pollard, Veronica Ryan, Andrea Telman and Leslee Wills. Battersea Arts Centre, London, November 30 – December 31 1983.

* *An Exhibition of Radical Black Art*, The Blk. Art Group, Battersea Arts Centre, London, 1–26 February 1984.

* *An Exhibition of Radical Black Art*, The Blk. Art Group, Winterbourne House, The University of Birmingham, 6 February – 1 March 1984.

Second Creation for Liberation Open Exhibition, Brixton Art Gallery, Brixton, London, 17 July – 8 August 1984.

Into the Open: New Paintings Prints and Sculptures by Contemporary Black Artists, Clement Bedeau, Sonia Boyce, Eddie Chambers, Pogus Caesar, Shakka Dedi, Uzo Egonu, Lubaina Himid, Gavin Jantjes, Claudette Johnson, Tom (as he was then known) Joseph, Juginder Lamba, Bill Ming, Tony Moo Young, Ossie Murray, Houria Niati, Ben Nsusha, Pitika Ntuli, Keith Piper, Ritchie Riley, Veronica Ryan, and Jorge Santos. Mappin Art Gallery, Sheffield, 4 August – 9 September 1984.

Room at the Top, Sonia Boyce, Gerard de Thame, Mary Mabbutt, Paul Richards and Adrian Wiszniewski. Nicola Jacobs Gallery, 9 Cork Street, London. 6 February – 9 March 1985.

Mirror Reflecting Darkly, Brenda Agard, Zarina Bhimji, Chila Burman, Jennifer Comrie, Novette Cummings, Valentina Emenyeonu, Carole Enahoro, Elizabeth Jackson, Lalitha Jawah Irilal, Rita Keegan, Christine Luboga, Sue McFarlane, Olusola Oyeleye, Betty Vaughan Richards, Enyote Wanogho and Paula Williams. Brixton Art Gallery, London, June 18 – July 6 1985.

3rd Creation for Liberation Open Exhibition of Contemporary Art by Black Artists, GLC Brixton Recreation Centre, Brixton, London, 12 July – 3 August 1985.

The Thin Black Line, Brenda Agard, Chila Kumari Burman, Sutapa Biswas, Sonia Boyce, Lubaina Himid, Claudette Johnson, Ingrid Pollard, Veronica Ryan, Marlene Smith, Jennifer Comrie and Maud Sulter. Institute of Contemporary Arts (ICA), London, 15 November 1985 – 26 January 1986.

The First White Christmas and Other Empire Stories, Donald Rodney. Saltley Print & Media, Birmingham (S.P.A.M.). The exhibition opened on 9 December 1985, closing date unknown.

Some of Us Are Brave All of Us Are Strong, Jo Addo, Brenda Agard, Simone Alexander, Sonia Boyce, Lubaina Himid, Amanda Holiday, Clare Joseph, Eve-I Kadeena, Mowbray Odonkor, Marlene Smith, Maud Sulter and Audrey West. The Black-Art Gallery, London, 13 February – 15 March 1986.

Third World Within: An exhibition of the work of AfroAsian Artists in Britain. Rasheed Araeen, Saleem Arif, David A Bailey, Sutapa Biswas, Avtarjeet Dhanjal, Uzo Egonu, Mona Hatoum, Merdelle Irving, Gavin Jantjes, Houria Niati, Keith Piper and Kumiko Shimizu. Brixton Art Gallery, London, 31 March – 22 April 1986.

Unrecorded Truths, Brenda Agard, Simone Alexander, David A. Bailey, Sutapa Biswas, Sonia Boyce, Allan deSouza, Keith Piper, Donald Rodney and Marlene Smith. Lubaina Himid at The Elbow Room, London, 16 April – 16 May 1986

Caribbean Art Now: Europe's first exhibition of contemporary Caribbean art, Commonwealth Institute Art Gallery, Kensington High Street, London, 17 June – 4 August 1986.

From Two Worlds, Rasheed Araeen, Saleem Arif, Franklyn Beckford, Zadok Ben-David, Zarina Bhimji, The Black Audio Film Collective, Sonia Boyce, Sokari Douglas Camp, Denzil Forrester, Lubaina Himid, Gavin Jantjes,

Tam Joseph, Houria Niati, Keith Piper, Veronica Ryan and Shafique Uddin. Whitechapel Art Gallery, London, 30 July – 7 September 1986.

Caribbean expressions in Britain: an exhibition of contemporary art organised by Leicestershire Museums, Art Galleries and Records Service and selected by Pogus Caesar, Bill Ming and Aubrey Williams in celebration of *Caribbean Focus 1986*. Leicestershire Museum and Art Gallery, New Walk, Leicester, 16 August – 28 September 1986.

Conversations: An Exhibition of work by Sonia Boyce, The Black-Art Gallery, 3 September – 4 October 1986.

Recent Paintings, Sutapa Biswas. Horizon Gallery, London, 17 June – 11 July 1987.

Sonia Boyce, Air Gallery, London, 11 December 1986 – 25 January, 1987.

Double Vision: An exhibition of contemporary Afro-Caribbean Art, Franklyn Beckford, Margaret Cooper, Uzo Egonu, Amanda Hawthorne, Lee Hudson Simba, Debbie Hursefield, Tam Joseph, Johney Ohene, Keith Piper, Madge Spencer and Gregory Whyte. Cartwright Hall, Bradford, 8 November 1986 – 4 January 1987.

Sekiapu: Nigerian Masquerade With Sculpture by Sokari Douglas Camp, The Africa Centre, Covent Garden, London, 12 June – 2 July 1987.

The Image Employed: The use of narrative in Black art. Simone Alexander, Zarina Bhimji, Sutapa Biswas, Sonia Boyce, Chila Kumari Burman, Eddie Chambers, Jennifer Comrie, Amanda Holiday, Claudette Johnson, Tam Joseph, Trevor Matthison and Eddie George, Mowbray Odonkor, Keith Piper, Donald G Rodney, Marlene Smith, and Allan deSouza. Cornerhouse, Manchester, 13 June – 19 July 1987.

ADVENTURES CLOSE TO HOME: An Exhibition by Piper & Rodney, Pentonville Gallery, London, 6 August – 5 September 1987.

Creation for Liberation Open Exhibition: Art by Black Artists, Brixton Village, Brixton, London, 7 October – 17 November 1987.

From Modernism to Postmodernism - Rasheed Araeen: A Retrospective: 1959–1987, Ikon Gallery, Birmingham, 21 November 1987 – 9 January 1988.

Sight•Seers: Visions of Afrika and the diaspora. Part Two of Eye-Sis • Afrikan Women's Photography, Afia Yekwai, Elizabeth Hughes, Ifeoma Onyefulu, Jheni Arboine and June Reid. The Black-Art Gallery, London, 3–19 December 1987.

The Essential Black Art, Rasheed Araeen, Zarina Bhimji, Sutapa Biswas, Sonia

Boyce, Eddie Chambers, Allan de Souza, Mona Hatoum, Gavin Jantjes and Keith Piper. Chisenhale Gallery, London, 5 February – 5 March 1988.

Sonia Boyce: Recent Work, New Gallery, Whitechapel Art Gallery, London, 13 May – 26 June 1988.

Alali: sculpture by Sokari Douglas Camp, Bluecoat Gallery, Liverpool, 28 May – 2 July 1988 and City of Plymouth Museums & Art Gallery, Plymouth, 23 July – 3 September 1988.

Black Art: Plotting the Course, Oldham Art Gallery October 22 – December 3 1988 and touring.

The Other Story: Afro-Asian Artists in Post-War Britain, Rasheed Araeen, Saleem Arif, Frank Bowling, Sonia Boyce, Eddie Chambers, Avinash Chandra, Avtarjeet Dhanjal, Uzo Egonu, Iqbal Geoffrey, Mona Hatoum, Lubaina Himid, Gavin Jantjes, Balraj Khanna, Donald Locke, David Medalla, Ronald Moody, Ahmed Parvez, Ivan Peries, Keith Piper, A J Shemza, Kumiko Shimizu, F N Souza, Aubrey Williams and Li Yuan Chia. Curated by Rasheed Araeen for the Hayward Gallery, London, 29 November 1989 – 4 February 1990.

In Focus, Horizon Gallery, London. Bhajan Hunjan, Chila Kumari Burman, Shanti Thomas and Jagjit Chuhan, 14 February – 2 March 1990; Mumtaz Karimjee, Zarina Bhimji, Nudrat Afza and Pradipta Das, 7 – 23 March 1990; Mali, Shaffique Udeen, Sohail and Shareena Hill; 28 March – 13 April 1990; Suresh Vedak, Amal Ghosh, Prafulla Mohanti and Ibrahim Wagh, 24 January–9 February 1990.

The Potter's Art: Ceramics by Chris Bramble, Jon Churchill, Tony Ogogo, and Madge Spencer, The Black-Art Gallery, London, 7 February – 24 March 1990.

Let the Canvas Come to Life With Dark Faces. Herbert Art Gallery, Coventry, 14 April – 29 May 1990 and touring.

Distinguishing Marks: Sonia Boyce, Allan deSouza, Shaheen Merali, Pitika Ntuli and Keith Piper. Bloomsbury Galleries, Institute of Education, University of London, London, 22 May – 9 June 1990.

Mali, Horizon Gallery, London, 29 August – 21 September 1990.

'Ask me no Question.... I tell you no lie', An exhibition of Painting & Sculpture Dedicated to the memory of Jo Olubo, The Black-Art Gallery, London, 6 September – 20 October 1990.

Denzil Forrester: Dub Transition, A Decade of Paintings 1980–1990, Harris

Museum & Art Gallery, Preston, 22 September – 3 November 1990 and touring.

Interrogating Identity, Rasheed Araeen, Rebecca Belmore, Nadine Chan, Albert Chong, Allan de Souza, Jamelie Hassan, Mona Hatoum,. Roshini Kempadoo, Glenn Ligon, Whitfield Lovell, Lani Maestro, Lillian Mulero, Ming Mur-Ray, Keith Piper, Ingrid Pollard, Donald Rodney, Yinka Shonibare and Gary Simmons. Gray Art Gallery and Study Center, New York University, 12 March – 18 May 1991.

History and Identity: Seven Painters, Said Adrus, Medina Hammad, Godfrey Lee, Mowbray Odonkor, Eugene Palmer, Tony Phillips and Lesley Sanderson. Norwich Gallery, Norwich, 16 March – 11 May 1991.

Keith Piper, Step into the Arena: Notes on Black Masculinity & The Contest of Territory, Rochdale Art Gallery, 3 May – 1 June 1991.

Four X 4, Shaheen Merali, Houria Niati, Sher Rajah and Lesley Sanderson, Harris Museum and Art Gallery, Preston, 8 September – 17 October 1991; Oso Audu, Val Brown, Stephen Forde and Rita Keegan, Wolverhampton Art Gallery, 21 September – 2 November 1991; Medina Hammad, Richard Hylton, Tony Phillips and Folake Shoga, The City Gallery, Leicester, 9 October – 16 November 1991; Permindar Kaur, Virginia Nimarkoh, Alistair Raphael and Vincent Stokes, Arnolfini, Bristol, 12 October – 24 November 1991. A fifth exhibition, featuring several installations, presented at the Preston, Wolverhampton, Leicester and Bristol venues, was titled *The Four X Retrospective* and was shown at The Castle Museum Nottingham, 18 January – 1 March 1992.

Colours of Asia, Bhajan Hunjan, Kary Ka-che Kwok, Keith Khan, Samena Rana, Tehmina Shah, Veena Stephenson, and Ali Medhi Zaidi. The Black-Art Gallery, London, 1 February – 7 March 1992.

Barclays Young Artist Award 1992, Richard Ducker, Janice Howard, Andrew Kearney, Gabriel Klasmer, Joanna Lawrance, Lisa Richardson, Stefan Shankland, Yinka Shonibare and Mari Tachikawa. Serpentine Gallery, London, 5 February – 8 March, 1992.

Crossing Black Waters, Said Adrus, Anand Moy Banerji, Arpana Caur, Allan deSouza, Nina Edge, Sushanta Guha, Bhajan Hunjan, Manjeet Lamba, Shaheen Merali, Quddus Mirza, Samena Rana, Anwar Saeed and Sashidharan. City Gallery, Leicester, March 1992.

Zarina Bhimji: I will always be here, Ikon Gallery, Birmingham, 4 April – 9 May 1992 and touring.

In This Skin: Drawings by Claudette Johnson, The Black-Art Gallery, 27 May – 11 July 1992.

Black People and the British Flag, Cornerhouse, Manchester, May 8 – June 13 1993 and touring.

Goldsmiths B.A. Fine Art Nineteen 93, Goldsmiths College, 25–27 June 1993.

Faisal Abdu'Allah: Censored! From Nigger to Nubian, 198 Gallery, London, 10 June – 10 July 1993.

Transition of Riches, Birmingham City Museum and Art Gallery, 2 September – 14 November 1993 and touring (part of *South Asian Contemporary Visual Arts Festival*, September – December 1993).

Beyond Destination: film, video and installation by South Asian artists, Maya Chowdhry, Sutapa Biswas, Alnoor Dewshi, Khaled Hakim, Shaheen Merali, Sher Rajah, Alia Syed and Tanya Syed. Ikon Gallery, Birmingham, 16 September – 19 October 1993.

Disrupted Borders: An intervention in definitions of boundaries, Shahidul Alam, Emily Anderson, Monika Baker, Karl Beveridge, Sutapa Biswas, Kaucyita Brooke, Sheba Chhachhi, Carol Conde, Darrel Ellis, Jamelie Hassan, Doug Ischar, Jorma Puranen, Samena Rana, Renee Tobe and Millie Watson. Arnolfini, Bristol, 18 September – 7 November 1993 and touring.

Eugene Palmer, Norwich Gallery, 15 November – 17 December 1993 and touring.

Double Dutch, Yinka Shonibare. Centre 181 Gallery, London, 2–25 February 1994.

Veronica Ryan: Compartments/Apart-ments, Camden Arts Centre, London, February 1995.

Mirage: Enigmas of Race, Difference and Desire, Lyle Ashton Harris, Sonia Boyce, Nina Edge, Ronald Fraser-Munro, Mario Gardner, Edward George and Trevor Mathieson, Renée Green, Isaac Julien, Keith Khan, Marcus Kuiland-Nazario, Marc Latamie, Susan Lewis, Glenn Ligon, Steve McQueen, Sarbjit Samra and Carmelita Tropicana. ICA, London, 12 May – 16 July 1995.

Seven Stories About Modern Art in Africa, Whitechapel Art Gallery, London, 27 September – 26 November 1995.

Africa: the Art of a Continent, Royal Academy of Arts, London, 4 October 1995 – 21 January 1996.

British Art Show 4, Manchester venues: Cornerhouse, Upper Campfield Market, Castlefield Gallery, City Art Galleries, Manchester Metropolitan

Gallery, the Chinese Arts Centre and the Whitworth Gallery, 12 November 1995 – 4 February 1996 and touring.

Cold Comfort, Permindar Kaur. Ikon Gallery, Birmingham, 16 May – 22 June 1996.

Permindar Kaur Cold Comfort, Mead Gallery, Warwick Arts Centre, University of Warwick, 25 May – 29 June 1996.

Frank Bowling: Bowling on Through the Century, Leicester City Gallery, 11 September – 12 October 1996; Gallery II, University of Bradford, 13 January – 7 February 1997; De La Warr Pavilion, Bexhill-on-Sea, 27 February – 31 March 1997; South Hill Park, Bracknell, 5 April – 10 May 1997; Midlands Arts Centre, 14 June – 27 July 1997; and Herbert Art Gallery and Museum, Coventry, 6 September – 26 October 1997.

Rhapsodies in Black: Art of the Harlem Renaissance, Hayward Gallery, London, 19 June – 17 August 1997 and touring

Documenta X, *Exhibition of contemporary art*, Kassel, Germany, 21 June – 28 September 1997.

Trade Routes: History and Geography, 2nd Johannesburg Biennale 1997, Artistic Director Okwui Enwezor, 12 October 1997 – 18 January 1998.

Transforming the Crown: African, Asian and Caribbean Artists in Britain 1966–1996, Faisal Abdu'Allah, Said Adrus, Ajamu, Henrietta Atooma Alele, Hassan Aliyu, Marcia Bennett, Zarina Bhimji, Sutapa Biswas, Sylbert Bolton, Sonia Boyce, Winston Branch, Vanley Burke, Chila Kumari Burman, Sokari Douglas Camp, Anthony Daley, Allan deSouza, Godfried Donkor, Nina Edge, Uzo Egonu, Rotimi Fani-Kayode, Denzil Forrester, Armet Francis, Joy Gregory, Sunil Gupta, Lubaina Himid, Bhajan Hunjan, Meena Jafarey, Gavin Jantjes, Emmanuel Taiwo Jegede, Claudette Elaine Johnson, Mumtaz Karimjee, Rita Keegan, Fowokan George Kelly, Roshini Kempadoo, Juginder Lamba, Errol Lloyd, Jeni McKenzie, Althea McNish, David Medalla, Shaheen Merali, Bill Ming, Ronald Moody, Olu Oguibe, Eugene Palmer, Tony Phillips, Keith Piper, Ingrid Pollard, Franklyn Rodgers, Veronica Ryan, Lesley Sanderson, Folake Shoga, Yinka Shonibare, Gurminder Sikand, Maud Sulter, Danijah Tafari, Geraldine Walsh, and Aubrey Williams. Donald Rodney was included in the catalogue, but his work was not in the exhibition itself. Studio Museum in Harlem, New York, 14 October, 1997 – 15 March, 1998; Bronx Museum of the Arts, 15 October, 1997 – 15 March, 1998; Caribbean Cultural Center, *Picturing England: The Photographic Narratives of Vanley Burke*, 16 October 1997 – 15 March 1998.

Anwar Shemza, Birmingham Museum and Art Gallery, 12 November 1997 – 1 February 1998.

Chris Ofili, Southampton City Art Gallery, 9 April – 31 May 1998 and touring.

Tam Joseph: This is History, Mappin Art Gallery, Sheffield, 7 March – 19 April 1998 and touring.

Aubrey Williams, Whitechapel Art Gallery, 12 June – 16 August 1998.

The Turner Prize 1998, An Exhibition of Work by the Shortlisted Artists, Tate Britain, London, 28 October 1998 – 10 January 1999.

Routes, Godfried Donkor, Juginder Lamba, Hew Locke, Johannes Phokela and Frances Richardson. Brunei Gallery, School of Oriental and African Studies, London, 22 January – 26 March 1999.

Steve McQueen, Institute of Contemporary Arts, London, 30 January – 21 March 1999 and Kunsthalle, Zürich, 12 June – 15 August 1999.

Slave to Champ, Godfried Donkor. The Art Exchange Gallery, Nottingham, 1–31 October 1999.

The Turner Prize 1999: An Exhibition of Work by the Shortlisted Artists, Tate Britain, London, 20 October 1999 – 5 February 2000.

Tariq Alvi, Whitechapel Art Gallery, London, 12 January – 4 March 2001.

Denzil Forrester: Two Decades of Painting, 4 Victoria Street, Bristol, 4 June – 6 July, 2002.

Documenta XI, Exhibition of contemporary art, Kassel, Germany, 8 June – 15 September 2002.

Ronald Moody 1900 - 1984: A Reputation Restored, Tate Britain, London, 24 March – 30 May 2003.

Fault Lines: Contemporary African Art and Shifting Landscapes, part of the 50th International Art Exhibition, La Biennale de Venezia, *Dreams and Conflicts: The Dictatorship of the Viewer*, 15 June – 2 November 2003.

Eugene Palmer: Index, Wolsey Art Gallery, Christchurch Mansion, Ipswich, 17 January – 28 March 2004.

Archive Season: Zarina Bhimji, INIVA, London, 28 January – 6 March 2004.

Africa Remix: Contemporary Art of a Continent, Hayward Gallery, London, 10 February – 17 April 2005.

Hew Locke, New Art Gallery, Walsall, 29 April – 26 June 2005.

Barbara Walker: Louder Than Words, Unit 2 Gallery, London Metropolitan University, 18 November – 16 December 2006.

Next We Change Earth, Said Adrus, Elshaday Berhane, Michael Forbes,

Samson Kambalu, Harjeet Kaur, Hetain Patel, Keith Piper, Nazir Tanbouli, Andrew Wright, Gary Stewart, Trevor Mathison and Obinna Nwasu. New Art Exchange, Nottingham, 6 September – 26 October 2008.

Chris Ofili, Tate Britain, London, 27 January – 16 May 2010

Lynette Yiadom-Boakye: Any Number of Preoccupations, Studio Museum in Harlem, New York, 11 November 2010 – 13 March 2011.

RCA Black, Henry Moore Galleries, London, Faisal Abdu'Allah, Tessa Alexis, Charlie Allen, Catherine Anyango, Yemi Awosile, Kevin Bickham, Frank Bowling OBE, RA, Simone Brewster, Ndidi Ekubia, Joy Gregory, Paul Jones, Taslim Martin, Ekua McMorris, Althea McNish, Edward Niles, Darren Norman, Harold Offeh, Lawson Oyekan, Eileen Perrier, Caroline 'Booops' Sardine, Emamoke Ukeleghe and Barrington Watson. Royal College of Art, London, 31 August – 6 September 2011.

Migrations: Journeys into British Art, including work by Rasheed Araeen, Black Audio Film Collective, Frank Bowling OBE, RA, Sonia Boyce MBE, Avinash Chandra, Mona Hatoum, Lubaina Himid MBE, Kim Lim, Yuan-chia Li, Steve McQueen OBE, CBE, David Medalla, Ronald Moody, Rosalind Nashashibi, Keith Piper, Donald Rodney, Zineb Sedira, Anwar Jalal Shemza, Francis Newton Souza and Aubrey Williams. Tate Britain, London, 31 January – 12 August 2012.

We Face Forward: Art from West Africa Today, Manchester City Galleries, Whitworth Art Gallery and Gallery of Costume, Manchester, 2 June – 16 September 2012.

Restless Ribeiro: An Indian Artist in Britain, Asia House, London, 24 May – 29 June 2013.

WEB PAGES CITED

Archives Hub, *Africa 95*. Available at archiveshub.ac.uk/features/050527r1.html (accessed 27 February 2013).

Art Institute Chicago, 'Zarina Bhimji: Out of Blue'. Available at www.artic.edu/exhibition/zarina-bhimji-out-blue (accessed 19 March 2013).

Bhimji, Zarina, *I will always be here*, installation. Available at www.zarina-bhimji.com/dspseries/4/1BW.htm (accessed 15 August 2013).

Birmingham Museums and Art Gallery, *The Wall*, oil painting. Available at www.bmagic.org.uk/objects/1998P81 (accessed 11 February 2013).

Luxonline, *The Nightingale*, digital video by Grace Ndiritu. Available at www.luxonline.org.uk/artists/grace_ndiritu/the_nightingale.html (accessed 4 October 2013).

Margaret Thatcher Foundation, 'Rather swamped', TV interview. Available at www.margaretthatcher.org/document/103485 (accessed 3 March 2013).

Piper, Keith, *The Nation's Finest*, video, 7 minutes, 1990. Available at http://vimeo.com/85809559 (accessed 20 March 2014).

Quadri, Saleem. A., 'Drawing into discovery, a personal account'. Available at www.saleem-arif-quadri.co.uk/ (accessed 3 March 2013).

Index